ART

MUSIC

AND

LITERATURE

1897–1902

ART
MUSIC
AND
LITERATURE
1897–1902

Theodore Dreiser

Edited by Yoshinobu Hakutani

University of Illinois Press
Urbana and Chicago

Library of Congress Cataloging-in-Publication Data
Dreiser, Theodore, 1871–1945.
Art, music, and literature, 1897–1902 / Theodore Dreiser ;
edited by Yoshinobu Hakutani.
p. cm.
Includes bibliographical references and index.
ISBN 0-252-02625-x (cloth : acid-free paper)
1. Arts, American.
2. Arts, Modern—19th century—United States.
3. Arts, Modern—20th century—United States.
I. Hakutani, Yoshinobu.
II. Title.
NX503.7.D74 2001
700'.973—dc21 00-009791

C 5 4 3 2 1

For Naoki, Yoshiki, and Jackie

Contents

PART 3: LITERARY HERITAGE

Acknowledgments

I would like to thank the following libraries for their courtesy: the Library of Congress; the public libraries of New York, Boston, Chicago, and Cleveland; and the academic libraries at Kent State University, Case Western Reserve University, Oberlin College, and the University of Pennsylvania. The University of Illinois Library, the Northern Illinois University Library, and the Milne Library at the State University of New York at Geneseo granted access to their holdings of *Ainslee's, Cosmopolitan,* and *Munsey's* volumes, respectively. I also wish to thank Debra Lyons of the Interlibrary Services at Kent State University for her assistance in borrowing many magazines and Michiko Hakutani for photographic reproduction of the illustrations.

I am especially grateful to Thomas Riggio, Robert Elias, David Ewbank, and Michiko Hakutani, who read part or all of the manuscript and offered useful comments and suggestions.

Editorial Note

A great majority of Dreiser's freelance magazine articles collected in this volume, twenty-two of thirty-three, have not been republished before. Nine of the remaining eleven were reprinted in my earlier collection, *Selected Magazine Articles of Theodore Dreiser: Life and Art in the American 1890s*, 2 vols. (Rutherford, N. J.: Fairleigh Dickinson University Press, 1985, 1987). The final two, as well as others, were republished in one or more of these collections edited by Orison Swett Marden: *How They Succeeded: Life Stories of Successful Men Told by Themselves* (Boston: Lothrop, 1901); *Talks with Great Workers* (New York: Crowell, 1901); and *Little Visits with Great Americans* (New York: Success Company, 1903). The appearance of Dreiser's magazine articles in these early collections was first noted by John F. Huth Jr. in "Theodore Dreiser, Success Monger," *Colophon* n.s. 3, no. 3 (Summer 1938): 406–10.

Dreiser sometimes republished his articles in his own books. One article in this collection appeared in *Twelve Men* (New York: Boni and Liveright, 1919) and one appeared in *The Color of a Great City* (New York: Boni and Liveright, 1923). On occasion Dreiser would rewrite his published pieces and republish them with new titles, frequently making extensive changes in the process. Under whatever circumstances an article was republished, however, Dreiser or the editor made alterations ranging from minor stylistic alterations to considerable revisions in content.

Unless otherwise indicated, all articles included in this volume originally carried Dreiser's by-line. The text of each article here matches the text of its original publication. I have emended obvious spelling errors, but otherwise have retained the original spelling, capitalization, hyphenation, and punctuation. I have appended notes identifying as

many of Dreiser's now obscure references as possible. I have also provided information on relatively well-known people when I believed that the context was insufficient for their recognition by modern readers. Other notes provide Dreiser's connections to topics raised in the essays or refer readers to other selections in this volume.

Where possible I have reproduced the photographs that accompanied the articles when they were first published and have presented the original captions with some slight modifications for consistency. Inessential photographs and those of poor quality have been omitted.

Introduction

Before Dreiser wrote *Sister Carrie* in 1899 and 1900, he had immersed himself in writing for nearly a decade. As an apprentice the young Dreiser wrote his first newspaper article for the *Chicago Globe* in 1892. For three years he made a living as a newspaper reporter in Chicago, St. Louis, Toledo, Pittsburgh, and finally New York. In 1895 he was working for the *New York World* but Joseph Pulitzer's dictatorial personality and the ferocious working conditions for cub reporters did not suit his temperament. He was appalled at the disillusioning gulf between the facade of such a moralizing paper and the mercilessness of its internal struggle. After only a few months of frustrating, underpaid work, Dreiser left the profession for good.

Although he was ambitious and had a great deal of confidence in his writing ability, he anxiously awaited an opportunity to write as uninhibitedly as possible. His brother Paul Dresser was a partner in the newly established music firm of Howley, Haviland, and Company and the partners thought that a new magazine would effectively promote its music sales. Frederick B. Haviland—still a shareholder of another firm, the Ditson Company, which published a popular magazine called *Musical Record*—argued that another magazine in the field would sell. Although Dreiser knew practically nothing about music, he agreed with Haviland and proposed that he edit the magazine.

Dreiser got the job, which paid as poorly as did the newspaper but rescued him from stress and overwork. He named the magazine *Ev'ry Month*,[1] and its first issue appeared on 1 October 1895 with "Edited and Arranged by Theodore Dreiser" on the cover. Not only was he proud, but he thrived on the work at an office where a vaudevillian could try

out a new song on the piano, as Dreiser vividly described in his freelance magazine article "Whence the Song."

As his editing proceeded, however, he felt restricted by the publishers. When Arthur Henry, to whom *Sister Carrie* was dedicated, asked him in the fall of 1897 whether he was succeeding as an editor, he complained: "I am drawing a good salary. The things I am able to get the boss to publish that I believe in are very few. The rest must tickle the vanity or cater to the foibles and prejudices of readers. From my standpoint, I am not succeeding."[2] Evidently he had a disagreement about editorial policy with the publishers and was forced to resign.[3] During his two short years as editor, Dreiser nonetheless learned the skills required of the magazine trade and seized numerous opportunities to visit studios and editorial offices in the city.

After completing the issue of *Ev'ry Month* for September 1897, he began working as a freelance magazine writer. Between November 1897 and December 1902 he published well over 120 articles, including short stories and poems, which appeared in such popular magazines as *Harper's, Cosmopolitan, Metropolitan, Munsey's, Ainslee's, Demorest's, Success, Truth, Puritan,* and *New Voice.* Although Dreiser did not gain as much freedom of expression as he had wanted and expected in his new role, he amply succeeded in discussing a variety of topics on American life and culture.

A century later, this massive body of writing, unparalleled by that of any other American fiction writer, reveals an exciting era of American society. As a cultural historian, and more importantly as a young individual who was to become a major American writer of the new century, Dreiser made original, innovative judgments on the status of painting, sculpture, architecture, photography, music, and literature.

■ ■ ■

Chicago's Columbian Exposition in 1893 was a glittering example of growing national consciousness not only in wealth but also in art. This historic event showed to the world that the United States had reached its golden age in art and architecture. At the time critics focused on individual national exhibits rather than the totality of the international works or on their overall beauty. John Pierpont Morgan, one of the most eminent financiers and art collectors of the generation, registered

his complaints about the paucity of the French exhibits at the fair. Thomas Beer notes that William Walton's official volume on the fair's art also revealed some disappointment with the entries.[4] Because the architecture was based primarily on the art of the Italian Renaissance, other critics regarded this as an impediment to American originality. Today we recognize that for the first time in the United States, architects, landscape artists, sculptors, and painters worked together as one cultural movement. The significance of all this was beyond anyone's imagination at the time, but artists planning the growth of cities—as they did for the fair—has become a fact of American life.

By the end of the nineteenth century the battle against prudery in American art had gained momentum. As Dreiser's magazine article on this issue shows,[5] a genuinely original work like Frederick MacMonnies's *Bacchante and Child,* often rejected for public display, was seriously considered for the chief monument at the Boston Public Library. As the nation turned into a more open society with urbanized and formally educated people, art came to reflect more of the society's diversity and freedom. Changes in society, of course, have no absolute value in themselves, but national characteristics are just as important as an artist's personality in the crafting of a work. As Dreiser's magazine articles strongly indicate, influences from society cannot create art but they can change it, help it grow—or stifle it. Similarly, native elements in the art of a young nation can be modified by influences from other lands and other ages. This interplay between personality, society, and history characterized a principal development of American visual art of this period. As Dreiser noted, foreign influences were often strong and the borrowing great, yet characteristics of its native culture proved to be the major determinants in forming American art.

Before the Civil War this link between the environment and art was not prevalent at the national level or at least not recognized abroad. Once the war was over and the domestic problems were well under control, American artists suddenly became cosmopolitan, as if to widen their unexplored horizon. This movement coincided with a new era of material expansion accompanied by increasing wealth and leisure. Museums, art institutes, and art magazines sprang up in major American cites. Women attended art schools as they had never done before and, as Dreiser's magazine articles demonstrate, women's influences in

art became far greater in the United States than in any other nation at this time. Young artists were virtually required to spend many of their prime years in Europe, especially Paris. Some leading American artists of the period, such as James Whistler, John Sargent, and Mary Cassatt—the predecessors of the artists Dreiser wrote about—expatriated themselves. Those who returned brought back the latest styles, such as French impressionism.

One would expect that the painters of this new group—Theodore Robinson, John Twachtman, Julian Weir, Abbott Thayer, and Kenyon Cox—would have produced work reflecting a pure European borrowing. But this did not happen; a typical timelag occurred in the arrival of French impressionism in America.[6] When it did arrive, the style was modified by native subject matter and temperament. Robinson and Twachtman did not paint exactly as did Claude Monet and Camille Pissarro. The American impressionists were fond of refinement rather than weight and power. They replaced exoticism and paganism with American optimism and freedom—the idyllic temperaments that mirrored everyday life.

By the nineties, American impressionism, however original it might have been, had failed to keep pace with modern American life. Artists still flocked to Paris, but encountered the conservative impressionist schools of painting. Those who cultivated native material at home were content with photographic realism. Although American women had entered almost every profession, they were still depicted in art as decorative and necessarily virtuous. Paul Bartlett's completely naked *Ghost Dancer,* displayed at the exposition, was admired by some viewers, while Rudolph Maison's proudly naked African American man bouncing on a donkey was only chuckled over by the same audience.[7] In the meantime, Anthony Comstock had declared that "nude paintings and statues are the decoration of infamous resorts, and the law-abiding American will never admit them to the sacred confines of his home."[8] With a few exceptions like the works by Bartlett and MacMonnies, considered major artists, American art of this period was strangely sexless.

Dreiser, however, advocated that a more direct study of men and women in the natural state could artistically be accomplished with the nude. Discussing the works of Fernando Miranda, a Spanish-born sculptor, Dreiser quoted Miranda's defense of the human form in its natural

beauty as "God's greatest work." Dreiser despised those who disliked nudes; with approval he repeated Miranda's comment that they were "misled by narrow conceptions of what is noble and good in the universe."[9] In such remarks, Dreiser hastened to point out the misguided concept of the viewer who was tempted to seek only the prurient from the nude. To Dreiser, clothes distorted and concealed the beauty of the form. The success of MacMonnies's *Bacchante and Child* came from the sculptor's capturing of the mother's momentary pose upon one foot. MacMonnies's motive, Dreiser suggested, "has plainly been to represent the beauty of a sudden and spontaneous movement, and not to glorify either inebriety or wantonness."[10] American art in this period revered gentility and ignored the broader realities of contemporary life. The city was seldom portrayed; if it ever was, one would see only Fifth Avenue. There was indeed little social satire, and humor was not considered a respectable province of art.[11]

The pastoral was a recurring theme, and American art in all its forms still ignored factories, railroads, and all such industrial scenes that gave the face of modern society its character. It was well into the new century before the group of young realists headed by Robert Henri turned to the teeming life of the city. Henri fostered many able pupils whose works are still influential to this day: George Luks, John Sloan, William Glackens, and Everett Shinn.[12] In the last decade of the nineteenth century, however, none of these painters was known in the United States. The nineties produced such iconoclastic writers as Stephen Crane, Frank Norris, Edward Arlington Robinson, and Dreiser, who skillfully rendered their social conscience and feeling for the urban masses. But many American artists—both visual and literary—still lingered on sweetness and light and on the calmness of the old century. They had to wait years for the arrival of the dark realism originating from Francisco de Goya and Honoré Daumier. Again a timelag of at least a decade occurred in America before the literary and art worlds took up realism and naturalism.

Dreiser's interest in the visual arts was on display in his own works— *The Financier* (1915), *A Hoosier Holiday* (1916), *Twelve Men* (1919), *The Color of a Great City* (1923), and *A Gallery of Women* (1929). Dreiser's magazine writing on art in the late nineties had a profound effect on his work for the rest of his career. In the early nineties, however, as his news-

paper writing indicates, his interest in drama was greater than his interest in art. As a struggling reporter, he had an ambition to become a playwright because drama criticism occupied a prominent place in the newspaper and his interest was naturally developed in that direction. Once he had established himself as a magazine editor and contributor, however, he could not help noticing readers' attraction to the colorful illustrations included in popular magazines. The art of engraving was also changing the way monthly magazines were presented. The contents of many magazines, too, reflected a growing sentiment for the aesthetic.

Despite his enthusiasm for the visual arts, Dreiser was by no means an expert in the field. In the beginning, his writings about painting and sculpture betrayed superficiality and exhibited an amateur's unabashed wonder at the vague notion of the beautiful. As he cultivated his taste and learned by visiting studios and making the acquaintance of artists, he became more confident in his commentary. By late 1897 he was already a member of the Salmagundi Club, the most prestigious artists' club in New York. Through such affiliations, he was requested by the painter J. Scott Hartley to compile an album of the work of George Inness, Hartley's father-in-law.[13]

In his contact with artists, Dreiser was always trying to elicit a theory of art to which he felt congenial. Initially he was anxious to resolve the artist's dilemma of reconciling poetry with that newly born child of the times—realism. In "Art Work of Irving R. Wiles," he made a sweeping indictment of realism: "A painter who must needs take a striking situation from every-day life and paint in all details as they would probably be found in real life, is, in a way, photographic and not artistic" (12). Dreiser agreed with Wiles's art for art's sake doctrine; realizing that each of the painter's works was based on "a prosaic enough reality" (13), Dreiser concluded that the artist's sense of beauty came not from reality itself but from imagination. Dreiser brought home this fundamental concept of art in another magazine article. After venturing an analogy with the "idealist" school of George Frederic Watts and Dante Gabriel Rossetti, Dreiser pondered how both the ideal and the real could coexist in the work of Benjamin Eggleston, a portrait painter from Minnesota well known at that time. "Perhaps it would be better to say," Dreiser wrote, "that he has the gift of impart-

ing to subjects realistically treated the poetry of his own nature, thus lifting them far above the level of 'faithful transcripts' of nature and life."[14]

Many of his essays about artists also concerned what was to become a major theme in his own work: the transcendental nexus of humanity and nature. Dreiser was appalled by most artists' blatant hypocrisy: they often formed an exclusive community by severing themselves from nature as well as from humanity. Chiding them for their "anemic," fragile vision, Dreiser pleaded for the artist's liberation from the artificial, indoor life as Walt Whitman did in "Song of Myself." Dreiser's affinity for the strength and roughness of nature buttressed many of his remarks on painting and sculpture. C. C. Curran, an Ohio painter, focused on children digging in the earth, sailing boats, and playing on the green turf and awakened such a responsive mood in Dreiser that he quoted lines from Robert Louis Stevenson's *A Child's Garden of Verses*.[15]

As Dreiser's early short stories, such as "Shining Slave Makers" (1901) and "Nigger Jeff" (1901), intimate, Dreiser was intensely curious about nature's effects on humanity. Lawrence E. Earle's paintings, he noted, abounded with aged, weather-beaten figures that suggested "the wear and nature of the various callings from which they are selected" (93). Every time Dreiser looked at one of Earle's figures, he or she became "a part of the soil and landscape, like the stumps and bushes." The figures "are queer baked products of sun and rain; quaint pleasant old creatures, selected by a feeling mind. In a way they seem to illustrate how subtle are the ways of nature, how well she coats her aged lovers with her own autumnal hue" (94).

These magazine contributions seldom gave a sign of the pessimism that, from time to time, marked his fiction. This might well have been the result of the "success story" pattern Dreiser was asked to follow by the magazines. One must recall Dreiser's disposition of mind during his editorial days. The columns he wrote in *Ev'ry Month* indicate that he was a disciple of Herbert Spencer and interpreted the Spencerian cycle of existence as progress for humanity. He readily applied this theory to the artist's mission in life. Dreiser's faith in the worth of humanity remained unshaken for a long time, as evidenced by the statement he made in 1909

as editor of *The Delineator*. His policy then was to accept only those contributions that were tinged with idealism and optimism and, in the case of a story, with a "truly uplifting character."[16] Earlier, in "Concerning Bruce Crane," Dreiser praised Crane's work as a landscape artist not because it adhered to nature but because it displayed a joyous, hopeful atmosphere. In "E. Percy Moran and His Work," Dreiser cited Moran's view of an artist's function as making life "better, handsomer, more pleasing" (65). In "America's Greatest Portrait Painters," Dreiser surveyed the gifted young painters of the day and came to this conclusion: "Intellectually, they are men of broad minds, and look upon art with clean, wholesome spirits" (74).

Among the visual artists Dreiser became acquainted with in the period, Alfred Stieglitz and William Louis Sonntag Jr. had the strongest influences upon the young writer's emerging aesthetic. At the end of the nineteenth century and well into the new one, the United States was building skyscrapers in earnest while modernists like Alfred Maurer and Max Weber had yet to struggle against academic domination. But the direction in art was clearly signaled: the modernist movement was helped by the radical Robert Henri school and the pioneer leadership of Stieglitz. It is easy to understand why Dreiser was inspired by Stieglitz and Sonntag: both advocated a closer and more harmonious relationship between art and technology than did their predecessors. Just as Henry James modeled his writing after French impressionist painters, Dreiser acquired from Stieglitz and Sonntag the technique of delineating how people delighted in a modern city and yet, when luck turned against them, were baffled by the complexity, impersonality, and loneliness that the city represented.

As Dreiser's essay "A Remarkable Art: Alfred Stieglitz" shows, Stieglitz's principle of photography was making a great impact not only on photographic artists but also on other artists around the country. Dreiser interviewed Stieglitz in the spacious quarters of the New York Camera Club on one late April afternoon in 1902. "Our idea," Stieglitz at once told Dreiser, "was to do the work and force recognition. We are 'photo secessionists'—seceding from that which is conventional. It is a revolution to put photography among the fine arts." To Dreiser's question about the secret of serious photographic

art, Stieglitz responded it was "individualism . . . working out the beauty of a picture as you see it, unhampered by conventionality—unhampered by anything—not even the negative." Dreiser ventured with some hesitation: "But strictly speaking, that is not photography." Stieglitz rejoined: "You admit it is beautiful. . . . Well, then call it by any new name you please" (119). On that afternoon both saw a remarkable scene of the city: "Dark clouds had clustered around the sun; gray tones were creeping over the plateau of roofs; the roar of the city surged up tense, somber and pitiless. 'If we could but picture that mood!' said Mr. Stieglitz, waiving his hand over the city. Then he led the way back to earth" (120).

While Stieglitz's influence was perhaps more obvious in Dreiser's work, Sonntag's influence was so personal that Dreiser wrote a poem about him and published it as an obituary in 1898. Years later Dreiser's magazine article on Sonntag, "The Color of To-Day: William Louis Sonntag," became a chapter in Dreiser's *Twelve Men* under the enigmatic title "W. L. S." Dreiser admits that the sense of insecurity and loneliness that his characters Carrie and Hurstwood experience in Chicago and New York came from his newspaper experience, but his actual portrayal of the scenes could not have been accomplished without Sonntag's ideas.

Dreiser's acquaintance with Sonntag goes back to *Ev'ry Month*. Looking for striking illustrations of city life for the Christmas issue of the magazine, Dreiser paid a visit to Sonntag's studio. He had been attracted to Sonntag not just by reputation but also by his colored depictions of New York at night that appeared in a Sunday newspaper. These drawings, in Dreiser's recollection, "represented the spectacular scenes which the citizen and the stranger most delight in—Madison Square in a drizzle; the Bowery lighted by a thousand lamps and crowded with 'L' and surface cars; Sixth Avenue looking north from Fourteenth Street" (98). Dreiser's fascination with Sonntag—a member of the Ashcan School famous for street scenes—is shown by Dreiser's drawing of Eugene Witla in the novel *The "Genius."*

As Dreiser often emphasized, good coloring was the first element of a successful painting after idea, form, or purpose. What was to become his own use of color in portraying urban scenes—streetlights,

carriages, department stores, restaurants, luxurious garments—was acquired through his contact with Sonntag. One drizzly autumn night Sonntag took Dreiser to such a scene on their way to the theater while they were involved in a serious discussion of art and life:

> He took me to a point where, by the intersection of the lines of the converging streets, one could not only see Greeley Square, but a large part of Herald Square, with its huge theatrical sign of fire and its measure of store lights and lamps of vehicles. It was, of course, an inspiring scene. The broad, converging walks were alive with people. A perfect jam of vehicles marked the spot where the horse and cable cars intersected. Overhead was the elevated station, its lights augmented every few minutes by long trains of brightly lighted cars filled with truly metropolitan crowds.
>
> "Do you see the quality of that? Look at the blend of the lights and shadows in there under the L."
>
> I looked and gazed in silent admiration.
>
> "See, right here before us—that pool of water there—do you get that? Now, that isn't silver-colored, as it's usually represented. It's a prism. Don't you see the hundred points of light?"
>
> I acknowledged the variety of color, which I had scarcely observed before.
>
> "You may think one would skip that in viewing a great scene, but the artist mustn't. He must get that all, whether you notice or not. It gives feeling, even when you don't see it." (108–9)

Above all, what Dreiser learned was a commitment to capture an incisive vision of the changing world at the turn of the twentieth century. Dreiser was also intrigued by Sonntag, in particular, for his amazing versatility. Not only was Sonntag well versed in fiction, drama, music, history, and politics, but he also surprised Dreiser by revealing that he was a highly imaginative and versatile engineer (competent to handle marine, railroad, and other machinery), architect, mathematician, and philosopher. It is little wonder Dreiser was drawn to Sonntag for his unique talents and experiences; during this period Dreiser himself was pursuing his apprenticeship as a journalist of science, technology, agriculture, commerce, politics, and many other fields the new century presented. The intensity and depth of vision Dreiser achieved as a commentator on art and artists was to have a profound influence on his fiction.

■ ■ ■

There is little doubt that the United States was a world leader in twentieth-century music. Few countries could boast the wide popularity American symphony orchestras enjoyed at the close of the century. The United States has also made important and original contributions to music with jazz, the blues, folk music, musicals, and rock and roll, each with roots at least as deep as the early twentieth century.

In the rapid cultural evolution of the 1890s, the musical world faced upheaval. The great force of romanticism was on the wane and the unknown and unpredictable music of the future was beginning to evolve. The new century stood for an age of science and technology and its influences on music were as profound as those of any other field of art.

As the nation's post–Civil War industry grew at a phenomenal rate toward the end of the nineteenth century, the stage was slowly set for the flowering of the arts. The completion of the transcontinental railroad in 1869 and the opening of the West stimulated the impressive growth of business that subsidized music. As native musicians began to travel across the country, musical styles slowly combined into new forms. The traditional choral singing of the East was presented in music festivals in the West, and to a rich opera tradition in Boston and New York was added fine orchestras. Eventually any top American performer could compete with any artist in the world. In New York, where the era of gaudy concerts was coming to an end, the fine arts were being brought to everyone. In "His Life Given Up to Music: Theodore Thomas," Dreiser recounts how Thomas—"the greatest living American leader"—struggled to build a broad base of support for classical music but finally succeeded (135).

A decade earlier the Metropolitan Opera House had made its grand opening in New York, attracting eminent singers from all over the world. Under the leadership of Leopold Damrosch and Anton Seidl, Wagnerian and other German operas began to mold the taste of American audiences hitherto accustomed only to the Italian school.[17] These developments created new listeners but also fostered world-famous American composers such as George Chadwick, Horatio Parker, and Edward McDowell.

At the beginning of the 1890s Americans were still under the spell of German romanticists, but were also responding to Debussy's *Prelude to the Afternoon of a Faun,* composed under the influences of Monet's painting and Stéphane Mallarmé's poem "L'Aprè-midi d'un faune" (1876). About this same time Anton Dvorák arrived in New York and made American composers and musicians aware of the value of native folk music, which up to then had received primarily local attention. The significance of his presence in the United States cannot be underestimated, for only Dvorák recognized the worth of both Native American and African American music at this time. He tried to develop a nationalistic school of music among his American pupils in much the same way he had revived Bohemian folk music in his own country. Other major cities established music auditoriums and opera houses and thus the musical arts attained a stronger hold on the general public. By the end of the century, Los Angeles—one of the youngest cultural centers to emerge—had hosted an opera company from Italy that gave the first American performance of Giacomo Puccini's *La Bohème.*

Despite a severe economic depression, the music of the nineties reflected the otherwise joyful sentiments of the nation. The Spanish-American War of 1898, short though it was, supplied many popular songs. "Hot Time in the Old Town Tonight" was said to have been sung by Theodore Roosevelt's Rough Riders during their attack on San Juan Hill. The Civil War song "When Johnny Comes Marching Home" resurfaced during this war and became popular again during World War I. Other songs of the decade are still remembered, including "Goodbye Dolly Gray" and "Just Break the News to Mother." "On the Banks of the Wabash," the official state song of Indiana, was originally composed by Dreiser's brother Paul Dresser with part of its lyrics written by Dreiser when he was editor of *Ev'ry Month.* The continued popularity of such songs indicates how widely music, regardless of its type, came to be shared by the masses at the end of the century.

Dreiser's commentary on music certainly influenced the choice of subjects for his fiction. *Sister Carrie* most obviously dramatized the career of a country girl who ventured into the world of theater and music and escaped the dreary world of her lover. Less obvious is the unusual respect for women musicians Dreiser demonstrates in the novel that is also evident in his articles. Although his commentary is marred

by condescending attitudes that were typical of his time, he was genu-
inely concerned about the status of the American woman, particularly
the artist, whose unusual restlessness in the 1890s prompted important
cultural changes. But, unlike most writers of the time, Dreiser consis-
tently wondered whether a woman's creative genius was hampered by
being a woman in American society and whether artists of both sexes
could compete on an equal basis.

In "American Women Violinists," Dreiser profiles Flavie Van den
Hende, a Swedish-born American violinist and violoncellist. Dreiser
comments on her "delicacy" in mastering her difficult instrument and
remarks on her "rare musical thought and breadth of conception" (157–
58). When he probes her about reactions to her choice in instruments
she responds only that "'It is all the more creditable that a woman
should be able to master it at all'" (158).

In contrast to his praise for violinists, Dreiser seems unconvinced
about a woman's ability to succeed on the piano, betraying the con-
ventional prejudice of the era. In "American Women Who Are Win-
ning Fame as Pianists," Dreiser calls the piano "a peculiarly difficult
field for women" because its study "is one involving so much labor and
patience and requiring so much innate ability and predisposition for
it" (161). The title of the article, however, does suggest the change in this
situation that would come in the next century—and perhaps Dreiser's
changing attitude as well. Singling out the young Ida Simmons, a ris-
ing star in the field, Dreiser praises her possession of "all the requisites
of a successful pianist,—an artistic temperament, a bright musical in-
telligence, an adequate technic, an abundance of strength, and a capti-
vating feminine delicacy. Her hands were made for the piano. They are
flexible, and possess extraordinary strength for a woman. Their reach,
too, is exceptional" (163).

The objectivity and compassion toward women that would emerge
in Dreiser's novels is apparent in his role as critic. In 1899 alone he pub-
lished seven articles in which he gave "portraits" of women violinists,
pianists, harpists, composers, playwrights, and novelists.[18] Many of his
accounts of these now largely forgotten celebrities merely summarized
their careers. But in "The Story of a Song-Queen's Triumph: Lillian
Nordica," Dreiser provides an incisive analysis of character, discipline,
and artistry. "'Did you ever imagine,'" he asked, "'that people leaped

into permanent fame when still young and without much effort on their part?'" "'I did,'" she replied. "'But I discovered that real fame,— permanent recognition, which cannot be taken away from you,—is acquired only by a lifetime of most earnest labor'" (181).

Dreiser may not have had an ear or a taste for serious music, but no other writer so vividly captured the exuberant spirits of the people involved in the music world of the 1890s as did Dreiser in "Whence the Song." From the perspective of a novelist-to-be, Dreiser envisioned in this piece the age of democracy that was beginning to manifest itself. In music this new way of thinking was reflected in the serious attention the public and critics were paying to women.[19] Further, composers and performers should not be viewed as types and patterns, nor considered embodiments of tradition and convention. As Dreiser emphasized, they should be viewed as individual artists deserving of recognition. The acknowledgment of the rich music native to the country continued this focus on unique compositions and profoundly affected the development of American music in the twentieth century.

■ ■ ■

Dreiser has traditionally been regarded as the most famous American literary naturalist, but more recent criticism suggests he is a unique American realist and modernist as well.[20] Over the generations Dreiser readers have also recognized in his work a strong affinity with American transcendentalist writers like Ralph Waldo Emerson, Margaret Fuller, Henry David Thoreau, and Walt Whitman. In 1948 Allen Tate, an eminent New Critic who apotheosized modernism, called Dreiser, William Faulkner, and Ernest Hemingway the three most important American novelists of the first half of the twentieth century.[21] Without categorizing Dreiser's fiction, Richard Wright, one of the major American novelists Dreiser influenced, called Dreiser the greatest novelist for America as Fyodor Dostoyevsky was for Russia.

Although naturalism and determinism are often attributed to Dreiser's fiction, his freelance writing expressed neither of these doctrines. This does not mean that as a young writer Dreiser was opposed to naturalistic fiction; rather, his work suggests the neutral position he assumed in the battle between realism and romanticism in American literature. In 1894 the newly founded *McClure's Magazine* printed Emile

Zola's defense of himself; Hamlin Garland openly called for a version of realism he coined *veritism*. The literary critic William Roscoe Thayer pronounced the death of realism by citing the achievements of such different writers as Robert Louis Stevenson, Arthur Conan Doyle, and Israel Zangwill. Dreiser was discriminating: he had a strong predilection for Stevenson, as several of his magazine articles suggest.

Dreiser was, indeed, more impressed by a nostalgic writer like Stevenson and a mystic poet of the older generation like Bayard Taylor than he was by a contemporary analytical critic who, Dreiser felt, often smacked of egotism. In "The Real Zangwill," Dreiser assailed the critic and his literary philosophy.[22] Zangwill's rule was that a book should not be criticized for not being some other book, and yet his first criterion was that a book must be worth criticizing. What irritated Dreiser was a dogmatism that underlay Zangwill's standard of judgment. "All that remains," Zangwill said, "is to classify" the work. "It is of such and such a period, such and such a school, such and such merit."[23] Dreiser realized that, in Zangwill's criticism, judgment necessarily preceded classification and analysis. Dreiser argued that what was lacking in such criticism was the heart of a critic. To him, Zangwill's criticism merely demonstrated "the great analytical spirit, useful no doubt, but the world loves an enthusiast better, who criticizes not at all, but seizes upon the first thing to his hands and toils kindly, if blindly, in the thought that his is the great and necessary labor," the principle of art and criticism alike that echoes what Dreiser learned from the artists he interviewed.[24]

Another eminent writer and critic Dreiser interviewed was William Dean Howells, "the Dean of American Letters." Before the interview Dreiser had read *My Literary Passions* and found his image of the great novelist readily confirmed. He found Howells "one of the noblemen of literature"—honest, sincere, and generous.[25] Such laudatory remarks sound incongruous today since it has become legend that the two men never liked each other. It is known from what Dreiser said later that Howells's novels failed to give him a sense of American life. Dreiser confided to one critic: "Yes, I know his books are pewky and damn-fool enough, but he did one fine piece of work, *Their Wedding Journey*, not a sentimental passage in it, quarrels from beginning to end, just the way it would be, don't you know, really beautiful and true."[26] On numerous occasions Dreiser revealed to his friends that *Their Wedding Jour-*

ney was the only work by Howells that he liked,[27] but he did admire Howells for championing young talents. In *Ev'ry Month* and again in *Ainslee's,* Dreiser called Howells a "literary Columbus" for discovering Stephen Crane and Abraham Cahan. Howells's support for Hamlin Garland and Frank Norris is well known, but Howells was blind to *Sister Carrie* and never tried to appreciate Dreiser's work.

To understand Dreiser's change of heart about Howells, one must look into a transformation that took place in Howells's later years. The Howells Dreiser met in New York was not an aloof, genteel novelist, the product of New England culture. A decade earlier Howells had witnessed the suppression of justice in the wake of the Haymarket massacre. With a vehemence reminiscent of Zola, Howells protested against the incident, which he felt destroyed forever "the smiling aspect" of American life. With this social and political upheaval that shook his conscience, Howells became a compassionate socialist thinker. In his interview Howells argued that true happiness cannot be achieved until "the whole human family" becomes happy (226).

While Dreiser was responsive to literary trends and criticism, he was also exploring the period's closer ties to the nineteenth-century American past expressed in myth and legend. In "Historic Tarrytown: Washington Irving," Dreiser tried to visualize the locale of Sleepy Hollow rather than write another biographical sketch of the famous storyteller. Despite his usual excitement over modern technology, Dreiser was vocal in his criticism of such an "incongruous trick" as arc lights with their unseemly glare that had invaded the Hollow road (203). His homage to the American past reached its apogee with a long piece on Nathaniel Hawthorne. As in his essay on Irving, Dreiser revisited the haunting romancer's life with a strong implication of the undesirable effects of the modern era on the town of Salem—railroads, electric lights, and trolleys that "glared upon, and outraged its ancient ways" (228).

In a similar vein Dreiser contributed a detailed account of William Cullen Bryant, his favorite poet. The thrust of Dreiser's commentary was given to Bryant's courageous activities as a journalist and poet during his last thirty-five years in the Long Island town of Roslyn. Dreiser astutely observed that although it was an old settlement with high "hopes and pretensions" years earlier, the town had "faltered and

lagged in the race of modern progress" (260). Dreiser's fondness for the poet is clearly shown by his frequent quotations of Bryant's poetry. Dreiser admired Bryant for "a deep seated, rugged Americanism, wholly unconventionalized by his success in the world" (266). Dreiser could have felt that Bryant's oft-quoted lines from "To a Waterfowl"—"Lone wandering, but not lost" would also refer to Dreiser's own disappointments and hopes as a journalist and future writer. To Dreiser, Bryant was "intrepid, persistent, full of the love of justice, and rich in human sympathies," a simple statement of what were to become his own qualities as a novelist (266).

Dreiser's articles on literary figures concern the two related themes in his own fiction: disillusionment with city life and longing for the beauty of nature. When he turned to contemporary authors, he searched for some transcendental reality beyond material appearances. He was surprised and at the same time gratified to discover that the commercial environment of Wall Street had made no mark on Edmund Clarence Stedman's creative work.[28] The work and career of the travel writer Bayard Taylor, who is forgotten today, provided Dreiser with quiet reflections and warm sentiments. Unlike Stedman, Taylor was born on a farm and struggled for existence in his early years. Much like Dreiser, Taylor was a self-made man, having left his native place in youth and built up a literary career in the city. Taylor, Dreiser learned, was not a materially successful man, and in his old age achieved happiness and peace of mind by retiring to Cedarcroft, his birthplace. The most significant point of this tribute comes toward the end of the essay, where Dreiser, foreshadowing his own characteristic turn of thought, portrays the old writer, who "drew out his rocking chair in the evening, and swayed to and fro as the light faded and sights and sounds gave place to the breath of night and the stars." Dreiser infused the scene with an Emersonian, mystic quality that one finds from time to time in his own fiction: "The pale moonlight flooded all the ground, and leaves grained voices from the wind, and over them all brooded the poetic mind, wondering, awed, and yearning."[29]

Dreiser's affinity to transcendentalism was evident in his writing of this period. As a Thoreauvian naturalist, Dreiser was strongly opposed to the exploitation of animals: the introduction of automobiles gave such a compassionate human being as Dreiser a sense of relief, for watching

clattering horses in the streets was "itself too often an object of real and piteous interest."[30] As a naturalist in the vein of Thoreau and John Burroughs, Dreiser could hardly promote the cause of people's happiness without due consideration for the welfare of other living objects. This is perhaps why Dreiser was curious about the intelligence and efficiency of pigeons when used for secret communications. But even as he expressed his idiosyncratic concern for pigeons, he concluded his essay with Bryant's poem "To a Waterfowl." His expression of sympathy was extended not only to animals but also to plants. Discussing the importance of studying plant roots scientifically, Dreiser illustrated how a microscope could trace down their "infinitesimal . . . threads as light as gossamer, almost—they did not naturally end." "In that unseen part," he envisioned, "there was a friendly union between the life of the plant and the life of the earth, and the latter had given some of itself to course up the hair-like root and become a part of the plant."[31] Based on new research on the relationship of weeds to the soil, Dreiser even pleaded for the preservation of some weeds: "There are weeds that are soil renewers, weeds that are food for man and beast, and weeds without which thousands of acres of our most fertile lands would be wastes to-day."[32]

Such sensitive treatments of plant and animal life in the light of human progress were characteristic of Dreiser the transcendentalist. In the late nineties his interest in this philosophy led to his reading of Emerson's and Thoreau's writings and to his interview with John Burroughs. In one of the two magazine articles Dreiser composed on this contemporary philosopher, "John Burroughs in His Mountain Hut," Dreiser asked him to define success in life and to compare Burroughs's success and that of Jay Gould, Burroughs's boyhood friend. Burroughs remarked, "'I always looked upon achievement in life as being more of a mental than a material matter'" (281). About writing, Burroughs told Dreiser that the most important element is not one's desire to describe objects like birds and trees, but "'enjoyment.'" "'Whenever the subject recurs to me,'" Burroughs stressed, "'it must awaken a warm, personal response. My confidence that I ought to write comes from the attraction which some subjects exercise over me. The work is pleasure and the result gives pleasure'" (284).

Reading the works of American transcendentalists of the past and making the acquaintance of this descendant inspired Dreiser to try his

hand at fiction writing. The compassionate attitude that he began to develop during these years came into full flower in characters like Sister Carrie and Jennie Gerhardt as well as the women featured in the two-volume edition of *A Gallery of Women* (1929).

Dreiser's zeal for women's causes came directly from his journalistic experience. Dreiser was fascinated by the success of women artists, musicians, and writers, as his article on Amelia E. Barr, an energetic English-born American novelist, indicates. He was much more impressed with "a very fine picture of success in letters" in this woman novelist (252), a widow who raised fourteen children through poverty and adversity and wrote thirty-two novels, than with a passion for social reform in the genteel, high-cultural moralist William Dean Howells. In "American Women as Successful Playwrights," Dreiser declared: "There may be spheres of human endeavor from which women will eventually turn away, as being unsuited to their capabilities, but playwriting will not be one." He argued against "that time-worn philosophic sarcasm which says that women have no sense of humor." Reminding that such a notion had long been dispelled by women novelists and poets, he urged the reader to see that "now it is completely annihilated in the realm of dramatic art" (270). Dreiser was eager to tell his audience that women were on the rise in every branch of the arts in the United States.

All in all, Dreiser's magazine articles in this period show a characteristic insight into his material. Whether he was commenting on artists, musicians, or writers, his attitude resulted from his lifelong conviction that "the surest guide is a true and responsive heart."[33] Sympathy and compassion indisputably color his fiction, but his magazine work bears witness to the fact that Dreiser was not the simple commiserator Edward D. McDonald portrayed him to be: in tears, devouring a tragic story in the newspaper.[34] His compassionate appreciation of all stories of human interest cannot be doubted, but Dreiser before *Sister Carrie* also acquired a capacity for detachment and objectivity. Rarely do his magazine essays display passionate outbursts. In effect, Dreiser was a literary realist and modernist in the best sense of the words. These magazine pieces suggest that although he was eager to learn from literary and philosophical sources, he trusted his own vision and portrayed life firsthand.

After 1900 Dreiser's writing fluctuated between naturalism and vitalism, but at the turn of the century Dreiser was clearly a vitalist in his freelance work. This vitalist philosophy was so deeply rooted in the most important period of his development that it likely remained with him for the rest of his career. In his novels Dreiser often writes of the apparently indifferent and uncontrollable forces that sweep over human life, but in reality he does not seem to have abandoned a belief in human beings' capacity to determine their own destiny. Although Dreiser has often been labeled a literary naturalist, his magazine writing suggests that he was, at least in his early years, a naturalist in the vein of Thoreau and Burroughs.

NOTES

1. The complete edition of this magazine has been published: Theodore Dreiser's *Ev'ry Month,* ed. Nancy Warner Barrineau (Athens: University of Georgia Press, 1996).

2. Arthur Henry, *Lodgings in Town* (New York: A. S. Barnes, 1905), 83.

3. Theodore Dreiser, *Twelve Men* (New York: Boni and Liveright, 1919), 101.

4. Thomas Beer, *The Mauve Decade* (New York: Armed Services, 1926), 43.

5. Theodore Dreiser, "The Art of MacMonnies and Morgan," *Metropolitan* 7 (Feb. 1898): 143–51, reprinted in *Selected Magazine Articles of Theodore Dreiser: Life and Art in the American 1890s,* ed. Yoshinobu Hakutani, 2 vols. (Rutherford, N. J.: Fairleigh Dickinson University Press, 1985, 1987), 1:212–17.

6. Sadakichi Hartmann, *A History of American Art* (Boston: L. C. Page, 1901), 160–63, 188.

7. Dreiser wrote about Bartlett in "He Became Famous in a Day," *Success* 2 (28 Jan. 1899): 143–44, reprinted in *Selected Magazine Articles,* 1:242–47.

8. Quoted in Beer, *The Mauve Decade,* 45.

9. Theodore Dreiser, "The Sculpture of Fernando Miranda," *Ainslee's* 2 (Sept. 1898): 113–18, reprinted in *Selected Magazine Articles,* 1:232.

10. Dreiser, "The Art of MacMonnies and Morgan," 1:212.

11. An exception was Randolph Hearst's cartoonist, Homer Davenport, on whose work Dreiser fondly commented in "A Great American Caricaturist," *Ainslee's* 1 (May 1898): 336–41, reprinted in *Selected Magazine Articles,* 1:223–28.

12. Shinn was Dreiser's friend and later became the subject of Dreiser's controversial novel *The "Genius"* (1915). Glackens illustrated Dreiser's magazine article "Whence the Song."

13. See the letters of J. Scott Hartley to Dreiser in the Dreiser Collection, University of Pennsylvania Library, Philadelphia.

14. Theodore Dreiser, "Benjamin Eggleston, Painter," *Ainslee's* 1 (Apr. 1898): 41–47, reprinted in *Selected Magazine Articles*, 1:218–22, quote on 221.

15. Theodore Dreiser, "C. C. Curran," *Truth* 18 (Sept. 1899): 227–31, reprinted in *Selected Magazine Articles*, 1:263–66, quote on 264.

16. See *Letters of Theodore Dreiser: A Selection*, ed. Robert H. Elias (Philadelphia: University of Pennsylvania Press, 1959), 1:94.

17. Henry Edward Krehbiel, *Chapters of Opera* (New York: Henry Holt, 1908), chaps. 8–12.

18. Theodore Dreiser, "The Career of a Modern Portia," *Success* 2 (18 Feb.): 205–6; "Amelia E. Barr and Her Home Life," *Demorest's* 35 (Mar.): 103–4; "Women Who Have Won Distinction in Music," *Success* 2 (8 Apr.): 325–26; "American Women as Successful Playwrights," *Success* 2 (17 June): 485–86; "American Women Who Play the Harp," *Success* 2 (24 June): 501–2; "American Women Violinists," *Success* 2 (30 Sept.): 731–32; and "American Women Who Are Winning Fame as Pianists," *Success* 2 (4 Nov.): 815.

19. Dreiser reported that although only one-tenth of the musical manuscripts had been written by women in the past, by the end of the century twice as many pieces were composed by women as by men. See Dreiser's "Women Who Have Won Distinction in Music," *Success* 2 (8 Apr. 1899): 325–26, reprinted in *Selected Magazine Articles*, 2:31–36.

20. See, for example, Shawn St. Jean's forthcoming book *Pagan Dreiser: Greek Mythos and the American Novelist* (Rutherford, N. J.: Fairleigh Dickinson University Press).

21. In ranking modern novelists writing in English, as compared with the three British novelists George Meredith, Thomas Hardy, and H. G. Wells, Allen Tate wrote in 1948: "I am convinced that among American novelists who have had large publics since the last war, only Dreiser, Faulkner, and Hemingway are of major importance." See "Techniques of Fiction" in *Modern American Literary Criticisms*, ed. Bernard S. Oldsey and Arthur O. Lewis Jr. (New York: E. P. Dutton, 1962), 86. Tate's essay first appeared in Allen Tate, *Collected Essays* (Chicago: Allan Swallow, 1948), 129–45.

22. Theodore Dreiser, "The Real Zangwill," *Ainslee's* 2 (Nov. 1898): 351–57, reprinted in part in *Theodore Dreiser: A Selection of Uncollected Prose*, ed. Donald Pizer (Detroit: Wayne State University Press, 1977), 124–30, and reprinted in full in *Selected Magazine Articles*, 1:67–76.

23. *Selected Magazine Articles*, 1:70.

24. Ibid., 1:73.

25. Theodore Dreiser, "The Real Howells," *Ainslee's* 5 (Mar. 1900): 137–42. This work was reprinted in *Americana* 37 (Apr. 1943): 274–82; in *American Thought and Writing: The 1890's*, ed. Donald Pizer (Boston: Houghton Mifflin, 1972), 62–68; in *American Literary Realism* 6 (Fall 1973): 347–51; in *Uncollected Prose*, 141–46; and in *Selected Magazine Articles*, 1:100–107. For the quotations, see *Selected Magazine Articles*, 1:103, 100.

26. Dorothy Dudley, *Dreiser and the Land of the Free* (New York: Beechhurst, 1946), 143. Dreiser was possibly thinking about *A Modern Instance* because his remark about the constant quarreling does not describe *Their Wedding Journey.*

27. In a letter of 15 October 1911 to William C. Lengel, Dreiser listed *Their Wedding Journey* as one of a dozen books making "quite the sum total of my American literary admirations" (*Letters of Dreiser* 1:121). As late as 1942 Dreiser mentioned the book to George Ade as part of "the beginning of my private library of American Realism" (*Letters of Dreiser* 3:949).

28. Theodore Dreiser, "Edmund Clarence Stedman at Home," *Munsey's* 20 (Mar. 1899): 931–38, reprinted in *Selected Magazine Articles*, 1:84–91.

29. Theodore Dreiser, "The Haunts of Bayard Taylor," *Munsey's* 18 (Jan. 1898): 594–601, reprinted in *Selected Magazine Articles*, 1:43–49, quote on 49.

30. Theodore Dreiser, "The Horseless Age," *Demorest's* 35 (May 1899): 153–55, reprinted in *Selected Magazine Articles*, 2:152–60, quote on 156.

31. Theodore Dreiser, "Plant Life Underground," *Pearson's* 11 (June 1901): 860–64, reprinted in *Selected Magazine Articles*, 2:172–77, quote on 174.

32. Theodore Dreiser, "The New Knowledge of Weeds: Uses of the So-Called Pests of the Soil," *Ainslee's* 8 (Jan. 1902): 533.

33. Theodore Dreiser, "Reflections," *Ev'ry Month* 2 (1 Sept. 1896): 2.

34. Edward D. McDonald, "Dreiser before 'Sister Carrie,'" *The Bookman* (U.S.) 67 (June 1928): facing 369.

■ Part 1

ART AND ARTISTS

A High Priestess of Art: Alice B. Stephens

In the heart of Philadelphia's great business quarter, on lower Chestnut Street, there stands a five-story, red brick building which is about as reserved-looking as Philadelphia business structures can be, and before which, in the street below, the tide of traffic rumbles and clatters and clangs from early morning until night. It doesn't look much like a place where a person could be free enough from noise and other distractions to exercise a fine artistic taste.

Yet it was here, I was informed, that Alice Barber Stephens had her studio, and to this I was bound. Mrs. Stephens takes rank with A. B. Frost,[1] Howard Pyle,[2] A. B. Wenzell,[3] C. D. Gibson[4] and others, and there are those who put her before several of these. I remember looking over a book of her drawings, published by some New York house, entitled "The American Woman in the Home," and admiring exceedingly the gentle, refined appearance of the mothers, the excellent sedateness and sympathetic beauty of the young married daughters, and the quiet modesty of the girls in these pictures.

You would say, looking at these drawings, "Here is a plain, commonplace, genuine person, who illustrates." She has swept, sewed, performed the duty that lay nearest. You can see it in the sketches. She paints because she likes to, and as well as she can. She has no thought of immortality, nor imagines that she will be hailed as a marvel, but simply believes it is well and interesting to do good work.

Considering these things, I made my way one afternoon up several flights of stairs,—artists must have the skylight, you know,—to a door labeled A. B. Stephens, which was opened by a tall, slender, re-

served-looking woman, who smiled as she admitted that she was Alice Barber Stephens. After a sentence or two of explanation, an invitation was extended to enter.

ART IGNORES NOISE

It was as if one had dropped a stage curtain upon the rattling, excited scene without. Comfortable chairs were scattered about. Screens and tall bric-a-brac cases of oriental workmanship divided spaces and filled corners. A great square of sunshine fell from a skylight, and in one corner a Dutch clock slowly ticked. The color of the walls was a dull brick red, and against them stood light brown shelves, holding white and blue china vases, jugs, and old plates. Sketches in ink, wash, and color were here and there on the wall, and in one place a large canvas showing Market Street, Philadelphia, near City Hall, on a rainy day, gave a sombre yet rather pleasing touch.

Mrs. Stephens had returned to her easel, on which was a large sketch in black and white, showing a young rake, with his body bent forward, his elbows resting on his knees, his face buried in his hands,—the picture of despair. Some picture for a novel it was, the title of which might easily have been "The Fool and his Money."

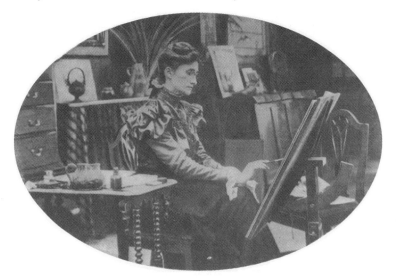

"You Won't Mind If I Work"

"You won't mind my working," said Mrs. Stephens, and I hastened to explain that I wouldn't and didn't.

She put touches here and there on the picture, as we talked of women in art, and the conversation did not seem to distract her attention from the work in hand, which advanced rapidly.

GIRLS' CHANCES AS ILLUSTRATORS

"Don't you believe it is easier, to-day, for a young girl to succeed in illustrating than it is for a young man?"

"Well, possibly," she answered. "Neither girl nor boy can succeed without aptitude and the hardest kind of work, but girls are rather novel in the field, and their work may receive slightly more gentle consideration to begin with. It would not be accepted, however, without merit."

"Hasn't the smaller remuneration which women accept something to do with the popularity of the woman illustrator?"

"Very little, if any," she answered. "I find that women are about as quick, perhaps more so, than men, to demand good prices for clever work, although they have less of the egotism of men artists."

"You judge from your own case," I suggested.

"Not at all. I never possessed cleverness. It was need and determination with me, and I can honestly say that all I have gained has been by the most earnest application. I never could do anything with a dash. It was always slow, painstaking effort; and it is yet."

"Do you ever exhibit?" I asked.

"No," said Mrs. Stephens, "not any more. There was a time when I had an ambition to shine as a painter, and as long as I had that ambition I neither shone as a painter nor made more than a living as an illustrator. I made up my mind, however, that I was not to be a great woman painter, and I decided to apply myself closely to the stronger, illustrative tendency which fascinated me. From that time on my success dates, and I am rather proud now that I was able to recognize my limitations."

"Did you find that in marrying you made your work more difficult to pursue?" I ventured, for her interesting home life is a notable feature of her career.

"I cannot say that I did. There is more to do, but there is also a greater desire to do it. I love my boy, and I take time to make his home life interesting and satisfying. When he was ill, I removed my easel from the studio to a room adjoining the sick-chamber at the house, and worked there."

HOW SHE BEGAN

Her instinct for art seems to have been a gift direct. As a very little girl her facility with the pencil delighted her teachers, and after the regular exercises of the day she was allowed to occupy her time drawing whatever fancy or surroundings might suggest. At seven years of age her parents removed to Philadelphia, and there the young artist encountered school regulations which rather debarred her from following her beloved pastime. But her talent was so pronounced that one day in every week was allowed her in which to attend the School of Design—an arrangement that continued until she entered the grammar school.

A few years later she became a regular student at this School of Design, where she took a course of wood engraving, but did not relax

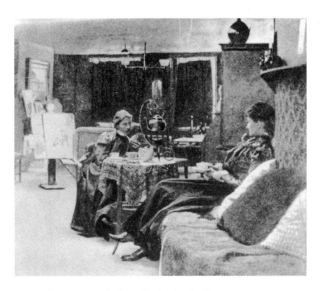

A Cozy Tea in the Studio

her study of drawing. As an engraver she became so successful that her work soon became remunerative, and gave her means to enter the Pennsylvania Academy of Fine Arts. At the same time her progress as an engraver was so marked that her efforts were brought to the attention of the art editor of "Scribner's Magazine," for whom, to illustrate an article on the Academy, she engraved the "Woman's Life Class," from her own drawing. Soon her drawings gave her a reputation, and she abandoned engraving. Her first published drawings were for schoolbook illustrations, from which her field widened and her work came into great demand.

In 1887 she was married and spent ten months abroad, studying for a part of the time in Paris in the school of Julien and of Carlo Rossi, devoting the remainder of her stay to travel. Upon her return she was prevailed upon to become an instructor in the Philadelphia School of Design, where she introduced life-class study, which has met with marked success.

Notes

"A High Priestess of Art: Alice B. Stephens," *Success* 1 (Jan. 1898): 55. Signed "Edward Al."

1. Arthur Burdett Frost (1851–1921) was a self-taught American painter who illustrated *Uncle Remus, Tom Sawyer,* and his own books.

2. Howard Pyle (1853–1911) was an American painter and illustrator who taught major illustrators around the end of the nineteenth century.

3. Albert B. Wenzell (1864–1917), an American illustrator and a pupil of Alexander Straehuber and Ludwig von Löfftz in Munich, painted the mural panels in the New Amsterdam Theater in New York.

4. Charles Dana Gibson (1867–1944) was an American painter who illustrated for *Life, Cosmopolitan,* and *Collier's.*

■ Work of Mrs. Kenyon Cox

Criticism there may be concerning the fitness and originality of woman in other branches of art work, but there can be no question that she is distinctly at home in the field of decoration. For ages she has studied the decoration of her person and her home, and her eyes have been trained to the harmonies of color. Everything, from the squaw's wampum necklace to the South Kensington period, has aided this development. A sense of the truth of this dawns upon one who studies the canvases of the women who are painting in this field of art. Particularly is this true of the work of Mrs. Kenyon Cox, who though partially obscured for a time by the prestige of her husband, Kenyon Cox,[1] is now receiving proper recognition.

In 1893 an exquisite little canvas representing a single, undraped figure, entitled "Psyche," attracted attention at the yearly exhibit of the Academy. It was signed Louise Cox, and won for the artist that rarest of all honors accorded to American women, admission to the Society of American Artists. The drawing was careful and true; the coloring charming; the pose of the figure, carelessly reclining upon a couch, natural and graceful. This artistic success was also emphasized by a gratifying financial recognition: the little canvas was sold within a few hours after the opening of the exhibition.

The following year, Mrs. Cox was represented at the Academy of Design by a more ambitious canvas, "The Three Fates." This beautiful piece of work is purely decorative in its nature, and as a decorative work received the unstinted praise of all who saw it. The drawing, grouping,

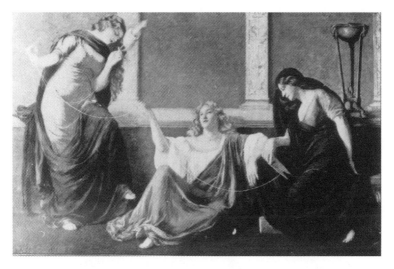

"The Fates"—Painted by Mrs. Kenyon Cox in 1894

coloring and interpretation are in a way new to the subject, and easily placed Mrs. Cox in the foremost ranks of American woman artists.

In 1895 Mrs. Cox exhibited the "Annunciation," at the Society of American Artists—a religious picture which would make a striking decorative window for a house of worship, and her reward was an immediate offer from one of the great church-window houses for the use of it as a model to copy in glass.

Again, in 1896 her moderate-sized canvas "Pomona" received a third prize at the Academy, where it was exhibited. It shows the usual atmospheric qualities and the beautiful coloring that characterizes all of Mrs. Cox's work. There is an admirable suggestion of mid-summer heat and noonday stillness in the bit of landscape visible. The center of the canvas is occupied by the figure of a woman of large, harmonious lines, a woman in the prime of life, holding in her hands a basket of fruit.

Mrs. Cox is an earnest worker, and her method is interesting. Each picture is the result of many sketches and the study of many models, representing in a composite way the perfections of many. For the Virgin in her picture of "The Annunciation," a model was first posed in the nude, and then another draped, the artist sketching the figure in the nude, and draping over it from the second model. The hands are

always separately sketched from a model who possesses peculiar grace in folding them naturally.

The manner in which she plans her pictures may be understood from her explanation of her picture, "The Fates." "My interpretation of 'The Fates' is not the one usually accepted," she says. "The idea took root in my mind years ago when I was a student at the League. It remained urgently with me until I was forced to work it out. As you see, the faces of the Fates are young and beautiful, but almost expressionless. The heads are drooping, the eyes heavy as though half asleep. My idea is that they are merely instruments under the control of a higher power. They perform their work, they must do it, without will or wish

"Angiola"—Painted by Mrs. Kenyon Cox in 1897

of their own. It would be beyond human or superhuman endurance for any conscious instrument to bear for ages and ages the horrible responsibility placed upon the Fates."

Such is the conception that led to the picture which is reproduced with this article—a picture which has made clear that while lack of physical strength may debar women from undertaking enormous mural canvases, art is not measured by the foot, and in decorations of a moderate size such success may be achieved as is worthy of the highest decorative genius.

NOTE

"Work of Mrs. Kenyon Cox," *Cosmopolitan* 24 (Mar. 1898): 477–80.

1. Kenyon Cox (1856–1919), an American painter and a pupil of Carolus Duran and Jean Léon Gérôme in Paris, specialized in portraits, figure pieces, and mural decoration.

■ Art Work of Irving R. Wiles

A few years ago, when Irving R. Wiles[1]—the only painter who was elected a member of the Academy of Design at the last fall exhibition—was an illustrator, his very valid excuse for painting small pictures was that "we painters are bothered by butchers and bakers like other people." He used to meditatively add: "I wish it were not so, but it is, and so most of us are driven to make little pictures that sell instead of big ones that don't." There has been a change in Mr. Wiles' size of pictures since then, but only because he has found that with the growth of his reputation the "big ones" sell also.

As a painter Mr. Wiles is greatly to the fore just at present, and his pictures are justly admired for a style that is not so much pleasing for what it accurately puts in as for what it leaves out. His art has originality, in that the situations presented are new, the attitudes possessing both the grace of naturalness and, what is not quite the same thing, the naturalness of grace. You can appreciate his work more when you understand that he believes art should present only the beautiful. He does not believe, for instance, that a picture should be interesting because it presents a moral lesson of some kind. A painter who must needs take a striking situation from every-day life and paint in all details as they would probably be found in real life, is, in a way, photographic and not artistic. Mr. Wiles prefers the genius of Sargent,[2] who paints no harrowing scenes, and whose pictures leave so much to the imagination. He would himself rather that his pictures attract the eye by a subtle suggestion of beauty than that they attracted attention because of a deed

being enacted or the merits of a good or bad deed shown. In short, he subscribes to a theory that has numerous eminent followers to-day.

And a glance at the pictures of Mr. Wiles which are presented in this connection confirms in fullest sense this judgment. In both the pictures, entitled the one "Dreaming" and the other "The Sonata," will be found evidenced this idea of beauty alone. No craving after purpose of any sort. A mere idyll, each, and caught from out a prosaic enough reality. "Russian Tea" is also delightful in this sense, gratifying the eye with grace and beauty, and in the canvas a unique condition of color. Everything is not accurately painted in, and the imagination has leave to roam and decide for itself what the additional conditions must be. As the imagination always delights to do this, the picture has a fascination from this side.

The portrait shown of a child is an able and fascinating picture. Not only has the artist painted himself a brilliant likeness of the subject, but he has painted a picture for the public as well—something that, aside from personality, is pleasing in its beauty. It is strong work, catching in a way, not the form, but the thought, and suggests the brush of Sargent. The colors also are all for the best.

The pictures and sketches of Mr. Wiles have been known for so long to frequenters of our art exhibits that most persons, upon meeting the artist for the first time, are surprised to find so young a man. He confesses to thirty-seven years, having been born in Utica, N. Y., in 1861, but he does not look it. The charm of his personality is sincerity and good-nature, untinged by the slightest affectation of weariness of anything. As Stevenson[3] suggested concerning the great Hazlitt,[4] "one could imagine him hastening to a dog-fight with great interest," and not being any the less able therefore, either. He delights in work and is pleased that matters have made it possible for him to give all his time to painting, and that the old divided task of working at illustration eight hours in order to be permitted to paint for himself is gone.

His first teachers were Nature, and his father, the well-known landscape artist, Lemuel M. Wiles,[5] the latter, of course, being the more evident earthly instructor. Mr. Wiles, Sr., was for many years the art instructor at Ingham University, near Rochester, N. Y. In 1879 he entered the Art Students' League in New York, and after a three years'

course went to Paris for two years under Lefebvre[6] and Carolus Duran.[7] Upon getting home in 1884 he settled down in New York City, and during the last fourteen years has worked hard, gaining, first, fame as an illustrator, and then as a painter.

Concerning his work as an illustrator, he told me that soon after his return from Europe he had two little sketches at the Salmagundi Club,[8] which attracted the attention of Mr. Fraser, of the Century Company, who gave him an order for some magazine work. "For a time then," he said, "I divided my days between painting and illustrating. So far as I can see, my book work has not hurt my painting, and, anyhow, there are so many instances in which admirable painters also turn out a great deal of illustrating as to make any such fear groundless. Bernard[9] and Rochegrosse,[10] the French artists, are both equally famous as painters and illustrators, and why should not others be?"

In 1886 Mr. Wiles won the Hallgarten prize at the Academy of Design, and in 1889 his picture, "The Sonata," won the Clarke Academy prize. In that same year, also, he received an honorable mention for a picture sent to the Paris Exhibition. In Chicago, in the summer of 1893, he exhibited the portraits of his father and mother at the World's Fair, and in acknowledgment of their excellence he was awarded a medal. So it has gone on, medals from the Water Color Society and the Tennessee Exhibition, until last fall he was admitted to the Academy.

Mr. Wiles has a pretty studio in the former home of the Mendelssohn Glee Club in West Fifty-fifth street.

NOTES

"Art Work of Irving R. Wiles," *Metropolitan* 7 (Apr. 1898): 357–61.

1. For more on Irving R. Wiles (1861–1948) see "America's Greatest Portrait Painters" in this volume.

2. John Singer Sargent (1856–1925), an American painter, was born of American parents in Italy. He spent much of his time in the United States, painting many of his best portraits in New York and Boston.

3. Robert Louis Stevenson (1850–94), a Scottish author, was very popular in the 1890s in the United States, especially for his works of adventure such as *Treasure Island* and *Kidnapped.* Dreiser read his works with great enthusiasm.

4. William Hazlitt (1778–1830) was an English essayist.

5. Lemuel M. Wiles (1826–1905), an American landscape painter, was a pupil of William M. Hart and J. F. Cropsey.

6. Jules Lefebvre (1836–1911), a French painter, became one of the best-known masters of the nude, rivaled only by William Bouguereau.

7. Carolus Duran (1838–1917), a French painter, concentrated on portraiture. John Singer Sargent was the most important of his many pupils.

8. The Salmagundi Club was the most prestigious artists' club in New York. Dreiser became a member in 1897.

9. Joseph Bernard (1866–1931), a French sculptor, exhibited between 1892 and 1900 at the Salon des Artistes Français works of descriptive realism, frequently tragic in inspiration, such as *Hope Defeated*.

10. Georges Rochegrosse (1852–1938), a French painter, printmaker, and illustrator, was one of the most popular salon painters at the end of the nineteenth century. As a lithographer, Rochegrosse's greatest achievements were his illustrations to works by Théophile Gautier, Charles-Pierre Baudelaire, Gustave Flaubert, Anatole France, and Victor Hugo.

■ The American Water-Color Society

New York takes its annual Water-Color Exhibition, like all other exhibitions, without inquiry and as a matter of course. It is to be questioned whether, of all the thousands of visitors who examine, criticise, and admire the hundreds of water colors shown annually during the exhibit, any but the members of the society know aught of the efforts required to gather such a collection of pictures.

Only those directly or artistically interested know how important this society of painters really is, what the nature of the movement may be, or what, with its annual meetings and exhibition, is its relation to American art.

Before many years a splendid building, devoted especially to water colors, will be opened; but until then, for many at least, the very existence of the society will remain unknown. Yet the erection of such a home for the work of American water-color painters is one of the important objects of this society, and a fund for the purpose, set aside at its formation thirty-one years ago, has continually grown, and, when the time is ripe, will be used for the building in question.

The latest exhibition at the Academy of Design, from which the METROPOLITAN has drawn the accompanying pictures, was one of the most successful ever held by the society, more than five hundred pictures being on exhibition, all representative work of American artists the country over. In merit the standard of the exhibition was slightly higher than it has been for several years. Very few of the important names in American art were lacking, and, at the same time, some new

names were seen and some contributions from men who have hereto-
fore confined themselves to oils. The position of honor in the south
room was duly awarded to the picture of the president of the society,
J. G. Brown, "Sunday in the Barn."[1]

It would be impossible here to deal with all the pictures, and so it
must suffice to say that in giving the prize in the first place to Albert
Herter's[2] sombre study "Sorrow," the committee voiced a very general
opinion that it was one of the best pictures in evidence. One of the rules
of the Water-Color Society is, however, that the annual prize must be
given to the best picture painted in America by an American painter.
In the case of Albert Herter, though an American, he has been for five
years a resident of London, and his picture "Sorrow" was painted there
and sent over for exhibition. The sudden intrusion of this fact caused
the committee to hastily withdraw its award.

In a more conservative spirit the prize was then bestowed upon C.
Warren Eaton's "The Brook," a very excellent landscape in itself, and
one of the best in the exhibition.

In such spirit of fairness as one can exercise when choosing from
over five hundred paintings, the pictures shown here were selected.
Childe Hassam's "The Yellow Rose" is a fair example of the excellence
of the work of that impressionist.[3] That it is good in drawing goes with-
out saying, and it is also strong in color. He is the object of much ad-
miration by a younger coterie for the manner in which he handles his
brush, though it is questioned whether the spirit which animates him
is at all high or enduring.

The "Attention" of James Symington is one of the many beautiful
women he paints so easily and quickly. The sharp distinction which he
gives the figures in these little pictures and the brilliant coloring he uses
are admired by many.

"The End of the Day," by Geo. R. Barse, Jr., fairly represents that
rising decorative artist, some of whose work is in the Congressional
Library at Washington. It has an allegorical charm, as well as a grace
of contour, but the delicacy of the coloring must be seen in the origi-
nal to be appreciated.

The study "Pink and Green," by Maud Stumm, is unquestionably
the best picture, by a woman, in the entire exhibit. It is also one of the

very best of the entire exhibit. With her there is no difficulty in representing the beautiful, and all of her pictures are strong in elemental grace, fascinating in color, and dashing in execution.

"Mending the Golf Sticks," by L. E. Earle;[4] "Sailing Away," by Percival de Luce; "To the Future Bride," by Walter Satterlee; and "Evening," by C. Morgan McIlhenny, are representative of the type of pictures which these artists paint.

This article, in brief, is a suggestion of the character of the present exhibition, and of all the exhibitions which the society holds. It is these exhibitions which foster the art in America and help genius to recognition. Some will be interested in knowing that the great question of permanence—whether pictures painted in water colors on paper would endure—was one of the chief hindrances to water-color painting in this and all other countries a half-century ago. Indeed, the opinion, well grounded in the minds of art lovers at that time, that such pictures would not endure, almost destroyed interest in the entire subject and practically ruined the first Society of Painters of Water Colors which endeavored to live and attract attention in 1850.

In the days of Payne water-colorists were accustomed to wash in the light and shade very thinly and delicately, with a gray made with India ink and indigo blue, which afterward came to be called Payne's Gray, and then to *tint* the work in parts with appropriate colors, very little pigment being used, and the particular gray being, to an extent, fugitive. Of course such pictures faded, but permanent colors are now used.

NOTES

"The American Water-Color Society," *Metropolitan* 7 (May 1898): 489–93.

1. John George Brown (1831–1913) was an English-born genre painter. He studied first at New Castle-upon-Tyne, then at Edinburgh Academy, and in 1853 at the School of the National Academy of Design in New York. His work was represented at the Metropolitan Museum in New York and at the Corcoran Art Gallery in Washington, D.C.

2. Albert Herter (1871–1950), an American mural painter and craftsman, was a pupil of J. Carroll Beckwith in New York and Henri Laurens and Carmon in Paris.

3. Childe Hassam (1859–1935) studied art in Boston before going to Paris to study under Louis Boulanger and Jules Lefebvre. Hassam's work is represented in permanent collections at the Pennsylvania Academy of Fine Arts, the Carnegie Institute in Pittsburgh, the Cincinnati Museum, and the Metropolitan Museum of Art in New York.

4. For more on Lawrence E. Earle (1845–?) see "Lawrence E. Earle" in this volume.

■ A Painter of Travels: Gilbert Gaul

To travel is, for the venturesome spirit, a heavenly privilege, for certainly the heart of the world "yearns in other worlds to be," but to travel and be able to paint the impressive sights by the way is both a privilege and an ability which for delight, passeth (with the uninitiated) all human understanding. Nights spent in the open; long days among strangers and constantly shifting scenes, with the ability to preserve the rarest of their beauties in color—here is happiness.

These accompanying eight pictures, paintings by Gilbert Gaul, are really illustrations of his travels and very striking representative scenes from Mexican and Western life. During the gold fever of 1890 he traveled in Mexico, looking up the several routes to the gold fields, which Easterners, coming by sea to Mexico, usually followed. He traveled from Acapulco to the City of Mexico on horseback, from the City of Mexico to Vera Cruz, and from Vera Cruz to Guadalajara by train, and from the latter city by stage and mules to San Blas, on the Pacific coast. Of this journey the pictures *Mexican Shepherd,* and *Mexican Ranchero,* are reminiscences. Going down the Pacific coast to Corinto in Nicaragua, he returned on horseback overland to the Atlantic coast, and of this journey the *Parrot Seller of Corinto* and *Three Bells,* are scenes which he witnessed.

At the time of the taking of the census, 1892, he was commissioned by the government to go among the Sioux, and other Western tribes of Indians, to learn all about them and write a report. For two years he went about this work, leading a nomadic life, among Indians and army officers. He passed his time along the upper sources of the Missouri,

Parrot Sellers of Corinto (Painted by Gilbert Gaul)

in the Rockies; visiting Forts Yates, Sully, Lincoln, Bennett, and indeed all the outposts designed to hold the restless savages in check. He also journeyed to the forts in Texas, and of this life the pictures, *Christmas Behind the Breastworks, A Desperate Mission,* and *Exchange of Prisoners,* are illustrative. There are many other paintings by him, all drawn from the wealth of incident and experience in the West and in Mexico, but they are no more to the purpose than these, nor more valuable as pictures.

With the spirit of Mexican life the pictures *Mexican Shepherd,* and *Mexican Ranchero,* are infectious. To realize them one must know the country. The great bulk of the republic is a high central plateau averaging seven thousand feet above the sea level. On the east this descends abruptly to the Gulf of Mexico, and on the west slopes more temperately to the Pacific. Here are grown coffee, sugar, bananas and other tropical fruits. The great plateau is called Tierra Frias, or frigid zone, but it is not frigid, and the slopes on either side are a little more than the Tierra Temploda, or temperate zones, that they are called. In one day's travel, passing down the mountains the traveler can see every variety of product and feel corresponding changes in temperature. The rainy season varies in different localities, but roughly speaking em-

"Three Bells" (Painted by Gilbert Gaul)

braces the months from June to October, while during the rest of the year rain falls but rarely. A clear sky always prevails, save for a few hours during the days of the rainy season.

In such a climate, where January is like our June, and where all nature when not parched brown beneath a too radiant sun, is green, the picturesque abounds. Cities are few and not populous as we think of cities. The great unmarked fields are given over to the shepherd and his immense flocks of sheep, or to herds of cattle. Such a character follows his flock night and day, for a month at a time, without ever seeing a village. By day he is wherever a little shade may be had; by night, when all is cool and the skies clear, upon his horse following slowly after the sheep as they ramble. For they too are wise, after the manner of the shepherd, preferring to sleep by day and to wander and eat by night when it is cool.

Not many of the nation are shepherds, but the traveler encounters such as are quite frequently. They are well known to those who travel other than by rail, for grazing territories in Mexico are large and numerous. They are in a sense mates of the rancheros, the men who gather

fagots for a living, and whose main object in life seems to be to do the least possible work for the cheapest possible existence.

The costume of the people of the upper and middle class of Mexico has conformed very generally to our own, so that no difference can be observed, and very often it is impossible to tell whether to address a person in Spanish or in English. The lower classes in some sections adhere altogether to their former dress, but in other sections of the country in this particular they have to a large extent followed the example of their superiors in social position. The distinctive features of the former dress, wherever retained, is for a man, a tall cone-shaped hat of felt or straw, with a wide brim, called a sombrero, a pair of exceedingly tight-fitting pants, and a gaudy blanket wrapped about the upper part of the body, and often held so as to conceal the mouth. This is called a *serape*. Often the sombrero is gaudily decorated, costing sometimes fifty dollars and even more, and the trousers are decorated with lace on the seams. This is when the adherent to the old costume has some means, in which case he sometimes adds to his dress a jacket bedizened with great quantities of gold lace or white braid. But these individuals are now few in number.

Often, especially further south, the humble *peon* is content with a costume consisting of a pair of coarse linen drawers, a coarse linen shirt

Tennessee Hunters (Painted by Gilbert Gaul)

and poncho, which last is a coarse blanket, with a slit in the middle
through which the wearer passes his head. This simple costume is completed by a cheap straw sombrero, with its high steeple crown, and a pair
of sandals, unless, as in most cases, the sandals are even dispensed with.
The women of the upper and middle classes almost uniformly conform
to our manner of dress save that the *rehoso,* a kind of mantilla, is still
often worn over the head in lieu of a bonnet. The *rehoso* is universally
worn by the poorer classes, doubtless on account of its cheapness and
durability as a covering for the head.

It is a type of the high sombreroed, tight-trousered Mexican that
is shown in the picture of the *ranchero.* He has brought his burro to
water, a fluid that is never unwelcome in Mexico. This woodsman is
common to those stretches of territory where there are scarcely any
trees or bushes above ground. The wood that he sells to make his living is all roots, which he digs, the stalk and branches above ground
being mere sprigs. There is little nourishment to be had above in the
way of rain, and so the bushes, which in a more watery clime would be
trees, take nourishment from the soil. Consequently the roots are large.
Fire is not needed for warming in Mexico, hence it is reserved for cooking, and the houses have no chimneys. Your wood gatherer ekes out a

The Mexican Ranchero (Painted by Gilbert Gaul)

living, however, with the aid of his faithful burro. It is his plan to go into the open, digging roots in the early mornings and late evenings for three days. By that time he has probably gathered enough to bring him a dollar and a half in coin. He then returns to the city, disposes of his fuel, and remains three or four days in idleness, sunning himself with companions in the public squares, until his means of subsistence have vanished. Then, like the shepherd, he returns to the fields and his vocations, where means for another period of idleness may be gathered. Mr. Gaul has painted him the idler that he is, and has given the tough, sulky, hard-headed qualities characteristic of the burro. These little animals are known to carry more than their own weight in loads, and when the latter are of spreading fagots, making a bulk three times the size of the animal, the moving spectacle appeals to one's sense of the ridiculous. Money is not an object with the Mexican—at least not so much as idleness. Like the poor Italians of the sunny south, who when asked to undertake an errand, often reply "Thank you, but I have had my dinner," so the poor Mexican, with a few *centavos* in his pocket, also refuses to labor until these have vanished.

The west coasts of Mexico and Nicaragua are but sparsely settled, and traveling north or south is quickest and cheapest by sea. From Acapulco on the Mexican coast southwest of the City of Mexico, to Corinto on the west coast of Nicaragua is a sea journey of a few hundred miles. The picture *Three Bells* is an incident often occurring at seven o'clock in the morning when the pilot is handed so humble a thing as a drink, after his hours of silent guiding. The painting *Parrot Sellers of Corinto* is a typical scene of the coast, where natives come out in small boats to sell such wares as the city has to offer. The tide in the harbor at that place runs strong, and to any but the skilful natives the handling of a canoe in such troubled water is a dangerous thing. The venturesome Nicaraguans who dwell along the coast and make their living by selling local merchandise to the passengers of the coast vessels, and the Pacific mail steamers which stop there on their journeys, inherit the ability to manage these small craft from their parents who sold to vessels before them. On days when several steamers arrive the harbor is alive with these small boats. They offer fruits and vegetables, and parrots and birds of rare plumage. Parrot selling in particular is profitable, and the offerings of these tamed birds are sometimes so large

that the gunwales of the boats will be lined with them. They hold their positions undisturbed by the rocking of the water, and chatter volubly on, heedless of the bargaining. The sight of a neat Spanish-American maiden, standing and balancing herself in the little boat as it rises and falls upon the waves, and holding parrots aloft on either hand, as in the painting, is not an uncommon one. Very low prices are asked, and the sales are not immense, but somehow the natives find it profitable, for living on shore is very cheap.

Traveling through Nicaragua is not without its element of danger as well as interest to the lone traveler. If you do not speak the language the natives are suspicious and are prone to cause you delay, if nothing more serious. Bandits are not unknown, and it has often been laid down as good advice, to hire a guide and then defer paying him until reaching your destination. This impresses him with the idea that your present supply of money in hand is small, and makes your safe conduct a money consideration involving his own interest. Even then a good revolver is not a bad thing to have concealed upon the person, as there are those who do not consult your own or your guide's interest.

A Desperate Mission (Painted by Gilbert Gaul)

A burro to carry the baggage, including the camping outfit, some small silver to appease the natives as you encounter them on fête days, together with a wise guide and large stock of discretion, makes traveling comfortable and allows time for enjoyment of the peculiar characteristics of life in so warm a clime. In many respects the people are like those of Mexico, and the difference exists more in a less orderly form of government and a much smaller number of educated persons. Mexico with its railroads and resident Americans is more orderly, and travel lacks danger—at least the kind of danger which is rather more abundant in the Central American States.

We are all more or less familiar with the frontier life of the West, of which Mr. Gaul has had such abundant experience. The picture *Christmas Behind the Breastworks* is not uncommon to-day when a Western division of the army is put in motion by some untimely uprising of the reservation tribes, and the soldiers are compelled to abandon possible holiday pleasures at the forts for the urgent duties of the field. *Exchange of Prisoners* tells its own story much better than words could, although one cannot help noting how anxious are the Indians to get back among their own tribesmen. It is a scene that may never be witnessed again, however, so few are the red men to-day, and so complete is the government's military supervision.

The painting, *A Desperate Mission,* is another army incident, really drawn from Western experience, but characteristic enough to have taken place in any of our American wars—a scene wherein a young soldier is made to realize how in obeying orders he takes his life in his hands.

Mr. Gaul's fame rests upon the dash and brilliant accuracy with which he puts on canvas the scenes and experiences of his travels. His have been days of camp life, months of long journeys alone through thinly settled lands. Like Stevenson,[1] he has been a wanderer, but over the American world only, and has learned to value nights in the open, and long forward tramps through late dusk and early dawn.

Any one can feel that it was much better for him to abandon figure painting, such as he did when he began his studies under J. G. Brown,[2] and afterward. He spent eight years under that painter and then for two years applied himself to *genre* subjects, but he wisely tired of that and began to paint imaginary war scenes. The desire to travel seized him

Gilbert Gaul

and he removed to Tennessee, where he spent four years and painted guerrilla warfare scenes, with much cleverness. At the end of that time he came East again, continued his painting of war subjects until 1890, when he took up his western travels again, returning only recently to the metropolis, where he rests at present.

NOTES

"A Painter of Travels: Gilbert Gaul," *Ainslee's* 1 (June 1898): 391–98.

1. Robert Louis Stevenson.
2. John George Brown.

Artists' Studios: Hints Concerning the Aim of All Decoration

In these days of picturesque house-furnishing, when all of us turn, with more or less interest, to any source from which new ideas concerning decoration may be drawn, a direct glance at those professors of the artistic, the artists, may not be amiss. Such men as Henry Mosler,[1] J. Carroll Beckwith,[2] J. H. Dolph[3] and the others selected are not apt to have mediocre conceptions of what constitutes art in decoration; and as their studios are more or less noted for their picturesque ornamentation and handsome appearance a hint or two may be gleaned.

It is not an uncommon idea that in "fixing up" a studio an artist has in his mind beforehand a distinct conception of the color-scheme, grouping and arrangement best suited to his taste, and that what greets the eye of the visitor is the natural appearance of a decidedly preconceived idea. Nothing could be farther from the truth, since in most cases a well-decorated studio is the growth of years, during which the Persian lamp, mediæval crossbows and swords, Ashantee shields and rugs, vestments and tapestries generally have slowly accumulated and been distributed after the most economic fashion. Your artist does not arrange his sanctum at once, nor has he, as a rule, much material to begin with. On the contrary, the appearance of his studio is a praise-worthy attempt to avoid ostentation and to escape a suggestion of bareness with a very limited supply of material.

It is quite true that as applied to decoration generally he believes in color-schemes and forms of grouping and composition, but he seldom practices his belief. Call him in consultation as to the best way to decorate a certain room, and, after he has ascertained what color the

principal material which it is to contain is to be, he will advise a color-scheme very much in harmony and very much after a distinct plan. The best proof of this can be had at the current exhibitions of pictures in the various galleries about New York, where decoration is attempted. If there are light water-colors in gilt frames to be hung, the whole room will suggest light water-colors and gilt frames. The walls will probably be hung with faded fish-netting, in which silver threads of tinsel have been twined. Papier-maché fish of a blue and silver hue will be caught in the folds, and long green imitations of water-grass will appear at the intersections where the netting is looped up. The whole thing will be held down to a single form, but it will be a form, and some tangible thing that any one can pick up and duplicate.

The stock or material with which artists as a rule accomplish the pleasing effects for which their studios are famous is, of course, pictures, books, etchings, furniture, costumes, arms and pottery. All of these are usually made to play an effective part. There are, ordinarily, faded tapestries that would do wonders for the not too well-lighted hall of some country house—that is, a house which is not the brand-new toy of some of the young architects *à la mode,* but one aspiring to ancestral honors, and with that slight flavor of antiquity given in our youthful land by a hundred years. Here, too, are embroidered silks from Persian and Turkish hands, useful properties to artists, or capable, in ingenious female hands, of ornamental application in drawing-room or sitting-room. But, perhaps, we had better pass to the consideration of the studios as they stand at present.

In the studio of J. H. Dolph, the celebrated cat painter, are to be found all the above and vastly more. Without any reference to arrangement, he has collected some rare pieces of furniture, the best of them being a Spanish cabinet on a stand, of the kind called "contadors," or safes for money and jewels. Though considerably worn and defaced, it is neither broken nor battered, and has never been in the least repaired. It is getting more and more difficult every day to find genuine pieces of furniture such as this, of the mediæval, or renaissance time, that have not been repaired or restored.

The pottery in Mr. Dolph's studio will repay examination, for it contains pieces that ought to be secured for a public collection. There are several pieces of Flemish ware, and one specimen, at least, of the time

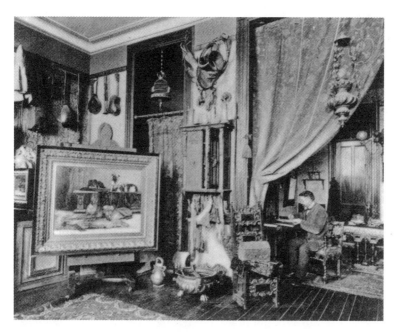

J. H. Dolph at Work in His Studio

of Palissy, a piece of undoubted value, whether it be the work of the famous potter or not. There are also two or three good bits of Italian majolica, and among the smaller objects some specimens of modern Mexican pottery made by hand and ornamented in free hand, which are worth owning.

Of course there are rugs, costumes, silks and arms, which are disposed in groups and with an eye to economy of space—a condition which artists never lose sight of.

As a good foil for pictures and keramics, artists prefer a wall tinted in the lightest of terra cotta—only a suggestion of tone, nothing more—against which sketches in oil and treasures in china stand out in a wonderful way. Floor covering of any kind seems invariably avoided, a red stain being preferred, which is easily waxed and made to shine anew. Three or four Indian rugs, or perhaps comfortable-sized skins, are laid down on this, and made to contrast, as well as harmonize amicably with the several Algerian-stripe coverlets which adorn a table or two at different angles. Tapestries hung upon the walls, dark-flowered silks hung

with an effect of carelessness over easels and other available objects, solid-colored bric-à-brac and dark assemblages of weapons and sheaths of mail of all ages, scattered profusely about, lend a distinct tone and feeling to the rooms, so that one might say a shade of sentiment is expressed by the whole.

The studio of J. Carroll Beckwith, however, is least of all arrayed with those selections of bric-à-brac calculated to adorn a room; and yet, though his work-room is really planned for work and not appearances, it can be repaired to for another decorative reason equally important as that of wall decoration. Where the great portrait and genre painter has neglected his walls he has compensated for it by collecting costumes, cloths and vestments, so precious to the painter for the aid they lend in establishing the correctness of a texture in a painting. The manner in which these are distributed about the room, in abundance and yet without suggestion of the overmuch, is a bit of art instinct which those house-keepers who love, but do not know how, to introduce color into a room unobtrusively, might well profit by seeing.

Long robes of purple, the raiment of some bygone dignitary of the Roman Church, silks from my lady's costume of a hundred years ago, precious for the colors which age has brought and which no newer material can imitate, and tapestries of a faded hue, but all the more

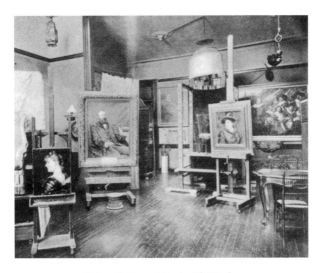

Where J. Carroll Beckwith Works

valuable because of their unobtrusive coloring, are among the gems which Mr. Beckwith preserves.

Of course, there are a few bits of chivalric metal and some pretty weapons, several Toledo blades and a Florentine hilt or two, with blades almost if not of equal age with the handles. There are Dutch and English halberds of the sixteenth century, cross-bows and guns and ancient pistols, and a store of such Flanders mugs and graybeard jugs as the old fellows of that time drank from when they were not fighting. Of these, his pictures, his cloths of gold and of other delicious faded hues, Mr. Beckwith makes a very simple showing, and when all is said the studio still leaves the impression of a chamber arranged for labor and the useful adjuncts of labor, and not for show.

The studio of Henry Mosler, the great story-teller in color, is a fine example of that solid, heavy style of ornamentation which shuns small curios and miniature bric-à-brac. Within his spacious apartments (for he is one of the few artists who employ a suite of rooms for studio purposes) there are many properties appropriate to the place and sufficient in number to stock a respectable museum of æsthetics. Large and rare vessels of hammered copper, keramics from Rome, a large, quaintly carved closet-bed from Brittany, a solid and heavy Breton cradle, and a huge Spanish chest, black and artistically finished with wrought iron, range boldly about the rooms, and indicate the artistic bent that will have nothing to do with odds and ends. He rejoices in carved woodwork of the sixteenth and seventeenth centuries, and has among his larger specimens two Byzantine chests, one bearing the date 1650, the other 1668.

In appearance the rooms are decidedly novel and fastidious in a large way, and yet no scheme of decoration nor plan of arrangement was attempted. The great pieces of furniture are placed almost at random, and the heavy bowls of copper and brass, with a similar lack of design, are hung upon the walls. He employs no cloths of rare color, no intricately woven vestments of past times, no huge tapestries, to the end of softening the appearance of the rooms. Rather, the whole place expresses his admiration for the large and durable materials of the world; and as he loves to paint the scenes of Breton peasant life, where everything is made thick and to endure long, so his studio is left to display the solid and honored workmanship of old times without minor distractions of any sort.

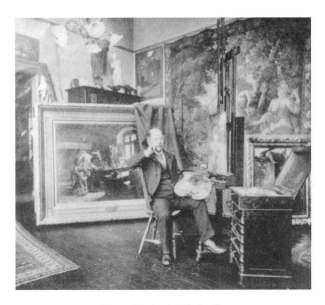

Henry Mosler in His Studio

In strong contrast to the studio of Mr. Mosler, with its "everything large and solid" lesson, is that of Stanley Middleton,[4] where the reverse idea of everything small and intricate is carried out, and with stunning results. Mr. Middleton, in his search for impressive genre subjects, has traveled much and gathered a great deal. Preferring things Oriental, colors that suggest the bright inlaid arabesque and carved work of Spain, Turkey, and Asiatic lands, he has gathered no end of little things, whose qualities and colors make his studio suggestive of the grotesque and the brilliant. Against walls low in tone are hung the endless little carved nothings of deep red and dark brown colors, side by side with weapons whose dark, steely sheen helps on the Oriental harmony.

There are wrought in, with a sure eye for pleasing contrast, robes of Oriental dye and images of Oriental hue. Brick-red turbans, deep blue mantles bargained for with roving Bedouins, iron candlesticks with twelve branches, of the Persian type, carved tables and cabinets from India loaded with Oriental coins, inch-high images, ivory carvings, and porcelain lamps—in short, all sorts of oddities which served some useful purpose in different times and lands are here mere orna-

ments. A wealth of material of this character confuses and blends, giving the impression of a carefully worked-out color scheme, and such is exactly the impression desired to be conveyed.

There is an unusual charm about a sculptor's studio, though the art suggestions it affords are less adaptable to application in the ordinary home, owing to the exclusive cast which is linked with the material common to his studio world. The layman cannot put hands upon the variety of casts which the sculptor simply preserves from the models executed in connection with his public commission, and it is not possible with the few available bits of sculpture that one can buy to-day to obtain a suggestion of the charm that lingers in some of the corners of the studios of French,[5] J. Q. A. Ward,[6] Hartley,[7] and others. Their walls are lined with shelves, peopled with antiques and pseudo-classic studies of their youth and first minute sketches of public works. They move among colossal figures, children of their own imagination, who seem alive and thinking, even when most unfinished, or half hidden in damp cloths. And the effect of eyes that seem to see, faces that smile, or brows that frown, lends something which is decidedly personal to such a studio. It is like a company assembled and conversing, who stay transfixed as the live eye travels around, refusing to resume until they are assured that you no longer heed them.

It is here that the sculptor labors quite in a world of his own. Garbed like a white-washer in canvas coat, apron and overalls, he is nevertheless a poetical figure as he moves about the forest of his own creations.

With a great sculptor like J. Q. A. Ward, no scheme of decoration for his workshop is ever contemplated. That decoration obtains is due to the primary reason of utility. He colors his walls a modest tint of green or brown, that his clay figures may be studied in a contrasting light. He utilizes his corners to the best advantage of storing, and yet displaying to his own eye his many studies and models to which he may have occasion to refer. No extraneous material, impertinent to his art, is included, and therefore the effect of harmony is secured. As a result it is artistic, wholesome and gratifying. And what a lesson it teaches to those who strive after the artistic in effect—to consult, first, the necessary and the useful, so that the ornamental, if taste exists at all, will follow.

Through the open portal of Sculptor Hartley's studio the working-

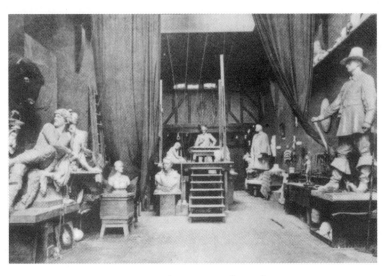

A Section of J. Q. A. Ward's Studio

room looms up into view, a medley of all sorts of objects in which clay and plaster are the modeling schemes; and soon one realizes that the beauty of it all is the constant and general reference of everything to sculptural use. A table without a cover, no more chairs than will soften the charge of inhospitality, a bit of faded drapery against which are grouped the busts of great men of the day—these make the decorations, and the artistic onlooker will conclude, after a glance, that none could be better. They are useful, relative and pertinent, and in praise of decorations no more can be said.

In Sculptor French's studio a similar condition prevails. The walls are about the same color; the models and statues scattered about, though larger and less numerous than those in Mr. Hartley's studio, are distributed after much the same fashion. The primary consideration is again utility. That it is artistic follows from the nature of the work and the fact that nothing is allowed to encroach upon the working space of the room. Busts, statues, sketches and fragments are given room on the walls and in the corners according to their value; and within the spaces allotted them they may look artistic if they choose, but they must not crowd about and hamper the work in hand. This is the keynote of appearance in a sculptor's studio, and it emphasizes the truth that ornament should

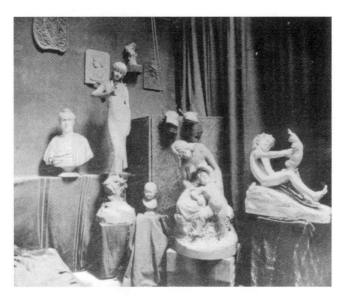

A Corner in the Studio of J. Scott Hartley

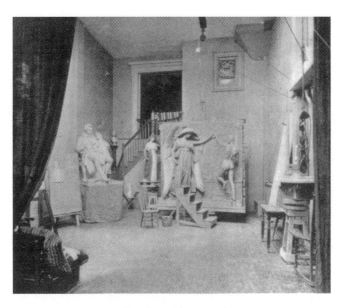

Studio of Daniel C. French

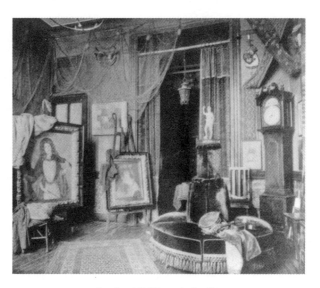

Stanley Middleton's Studio

be ornament, and not assume the rights of the users of the room and occupy the general space, which is so often the case in even the abode of the educated.

On the whole, both painters and sculptors realize this, and their rooms are first of all studios, roomy, well lighted, comfortable, and then ornamented. Very few of them attempt decoration until they have made an important collection of things worth seeing. They set no store by new furniture, new tapestries, or new anything, and bide their time until they can pick up the aged work of other days, which time has colored and sanctified. They prefer the subdued tone and modest face of old things, and they aim to destroy the bleakness and bareness of a large room by breaking up the flat spaces with things of so solemn and retiring a shade as will tend to soothe the senses into forgetting them. The result is that these work-rooms are strangely pleasing and harmonious places, where the stranger mind afflicted all day with the inharmonies of the streets and shops loves to sun itself and rest. So the true aim of all decoration—an arrangement of material things to harmonize with the spiritual thoughts and aspirations of the mind which is to dwell with them—is attained; and the result is satisfaction and rest, or, in other words, the thing that produces these, namely, beauty.

NOTES

"Artists' Studios: Hints Concerning the Aim of All Decoration," *Demorest's* 34 (June 1898): 196–98.

1. Henry Mosler (1841–1920) was an American painter. Dreiser contributed "Henry Mosler, a Painter for the People" to *Demorest's*, which was reprinted in *Selected Magazine Articles of Theodore Dreiser: Life and Art in the American 1890s*, ed. Yoshinobu Hakutani, 2 vols. (Rutherford, N. J.: Fairleigh Dickinson University Press, 1985, 1987), 1:205–11.

2. For more on J. Carroll Beckwith (1852–1917) see "America's Greatest Portrait Painters" in this volume.

3. For more on John Henry Dolph (1835–1903) see "A Painter of Cats and Dogs: John Henry Dolph" in this volume.

4. Stanley Grant Middleton (born 1852) was an American painter. Born in Brooklyn, he was a pupil of Jaxquesson de la Chevreuse and other painters at Julien Academy in Paris. He exhibited such works as *Normandy Fish Wife* and *Portrait of Honorable Lynn Boyd* at a variety of museums.

5. For more on Daniel Chester French (1850–1931) see "America's Sculptors" in this volume.

6. For more on John Quincy Adams Ward (1830–1910) see "America's Sculptors" in this volume.

7. For more on Jonathan Scott Hartley (1845–1912) see "America's Sculptors" in this volume.

■ America's Sculptors

That American sculpture is no longer a subject for flippant European comment, but really a distinctive world of art, which ranks with that of any other national school and which already presents indications that it is soon to lead the world, is due to the long labor and conscientious efforts of a very few men who early learned to ignore tradition and who long since broke away from the teachings of foreign schools in order that they might present untainted the epochs and traditions of their own country in bronze and stone.

These men have had a world of indifference to overcome. More than once the foreigner has invaded their domain, and without either equal talent or honest effort has been received with open arms, lauded and commissioned by the Europe-worshipping populace, and sent away with a fat purse and a shout of applause to his "ain countree," where he could spend the money and vent his long-choked amusement. Not wholly discouraged, however, the work has gone bravely on, until at present not only have they assumed honored control of the home field, but some of our young talent has crossed the Atlantic and wrested honors from those who have long been satisfied that no good could come out of the American Israel.

Of the careers of St. Gaudens[1] and MacMonnies[2] the public is only too well aware—careers that have been favored with peculiar conditions of publicity. Of those of Ward,[3] French,[4] Bartlett,[5] Hartley,[6] Rogers,[7] Bitter,[8] and Bissell[9] not so much has been written, although they divide the distinguished sculptural work of the land very evenly among themselves. They represent in a measure separate phases of sculpture, as, for

40 ■

instance, Bitter, whose work is decorative, and again Hartley, whose compositions belong to the ideal class.

Among the foremost of our American sculptors is J. Q. A. Ward, a man whose striking sculptural conceptions are perfectly familiar to New Yorkers. Those who have ever visited Wall Street have of course looked upon Mr. Ward's statue of Washington. The fine statue of Shakespeare in Central Park and that of Conkling in Madison Square are his work, as are a number of others in the city's public institutions.

Mr. Ward is the oldest working sculptor in the United States, and is often referred to as the "father" of the sculptors of the present day. He was born in Urbana, Ohio, in 1830, where he remained until his twenty first year. During the time he had gone through the common and high schools and taken up the study of medicine, but upon attaining his majority he decided that his art inclinations were more important, and therefore went to study with H. K. Brown,[10] a sculptor of some note at that time. With him he studied for some six years, and then moved East, stopping in Washington for a few years, but eventually, in 1861, opening a studio in New York.

He had by this time achieved a marked degree of success, and his career was from then on one of renown and prosperity. In 1874 he was made President of the National Academy of Design, and has since attained to various honorary distinctions in the world of art. He has produced about twenty five public statues, and although he is now in his sixty eighth year the productions of his later years appeal with undiminished force to art lovers. His is one of the most elegantly equipped studios in the New World, and among artists his popularity is great and secure.

Although a much younger man, Daniel C. French ranks with Ward in the world of art—a sculptor whose statue of Herodotus and of that typifying History, now in the Congressional Library at Washington, have only recently been widely commented upon by both art and lay journals.

Mr. French was born in Exeter, N. H., and is forty eight years of age. He began his studies under Thomas Ball,[11] the veteran sculptor, and at the age of twenty had already spent three years in Florence and Paris studying. At this time he modeled his well-known statue, "The Minute Men," which he presented to the City of Concord, and for which the

city returned him a gift of $1,000. He then executed a portrait bust in relief of the sculptor John Millmore, which was given a place as a memorial in Forest Hill Cemetery, Boston. His next work was a statue of John Harvard[12] for Harvard University, which he finished and took with him to Paris. There he exhibited it at the Salon, and was awarded a gold medal, the first ever presented to an American sculptor by the French Government. The work was then retransported to this country, and is now in possession of Harvard.

Nearly all of the work done by Mr. French has been of more or less public importance, and his statues of ex-Secretary Cass[13] of Michigan for Statuary Hall at the Capitol; Dr. Gallaudet,[14] the first teacher of deaf-mutes; John Boyle O'Reilly and Rufus Choate[15] for the City of Boston have all been matters of public discussion at one time or another.

That the career of genius has in it elements of romance is shown by the life of Karl Bitter during the seven short years in which he rose from obscurity to fame. At the age of nineteen the young sculptor won a gold medal in his native city, Vienna. His country then showed its appreciation for art and genius by drafting the lad into the army as a common private, where an ill-natured martinet of a Lieutenant did his best to humiliate and grind down anything that smacked of higher aspiration by making Bitter the special butt of the pettiest of military persecution. After a year of such service in the King's coat the young soldier deserted, and fleeing to Halle was employed with Kaffsack, the German sculptor, on a colossal monument of a Valkyrie, which now looks down upon the River Saale near that town.

The attention of the authorities being directed toward him, extradition proceedings were apprehended, so that young Bitter, tired of being considered an outlaw, took the next ship to America, and, once here, lost no time in taking out naturalization papers. He found work with a firm of architectural decorators as a skilled laborer, and in this capacity entered in competition for the famous Trinity $200,000 bronze doors, a presumption which was duly ridiculed by his fellow-workmen. When the prize was awarded him—the youngest of the half dozen sculptors who submitted designs—it dawned upon the two sculptors who had hitherto divided the field of New York and America between them that they would have to look to their laurels.

Two years later, when the decorations of the foremost building (Ad-

ministration) at the World's Fair was assigned to this young sculptor by Messrs. Burnham[16] and Hunt,[17] this apprehension became a certainty. After the formidable task of completing more than twenty colossal groups within the specified time had been completed, and Mr. Bitter had returned to New York to establish himself in a suitable studio, the fickleness of fortune offered him a sublime revenge. His former superior officer and persecutor in the Austrian Army one day knocked at his door and humbly begged for work, having in some way come to grief. The sculptor, after hearing his pitiful tale, employed him as his manservant, and thus the initiates of the artist's friend beheld for several years the spectacle of the former bully and tormentor serving him he had maltreated of yore.

Mr. Bitter's works are now conspicuous in New York and Philadelphia, the chief one being an immense terra cotta pediment with colossal figures, allegorizing steam power, stretching across the entire breadth of a street. Another is an immense terra cotta panel presenting Transportation, which is the chief feature of the Broad Street station, Philadelphia.

A well-known Boston wit who chanced to find his way to a sculptor's studio the other day, speaking of John Rogers, said that he had made more people happy than any other sculptor in the land. If not exactly that, he has certainly done more to educate the American people than any other contemporary sculptor.

Mr. Rogers's career as a sculptor dates from the day when as a boy he turned one day into a side street in Old Boston where a man was modeling some simple figures in clay. He had just found out after starting upon an energetic course of mechanical engineering that his eyes were giving out, and was consequently heavy of heart. But as he looked at the worker in clay the thought came to him that here was something he also might do, and the same was an inspiration. Not long after he got possession of some clay, cut a stick into the shape of a tool, and produced some work that delighted his family. Then he went to work with all seriousness and produced his first work, "Checkers at the Farm," which represents a familiar New England scene.

From the creation of his first group until his last, a striking group entitled "Football," he produced about fifty subjects, covering many of the most interesting scenes of American life. The titles of these will in

themselves indicate the simple force and strength of many of them. "One More Shot," "Union Refugees," "Taking the Oath and Drawing Rations," "The Returned Volunteer," are a few which illustrate the misery of the rebellion. In a more general field, "It Is So Nominated in the Bond," representing the famous trial scene in "The Merchant of Venice," is an excellent illustration of Shakespearean character. "The Charity Patient," "The Landing of the Norsemen," "Ichabod Crane and the Headless Horseman," "Fighting Bob," and "The Council of War," a group including Lincoln, Grant, and Stanton, whom Mr. Rogers knew personally, give an idea of the generality of his subjects. All of these are felicitous works, wonderful in their handling of our modern, ungainly dress, in spite of which most artistic effects are secured.

It was about the time when Mr. Rogers completed his first work that gelatin molds were invented, and the casting in these molds was carried forward to such perfection as to enable the sculptor to reproduce his work accurately and with little cost.

He was enabled to start in a small way in New York with one Italian workman, who did his casting, and who, I believe, remains with him at the present time. These reproductions of his work have had an astonishing sale, and there are very few homes in America to-day which do not contain a replica of one or another of his groups.

Mr. Rogers is one of the men whom we may rightly call self-educated. He was born at Salem, Mass., in 1839, and attended the public schools of Boston for a time, but was obliged, while still young, to seek employment in a dry goods store, and later in a machine shop. By night he made a careful and conscientious study of mechanical engineering, only to find upon completing his knowledge that his eyes were failing. His success was not thereby defeated at all, and he lives to-day with his family in the quiet of New Canaan, Conn., fully assured of the general respect of the world of art and the genuine appreciation of the people.

The story of the life of Jonathan Scott Hartley is the story of a high purpose stead-fastly followed and of success achieved not by any fickle favor of fortune, but by an indefatigable pursuit of the ideal. Mr. Hartley was born in Albany in 1845. He was a marble cutter, and undoubtedly a good one. His mechanical skill while a boy was brought to the notice of Erastus D. Palmer,[18] one of our earliest sculptors, and in Mr. Palm-

er's studio was first awakened in young Hartley's breast the aspirations which led him on to success.

He was only twenty-two when he departed for England, where he began serious work at the Royal Academy. There he remained three years, sustaining himself by working as a marble cutter during the day. He won a silver medal there in 1869, then went to Germany for a year, and thence to Paris and Rome. On his return to America Mr. Hartley made his home in New York, where he has since had his studio, while living with his family at Montclair, N. J. His wife was a daughter of the renowned George Inness.[19]

Mr. Hartley's fame is largely due to his ideal subjects in clay, one of which, entitled "The Whirlwind," created no end of public discussion in 1878. This remarkable work, the personification of the whirlwind, was first exhibited in 1878, the year in which Mr. Hartley was made an associate of the Academy of Design. This beautiful nude figure of a woman, involved in whirls of drapery, appears to spin in perfect poise, in a pillar of cloud. The criticism which it aroused was due to a certain feeling that action is not permissible in sculpture. Mr. Hartley's works are exceedingly numerous, and include the statue of Ericsson,[20] which graces Battery Park, and a splendid statue of Daguerre[21] in Washington.

Of the younger sculptors none has exhibited more evidence of genius or risen more rapidly into artistic favor than Paul Bartlett, who hails from Boston, but for the past nine years has had his studio in Paris. Mr. Bartlett is now completing the fourth of a series of historical characters, which belong in the great rotunda of the new Congressional Library. The arrival in this country last August of the second of this series, a statue of Columbus, to be cast in bronze in New York, was an event much discussed at the time. Mr. Bartlett is only thirty-five years of age, but his talent is mature, and his knowledge of bronzes and bronze casting is something awesome. At the last Paris Salon a number of his small bronzes were assigned a case to themselves and shared equally with those of MacMonnies, who also exhibited.

An equally interesting career is that of George E. Bissell, whose life began in 1839, but whose work as a sculptor dated from 1871. Until his fourteenth year young Bissell lived in New Preston, Conn., where his father owned a marble yard and conducted a marble sawmill, about

which the son was employed in various capacities. Then he removed to Waterbury, Conn., where he remained a clerk in a store until the war broke out, when he enlisted as a private for one year. On the expiration of that year he was appointed Assistant Paymaster in the navy, South Atlantic Squadron, Admiral Dahlgren commanding, and served until the war ended.

On his return Mr. Bissell joined with his father and brother in the marble business at Poughkeepsie, and his inspiration as a sculptor began with a local order for a soldiers' monument, which did not need any statue. The firm gave the task into the hands of the ex-Paymaster, who thought a flag draped over a shaft and looped over a sword at the side would be suitable. He knew nothing of clay or modeling from it, and so went at it in what he conceived the natural method, which was to first build a shaft of wood, actual size, fasten a real sword to one side, and drape a flag over both appropriately. From this model he carved into marble direct, and the result was the subject of much local comment and praise.

Not long after there was a call in Poughkeepsie for a life-size marble statue of a fireman, and a competition was had for this important work, in which the young artist came off victorious. He immediately came to New York to inquire of a sculptor the manner of going about building a frame to carry clay, and so on. When he had learned this he returned, divided off a portion of the shop with curtains, employed the most shapely of the sawmill hands as a model, first in the nude, then in a fireman's costume, and the result was a real work of art.

With this his fame began to spread, and after completing a soldiers' monument in marble at Schenectady and another in granite at Colchester, Conn., he decided to visit Europe, which he did, spending six months studying in the studios of Paris and Rome, and drawing from the nude and the marbles in the Vatican.

On his return he obtained commissions for a soldiers' monument in bronze to be erected at Waterbury, Conn., and also a portrait statue of Col. John T. Chatfield. In order to do these correctly he revisited Paris, devoting three years to study and their completion. On his return he modeled a statue of Gen. Gates[22] for the Saratoga Battle Monument, with which his reputation was fairly made. Since then Mr. Bissell's works have been both numerous and important, including as they

do a statue of Lincoln, which crowns the Soldiers' Monument at Edinburgh, Scotland.

NOTES

"America's Sculptors," *New York Times Illustrated Magazine* (25 Sept. 1898): 6–7.

1. Augustus Saint-Gaudens (1848–1907) was an Irish-born sculptor who worked in America.

2. Frederick William MacMonnies (1863–1937), an American sculptor, was featured in "The Art of MacMonnies and Morgan," *Metropolitan* 7 (Feb. 1898): 143–51, reprinted in *Selected Magazine Articles*, 1:212–17.

3. For more on John Quincy Adams Ward (1830–1910) see "Artists' Studios: Hints Concerning the Aim of All Decoration" in this volume.

4. For more on Daniel Chester French (1850–1931) see "Artists' Studios: Hints Concerning the Aim of All Decoration" in this volume.

5. Paul Weyland Bartlett (1865–1925) is the subject of "He Became Famous in a Day," *Success* 2 (28 Jan. 1899): 143–44, reprinted in *Selected Magazine Articles*, 1:242–47.

6. For more on Jonathan Scott Hartley (1845–1912) see "Artists' Studios: Hints Concerning the Aim of All Decoration" in this volume.

7. John Rogers (1839–1904), a native of Salem, Massachusetts, became famous by producing little plaster and genre groups. He always designed and modeled the groups himself, drawing on everyday scenes from mid-nineteenth-century America, the Civil War, literature, and sports.

8. For more on Karl Theodore F. Bitter (1867–1915) see "Karl Bitter, Sculptor" in this volume.

9. George Edwin Bissell (1839–1920), the son of a stonecutter, went to Paris to become a sculptor but was not inspired by the new impressionistic modeling practiced in Paris. His dry and often prosaic style was of mid-nineteenth-century naturalism.

10. Henry Kirke Brown (1814–86) studied sculpture in Italy but believed that the United States should have a national art of its own. His most important project in the midcentury was an equestrian statue of George Washington, a calm but heroic interpretation he modeled with the help of Ward.

11. Thomas Ball (1819–1911), believing his art could develop better in Italy, produced most of his best pieces in Florence. Ball did not attempt symbolic works because his patrons demanded prosaic naturalism. His bronze *Emancipation Group*, showing Abraham Lincoln freeing a black man from his chains, was erected in Washington, D.C., in 1875.

12. John Harvard (1607–38) was an English clergyman in America. He left his library and half of his estate to the college just founded in what would become Cambridge. The college was later named for him.

13. Lewis Cass (1782–1866) was an American statesman.

14. Thomas Hopkins Gallaudet (1787–1851) was an American teacher of the deaf. Gallaudet University in Washington, D.C., is named for him.

15. Rufus Choate (1799–1859) was an American jurist.

16. Daniel Hudson Burnham (1846–1912), an American architect and pioneer in city planning, was a leader of the "City Beautiful" movement of the early 1900s.

17. William Holman Hunt (1827–1910) was an English painter in America.

18. Erastus Dow Palmer (1817–1904), unlike most nineteenth-century American sculptors, did not go to Europe to study and seldom traveled.

19. George Inness (1825–94), an American painter, received little academic art education. From about 1878 to his death he was one of the greatest landscape painters of the nineteenth century. His best work possesses individuality, unusual depth, a great quality of tone, and a variety of color.

20. John Ericsson (1803–89) was a Swedish-born American engineer and inventor.

21. Louis Jacques Mandé Daguerre (1789–1851), a French painter, invented the daguerreotype.

22. Horatio Gates (1727–1806) was an American general in the Revolution.

■ A Painter of Cats and Dogs: John Henry Dolph

It is a notorious fact that "Care once killed a cat," and that Puss once wore boots, but I doubt sometimes if these ancestral happenings are any more widely known of the grimalkin family than that numerous of its latter-day members have had their portraits painted by Dolph.[1] "Dolph's Cats!" Why, truly, such of them as have had their charms canvased by this eminent painter of felines come into a class by themselves, and to be a "Dolph cat" is, in the realm of cats, to be what a Legion of Honor man is among ordinary men. Somehow, in painting Thomas and his family, Mr. Dolph seems to generally overlook their failings and present only their more pleasing points of character.

It is by no means depreciative of the richer gifts of John H. Dolph, extremely talented painter that he is, to say that he paints cats, for he painted portraits with great success at one time, and scenes from American farm-life—the farmer ploughing, sowing, and reaping. Indeed, he did these things so excellently well that to those with a taste in their direction it seems a pity that Mr. Dolph did not continue and make this field his own. No American has done for our soil what Israels[2] and others have done for Holland, or Millet[3] and others for France, and yet our farmer is not less picturesque, nor is his life less full of those tendencies which we deem poetic. But the general public have a more generous fancy for "Kitty" and "Puppy" pictures, which they satisfy at the expense of their purse. Naturally a field of such evident reward claims its share of talent.

To appreciate Mr. Dolph's work in this field one must consider well the cat and her ways. Thus, to look at one's sober-sided house cat, with

The Society Lion

her dull, sleepy glance, her grave, slow walk, and dignified, prudish airs, who could ever think that once she was the blue-eyed, whirling, scampering, head-over-heels, mad little firework that we call a kitten? That she could ever have been one of those marvelously vital things of fur, about the size of a doughnut, that rush about, and mew and spring, dance on their hind legs, embrace everything with their front ones, roll over and over, and lie on their backs and kick, seems like some utterly heretical untruth. And yet it is these almost paradoxical characteristics of the feline that find expression through the brush of Mr. Dolph. How he does it is one of the mysteries of genius, for it never seemed to me that the delightfully quizzical expressions which both kittens and puppies wear in Mr. Dolph's pictures ever showed in a live kitten's face or attitude long enough at one time for anyone to secure even a fleeting realization, let alone a painter's exact conception of the whole. However, the thing is done. Mr. Dolph's pictures are in evidence, and there you are.

To say that he is droll before anything else is but to do him justice, and casts no reflection upon his art, for drollery is the pleasing quality in his work.

The man has such a reasonable, lenient, and tolerant conception of men and the weaknesses of men that he cannot help but be droll. He has probably turned away from the consideration of the antics of his fellow men, who consciously shirk responsibility and duty, to these lesser creatures, that look so helpless and seem so guiltless of all intention in the good or evil that they do. It is true that he works out a fine cynicism through this feline medium, but it is a kindly cynicism after all, and points a modest moral for him who runs.

An example of the lurking humor in his pictures is seen in the one entitled "In Temporary Possession," where a number of young kittens are investigating the interior of the canary's cage. The canary is not visible, and Mr. Dolph does not explain its whereabouts. There springs the thought that the kittens might know, and they look twice as impish and fascinating for the suspicion. A delightful touch is expressed in another of Mr. Dolph's pictures, "Listeners Never Hear Any Good of Themselves." A poor, jealous little feline intruder in the background is listening to a mottled kitten and a yellow puppy conferring in the foreground. The suggestion of possible slander is drollery in its most telling form.

Even stronger is the fine cynicism displayed in the conception he has given of La Fontaine's fable, "The Rat Retired from the World."[4] The painting shows the old rat, who has made his home in a well-stocked larder, where ease and plenty have given him a full stomach and the gout, turning a deaf ear to the appeals of his less fortunate relatives.

"My poor friends," is the rat's remark, with a patronizing air, from the luxurious depths of the cheese where he has fed, "my friends, you are lean, hungry, and lame, and present petitions. Yes? And Ratopolis is invaded by the cats—what then? They would not enjoy my cheese. Your affairs I have really nothing to do with. Sublunary things no longer interest me. I have retired within the rind of my cheese. Pray be good enough to depart and seek to disturb me no further."

La Fontaine's deadly conclusion of this indifference is not depicted, of course, but the scene in question gains meaning from Dolph's delineation of the types of rats.

Again, "The Society Lion" is the counterpart in cat nature of many an episode of society in ballrooms, where the floors are resplendent with richly decked women and marked by a paucity of men, the latter

showered with attentions, because so indispensable. The decorated, traveled, and world-tried gentleman in this picture is a pug dog, and from his little pedestal he looks with a fatigued expression upon the four little débutante kittens at his feet. To be sure, the coy white and gray miss at the edge of the sofa is not going to indicate all at once her subjection to his many charms; but this is more than compensated for by the open and fervent admiration of the others.

In Mr. Dolph's larger pictures his mature cats are self-respecting creatures always. You look over his paintings and you conclude that puss carries herself with dignity under the most embarrassing circumstances. Ponto, caught in a transgression, curls his tail between his legs and sneaks away; but Tabby? No. Though cream be on her whiskers, or the blood of the canary on her jaws, she looks you placidly in the face. If she discerns that the evil spirit is upon you, she makes a graceful exit through the window. And never, never does she fawn. Whether her feet be clean or muddy, she does not with a too confident familiarity approach you. In no case does she paw you. Instead, she steps up gingerly, inquiringly, her back arched into a query, and her tail an interrogation point. One deprecating gesture on your part and she is gone. It is not necessary to supplement your silent discouragement with a ruder impulse; at the first hint of dislike she vanishes. I think Dolph understands cats.

And yet he did not intend to specialize in cat painting. He tells entertainingly that he always had a desire to paint horses. "I think," said he, "that I painted them fairly well. The artists said so, but the public failed to respond. When I had returned from my first trip to Europe, I had been studying at Antwerp with the celebrated horse painter, Louis Van Kuyck.[5] It had been all outgo and no income of the kind that, as Stevenson[6] said, would 'come in.' I needed money, and in my studio I found a little frame which had cost me about twelve dollars. It occurred to me that I might paint something to fit it, and I took the first subject that presented itself, a kitten frisking about the room. For my picture the auctioneer to whom I sent it returned me one hundred dollars, and I did not regain my breath for some time. Naturally, I painted other cats, and before long I was overrun with orders." That was in 1875.

All those who recall Mr. Dolph's work before that year will remember seeing a picture by him representing a cross-country hunt. It goes

High Life

without saying that hounds and horses were well painted, but so was the landscape. Under a gray sky the dogs were chasing across a bit of swampy meadow, the riders following close behind; in the near foreground, tall weeds and bushes; just beyond, the marshy land and leafless trees, throwing their well-formed branches against the sky; back of these, a stretch of pasture skirted by a bit of woods. The trees were beautifully drawn, and painted with all the skill and knowledge of a trained landscape painter, which, indeed, Mr. Dolph is. The whole picture was rich in color and general excellence.

For such scenes, however, he did not, as he says, find as ready a market as he desired. No more quick-selling were his excellent figure subjects—gentlemen, courtiers, and pages of that period in French history when men and women looked not so much as if they had just stepped out and down from the frames of their ancestors, as that they were just ready to step into frames for the glory of their posterity. Upon the walls of his studio there still hang examples of this period, small cabinet pictures, in which the greatest care and attention have been given to the painting of the still life and accessories as well as to the figures. Indeed, Mr. Dolph has always had a liking for the rendering of

textures, and he catches with rare skill the sheen and glint of metal, the play of light on silk or satin, the bloom of a velvet gown, or the glow on the turn of a Turkish rug.

In his many salable paintings of cats and dogs one sees the old decorative touch newly applied, and with delightful results. His sense of light expresses itself in the glow of the eyes of his animals, which seem to truly shine, and follow one at times. The value of his work is enhanced by contrast, and it is a conservative statement that no other artist has with greater success sought out and painted the manifold phases of feline life. He has not dressed nor caricatured the cat in any way, but has merely discovered her expression. In this the difficulties are not small. The lines defining the figure of a horse, for instance, or almost any animal except young kittens and puppies, are pronounced. But a cat has no anatomy apparent, and a puppy is distressingly full of irregular lumps, depressions and protuberances. You have heard of the boy who was all "hands, feet and freckles." Well, a similar exaggerated condition prevails in Mr. Dolph's subjects. And for these, once painted, it is his desire, as he drolly expresses it, "to find Christian homes."

"The ethics of painting these things," he once said to me, "is to study the living creature until you are well acquainted with it, and see it from its best side. Then paint away until you get a likeness. The *painting-in* of intelligence, sympathy, humor, and the human qualities in general is, of course, the real strength and beauty of any picture, and cannot be explained."

Cleveland, O., may in a manner claim Mr. Dolph, as he received his first instruction from one of that city's well-known artists, Allen Smith,[7] in 1852. He earned his bread in the early part of his career decorating the interior of passenger coaches, and there still runs on the Lake Shore Road one of the old coaches that his skill adorned. Subsequently he followed portrait painting with considerable success in Detroit and Chicago. In 1860 he returned to Cleveland, where he spent three years painting portraits and genre subjects, when he came to New York. Here he studied and painted until 1870, when he had laid by sufficient to visit Europe, where he prosecuted his studies at the Royal Academy, Antwerp. Returning to New York, he fought his good fight for recognition until 1875, when he painted his first cat picture, the success of which carried him onward in his present field to fame.

But for four or five years, beginning with 1885, he forswore animals, except as they filled in as valuable accessories for rich studies of the time of Louis XIII., and decided to ignore a public demand for cat pictures, which left him no time for any other form of art. In these years he studied architecture in Paris, making visits to various palaces and old chateaux in and about the city, acquiring a knowledge of costumes and architecture of the different periods which is not exceeded by that of any other American artist. At this time also he painted his "Choice of Weapons," a picture of note, which shows a tall cavalier standing in the house of a wealthy armor merchant carefully examining a handsome hilted sword. Costumes, decorations and armor are of the time of Louis XIII., giving an historic as well as artistic value.

But—what would you? The public wants Mr. Dolph's animals, and in supplying an occasional urgent demand he gradually drifted back into his old field, where, after all, he is fond of laboring, and since then he has devoted himself to this form of art exclusively.

In person, Mr. Dolph is a big, handsome, good-natured individual, who would walk a mile to do a good turn for man or animal. He is a lover of humorous stories and has an inexhaustible store at his tongue's end, with which he is fond of illustrating, Lincoln fashion, any point he desires to emphasize. In the art world he is credited with no end of waggish concoctions, and his *bons mots,* like those of Whistler,[8] have a currency which keeps his name constantly uppermost with those who love wit. One or two of these will be welcomed, as, for instance, that of the gentleman who turned up a portrait of the late Senator Dolph in the artist's presence, and at that early period when the Senator was famous and the artist unknown.

"Is he a relative of yours?" said the visitor.

"Well," said Dolph, dryly, "he claims it, but you never can tell. Senators boast so."

Another one of his exceedingly witty speeches occurred at an art dinner, where the artistic merits of the famous trio, Diaz,[9] Daubigny[10] and Corot,[11] were in question.

"Pshaw," said one artist, "anybody can paint like Corot; only yesterday my friend Perry here dashed off an impression that would have passed for a Corot, and did it in less than half an hour."

"And it wasn't so dreadfully bad," said Perry, in a reflective tone.

The Fish Commissioners

"Probably because you spent so little time on it," said Dolph.

But these are only tidbits, two out of many which Whistler would gladly have said.

Up at Ardsley, N. Y., Mr. Dolph has a country place, where his animals are kept, and in the Sherwood Building, in Fifty-seventh street, is his studio. There are few artists in New York who have a larger, and none a working place more beautifully decorated with valuable antiquities. It is a solemnly shaded place, and forms a rather effective setting for so genial a countenance and such lively pictures.

NOTES

"A Painter of Cats and Dogs: John Henry Dolph," *Demorest's* 35 (Feb. 1899): 68–69.

1. For more on John Henry Dolph (1835–1903) see "Artists' Studios: Hints Concerning the Aim of All Decoration" in this volume.

2. Jozef Israëls (1824–1911), a Dutch painter, was known for painting scenes of peasants and fishermen and the milieu in which they lived.

3. Jean François Millet (1814–75) was a French painter.

4. Jean de La Fontaine (1621–95) was a French fabulist.

5. Louis Van Kuyck (1821–71) was a popular Dutch painter.

6. Robert Louis Stevenson.

7. Allen Smith (1810–90), an American portrait and landscape painter, spent most of his professional career in Cleveland and painted many excellent portraits of prominent citizens. His work compares with that of George Healy, Daniel Huntington, and Benjamin Elliott of the same period.

8. James Abbott McNeill Whistler (1834–1903), an American painter and etcher, was born in Lowell, Massachusetts, and died in London. Earlier in his career, he was associated in Paris with such artists as Edgar Degas and Félix Bracquemond. In 1898 he was elected the first president of the International Society of Sculptors, Painters, and Gravers. He is best known for *Portrait of My Mother,* known commonly as *Whistler's Mother.*

9. Narcisse Diaz (1807–76), a French painter, became the friend of Honoré Daumier, Henri Rousseau, and Paul Huet. Claude Monet, Pierre Auguste Renoir, Alfred Sisley, and Frédéric Bazille admired Diaz's brilliant colors, and his late landscapes are said to have influenced the impressionists.

10. Charles François Daubigny (1817–78), a French painter and printmaker, became Jean Baptiste Camille Corot's friend, spending much of his time painting in the Dauphiné and in Switzerland. He belonged to the Barbizon School.

11. Jean Baptiste Camille Corot (1796–1875), a French painter and printmaker, became known when Charles Baudelaire and Champfluery began to write warmly about his art. Corot also belonged to the Barbizon School.

■ Karl Bitter, Sculptor

There is but one sculptor in America who leans wholly to the decorative art and who has made a reputation for work in that particular field. All sculpture is, of course, more or less decorative, and no matter what an artist evolves out of clay, it can be used to decorate something somewhere, whether it be a public building or a mountain-side. But all sculpture cannot be called decorative, except that it has that particular quality of vast and elegantly harmonized detail and is an ornament, pure and simple, and not a historical memento placed in a decorative sense.

A clearer idea of what is meant by this will be come at through an example. All those who have ever entered Philadelphia by way of the Broad street depot have no doubt noticed in the great waiting room the sculptural panel which is placed over the doors opening out into the train shed. This immense panel, forty by fifteen feet in dimensions, is probably the best example of purely decorative sculpture in the Western hemisphere. It represents Transportation, and there are in it not only many figures of men and women, horses, chariots, and implements, but a landscape and all the detail of a living, moving picture. It is purely allegorical, and the various arts and sciences are represented by different figures—engineering science, for instance, and the thriving railway genius of America being typified by a beautiful female figure bearing in her arms the model of an engine. The great farming and ranching industries, so important in any idea of transportation, are suggested by a drover and his flock. Transportation as a thought, or unity, is represented by a charmingly garbed female placed in a chariot drawn by horses, every one of which typifies industry, and she is

accompanied by such a train of followers as only transportation could have, two of whom have been described.

This panel is by Karl Bitter,[1] the leading decorative sculptor of this country, and the work he has done in this is a fine example of what the decorative idea involves. It is not historical, though it might well have involved historic facts; and it is not religious, though some of the world's finest decorations are religious in feeling. It is purely allegorical, and while as a panel it serves to ornament the room it occupies (which is the primary consideration), it also harmonizes in the idea it involves with the great fact of the depot itself, which is an actual factor in transportation.

Mr. Bitter is a talented young sculptor, who has genius for this kind of art and loves to work it out on every occasion. He has done beautiful doors (one of the $200,000 bronze doors of Trinity Church being his handiwork), mantelpieces, andirons, friezes for public buildings, and decorative figures of all kinds for private and public ornamentation. Quite a number of New York mansions contain sculptural compositions of his, either as separate ornaments which can be moved about or as parts of the walls and pillars of the house. The mantelpiece, for instance, in the dining room of Mr. George Gould's[2] New York house contains a decorative panel by Mr. Bitter, representing the hunting Diana; and Biltmore, the home of Mr. George Vanderbilt,[3] at Ashland, North Carolina, contains a pair of andirons, designed by the same hand, which cost nearly eight thousand dollars. There are a number of important portrait busts of well-known people around New York done in marble and bronze, all evidencing the same remarkable decorative feeling for which this man is distinguished; and in the architectural field several of the best examples of his work are to be seen by those who pass the St. Paul building on Broadway. There three stooping giants upbear on their solid shoulders the weight of an ornamental cornice which projects from the façade of the building.

Mr. Bitter is anything but a peculiar individual. He seems to have no art pretensions whatever. Only a little past thirty years, he looks the artist in form and features, and he lives the artist in style and surroundings, but in conversation and manners he has the air of a man in any other field of endeavor. He seems to take great interest in other things besides art; loves sport, amusements, and the affairs of the

world in general. He studies other fields most carefully and is informed on topics which go to make the philosopher more than the artist. He has had hard knocks, too, and that has removed any trace of professional egotism, if any such thing may be thought to have existed in him.

In the sense of living the artist, he has one of the largest and most pleasingly equipped studios that are to be found in this country. It is not one room, nor two, but a whole building, which adjoins his home in Weehawken, opposite Forty-second street, and immediately overlooking the Hudson. In fact, it so immediately overlooks the Hudson that it is right on the edge of that imposing precipice known as the Palisades,[4] and from the river's edge below looks like a handsome bird-house high up in the air. If the rock on which it stands ever begins to crumble, the whole thing will land hurriedly in the water below; and yet this thought never seems to trouble the occupant. A narrow stair leads sharply up the steep hillside until it halts at his cellar door, from whence others lead up into the main rooms of his workshop.

I should think that an artist poorer in this world's goods than Mr. Bitter would have rather a sad feeling of poverty after visiting this beautifully equipped place. The owner of it is rather a connoisseur and collector of bric-à-brac and interesting things in general, and his workrooms are handsomely set with charming art pieces of all kinds. He has, besides paintings and etchings, a collection of books, military arms and trappings, mediæval beer mugs, and the like, which are unassumingly disposed of here and there about place. His own works under way occupy a considerable space, and he has furniture which is the pick of years of travel and selection.

In this place, lighted exactly as his work requires, he labors so long as the light and his patience hold out. He has great physical strength and no end of solemn patience for the minute details which go to make up the merit of his work. Hour after hour he pursues his unobserved task in silence, and is frequently known to lock his doors and shirk his meals when deeply interested in the outcome of a difficult piece of work. He not only molds in clay, but carves exquisitely direct out of marble. Some of his best portrait busts have been done in this manner.

Of course it is not all work. One room of the studio has been fitted

up in the form of a library and another as a reception room, in which he spends his leisure hours and entertains his friends and visitors. Both of these rooms command a general panoramic view of the Hudson, north and south, all New York and its harbor spreading out broadly beneath the gaze. Into his reception room he has placed old, carved furniture of historic interest as well as beauty, and hung up his trophies of the hunt, as well as other interesting memoirs of his early struggles. The scheme of decoration, which is looked upon as one of the most admirable in all the round of New York studios, is his own, from the stained glass windows to the ornaments of the wall and ceiling.

Mr. Bitter is, originally, a native of Vienna, but came to this country somewhat over fifteen years ago, and is now an American of the Americans, patriotic in his love of the country, and faultless in his use and understanding of the language. He early manifested the genius which has since so successfully matured, but he was forced to enter the army, and for several years was compelled to abandon and almost forget the inclination he had to study in the direction of his tastes. He was under severe military training all the time, and ruled by a martinet of such a harassing disposition that the young sculptor found he could not stand it at all and so finally deserted. There was a great to-do about it at the time, and the young deserter, not being able to get out of the country undetected, entered the service of an Austrian stonemason, where he worked in the humblest capacity as a cutter for over a year. His taste and clear advisory sense brought him consideration in this quarter even, and he was put to the finer and more conspicuous work by the master, until finally he was set about the repair of one of the great churches of the capital, where he was recognized for the deserter that he was.

Fortunately for his life, he recognized his "recognizer" first, and fled, going to Germany, and finally drifting to New York.

NOTES

"Karl Bitter, Sculptor," *Metropolitan* 9 (Feb. 1899): 147–52.

1. For more on Karl Theodore F. Bitter (1867–1915) see "America's Sculptors" in this volume.

2. George Jay Gould (1864–1923) was the eldest son of Jay Gould (1836–1892), the American financier.

3. George Washington Vanderbilt (1862–1914) was the grandson of Cornelius Vanderbilt (1794–1877), the American financier.

4. The Palisades is the line of cliffs fifteen miles long in southeast New York and northeast New Jersey on the west bank of the Hudson.

■ E. Percy Moran and His Work

If all Americans were as familiar with paintings as they are with, let us say, their household necessities, the name of Moran would be a synonym for merit in the art world. There are so many members of the family, nearly fourteen in all, and all of them painters. Three brothers Edward, Peter and Thomas Moran[1] attained distinction years ago as marine and landscape painters and from them sprang a brood, all with the artistic talent. Edward alone had two sons, Percy and Leon, both of whom developed peculiar talent, and it is of the work of the former that the present article is to concern itself. The whole family is so clever in its respective fields that it seems rather partial to choose but one member for consideration. However from certain points of view the work of Percy Moran deserves special notice as he comes nearer the popular heart with his work, and is esteemed a really meritorious and charming painter. You will find his pictures regularly in the exhibitions, with that brightness and color in them which makes the thing of beauty. They may be all but devoid of any deep moral significance or stirring sentiment, but they are always pleasing in the sense that a picture should be pleasing.

Some artists take themselves too seriously. As the collector Clarke once remarked—of another well-known American painter—"his ability pains him." They get an exaggerated idea of the significance of what they do and feel called upon to express a deep something which is to move the world upward. This is all well enough and even admirable when combined with world-genius, but the resulting pictures are usually too deep for the average lover of pictures. Mr. Moran, on the con-

trary, belongs to that school which looks upon art with an almost decorative eye and strives to produce something which will be colorful and dainty. He is unconsciously in line with the adage, "reach a man through his stomach," for what is that but a special application of the larger thought, "elevate" the world by pleasing it.

This idea, however it may be disagreed with here and there, pleased art lovers in general when Mr. Moran worked it out in his paintings. He had not been long out of his uncle's studio, under whose direction he studied, before his work was approved. So far back as 1881 he made a stir with one of his paintings—"Great Expectations"—and a little later with another, entitled "Sunshine and Shadow." In 1882 he painted two of his best known pictures—"Good Friends" and "An Old Time Melody." These pictures were pretty in an individual way—they had really a rare feeling for the beauty of women, and as for textures and coloring, were remarkable. All the members of the Moran family excel as colorists, and Mr. Percy is no exception. There followed what every good artist endures before he settles down to his true status in the world, a *vogue*, in which he and his work were generally discussed. Many pictures were sold, and since then he has never wanted a market for the amount of work he desires to do.

At this period of his life he was what can best be described as a man about town. The clubs knew him, and wherever artists congregated, there he was. He joined the leading club of artists—*The Salmagundi*, and for a long time was foremost in all affairs which tended to make that organization a success. Later on, after he had a round of metropolitan life, he married and disappeared from his old haunts. The change was quite noticeable and much remarked. He resigned from the clubs, stayed away from artist festivities of nearly all kinds, and buried himself in a measure in his home affairs and his studio work. He was not forgotten, however, for the amount of his work did not fall off, nor was there anything save a somewhat solid improvement in the treatment he gave his line of subjects. There has never been any return on his part to the old form of life. But his fame has not diminished, and to-day his name commands as much attention as ever—a rather certain assurance that the original vogue was better grounded than are most structures of public praise.

Those not knowing Mr. Moran personally might imagine from the individuality that attaches to his name that he is an old man. He was

born in 1862, and has only now reached that age in which most paint-
ers first attain to any success that can be considered permanent. The
reason for his early rise probably lies in the fact of his having been born
into a wholly artistic family, with a famous father and uncle to guide
and develop his artistic taste. Like all the members of the family he has
traveled abroad more or less, but still lays claim to having received his
art education in America and practically in his own family.

Mr. Moran is a rather slight, dapper gentleman of decidedly unpro-
fessional make-up. He reminds one of a well groomed American busi-
ness man rather than an artist, for he has none of those touches of
personal adornment which artists very often affect. He makes his stu-
dio a part of the charming home over which his wife presides, and has
located it in one of those quiet New York apartment houses, where
everything is most reserved and exclusive. Here he spends his days—
studying his models and painting while the light lasts. There is quite
an air of luxury about him, but it does not seem to affect his individu-
al simplicity. Into his pictures he puts all that the subjects suggest. His
ideal studies of women are truly ideal. He gives them grace of position
as well as beauty of face and figure. The environment is always well
painted in detail, and where the figures have vivacity and beauty, the
textures have reality and a harmony of tone pleasing in the extreme.
As I have said, his pictures teach no moral, although the majority of
them might easily adorn a tale.

"What do you think is the mission of the artist?" I once said to
him. "Are you going to ask that?" he replied. "Well, we all must some-
times privately take account of ourselves and wonder why we are gift-
ed as we are."

"Quite true, and when the thing is considered intelligently it always
has interest. I should say an artist's mission in life is to make it better,
handsomer, more pleasing. Different men have different fields, and
there is no room for quarreling over who precedes. If I could I would
be pleased to make life handsomer for my work. I should like to give
the eye something to charm and soothe it. Many may not consider that
a high ambition. Very well, we must do what we can do and leave the
riddle of it to others."

It was rather a good thing to say, I thought; not boastful; not apol-
ogetic; not indifferent. Whatever individual critics here and there may

think concerning Mr. Moran's work, the public in general, by its approval of it, seems to be trying to convince him that he does *very well* indeed.

NOTE

"E. Percy Moran and His Work," *Truth* 18 (Feb. 1899): 31–35.

1. Thomas Moran (1837–1926), E. Percy Moran's uncle, born in England, was an official artist with a government expedition of the United States to Yellowstone in 1870. He established his reputation as a delineator of Western landscapes.

America's Greatest Portrait Painters

The recent portrait exhibition held in the Academy of Design, in New York City, has awakened society, and art lovers in general, to a fact not hitherto clearly understood, and that is, that there are a number of very able and distinguished portrait painters in this country, whose power of characterization and color sense are not to be ranked below similar powers possessed by artists in any age. Over five hundred portraits, representing nearly all the portrait artists of this century, together with a gallery of old masters, served to bring the work and methods of the various schools and cults into such contrast as to enable the critics to form a very accurate judgment as to their respective merits.

The world of our living American portrait artists proved an agreeable surprise. The average of accuracy is higher, and it is an open question whether their reading of character is not better, more felicitous and yet more incisive than that of any previous period.

Eastman Johnson[1] and J. Alden Weir[2] were both represented in their finest manner. Portraits by Irving Wiles,[3] William Thorne,[4] Frank Fowler,[5] and Carroll Beckwith[6] were all well placed, and deserved the position and attention which they received. The Moslers,[7] father and son, Childe Hassam, and the Morans[8] were all in evidence, with canvases so good in the general details of excellent portraiture that the merit of the exhibition could not fail to be remarked.

It followed that considerable discussion as to the merits of leading American portrait artists took place, in which the strength of the principal men was canvassed, with the result that many of the visitors to

the exhibition managed to fix definitely in their minds some of the leading Americans in this field.

WHERE ALL EXCEL, WHO PRECEDES?

It is rather difficult to mark precedence of individuals in this art. The field is so large, the artists so numerous, and the work so generally meritorious, that to select anyone as preëminent is simply to disagree with others who have preference. In selecting a few for criticism, it is done wholly in a spirit of friendly discussion, the reputation of the individuals with the public being more nearly considered.

The fame of Eastman Johnson as a portrait artist is more of an evolution than a direct result of effort. He did not originally contemplate becoming a portrait painter, but time and the opinion of the public as to his ability in this line, have worked the change.

He has always shown marked ability for character delineation. People remember his pictures. A face painted by him is usually so true to the original that it is startling. He was more than once accused of reading character too inquisitively, and putting into the face of the sitter traits that were deeply heart-hidden and held in abeyance by the greatest stress of moral effort. In one instance, a trace of something weird and unreasoning appeared in the face of his portrait of a young lady. This was inexplicable until several years later, when the girl became insane;—then the painting looked like her.

BUSY ALWAYS, ASPIRING EVER

Such ability was bound to attract attention. From the time he began to paint portraits in Washington, in 1845, until the present day, he has suffered no declination of either popularity or ability. At that time, though a mere youth, he had more portrait work than he could do, and the same condition holds with him to-day.

From his boyhood, which was spent in Lovell, Maine, he exhibited the usual artistic symptoms and made the usual crayon drawings—innumerable. His parents were poor, but by local work he managed to sustain himself and save money for higher ventures. He came to New

York in 1843, where he studied art and then went to Washington, painting, first, *genre* subjects, and then, in 1845, portraits. By 1846, his fame had spread so that he was invited to Harvard to paint a portrait of the president of that institution. His success was such that he remained almost the entire year, exercising his brush over likenesses of the faces and figures of the notable Harvard professors. This so filled his purse that he took a vacation for a short period, and, in 1849, sailed for Europe, where he purposed studying. For a time he occupied a studio with Emanuel Leutze,[9] in Dusseldorf, after which he devoted four years to art at the Hague and then went to Paris.

FROM LANDSCAPE WORK TO PORTRAITURE

On his return, he found his fame had increased rather than diminished, and he undertook portrait work in Washington, remaining there for some ten years, when he again removed his studio to New York. Here he soon became an important figure in the art world, and has so remained. His portraits, wherever exhibited, are always subjects of favorable comment. In the recent portrait exhibit, his work was given precedence for merit. Despite the fact that hundreds of younger men have entered the field since he began, and artistic reputations have been made and lost, Mr. Johnson is still acknowledged to be one of the very few leading portrait painters.

In further discussing this subject of precedence, it will be appropriate to first do grace to the ladies, and acknowledge, whether out of order or not, the able work that has been done by at least one of them. It is well known that the portrait field is not often essayed by women, but there are a few exceptions. Of these, by reason of talent in several directions, Mrs. Rhoda Holmes Nicholls[10] takes precedence. It is hardly fair to give her credit as a portrait painter only, for her reputation was primarily founded on landscape and figure work of a very high order of merit. Neither is she American by birth, but she has so long resided here, so much identified herself with American aims and interests, and in every way united herself with her adopted land, even to the extent of marrying an American husband, that she is looked upon as wholly belonging to our country. As a portrait artist, Mrs. Nicholls

has risen to great prestige, and has a following of her own. She paints brilliantly, and makes her studies of individuals not merely representative, but very often works of art aside from the individuality.

A QUEEN OF PORTRAIT PAINTERS

It is a question whether, in another land and atmosphere, she would attempt to push her way forward in this line, but America is a peculiar country, with egotism run mad, and wishes itself portrayed personally more than it wishes anything else, so that the pecuniary advantages are all in favor of this work. For one having talent like Mrs. Nicholls, it is an honorable field, and she does not hesitate to devote her time to it.

Her training was good. From early school days, Mrs. Nicholls's talent for art was marked. An only daughter of the vicar of Little Hampton, England, had an early opportunity to complete her education in London, and take up the study of art in the Kensington Museum. In the latter school she won the Queen's prize (£60 for three years), with an additional £10 for high approval. After one year, however, she sacrificed the prize to go to Italy, where she studied landscape painting with Vertunni,[11] and the human figure with Camerano. Here she distinguished herself, and, though still so young, was summoned by the Queen of Italy to receive compliments upon her attainments. She then visited Africa, and subsequently came to America, where she was married to Burr H. Nicholls.

New York, Chicago and Boston at once recognized her merit, and awarded prizes to her. She sold her pictures at very high prices, and gathered about her large classes of students anxious to study under her direction. Her prestige has never waned, and she still has about her as many disciples as she cares to accommodate. June locks her doors and allures her to pastures new, where the flock of students follows for out-of-door study.

Quickness of conception, bold treatment and fine color mark all the work of Mrs. Nicholls. Her portraits are distinguishable by a certain decorative grace in their treatment as well as their remarkable accuracy. She takes great interest in all art politics, is vice-president of the

New York Water Color Society, a member of the Women's Art Club, of New York and of Canada, and of the Aquarell Club, of Rome, Italy. The Nineteenth Century and the Barnard Club also have her enrolled as a member. In 1896, one of her exhibited portraits received a silver medal at the Atlanta International Exposition, and New York and Chicago have frequently awarded her gold and silver medals for similar distinguished pictures. She is still quite young and constantly attracts attention by the merit of her labors.

THE ARTIST WHO PAINTED PETER COOPER

For his portraits, almost exclusively, J. Alden Weir is noted, and not undeservedly so. New York cherishes his warm-blooded representation of old Peter Cooper,[12] and there is no better likeness extant of Richard Grant White than the one painted by his brush. In Paris, he received honorable mention at the Salon in 1881; and, in 1888, the prize was awarded to him at the exhibition of the American Art Association for one of his paintings. More, he has had a following not only among laymen, but artists, ever since he entered the New York art circle. Some of the big art events have been planned in his studio, and he is well fixed, in the mind of every artist, as one of the founders of the now famous Society of American Artists. As a National Academician (to which body he was elected in 1885), and one of the chief councillors of the society, he has art prestige enough and to spare.

Mr. Weir is a hale, jovial individual, popular for his genial disposition and abundant wit. He has that easy talent, born in some men, of mingling with men and affairs. His art comes to him by way of his father, who was the noted Robert W. Weir, a historical painter and distinguished academician of the middle half of the century. J. Alden studied under him, and, later, under Jean L. Gérôme,[13] at Paris, where he did excellently. On his return to America, he first painted *genre* subjects, but, in 1880, essayed portrait work, and therein found the field of his subsequent success and distinction. It was a striking portrait of his father, which he painted in that year, that first drew attention to him: and thereafter portraits of Warren Delano, Olin T. Cooper, John Gilbert, and a score of others, marked him as one of the ablest men in this field.

A TYPE OF THE ARTIST IN SOCIETY

No American artist is better known for portraits than Carroll Beckwith. Besides a refined ability to catch the fleeting character expression of individuals, he has so many other qualifications peculiar to his work, he smacks of the art world. Although born in Hannibal, Missouri, and reared in Chicago, he looks like a Frenchman, or an Italian, of the most pronounced artistic type, and possesses a manner so greatly modified from that customary in Americans, that one is troubled to account for it. He seems an artist without a country, or at least out of place in the country which he claims as his fatherland.

In a sense, Mr. Beckwith stands as typical of the artist in society. He belongs to the Four Hundred in his leisure moments. His patronage is out of that body and his social relations with it. His latest portrait is almost invariably one of them. In most of the notable functions indulged in by the wealthy, he has a part, and, it is needless to add, has the means wherewith to bear himself equably in that sphere. How much it contributes to his ability as a painter, is a matter of speculation, but there can be no disputing that his social relations lend him importance in the eyes of the uninitiated. He has what most persons envy,—distinction, position, ability. He carries it all with an air and a *sang froid* that makes markedly a type, and a very interesting one.

Beckwith was born in Hannibal, Missouri, in 1852, but passed his youth in Chicago, whither his parents removed early in his life. He had excellent public school training there, and after the fire, in 1871, removed to New York, where he studied in the schools of the National Academy of Design. He had artistic ability ingrained in him, and did his fancies in black and white with a dash and an accuracy that invariably brought attention and favorable comment. "You have the gift," said his earliest teacher, significantly. His parents had money, and furnished him the means to prosecute his studies. It did not injure him, however. As an artist, he has undoubted talent. His paintings have both poetic fancy and excellent color values, and are of strong subject matter. His portraits are strong in the essential point,—analysis. He has a fine, discriminating sight back of his wonderfully affable demeanor,—a discrimination sometimes sharpened with sarcasm, and he uses it to fine advantage. Many of our

best portraits of prominent Americans are by him, and many more will be, as he is the soul of industry, and has a waiting list always far in advance of his ability to complete it.

In connection with him, should be described the genial Frank Fowler, an eminent portraitist and decorator,—the author of so much art criticism himself. Fowler has painted the notable men in public life. He has done portraits of ex-Governor Flower, and ex-Governor Morton, Charles A. Dana, and James Gordon Bennett. The best portraits of Archbishop Corrigan,[14] John D. Crimmins, and Richard Croker, all are by him, and there are yet more to be recounted. He seems to be in vogue with men in public life, and it is easy to imagine of how much interest his gallery of celebrities will be a hundred years hence, when all of these men are historically included in a period of great American development. He seems to paint them with an eye to the future, putting down character in the simplest colors, and avoiding all decorative effect in order that the individual may look out upon you in almost personal conjunction. Fowler went to Paris to pursue his studies. Like Beckwith, he betook himself to the *atelier* of the distinguished, Duran,[15] where he met Sargent and Beckwith, and made friends with a number of Americans then studying abroad. In a short time, he was picked out as a student possessing talent. Duran favored him, and as a mark of his interest, duly allowed him to do a large amount of difficult work for him for nothing. It was the practice of this distinguished Parisian, when he had great commissions to execute, to allow his talented favorites to lay in the backgrounds, copy historic draperies and otherwise make studies and prepare sketches of things which he would have to make use of in the course of his distinguished labor. For reward, he would, as I have said, allow them to accompany him about Paris, much as a prince allows his retainers to walk at his side, while awe-struck Parisians gazed and exclaimed, "Ah, the great Duran!"

AMONG THE YOUNG MEN

Fowler made much of his opportunity. He exhibited in the Salon as soon as possible, got his medal, and came home, where he soon earned distinction.

Among the younger men, Irving R. Wiles, and William Thorne give most promise of being the famous Americans, in this field, of the future. Both are about thirty, both began as magazine illustrators, and paint with a certain likeness of feeling that is remarkable to one familiar with their works. Their studios are within a stone's throw of each other, in Fifty-fifth street, and they are such good friends as to be often found together, lounging, commenting, working, in the merriest of moods. Mr. Wiles's teacher was his father, the well-known landscape artist, Lemuel M. Wiles, who was for many years the art instructor at Ingham University, near Rochester, New York. Wiles came to New York when he was eighteen (1875) and entered the Art Students' League, where he took a three years' course. After that he went to Paris and spent two years under Lefebvre[16] and Carolus Duran, from the latter of whom he gained much that is best in his technique. Indeed, he is one with Beckwith and Fowler in singing the praises of this vain Parisian genius, who, for all his airs, has the rarest ability as a painter.

Upon getting home in 1884, he settled down in New York City, and since then has worked hard, first at illustrating, then at painting and teaching, and later at painting altogether.

Mr. Thorne has had quite a similar experience. He also studied at the Art Students' League, went abroad, returned home and made a marked place for himself as an illustrator, and finally drifted wholly into his true field.

Of the work of these young men, too much cannot be said in praise. They are character students of the clearest insight, and are masters of the teachings of the portrait artist. They are hard and rapid workers, and have the advantage over some artists in being such good friends that each one may freely draw upon the other's knowledge and opinion. Curiously enough, both draw their patronage from the highest social life of the city, and have taken about equal rank in the eyes of their patrons. In the recent portrait show, their work was very much in evidence, the committee on hanging having given them considerable precedence for merit. Intellectually, they are men of broad minds, and look upon art with clean, wholesome spirits. And by their art only they aim to succeed.

NOTES

"America's Greatest Portrait Painters," *Success* 2 (11 Feb. 1899): 183–84.

1. Eastman (Jonathan) Johnson (1824–1906) was an American but studied in Europe. When his family moved to Washington, D.C., he began to draw many crayon portraits, working in the Senate Committee Rooms at the Capitol in his youth.

2. Julian Alden Weir (1852–1919) was awarded many medals at the Paris Expo, the Carnegie Institute in Pittsburgh, the Chicago Art Institute, and other museums.

3. For more on Irving R. Wiles (1861–1948) see "Art Work of Irving R. Wiles" in this volume.

4. William Thorne (1864–?) was a pupil of Benjamin Constant, Jules Lefebvre, and Henri Laurens in Paris. His work is represented by *The Terrace* in the Corcoran Art Gallery in Washington, D.C.

5. Frank Fowler (1852–1910) studied at the École des Beaux Arts and exhibited portraits at the Society of American Artists in New York.

6. For more on J. Carroll Beckwith (1852–1917) see "Artists' Studios: Hints Concerning the Aim of All Decoration" in this volume.

7. Dreiser featured the Moslers in "Henry Mosler, a Painter for the People," reprinted in *Selected Magazine Articles,* 1:205–11. Henry Mosler Jr. (1841–1920) was an American genre painter. Henry Mosler Sr. was an American lithographer.

8. For the Morans see "E. Percy Moran and His Work" in this volume.

9. Emanuel Leutze (1816–68), a German-born American painter, was instructed by John A. Smith, an American portrait painter. He later established himself in Dusseldorf and executed a considerable number of paintings.

10. Rhoda Holmes Nicholls (1854–1933), an English-born American painter, exhibited many of her best works at international expositions such as the Columbian Exposition in Chicago (1893), the Atlanta Exposition (1895), the Nashville Exposition (1897), and the Pan-American Exposition in Buffalo (1901).

11. Achille Vertunni (1826–97) was an Italian landscape painter.

12. Peter Cooper (1791–1883) was an American manufacturer and philanthropist.

13. Jean L. Gérôme (1824–1904) was a French painter.

14. Michael Augustine Corrigan (1839–1902) was the third Roman Catholic archbishop of New York.

15. Carolus Duran.

16. Jules Lefebvre.

■ Concerning Bruce Crane

Of all those who depict life upon canvas, the landscape painter may be said most truly to hold fellowship with nature. His best friends are the streamlet, a company of trees, the southern slope of a hill. He confers tenderly with all that is beautiful in the world outside—the rain and the wind, the gossamer and dew of morning, the wistful purple of the horizon at sundown. What is appealing in the lamp-shine of a window or the moonlight dancing upon water, he knows. All the delicate tints of the morning and the full majestic colors of the noon he remembers. In his heart dwells a constant desire to express nature in its simplest aspects. In so much as he succeeds is he truly a great painter. Not every artist who essays to reproduce the face of nature succeeds thus perfectly. It may be questioned whether ever a canvas truly conveyed the feeling which a sunny, green slope wakes in the observer direct. It requires a mind of the finest spiritual attributes to see, and seeing to *feel*. If he can feel the beauty of a scene it will not matter so much whether he paints in, correctly, every twig and stem. It will be enough if he merely indicates the general features, and so blends and diffuses his color as to give one the feeling of the wide outdoors. Our greatest landscape painters possessed more or less of this power.

Since George Inness died, no American has had time to develop an equally great reputation. There are many candidates with fair reputations and some ability, and there are hundreds who paint landscapes, but the great distinction which he attained has in a measure overshadowed them all. Minor[1] and Eaton[2] and Murphy and Crane lead all the others, but not one of them has as yet the distinction of an Inness. The

pictures of Mr. Bruce Crane, the subject of the present sketch, show an individual feeling concerning nature, which is most delightful. All that he draws is strong. He uses simple material and seems to depend not at all upon a maze of color.

If you have the pleasure of seeing a number of his canvases you will learn that his range of subject-matter is wide. Not every landscape artist essays to paint the morning and evening aspects of nature. Few have the temerity to attempt to express the mystery and vague beauty of the night. The gloom and sadness of a gray day and the rare buoyancy of a bright one, form separate fields, in reproducing which many an artist becomes a specialist.

Mr. Crane is a bright, clever New Yorker, and, if a man is no older than he looks and feels, cannot be more than thirty-five. As a matter of fact he was born in 1857, and save for summer outings and an occasional trip to Europe, has always lived in New York. He has developed himself as an artist by that hardest kind of labor which is best described as cheery persistence. Beginning with scarcely any money, he weathered with a happy-go-lucky air the most desperate period of his apprenticeship, and came out all right.

Mr. Crane came of parents who were neither poor nor prosperous. His father, a designer, was evidently a man of most poetic feelings. He loved to read and recite poetry and to paint. It is easy to understand from the son's humorous though tender memories of his sire, that the paintings were not of a high order of merit, but the poetic instinct was back of them. Mr. Crane, the elder, did not trouble himself about a north light or any other kind of light. He got his canvas and his brushes, and to work he went. When the picture was finished he would admire it for a while, and then lay it aside and begin another.

Of course the son gained no artistic training from this. His father could teach him nothing about the technicalities of art. He did influence him radically, however, by his example, for when the boy saw what the father did, he forthwith desired to do likewise.

The lad was taken about to exhibitions of pictures and had constantly instilled into his mind the idea that he was to make a success of art. Later the father decided that his boy must not go through the usual struggles of the poor artist, but should be made independent in the matter of living expenses before settling down to his studies. Conse-

quently he set aside a sum with which he intended to buy his boy a twentieth interest in a large architect company, which not only drew plans of houses but manufactured the material out of which they were built. Here young Crane was to serve three years learning the profession, after which, a certain sum was to be paid over to him and the interest declared.

Before the expiration of the allotted three years of service, however, the concern failed.

By dint of saving almost all that he earned, he finally managed to take a course of lessons under Wyant,[3] the great landscape artist. This corrected his artistic perception. Where before he had copied and followed others, he now originated. Wyant taught him that, however poor one's own ideas may be, they are better followed for the sake of personal development than are those of some one else. Crane had naturally an independent and self-reliant nature. He had fine sentiments and more or less of the make up of the poet. It was not much trouble to wake in him a soulful affection for the wondrous shifting scenes of earth. He went out and sketched from nature direct. Practice gave him a technique all his own. He learned to see for himself, to paint the fine, distinctive points which he admired and to handle his brush in a quaint and thoroughly individual way.

After his course under Wyant his poverty came to an end. He began to paint little pictures which he signed with an assumed name and offered for sale among the dealers. These latter noted their individuality and paid him fair prices.

Mr. Crane's reputation grew with years until finally he was admitted as a member of the Society of American Artists, and later as an associate member of the National Academy of Design. One of his pictures took the Webb prize a few years ago. He has a great many admirers, including the critics, who see enough merit in his work to watch it and reprimand him if he does not constantly strive to live up to what they consider his ideal. Withal he puts a joyous, hopeful atmosphere into his painting, which is significant.

Socially, there is no more popular artist than Mr. Crane. His brother artists all like him personally and admire his work. He is a lively member of the Salmagundi Club, a member of several of its committees and has considerable influence in the world of art, generally. Artists look

upon him as a man of much executive ability and invariably call him to advise and help along whatever plans are brewing for exhibition. He has an unusual and striking appearance, and above all is sincerely unaffected in manner.

NOTES

"Concerning Bruce Crane," *Truth* 18 (June 1899): 143–47.

1. Robert Crannell Minor (1839–1904), an American landscape painter, was a familiar figure in the studio buildings of New York's Washington Square.

2. Charles Warren Eaton (1857–1937), an American, was known for painting tall white pines of New England and Belgian landscapes.

3. Alexander Helwig Wyant (1836–92), born in Ohio, devoted himself early in his life in Cincinnati to painting photographs and portraits. At twenty-one he visited George Inness, whose work influenced many of his most important pieces. Wyant painted his early landscapes following the detailed naturalism of the Hudson River School, but later his style became personal, reflecting an interest in a new poetic tonalism. He was one of the founders of the American Water-Color Society.

■ The Camera Club of New York

The spirit of the Camera Club is compounded of a warm enthusiasm for the beauty and the sentiment of the world. And in accordance with the very strength of this feeling it has become a beneficent influence among those who love beauty in photography. Not strange, then, that it is dominated by men of more or less poetic inspiration. They have a great opinion of their art and a truly rare insight into the beauties of nature. They have striven to make the club the honored parent of a new delight; to give it a scientific and educational turn, and so to invest its doings as a body with an authority that it shall reflect credit upon photography the world over.

To appreciate the work being done here we should know something of the new aspiration which actuates the masters of the camera. They desire to take rank in the eyes of the world as great artists. They believe that artistic photographs are only secured by artistic natures, and that great photographs are made only by great men. The camera is nothing, a mere implement, like a painter's brush. It is the soul of the man who manipulates it that gives every picture secured its value. These leaders of the photographic art propose to force the world to accept their contention that photographs may be artistic treasures, and their labors are unswervingly directed toward this end. They teach their doctrine of superiority to the photographic beginners of the club. They set it forth in lectures and criticisms, and a club journal. They argue for it with directors of museums, and the officers of the various art bodies throughout the land, which make exhibitions of paintings and art treasures. Their one desire is to make the club so large, its labors so

distinguished and its authority so final, that they may satisfactorily use its great prestige to compel recognition for the individual artists without and within its walls. Like all promulgators of a new idea, they are enthusiasts, and their claims more or less exaggerated.

Until 1884 the photographic interests of the country were neither large enough nor artistic enough to warrant an organization of any kind, representative of the art or its ambitions. At that time, the occasion having arrived, the Society of Amateur Photographers was formed, with only a very few members and a large number of objects. Those who joined were men who had proved to their own satisfaction, and that of others, that there were distinct art possibilities in the sensitive plate. Each one had made a few pictures. They wished to make more and better ones, and above all they wished for advice. It was really a plan to cultivate social acquaintance with men who had done interesting things with the camera, and so gain by their experience. It was rather an exclusive body, composed chiefly of men of some talent in the photographic field. This left room for a more liberal body, composed of photographers and would-be photographers, who could lay no claim to achievement, but who were ambitious to learn. As was to be expected, it was eventually occupied by the old Camera Club, an organization formed exactly on these lines. It came into existence in 1888 and struggled along rather feebly until in 1896, when it united with the Society of Amateur Photographers and began its present prosperous career.

The reason that neither of the two societies flourished was due to the fact that each body lacked what the other had. The Amateurs had artistic talent to compel recognition and position. It lacked numbers and revenue to give it corporate greatness and importance. The Camera Club had numbers and revenue, but no talent to compel recognition and public esteem. When the two combined the result was almost immediate growth and action. Those in the Camera Club began to feel the educative and regenerative influence of the talented amateurs, who freely gave of their experience. The latter in turn enjoyed the advantages of the revenue which would permit them to take the practical and artistic steps so necessary to every lover of photography. A liberal working establishment had been the dream of both bodies, and with the union came the realization, a ten-thousand-dollar photographic plant,

which is as free and as ready to the hand of every member as his own household.

That the club has flourished is unquestionably due to its ideals. It is because those who joined it have been taught concerning the practical and awakened to the artistic. No mere matter of club privileges has worked so great a success. Large as these are, the inspiration received is more binding. He is initiated into a conception of the club's ideals. He is familiarized by frequent exhibits with the rare work of its chief members. Indeed, he is shoulder to shoulder with the leaders of the art, who, after the boasted spirit of the club, are ready to advise and correct; to give of their full and often costly experience to those who stand in need of it.

The present quarters of the club are in Twenty-ninth street, near Fifth avenue, where they occupy an entire floor of the building. The members are pleased with what most clubmen would object to—the fact that all the club's rooms are on one floor and not scattered, variously, as in the more purely social organizations. The space which it covers—5,000 square feet—is divided into one general reception and lounging room, a suite of offices for the executives, a library, a huge working room, filled with cameras and lockers, and twelve dark rooms. There is, in addition, a well-appointed studio on the roof of the building which offers the members facilities for portraiture under ideal conditions.

The paraphernalia of the club is simple enough, almost severe, but the equipment is not in furniture. More attention has been paid to the arrangement of five hundred lockers, where each member keeps whatever relates to his work. Practical judgment has been exercised in equipping the dark rooms with every convenience which aids in the proper development and printing of a picture. Here are electric lights arranged so that the most perfect gradation of development may be had. Whatever chemicals are necessary are also present and free. Best of all, there is what no home-equipped dark room could have, a vast amount of experience and knowledge, ready outside the door. Several of the most able and justly famous artists are connected in an official capacity with the club, and upon their wisdom the perplexed worker in the dark room is free to draw. There are a dozen cameras scattered about the room, large and small, which any member may use at any time; and, lastly,

there is always an exhibit of some artist's work on the walls, which constitutes in itself a lexicon of photographic wisdom.

To the beginner who has spent some months wrestling with his new fad and its representative, a small camera, this atmosphere is certainly pleasing. Entering from an individual state in which he has worked alone in his more or less incomplete dark room at home, he must feel the privileges which the club offers. During a single month he will pass from the beginning to the end of practical picture-making. One evening of each week the club holds its weekly test of lantern slides, where new work in this line may be seen and the criticism of the club's experts on the same be heard. On another evening of each week occurs the regular lecture on "Practical Photography," in which now one and now another phase of the work is discussed. Less frequently, and at irregular periods, come lectures by members or others who have specialized in some branch of the art, and who now offer a detail of their failures and achievements.

The lantern slide tests are most important, as they include an assemblage of half a hundred amateurs, some of them the most expert in the land, who offer freely of their advice and experience. The student who may be new to the field meets with men who are most distinguished—stars of a heretofore unreal world—who extend to him a serviceable and wholesome opinion. His lantern slides may be critically torn to pieces, but his store of knowledge will be proportionately enlarged. He has also the consolation of knowing that, if in this instance he has endured the rack, all those who have gone before, or who may follow, will scarcely fare better. Very few photos are perfect, and the critical zeal of the camera masters is exacting far beyond the pale of humble human accomplishment.

And yet it occasionally serves to make an humble student of a self-opinionated and self-exaggerated individuality. A case in point is a now distinguished member who came from Brooklyn.

"I was fine in Brooklyn," he remarked one time. "My experience there gave me a good opinion of my work. I began to make lantern slides and exercised my individual taste, with the result that my work was admired. Gradually I began to exhibit it more and more. I joined a local club whose fad was lantern slides and became a star member. Finally I gained such repute that I decided to come to New York and

astonish them. I decided that I would quietly enter my plates for exhibition, and, in the vernacular, 'sweep 'em off their feet.'"

"Well?" I inquired as he mused reflectively.

"Oh, I exhibited. They walked on me. One of my pictures made them laugh, and it was intended to be sad. There were twenty-seven objections made to another. My best one came off easy with three criticisms, and all valid. Oh, lord! I thought I would never get out alive."

"Were they fair?"

"Yes; that was the bitter thing. I could realize that it was all kindly said and meant, and was good for me. After it was all over, one gentleman, who noted my crest-fallen state, came up and told me that my work was not bad. It was only the high standard of the club that laid it open to so much criticism. This was too much, and I went home in despair."

"And yet you profited by it."

"It was the best thing that could have happened. I began studying in earnest after that, merely to blot out my terrible defeat. In another year I exhibited again, and the whole set passed the 'test' audience with only a few suggestions."

And yet the club is not hard on any aspiring member. The veriest tyro may drop in to the chambers at any hour with a few exposed plates to develop and learn in a half hour, from the experts of the land, more than he has been able to acquire in months of solitary plodding. He sees the busy members at work printing, mounting, burnishing, and making slides day after day, and without asking even a question, he may often gather information sufficient to serve his needs. Certainly the recited experiences heard on every hand are to the point with him, and the library stored with all that pertains to the literature of the subject is open for his consideration. Lastly, the complete educational trend, so far as photography is concerned, of all that is said and done makes an atmosphere which is unquestionably conducive to growth and artistic understanding of the subject.

Atmospheres are the result of distinct personalities, and this of the Camera Club issues as the persuasive spirit of its chief exponents. It has among its active and interested members Alfred Stieglitz,[1] that guiding light of the whole American photographic contingent; Rudolph Eickemeyer, Jr.,[2] whose sympathetic representations are still the wonder and

despair of the beginner; Chas. I. Berg, distinguished for the classic and architectural flavor of all that he has done in the photographic way; W. A. Fraser, the photographer of so many brilliant night scenes; W. E. Carlin, who has specialized as the aid and abettor of the natural historian; Miss Frances B. Johnston,[3] the portrait artist, and W. D. Murphy,[4] the photographic Ishmael. All of these men have accomplished something, many of them a great deal, and it is the contemplation of their art and the distinction that has accrued to them because of it that lifts the average worker in the club out of the routine of average accomplishment and fills him with a desire to do something better.

Mr. Alfred Stieglitz is not only vice-president of the club, but the founder and editor of its distinguished organ. He spends the major portion of every day in the rooms of the club. His influence on development is not so much understood as felt. No man has done subjects more widely apart in conception and feeling, and none has done better. He has no specialty, and apparently no limitation. In every branch in which amateurs have specialized and distinguished themselves he has proved himself superior. If he has one desire it is to do new things— not new in an erratic way, but only new as showing to all the sentiment and tender beauty in subjects previously thought to be devoid of charm.

He may be justly said to lead. There is that in his pictures which gives value to the masterpieces in every field of art. Some of his work has all the charm that poetic insight can devise. It was said of his "Winter on Fifth Avenue," far back among the early examples of his art, that it was "a lucky hit." The driving sleet and the uncomfortable atmosphere issued out of the picture with uncomfortable persuasion. It had the tone of reality. But *lucky hit* followed *lucky hit,* until finally the accusation would explain no more, and then *talent* was substituted.

His attitude toward the club has come to be the club's attitude toward the world. He openly avows that he has planned to accomplish three things: First, to elevate the standard of pictorial photography in this country; second, to establish an annual national exhibition, giving no awards, but whose certificate of admission should be prizeworthy above all medals; and third, to establish a national academy of photography. That he will accomplish these ends is almost certain. His work in uniting the two withered photographic organizations into one of the wealthiest and most useful clubs of the nation augurs well for

his other plans. So far he has succeeded in gaining for photographs an entrance into several notable art exhibits, namely, those of Boston and Philadelphia. As to the national academy, it is his ambition to see the Camera Club develop into that.

The club is not so much indebted to Rudolph Eickemeyer, and yet in part belongs to him the vigor of its aspiration. He undoubtedly ranks with the very greatest of living photographers. Imperfect as some of his studies are, no other photographer outreaches him in delicate sentiment. In those pictures in which he does exercise conservative methods he is superb. In those in which he is over-sentimental, it is fortunate that they do not. For he does err in this direction, and sometimes sadly. Again his work is not broad—does not cover a very wide range of subjects. His greatest achievements have been bits of landscape which seem to present all that can charm in either earth or sky. His figures and groups have made him most popular, however, and in them he has done exceeding well. They remind you, in a certain way, of old German and Dutch paintings, everything being carefully arranged and showing a trace of almost forced order. And yet they are immensely clever, as witness "Vesper Bells," here reproduced. Its beauty would not cause an outcry, and yet it is so tender and delicate as to leave the imagination soothed and charmed.

From the old point of view, held by the generation of photographers which preceded the present one, Mr. Eickemeyer's work is perfect in technique. It would be generally termed clean and sprightly. It is not all the simple impression of the camera, sometimes showing an oppressive shade of retouching. Only a brother artist would dare to criticize, however, for to the uninitiated they are perfect art, and in so much serve the purpose of all art which is to delight and correct and inspire.

Between Stieglitz and Eickemeyer and Chas. I. Berg the club fares well enough. When one is not forward with something of interest the other two are sure to make up the deficiency. Mr. Berg is a goodly patron of the club, and a giver of prizes as well as a great photographer. His work is of a kind that will never have a marked influence on the higher phases of pictorial art as now conceived of; but it is nevertheless beautiful in part. His field is figure studies of a decorative turn, nude or draped. Being an architect, he has had some of the advantages which that profession renders, and he has used them in so marked a

manner that all of his photos possess an architectural flavor. Much of his work has been inspired by famous paintings after which he has posed his models, and yet even in these there is a certain artistic and unusual merit.

Mr. Berg believes in the mission of the club not so much as a social institution, but as the forerunner and parent of a great awakening to the artistic possibilities of the camera. He has found it of advantage and inspiration to himself from the very beginning. Indeed, it had started on its career when he first began to photograph twelve years ago, and he has been more or less closely identified with it ever since. Some of his earliest exhibitions made seven or eight years ago were here, which since then have been made all over the world. A little bit slovenly in his technique—a failing which shows occasionally in a background where the accessories are much poorer than they need be, he is still a good, honest workman, great in comparison with the common photographer, and always a student. Unlike Eickemeyer, he has not stopped growing.

Quite the most distinguished of all the club's women photographers is Miss Frances B. Johnston, of Washington, who was originally an amateur far above the average. At that time she had fine sentiment and rare technique of an old order. Unfortunately for the art-loving public, though not for herself or her patrons, she drifted into commercial work. Even there, where it could have no especial individuality, it still has certain refinement and none of the bad qualities of trade.

At the time first mentioned, Miss Johnston was an ardent artist with a specialty which was portraiture. She gave exhibitions in which negatives long since counted rarities in the art were shown. Her "Gainsborough Girl," one of the best of her later works, is still going the rounds of the exhibits, and some others of hers have not been forgotten. She was also an ardent worker in the course of the amateur and art photography in America, and did her best in the public prints to make the various masters who had sprung up well known. With the advent of her own commercial success her enthusiasm was curbed by individual interests to the extent of putting an end to exhibition pictures by her except at the rarest intervals. Still, her work and her career is to-day a living influence in the club, and examples of the best of her work, exhibited now and then, never fail to enlist the applause and the emulation which they deserve.

Another specialist whom the club has fostered, and who in turn has reflected credit upon the spirit and ideals of that organization, is Mr. W. A. Fraser, a New York business man, whose specialty is night scenes. This is no longer so novel as it was a year or two ago, though it has not lost any of its charm. The photographer in this case is an excellent one, possessing that first quality of genius, patience. He has some taste and sympathy, and a good-natured faculty of weathering storm and public opinion for hours at night getting photographic impressions of some of the glittering night scenes about New York. The subject is not wholly his own, having been originated, one might say, by Mr. Stieglitz, and since entered into by other amateurs, who, be it said to the credit of Mr. Fraser, have not been wholly so successful as he.

A third specialist who has been aided and abetted by the club is Mr. A. L. Simpson, who has for years pursued the rumbling fire engine in its diurnal and nocturnal meanderings in the quest of fire pictures. He is not a great photographer by any means, if endurance and energy be not greatness, but his subject is a peculiar one, and his pictures absorbingly interesting. He has photographed fires for nearly twelve years, with the result that out of tens of thousands of negatives taken he has a number of hundreds which are gems of the curious and thrilling order. Everything from incipient flames to startling escapes and crashing walls are told by his unique collection.

And there are others, much of this order, who, not being masters, are yet individual and above the crowd.

The club advocates the idea thoroughly, believing it to be an incentive to greater things. "Every man should at least have a specialty," say the leaders, "for if they do no more than illustrate one phase of life graphically they put the camera one step higher in the commercial and scientific world, and illustrate its value as nothing else can."

The world a little prefers beauty set forth by great or little labor to any practical or utilitarian energy, however ingeniously and sympathetically undertaken and executed, and so the true artist of the camera is always first in interest. To see him at labor is to understand the wonder of that insight which can feel and know the presence of that spirit of beauty which ever dances before us, across hills and fields, but is so rarely captured and made our own. And so I have thought it well to append a statement by one of the club's distinguished trio, Mr. Rudolph

Eickemeyer, who has explained most sympathetically the steps by which we came at last to that final realization of beauty which is in the picture "Vesper Bells," here reproduced:

"My camera and I have pastured on a few old farms every Sunday for five years, rain or shine, in all seasons, and we find so much to occupy us that we have grown to look upon this territory as inexhaustible, so we may never go to Europe together.

"Nearly all my contributions to photographic literature deal with this deserted section of Westchester County. It is getting to be a task to write a new description of the odd hours in which the picture illustrating this article was taken. For it is the same old house, built a century ago with low, slanting roof, and large chimneys telling of huge fireplaces and comfort within. A winding road leads to it, and standing back from the main highway, at the foot of a high hill, crested with chestnut trees, it looks decidedly picturesque, quaint and old.

"It was a hot summer day when my wife and I drove over to the farm, on which this house stands, to spend the day. The milkroom was the coolest place in the house, and there we found an old lady shelling peas. This room is more easily described than illustrated with a photograph. It is about twenty feet square with a low ceiling. Standing upright, I could just walk between the rafters. The side-walls were stone. On the north side were two little windows, near which, and running the full length of the room, was a double shelf covered with pans of milk and garden produce. The room was whitewashed throughout, shelves, ceiling, side walls. The place where the old lady sat was near the door and away from the two little windows. The light about, therefore, was dim and quite lost upon her. I had her stand near the windows in order that I might see the effect of the wall back of her and note the light on her face.

"After moving the shelves and other appurtenances out of the way, I photographed her shelling peas. When the print was made I studied it closely. Regarding it as a picture, it seemed coarse, and I realized that I should have to depict her in some other attitude or occupation if I would bring out the true refinement of her character. The picture, however, served its use; it showed the possibilities of this little corner of the milkroom. The following Saturday was cloudy, and the light insufficient for photographing, but the time was not lost. I placed a bench in the corner for my model, and put a potted geranium in one

of the windows. This brightened up the corner and it began to look less prison-like, reminding me of the cozy interiors so common in the Tyrol, and in South Germany. I recalled the simple but impressive devotion of the people there at the tolling of the bell for prayers, and before the morning had passed I had planned the following Saturday's work. My crucifix from Oberammergau should be placed on the vacant wall space to the right and the old lady seated in the corner would bow in prayer at the sound of the vesper bell.

"The result of this plan is shown in the second picture. The close quarters made the work trying, as the day was hot. Although the sun was shining bright, the plate required fifteen seconds' exposure, so weak was the light from the windows. Anticipating this, I had brought with me a head rest, which proved to be a relief for my model, as the task of posing was not easy on account of her eighty odd years. I had given so much time and trouble to the making of this picture that it took some time for me to realize that it was not yet complete, and that all would have to be done over again.

"The moment I began to distrust the success of my effort that moment the faults began to be apparent. First of all, I thought, why should the old lady be seated in the corner with nothing to do? She should be reading, or, upon second thought, she would better be knitting, as this would enable me to cover up the bare space on the bench with a ball of yarn; besides the monotonous dress front would be relieved by the stocking in her lap, and the composition would thus be made more complete. The picture would then show that the old lady on hearing the bell had dropped her work, folded her hands, and bowed her head in solemn prayer. The crucifix, too, I saw, should be less prominent, and the background much darker, giving the figure 'envelope,' then the composition as a whole would have a beautiful balance of light and shade. All very true, but this meant another Saturday, the fourth one since the first picture was taken. On the fourth Saturday everything went as I had planned it. The light was perfect. A sheet was used to illuminate the deep shadows on the model's face. This would, of course, render the whole corner lighter, but such a defect would be corrected by developing the exposed plates locally, allowing but a trace of the developer to touch the background or the window. In this way the whitewashed walls were given the proper degree of depth and density, and the old lady's face was light-

ed up and brought out in strong relief. It will be seen that after all the carefully laid plans, to make a harmonious picture, my labor would have gone for naught had the plates been treated in the ordinary commercial way.

"The question may be asked whether the resulting picture is a success and commensurate with the labor of producing it? This is neither here nor there. I have taken the reader into my confidence for another purpose: To teach him among other things a lesson in patience. Telling him to study his subjects carefully that he may get the most out of them, not to stop when he has made a mere photograph. And to remind him, moreover, that his camera should be a means of translating his artistic sentiment without which his work will be merely a record of cold and lifeless facts."

Whether the club is eventually to give us a national academy of photography or itself to merge into that desirable institution after Mr. Stieglitz's idea, remains to be seen. In the latter case it will need to be endowed as colleges are, and so open a large and commodious building, where an accepted course of study, with thoroughly competent men as instructors, may be followed. For this course there should be a professor of chemistry and of optics, to teach concerning the theoretical part, and others to teach the technical side exposure, lighting, development, printing in all the mediums; lantern slide making, enlarging, and so on, that the student might gain the greatest possible understanding and control of his tools. Besides these there should be classes in drawing, composition, design, clay modeling, and even painting, supplemented by a thorough study of the works of the masters old and new. In a word, it would be a place where one would receive the same art training as a painter, together with a more complete technical schooling than is given anywhere at present, and step by step, this aim is being accomplished.

NOTES

"The Camera Club of New York," *Ainslee's* 4 (Oct. 1899): 324–35.

1. For Alfred Stieglitz (1864–1946) see "A Remarkable Art: Alfred Stieglitz" in this volume.

2. Rudolph Eickemeyer Jr. (1862–1932), born in Yonkers, N.Y., went to work as a draftsman to his inventor father's firm (1884–95) and began photographing on his own in 1893. In 1895 he became associated with James L. Breese of the Carbon Studio in New York and in 1900 became art manager of the Campbell Art Studio. From 1905 to 1911 he worked in his own studio, David and Eickemeyer. His memberships included several European associations of photography in addition to the Camera Club of New York. A leader in the field, Eickemeyer excelled in genre scenes, landscapes, and portraits of notable persons in New York. Among his publications were *How to Make a Picture* (1898) and *Letters from the Southwest* (1894).

3. Frances Benjamin Johnston (1864–1952) was born in West Virginia and died in New Orleans. After attending Notre-Dame Convent in Maryland, she studied painting and drawing first in Paris (1883–85) and then at the Art Students League in Washington, D.C., and served an apprenticeship at the Smithsonian Institution's Photography Division. In the early 1890s she opened a portrait studio in Washington, D.C., and around the end of the nineteenth century took on a partner, Mattie Edward Hewitt. Johnston was the unofficial White House photographer through the administrations of Cleveland, Harrison, McKinley, Roosevelt, and Taft. She also traveled widely and wrote for such magazines as *Tester's Magazine* and *Town and Country* while remaining a member of the Camera Club of New York. Known as the first woman press photographer, she worked mainly in straightforward reportage, using gelatin dry-plate negatives and producing platinum and silver prints. Her photographs were regarded as extremely careful documentations of the events and customs of her day.

4. William D. Murphy (b. 1834) was an American portrait painter and photographer. With his wife, Harriet Anderson, he painted portraits of many prominent men in the late nineteenth and early twentieth centuries.

■ Lawrence E. Earle

The subject of the present sketch, Mr. Lawrence E. Earle, frankly says: "My work, for the most part, has been an endeavor to depict strong character heads—principally in water colors"; and to this may be added the fact that this endeavor has proved most successful. Mr. Earle's work consists of aged male figures, suggestive of the wear and nature of the various callings from which they are selected. Thus the pictures reproduced to illustrate the present article amply explain what is meant. They are representative paintings by Mr. Earle, and are familiar to the frequenter of the exhibitions during the past three years. Like all of Mr. Earle's works, their import is distinctly obvious. There are no subtleties of spirit; no complications of scene in them. What you see here, you will see in all of his later and more successful work. The picture, "Mending the Golf Sticks," is one of a favorite type with him—the old land castaway. In many of Mr. Earle's pictures you will see an individual partaking, in a measure, of the same characteristic, as if, perchance, he might belong to the same tribe, or clan. Menders of umbrellas, of shoes, of clothing, and the like, all appear, and they have something in common with this "Mending the Golf Sticks." Similarly, in the picture entitled, "Consulting the Chart," there is somewhat of many others. You will see old sailors done by him in various ways and in different conditions. Most of them are excellent, none ever dramatic. Mr. Earle seldom makes use of that element in its more vivid forms. And yet, his art has a very pleasing turn, and in these forms is most appealing. In it, he seems both to study and present the many distinguishing marks of both time and ill or good fortune as related to human beings. Al-

most always, there is the element of labor—something to interest—where minds are already losing their grip on the quality of life. Groups, pairs, single figures, with now and then a pleasing child introduced. These compose the personnel, so to speak, of his art, as at present produced. As characters, all of his subjects are noticeable for a certain quality of deliberation and contentment, having seen, evidently, much of life, but weathered it more like trees than men. In their faces one finds but few traces of intellect and less of feeling, but, nevertheless, nature is there—the quality of well-seasoned years—rustic, brown and hearty.

I am reminded, every time by anyone of these pictures of Mr. Earle's, of Thoreau's[1] description of the old, quiet fisherman in his worn brown coat, who was so regularly to be found in a shady nook at a certain bend in the Concord River. He seemed, according to Thoreau, to at last become a part of the soil and landscape, like the stumps and bushes. It would be difficult to say what emotions wake and turn beneath these wrinkled garments and yet more wrinkled and leathery skins, they are queer baked products of sun and rain; quaint pleasant old creatures, selected by a feeling mind. In a way they seem to illustrate how subtle are the ways of nature, how well she coats her aged lovers with her own autumnal hue. Are they satisfied with life as they find every seam and lineament of dress and countenance rightly express it. They are gnarled trees out of some old brown garden, flourishing, one should judge, just without the walls of Arcadia.

Mr. Earle has not always painted these figures, nor truly always painted so well. The works he produces to-day are seasoned and tempered with a ripened artistic judgment. His present choice of subjects naturally marks the evolution of his disposition. Years ago, at the beginning of his artistic career, he preferred still life—dead birds and animals, the trophies of the chase. Still later, he touched upon landscapes, and then *genre* figures of natural variety, doing work which was as delicate and lasting in quality as most of that done by specialists in these fields. Natural propensities led him into the line in which he has distinguished himself—a field which reflects, possibly, what he considers most pleasant and delightful in age.

"As to the birth of my interest in things artistic," he once said to me, "I can set no date. My fondness for sporting and fishing—Michigan, where I lived then, furnished abundance of it—led me to en-

deavor to depict 'the spoils of the chase.' My first efforts were in the way of still life—'dead game.' Later, I painted birds, and then animals, in action.

"Until 1869, I worked by myself in this way without instruction, simply studying nature. Walter Shirlaw[2] was then teaching in the Academy at Chicago, and desiring to study, I went there. Of course, I had a studio in the old Crosby Opera House, where nearly all the artists were, and got along fairly well. Shirlaw went to Europe, and, in 1872, I decided to follow and do more work under him at Munich. Ludwig Barth was there, and Stueghofer, and from these men I also gathered knowledge. I should have remained there for some years if my father had not died. That brought me back, and with one exception, I have been here ever since."

Mr. Earle fixed his career in this country by accepting, not long after this, the position of instructor of drawing and water color at the Chicago Academy, where he remained until 1880. Then he returned to Europe, brushing up at Florence and Rome preparatory to opening a studio in New York. Fortune was to will it otherwise, however; for upon returning here to carry out his plan, he made a flying visit to some Western relatives and was caught. Love proved the trap in this instance. While staying in Chicago, he met Miss Nelly Harmon, who interested him much more than art possibly could. For the time being, he lingered, paid court, and finally married, deciding to hold forth in Chicago, where his and her relatives were, and, if possible, make it their home. For nine years he was a well-known and interesting figure in Chicago art-circles, being a member of nearly all local artistic bodies, and is to-day looked upon by his Western friends as a Chicago man, camping out. When the World's Fair came on, he was assigned a most important commission, the execution of which forms a very interesting incident, and even chapter, in his life. It was this way:

Having left Chicago not long before the World's Fair, he was almost forgotten in the doling out of the various art commissions, until nearly the last moment, when he was hastily called upon to fill an immense architectural lunette over one of the great entrances to the manufacturing building. Being on a visit to Chicago at the time, he was rather unprepared to take up the task and finish it, as desired, in the short space of three months. Still, he accepted, and having signed the con-

tract, found himself without canvas to work on. The place he had to fill with his picture was nearly thirty feet wide, and there was not a piece of canvas suitable for the purpose to be found in all Chicago.

"To Holland," was the invariable recommendation. "We shall have to send to Holland."

In despair, he pondered before abandoning the order, and finally hit upon a splendid idea. He would call in the sellers of heavy hemp coffee-bagging and have them fill it with that. When it was up, he gave it a rich coat of glue and cement to give it surface, and finding that this left fine hairs sticking out, and that he must have a more cleanly colored surface, he added a coat of white lead. This gave a satisfactory surface so far as hue was concerned, but still there were the disturbing hairs, and the surface was rough. Now he bethought himself again, and this time made haste to secure sandpaper, with which he personally polished down the surface to the desired smoothness and that state in which no hairs could be. Upon this he painted his great manufacturing scene, one of the objects of interest at the Fair, in double quick time, having neither studio, models, nor that opportunity to prepare preliminary sketches, considered, as a rule, so necessary. It was "top ladder" work, high up over the heads of his fellowmen, and something of which he could get no perspective, save by descending and walking out fully a hundred and fifty feet. Under these conditions the task was accomplished, however, and with all else artistic about the great Fair, received its due modicum of praise. This has fixed his art reputation in Chicago, as well as in America, and it will long be hard for those who remember it to accept him as a specialist, even in so good a field as that now finally selected.

Still, among the artists, Mr. Earle ranks with the best among those who have specialized. All of his work is strong in feeling and sentiment, and there is no lack of vigor in handling nor in the discrimination of color. The same amount of ability and energy brought to bear upon any other phase of the artistic field, would have brought its possessor equal fame and position.

At present, the artist's home is at Montclair, New Jersey, where he has both his residence and studio. All New York societies have him enrolled as a member, notably the New York Water Color and Salmagundi Clubs, the National Academy of Design, and the American Wa-

ter Color Society.[3] He is also an honorary member of the Art Institute of Chicago.

On the whole, Mr. Earle has had a rather varied and traveled life, and though born in New York, was for a long time considered a Chicago painter. He came of a family whose ancestors date back to the Revolution, his father being John E. Earle, once a resident of Newbamsburg-on-the-Hudson, and later a well-to-do merchant in New York. His grandfather was Lieut. Edward Earle of the British army, who served for King George, in New Jersey. Retired on half pay, the latter preferred to remain in the newly-formed country, and so located at Newbamsburg, where the father of the artist was born. He, in turn, came down to New York, in 1816, and engaged in business as an importer, having, by the time Lawrence was born—November 11, 1845—succeeded to the important commercial business of John P. Slay & Co., and amassed a comfortable fortune.

NOTES

"Lawrence E. Earle," *Truth* 20 (Feb. 1901): 27–30.

1. Henry David Thoreau was one of Dreiser's favorite authors. Dreiser wrote a lengthy introduction, "Presenting Thoreau," to *The Living Thoughts of Thoreau,* ed. Alfred O. Mendel (New York: Longmans, Green, 1939).

2. Walter Shirlaw (1838–1909), a genre, portrait, and mural painter, was born in Scotland and trained in Munich. He was known primarily for picturesque compositions of idealized female nudes. He helped found the Art Institute of Chicago and was instrumental in the founding of the Society of American Artists and the Art Students League, where he was an influential teacher.

3. For the American Water-Color Society see "The American Water-Color Society" in this volume.

■ The Color of To-Day: William Louis Sonntag

Life's little ironies are not always manifest. We hear of its tragedies like far-distant sounds, but the reality does not work itself out before our very eyes. Therefore, the real incidents which I am about to relate have value if for nothing more than their simplicity and the color of to-day which they involve.

I first called upon W. L. S——, Jr., in the winter of 1895. I had known of him before only by reputation, or, what is nearer the truth, by seeing his name in one of the great Sunday papers, attached to several drawings of the most lively interest. These drawings depicted night scenes in the city of New York, and appeared as colored supplements, ten by twenty-six inches. They represented the spectacular scenes which the citizen and the stranger most delight in—Madison Square in a drizzle; the Bowery lighted by a thousand lamps and crowded with "L" and surface cars; Sixth Avenue looking north from Fourteenth Street.

I was an editor[1] at the time and on the lookout for interesting illustrations of this sort, and when a little later I was in need of a colored supplement for the Christmas number I decided to call upon S——. I knew absolutely nothing about the world of art save what I had gathered from books and current literary comment of all sorts, and was, therefore, in a mood to behold something exceedingly ornate and bizarre in the atmosphere with which I should find my illustrator surrounded.

I was not disappointed. I was greeted by a small, wiry, lean-looking individual arrayed in a bicycle suit, whose countenance could be best

described as wearing a perpetual look of astonishment. He had one eye which fixed you with a strange, unmoving solemnity, owing to the fact that it was glass. His skin was anything but fair, and might be termed sallow. He wore a close, sharp-pointed Vandyke beard, and his gold-bridge glasses sat at almost right angles upon his nose. His forehead was high, his good eye alert, his hair sandy-colored and tousled, and his whole manner indicated thought, feeling, remarkable nervous energy, and, above all, a rasping and jovial sort of egotism which rather pleased me than not.

I noticed no more than this on my first visit, owing to the fact that I was very much overawed and greatly concerned about the price which he would charge me, not knowing what rate he might wish to exact, and being desirous of coming away at least unabashed by his magnificence and independence.

"What's it for?" he asked, when I suggested a drawing.

I informed him.

"You say you want it for a double-page centre?"

"Yes."

"Well, I'll do it for a hundred and fifty dollars."

I was taken considerably aback, as I had not contemplated paying more than a hundred.

"I get that from all the magazines," he added, seeing my hesitation, "wherever a supplement is intended."

"I don't think I could pay more than a hundred," I said, after a few moments' consideration.

"You couldn't?" he said, sharply, as if about to reprove me.

I shook my head.

"Well," he said, "let's see a copy of your publication."

The chief value of this conversation was that it taught me that the man's manner was no indication of his mood. I had thought he was impatient and indifferent, but I saw now that it was more, or rather less, than that. He was simply excitable, somewhat like the French, and meant only to be businesslike. The upshot of it all was that he agreed to do it for one hundred, and asked me very solemnly to say nothing about it.

I may say here that I came upon S—— in the full blush of his fancies and ambitions, and just when he was upon the verge of their real-

ization. He was not yet successful. A hundred dollars was a very fair price indeed. His powers, however, had reached that stage where they could soon command their full value.

I could see at once that the man was ambitious. He was bubbling over with the enthusiasm of youth and an intense desire for recognition. He knew he had talent. The knowledge of it gave him an air and an independence of manner which might have been irritating to some. Besides, he was slightly affected, argue to the contrary as he would, and was altogether full of his own hopes and ambitions.

The matter of painting this picture necessitated my presence on several occasions, and during this time I got better acquainted with him. Certain ideas and desires which we held in common drew us toward each other, and I soon began to see that he was somewhat of a remarkable individual. He talked with the greatest ease upon a score of subjects—literature, art, politics, music, the drama, and history. He seemed to have read the latest novels; to have seen many of the current plays; to have talked with important people. A recent Governor—then a Commissioner—often came to his studio to talk and play chess with him. A very able architect, more private in character, was his bosom friend. He had artist associates galore, many of whom had studios in the same building or the immediate vicinity. He had acquaintances in other walks of life—literary and business men, all of whom seemed to enjoy his company, and who were very fond of calling and spending an hour in his studio.

I had only called the second time, and was going away, when he showed me a steamship he had constructed with his own hands—a fair-sized model, which was complete in every detail, even to the imitation stokers in the boiler-room, and which would run by the hour if supplied with oil and water. This model illustrated his skill in mechanical construction, which I soon learned was great. He was a member of several engineering societies, and devoted some of his carefully organized days in studying and keeping up with the problems in mechanics.

"Oh, that's nothing," he observed when I marvelled at the size and perfection of the model. "I'll show you something else, if you have time some day, which may amuse you."

I begged him to give me an idea of what it was, and he then explained that he had constructed several model war-ships,[2] and that it

was his pleasure to take them out and fight them on a pond somewhere out on Long Island.

"We'll go out some day," he said when I showed appropriate interest, "and have them fight each other. You'll see how it's done."

I waited for this outing some time, and then finally mentioned it.

"We'll go to-morrow," he said. "Can you be around here by ten o'clock?"

Ten the next morning saw me promptly at the studio, and five minutes later we were off.

When we arrived at Long Island City we went to the first convenient arm of the sea and undid the precious fighters, which he much delighted in.

After studying the contour of the little inlet for a few moments, he took some measurements with a tapeline, stuck up two twigs in two places for guide-posts, and proceeded to load and get up steam in his war-ships. Afterwards he set the rudders, and then took them to the water-side and floated them at the points where he had placed the twigs.

These few details done, he again studied the situation carefully, headed the vessels to the fraction of an inch toward a certain point on the opposite shore, and began testing the steam.

"When I say ready, you push this lever here," he said, indicating a little brass handle fastened to the stern-post. "Don't let her move an inch until you do that. You'll see some tall firing."

He hastened to the other side, where his own boat was anchored, and began an excited examination. He was like a school-boy with a fine toy.

At a word, I moved the lever as requested, and the two vessels began steaming out toward one another. Their weight and speed were such that the light wind blowing affected them not in the least, and their prows struck with an audible crack. This threw them side by side, steaming head on together. At the same time it operated to set in motion their guns, which fired broadsides in such rapid succession as to give a suggestion of rapid revolver practice. Quite a smoke rose, and when it rolled away one of the vessels was already nearly under water, and the other was keeling with the inflow of water from the port side. S—— lost no time, but throwing off his coat, jumped in and swam to the rescue.

Throughout this entire incident his manner was that of an enthusiastic boy who had something exceedingly novel. He did not laugh. In

all our acquaintance I never once heard him give a sound, hearty laugh. His delight did not express itself in that way. It showed only in an excess of sharp movements, short verbal expressions, gleams of the eye.

I saw from this the man's delight in the engineering of the world, and humored him in it. He was most pleased to think that any one should feel so, and would thereafter be at the greatest pains to show all that he had under way in the mechanical line, and schemes he had for enjoying himself in this work in the future. It seemed rather a recreation for him than anything else. Like him, I could not help delighting in the perfect toys which he created, but the intricate details and slow process of manufacture were brain-racking. For not only would he draw the engine in all its parts, but he would buy the raw material and cast and drill and polish each separate part.

One of the things which impressed me deeply upon my second visit was the sight of a fine passenger engine, a duplicate of the great 999 of the New York Central, which stood on brass rails laid along an old library shelf that had probably belonged to the previous occupant of the studio. This engine was a splendid object to look upon—strong, heavy, silent-running, with the fineness and grace of a perfect sewing-machine. It was duly trimmed with brass and nickel, after the manner of the great "flyers," and seemed so sturdy and powerful that one could not restrain the desire to see it run.

"How do you like that?" S—— exclaimed when he saw me looking at it.

"It's splendid," I said.

"See how she runs," he exclaimed, moving it up and down. "No noise about that."

He fairly caressed the mechanism with his hand, and went off into a most careful analysis of its qualities.

"I could build that engine," he exclaimed at last, enthusiastically, "if I were down in the Baldwin company's place. I could make her break the record."

"I haven't the slightest doubt in the world," I answered.

This engine was a source of great expense to him, as well as the chief point in a fine scheme. He had made brass rails for it, sufficient to extend about the four sides of the studio—something like seventy feet. He had made passenger-cars of the most handsome order, with all the

equipments of brakes, vestibules, Pintsch gas, and so on, and had labelled it "The Great Pullman Line."[3] One day, when we were quite friendly, he brought from his home all the rails, in a carpet-bag, and gave an exhibition of his engine's speed, attaching the cars and getting up sufficient steam to cause the engine to race about the room at a rate which was exciting, to say the least. He had an arrangement by which it would pick up water and stop automatically. It was on this occasion that he confided what he called his great biograph scheme.

"I propose to let the people see the photographic representation of an actual wreck—engine, cars, people, all tumbled down together after a collision, and no imitation, either—the actual thing."

"How do you propose to do it?" I asked.

"Well, that's the thing," he said, banteringly. "Now, how do you suppose I'd do it?"

"Hire a railroad to have a wreck and kill a few people," I suggested.

"Well, I've got a better thing than that. A railroad couldn't plan anything more real than mine will be."

I urged him to tell me if he valued my sanity and not cause me to puzzle any longer.

"This is it," he exclaimed, suddenly. "You see how realistic this engine is, don't you?"

I acknowledged that I did.

"Well," he confided. "I'm building another just like it—it's costing me three hundred dollars, and the passenger-cars will cost as much more. Now I'm going to fix up some scenery on my roof—a gorge, a line of wood, a river, and a bridge. I'm going to make the water tumble over big rocks just above the bridge and run underneath it. Then I'm going to lay this track around these rocks, through the woods, across the bridge, and off into the woods again.

"I'm going to put on the two trains and time them so they'll meet on the bridge. Just when they come into view where they can see each other, a post on the side of the track will strike the cabs in such a way as to throw the firemen out on the steps just as if they were going to jump. When the engines take the bridge they'll explode caps that will set fire to oil and powder and burn it up."

"Then what?" I asked.

"Well, I've got it planned automatically so that you will see people

jumping out of the cars and tumbling down on the rocks, the flames spring up and taking to the cars, and all that. Don't you believe it?" he added, as I smiled at the idea. "Look here," and he produced a model of one of the occupants of the cars. He labored for an hour to show all the intricate details, until I was bound to admit the practicability and novelty of the idea. Then he explained that instantaneous photography was to be applied at such close range that the picture would appear life size. The actuality of the occurrence would do the rest.

Incredulity still lingered with me for a time, but when I saw the second train growing, the figures and apparatus gradually being modelled, and the correspondence and conferences going on between the artist and several companies which wished to gain control of the idea, I was perfectly sure that it would some day come to pass.

As I have stated, when I first met S—— he had not realized any of his dreams. It was just at that moment when the tide was about to turn. He surprised me by the assurance, born of his wonderful ability, with which he went about all things.

"I've got an order from the *Ladies' Home Journal*," he said to me one day. "They came to me."

"Good," I said. "What is it?"

"Somebody's writing up the terminal facilities of New York."

He had before him an Academy board, on which was sketched in, in wash, a midnight express striking out across the Jersey meadows, with sparks blazing from the smoke-stack and dim lights burning in the sleepers. It was a vivid thing, strong with all the strength of an engine, and rich in the go and enthusiasm which adhere to such actual affairs.

"I want to make a good thing of this," he said. "It may do me some good."

A little later he got his first order from *Harper's*. He could not disguise that he was pleased, much as he tried to carry it off with an air. It was some time before the Spanish war broke out,[4] and the sketches he was to do related to the navy.

He labored at this order with the most tireless enthusiasm. Marine construction was his delight anyhow, and he spent hours and days making studies about the great vessels, getting not only the atmosphere,

but the mechanical detail. When he did the pictures they represented all that he felt.

"You know those drawings?" he said, the day after he delivered them.

"Yes."

"I set a good stiff price on them and demanded my drawings back when they were through."

"Did you get them?"

"Yep. It will give them more respect for what I'm trying to do," he said.

Not long after he illustrated one of Kipling's stories.

He was in high feather at this, but grim and repressed with all. One could see by the nervous movements of his wiry body that he was delighted over it.

Not long after Kipling came to his studio. It was by special arrangement, but S—— received him as if he were nothing out of the ordinary. They talked over the galley proofs, and the author went away.

"It's coming my way now," he said, when he could no longer conceal his feelings. "I want to do something good on this."

Through all this rise from obscurity to recognition, he lived with his friends and interested himself in the mechanics I have described. His drawing, his engine-building, his literary studies, and recreations were all mixed, jumbled, plunging pell-mell, as it were, on to distinction. In the first six months of his studio life he had learned to fence, and often dropped his brush to put on the mask and assume the foils with one of his companions.

As our friendship increased, I found how many were the man's accomplishments and how wide his range of sympathies. He was an expert bicyclist, as well as a trick rider, and used a camera in a way to make an amateur envious. He could sing, having a fine tenor voice, which I heard the very day I learned that he could sing. It so happened that I owed him an outing at the theatre, and invited him to come with me that evening.

"Can't do it," he replied.

"All right," I said.

"I'm part of an entertainment to-night or I would," he added, apologetically.

"What do you do?" I inquired.

"Sing."

"Get out!" I said.

"So be it," he answered. "Come up this evening."

To this I finally agreed, and was surprised to observe the ease with which he rendered his solo. He had an exquisitely clear and powerful voice, and received a long round of applause, which he refused to acknowledge by singing again.

The influence of success is easily observable in a man of so volatile a nature. It seems to me that I could have told by his manner, day by day, the washing in of the separate ripples of the inrolling tide of success. He was all alive, all fanciful, and the tale of his conquests was told in his eye. Sometime in the second year of our acquaintanceship I called at his studio in response to a card which he had stuck under my office door. It was his habit of drawing an outline head of himself—something almost bordering upon a caricature—and writing underneath it "I called," together with any word he might have to say. This day he was in his usual high good spirits, and rallied me upon having an office which was only a blind. He had a roundabout way of getting to talk about his personal affairs, and I soon saw that he had something very interesting to himself to communicate. At last he said.

"I'm thinking of going to Europe next summer."

"Is that so?" I replied. "For pleasure?"

"Well, partly."

"What's up outside of that?" I asked.

"I'm going to represent the American Architectural League at the international convention."

"I didn't know you were an architect," I said.

"Well, I'm not," he answered, "professionally. I've studied it pretty thoroughly."

"Well, you seem to be coming up, Louis," I remarked.

"I'm doing all right," he answered.

He went on working at his easel as if his fate depended upon what he was doing. He had the fortunate quality of being able to work and converse most entertainingly at the same time. He seemed to enjoy company under such circumstances.

"You didn't know I was a baron, did you?" he finally observed.

"No," I answered, thinking he was exercising his fancy for the moment. "Where do you keep your baronial lands, my lord?"

"In Germany, kind sir," he replied, banteringly.

Then in his customary excitable mood he dropped his brushes and stood up.

"You don't believe me, do you?" he exclaimed, looking over his drooping glasses.

"Why, certainly I believe it if you are serious. Are you truly a baron?"

"It was this way," he said: "My grandfather was a baron. My father was the youngest of two brothers. His brother got the title and what was left of the estate. That he managed to go through with, and then he died. Now, no one has bothered about the title—"

"And you're going back to claim it?"

"Exactly."

I took it all lightly at first, but in time I began to perceive that it was a serious ambition. He truly wanted to be Baron S——, and add to himself the lustre of his ancestors.

With all this, the man was not an aristocrat in his feelings. He had the liveliest sympathies for republican theories and institutions—only he considered his life a thing apart. He had a fine mind, philosophically and logically considered. He could reason upon all things, from the latest mathematical theorem to Christian Science. Naturally, being so much of an individualist, he was drifting toward a firm belief in the latter, and was never weary of discussing the power of mind—its wondrous ramifications and influences. Also, he was a student of the English school of philosophy, and loved to get up mathematical and mechanical demonstrations of certain philosophic truths. Thus he worked out by means of a polygon, whose sides were of unequal lengths, a theory of friendship which is too intricate to explain here.

From now on I watched his career with the liveliest interest. He was a charming and a warm friend, and never neglected for a moment the niceties and duties which such a relationship demands. I heard from him frequently in many and various ways, dined with him regularly every Wednesday, and rejoiced with him in his triumphs, now more and more frequent. He went to Europe and spent the season which he had

contemplated. He did the illustrations for a fine fast express story which one of the magazines published, and came back flushed and ready to try hard for a membership in the American Water-Color Society.

I shall never forget his anxiety to get in that notable body. He worked hard and long on several pictures which should not only be hung on the line, but enlist sufficient interest among the artists to gain him a vote of admission. He mentioned it frequently and bored me with his eyes to see what I would think of him.

"Go ahead," I said; "you have more right to membership than many another I know. Try hard."

He painted not one, but four pictures, and sent them all. They were very interesting after their kind, two being scenes from the great terminal yards of the railroad, two others landscapes under misty or rainy conditions. Three of these pictures were passed and two of them hung on the line. The third was *skyed,* but he was admitted to membership.

I was delighted for his sake, for I could see, when he gave me the intelligence, that it was a matter which had keyed up his whole nervous system.

Not long after this we were walking up Broadway, one drizzly autumn evening, on our way to the theatre. Life, ambition, and our future were the *small* subjects under discussion. The street, as usual, was crowded. On every hand blazed the fire signs. The yellow light was beautifully reflected in the wet sidewalks and gray cobblestones shiny with water.

When we reached Greeley Square, that brilliant and almost sputtering spectacle of light and merriment, S—— took me by the arm.

"Come over here," he said. "I want you to look at it from here."

He took me to a point where, by the intersection of the lines of the converging streets, one could not only see Greeley Square, but a large part of Herald Square, with its huge theatrical sign of fire and its measure of store lights and lamps of vehicles. It was, of course, an inspiring scene. The broad, converging walks were alive with people. A perfect jam of vehicles marked the spot where the horse and cable cars intersected. Overhead was the elevated station, its lights augmented every few minutes by long trains of brightly lighted cars filled with truly metropolitan crowds.

"Do you see the quality of that? Look at the blend of the lights and shadows in there under the L."

I looked and gazed in silent admiration.

"See, right here before us—that pool of water there—do you get that? Now, that isn't silver-colored, as it's usually represented. It's a prism. Don't you see the hundred points of light?"

I acknowledged the variety of color, which I had scarcely observed before.

"You may think one would skip that in viewing a great scene, but the artist mustn't. He must get that all, whether you notice or not. It gives feeling, even when you don't see it."

I acknowledged the value of this ideal.

"It's a great spectacle," he said. "It's got more flesh and blood in it than people usually think for."

"Why don't you paint it?" I asked.

He turned on me as if he had been waiting for the suggestion.

"That's something I want to tell you," he said. "I am. I've sketched it a half-dozen times already. I haven't got it yet. But I'm going to."

I heard more of these dreams, intensifying all the while, until the recent war broke out. Then he was off in a great rush of war work. I scarcely saw him for six weeks, owing to some travels of my own, but I saw his name. One day in Broadway I stopped to see why a large crowd was gathered about a window in the Hoffman House. It was one of S——'s drawings of our harbor defences, done as if the artist had been sitting at the bottom of the sea. The fishes, the green water, the hull of a massive warship—all were there—and, about, the grim torpedoes. This put it into my head to go about and see him. He was as tense and strenuous as ever. The glittering treasure at the end of the rainbow was more than ever in his eye. His body was almost sore from travelling.

"I am in it now," he said, referring to the war movement. "I am going to Tampa."

"Be gone long?" I asked.

"Not this first time. I'll only be down there three weeks."

"I'll see you then."

"Supposing we make it certain," he said. "What do you say to dining together this coming Sunday three weeks?"

I went away, wishing him a fine trip, and feeling that his dreams must now soon begin to come true. He was growing in reputation. Some war pictures, such as he could do, would set people talking. Then he would paint his prize pictures, finish his wreck scheme, become a baron, and be great.

Three weeks later I knocked at his studio door. It was a fine spring-like day, even though winter was still in control. I expected confidently to hear his quick, cheery step inside. Not a sound in reply. I knocked harder, but still received no answer. Then I went to the other doors about. He might be with his friends, but they were not in. I went away, thinking that his war duties had interfered—that he had not returned.

Nevertheless, there was something depressing about that portion of the building in which his studio was located. I felt as if it should not be, and decided to call again. Monday it was the same, and Tuesday.

That same evening I was sitting in the library of the Salmagundi Club, when a well-known artist addressed me.

"You knew S——, didn't you?" he said.

"Yes; what of it?"

"You knew he was dead, didn't you?"

"What?" I said.

"Yes, he died of fever, this morning."

I looked at him without speaking for a moment.

"Too bad," he said. "Such a clever boy, Louis was. Awfully clever. I feel sorry for his father."[5]

It did not take long to verify his statement. His name was in the perfunctory death lists of the papers the next morning. No other notice of any sort. Only a half-dozen seemed to know that he had ever lived.

And yet it seemed to me that a great tragedy had happened—he was so ambitious, so full of plans. His dreams were so likely of fulfilment.

I saw the little grave afterward and the empty studio. His desks revealed several inventions and many plans of useful things. But these came to nothing. There was no one to continue the work.

It seemed to me at the time as if a beautiful lamp, enlightening a splendid scene, had been suddenly puffed out; as if a hundred bubbles of iridescent hues had been shattered by a breath. We toil so much, we dream so richly, we hasten so fast, and, lo! the green door is opened.

We are through it, and its grassy surface has sealed us from the world, forever, before we have ceased running.

Notes

"The Color of To-Day: William Louis Sonntag," *Harper's Weekly* 45 (14 Dec. 1901): 1272–73. Reprinted, with many stylistic revisions, as "W. L. S." in Dreiser's *Twelve Men* (New York: Boni and Liveright, 1919), 344–60. The *Harper's Weekly* version is reprinted in *Selected Magazine Articles*, 1:267–78.

1. During this time Dreiser was the editor of *Ev'ry Month*.

2. Dreiser was genuinely interested in this subject and had written "Where Battleships Are Built," *Ainslee's* 1 (June 1898): 433–39.

3. Dreiser wrote a detailed article, "The Town of Pullman," *Ainslee's* 3 (Mar. 1899): 189–200, in which he describes how the legendary train was manufactured in Pullman, then a small town outside Chicago.

4. The Spanish-American War broke out in 1898.

5. Sonntag's father, William Louis Sonntag (1822–1900), was an American landscapist.

■ A Remarkable Art: Alfred Stieglitz

Artists Who Paint with Light and Chemistry—The New "Pictorial Photography"—Explanation of the Glycerine and Gum Processes— Legerdemain with the Camera—An Interview with Alfred Stieglitz, Discoverer of the Glycerine Process

Under our very eyes there has sprung up in the last few years a new school of art which bids fair to do distance the pictures done in oil, water-color, chalk, pastelle, pen-and-ink and all the other known mediums in the race for supremacy. The artist of the new school paints upon a canvas which has an eye as sensitive and impressionable as his own; indeed, the canvas shares his confidence. He shows it the subject he would produce, and it preserves all the details for him. It sees the same nice composition and arrangement of objects; the same contrast of light and shadow are as indelibly impressed upon its mechanical retina as they are upon the eye of the artist, and with far greater accuracy. When he begins, in the cold glow of his studio, to revive his impression of the scene once so clear to him, the canvas becomes an allied memory, a latent sketch, so full of detail that it needs only his coaxing to bring out the outlines of fences, trees, clouds, with a wealth of exactness and detail that is beyond contradiction.

PICTORIAL PHOTOGRAPHY

But the canvas contains no more than the rough outline sketch. The charm is in the eye and soul of the artist. His brushes are shafts of light; his paints are the secrets of chemistry; his palette is the spirit of modern invention. He has made science the tool of art. In the light of re-

cent accomplishment it may be safely said that there are now no limitations to the scope of "Pictorial Photography."

Pictorial photography, however, achieves something that differs materially from the pictures made by the female pedestrian who, with a snap-shot box hung from a long strap over her shoulder—tourist-like—goes to the country or the seashore over Sunday, and comes back Monday morning with film-rolls full of grazing cows, family groups on the piazza, waterscapes of sailboats or multiple poses of herself in a bathing costume, which she entrusts to the nearest photographer—who does the rest. In fact, pictorial photography is the very antithesis of this first laudable outcropping of an artistic nature. The pictorial photographer, however, must be at as great pains in selecting the subject he will "snap" as was the lady-tourist with her over-Sunday impressions. He will look for pictorial possibilities in the landscape. The bare, hard outlines of a scene are nothing in themselves. It is the beauty which he sees; the individuality of his own impression which he wishes to convey to others, and the subject which he selects must, in a way, embody these. No two men see the same elements of beauty. Each must catch his own impression, then so manipulate and soften the cold facts of the negative that the concrete manifestation will satisfy the eye, the mind, and the heart of others.

MODERN PROCESSES OF PAINTING

How does the new pictorial photographer get the effects? By the glycerine, gum, and other modern processes. Little attention is paid to the negative; the thought and care go into the printing. The old idea of photography was to get a picture, clear, sharp, pretty, built up on conventional lines. There were inviolable rules for everything. The second-hand of a watch was the brains of the business. If one second of the rule were violated, the result was a bad picture.

Instead of depending altogether on the sunlight to bring a picture to its proper tone, the pictorial artist of to-day employs chemical action. The discovery that certain chemicals will print better than sunlight was the open door. Platinum paper was the practical invader to make an entrance. Expose this paper, prepared with an iron and platinum solution, to the light, and it takes a faint image. Plunge it into a

bath of developer, and a chemical action takes place which gives a precipitate of black and white, and all the intermediate shades of grays.

THE REFINING INFLUENCE

Photography owes its first refining influence to the discovery of this platinum printing. Work done on platinum paper is soft, more like an etching. The development of this paper, in time, brought out the discovery of the glycerine process. In this treatment a faint image is printed from the negative upon the platinum paper. Instead of plunging the print into a chemical bath, the photographer develops the picture locally—that is, by painting with a fine brush. He mixes the developer with glycerine, which retards the action of the chemicals and gives him a chance to watch the effects he is producing and gradually heighten or lower them where he thinks necessary. He can accentuate or eliminate any detail he may see fit. It is at this point in his progress that the photographer, *per se,* kicked off his chrysalis, and became a real live artist with silken wings and a chance to get to glory.

From "Camera Notes"
"An Icy Night." This Photograph was taken by Alfred Stieglitz at Midnight during a Blizzard.

Suppose the picture to be printed is a farmer driving a flock of sheep down a dusty road in the late afternoon. At the time when the picture was taken there was a glorious sky filled with great pink-tinted, cumulous clouds piled up like snow banks. The trees on the right were bold silhouettes. The warm sunlight glinted from the backs of the sheep in merry highlights which had tempted the artist to try his camera even though the light was almost too weak.

THE DEVELOPER-ARTIST AT WORK

Before him is the faint image of the old peasant with his bent shoulders, stick under arm, and hands in pockets. The sheep come up on the platinum paper very faintly, and the silhouetted trees promise to be nothing more than birch spectres. Taking his brush, the artist dips it into the developer (retarded with the glycerine) and begins on his sky, which is absolutely white, not a sign of a pinkish cloud—the sky affects a plate much more quickly than the landscape. He carelessly daubs the developer over the entire white mass till faint outlines of the clouds begin to come up; then he works more carefully. The impressions of the picture as he saw it grow more vivid as the shadows multiply. That done, he begins on the sheep, endeavoring to make these highlights sparkle, just as they did in the real sunlight. He darkens up his trees against the bright sky, blotting out whatever details—even though they be true—mar the picture as he conceives it. If the developer works too fast, he paints the picture over with pure glycerine, which immediately stops all chemical action. Thus the photograph artist works and watches. His is no longer the work of an imitator. He must know all that the painter in oils knows about composition, tones, colors, drawing, light and shade, and with his own mediums he creates effects just as original as can be got with canvas, brushes, and paints. Truth in art is a watchword; in this the photographic artist whose sketch is made with the exactness of the laws of light adds precision to inspiration.

PHOTOGRAPHERS ARE PAINSTAKING

The accusation that pictorial photography must always remain cheap because the pictures can be indefinitely reproduced, when once a neg-

ative is made, is not based on facts. It often takes a year or more to produce one good picture which, when it is finished, can never be exactly duplicated. It can be copied by the same amount of pains and effort that was at first employed, just as any painting may be copied.

The newest process is the bichloride of gum, discovered and made practical by a man named Demachy,[1] the leader of pictorial photography in France. The process is simple, consisting of a basis of bichloride of gum arabic and bichloride of potash, to which can be added any shade of coloring matter. The artist can use any paper and print in any color or as many colors as he likes. So far, the color work produced is very rare in this country. It resembles color lithography. The Viennese have made a specialty of color printing.

TRICKS OF THE TRADE

While not representative of serious photography, there are some tricks in the trade of picture-making which attract to themselves a vagrant interest on account of their novelty and cleverness. Suppose a photographer wants to make a picture which will give the appearance of being done on canvas with the texture of the weave, and the deep, rich effects of shadows given in oil painting. He photographs his picture through bolting cloth, and gets exactly the effect desired, even though it is printed on smooth paper. Almost all "moonlight" pictures are taken in broad daylight, by pointing the camera toward the sun when it is under a cloud. Hazy day pictures, with dim phantom ships, are another form of high-class legerdemain. These are done through bolting cloth, with an exposure of one minute. At the end of fifty seconds the lens is thrown wide open and the light is allowed to flood in upon the negative for three seconds. Then the exposure is finished as before.

WHY SUN PICTURES ARE IMPOSSIBLE

The reason why a camera cannot be aimed into the sun may be of interest to those who have had disastrous results by overlooking this primary rule. The light passes through the sensitive emulsion on the plate or film, strikes the back surface, and is reflected, thus setting up a con-

tradiction of lights, the emulsion being affected by rays from opposite directions at the same time.

MR. STIEGLITZ

In order to find out how, and when, and by what means this new movement in pictorial photography has progressed, it is well to go to headquarters. Probably the best authority in the United States is Mr. Alfred Stieglitz (editor and manager of *Camera Notes,* a beautiful quarterly publication) who, with Mr. Joseph Keiley,[2] discovered and made practical the glycerine process which is now being used all over the world. Mr. Stieglitz was found, one afternoon last week, in the spacious quarters of the New York Camera Club. After showing the writer all the interesting features of the club, beginning with the library—which is said to be the largest in the world on photographic subjects—and continuing through all the dark rooms and developing rooms—with apparatus the most modern and devices the most clever—we ended in the little portrait studio which was built for the club on the roof of the sky-scraper where the club has its home. We had walked over to the west wall of the building and stood watching the panorama of roofs and spires and jetting steam-pipes, and the narrow grottoes of streets, in the depths of which the turgid stream of humanity flowed noisily. Lower New York and the Harbor were a fogged negative; Brooklyn Bridge was an indistinct detail of sweeping lines which seemed to be responding quickest to the touch of a developer. The "noble Hudson" and a few gilded towers were the only accents of shimmering light in the vast waste of buildings.

AN INTERVIEW WITH MR. STIEGLITZ

As Mr. Stieglitz leaned against the wall, talking enthusiastically, his hatless head—sharply defined against the bright sky which was preparing for sunset over Jersey—made a picture for his own artful camera. His sensitive face—dark, piercing eyes, firm mouth, and sharp, forceful chin—under its thatch of black hair, explained why the movement he chose to champion in this country was meeting with recognized success.

From "Camera Notes"
"The Stage" By Alfred Stieglitz
This Photograph is made by the Gum
Process and shows the effect of reflec-
tions and soft shadings that can be pro-
duced.

"It is fifteen years since we started," he was saying. "A few men over in London, wanting the best, decided to pull together. We had annual exhibitions of such work as carried out the idea of pictorial photography as the leaders understood it. Our idea was to do the work and force recognition. We are 'photo secessionists'—seceding from that which is conventional. It is a revolution to put photography among the fine arts. Time, talent, and hard work were necessary. There has also been an awakening in France, Austria, Germany, and America. We are going pretty fast here. We received our vindication only a few weeks ago. Our recent exhibit at the National Arts Club spoke for us in no muffled tones, but the cablegram from Paris saying that Edward J. Steichen,[3] of Milwaukee, had broken into the world's annual art exhibition at the Champe de Mars Salon and had hung ten photographs in that most exclusive fine arts show, was a voice from the housetop."

He glanced over the moaning city with a smile when he realized that his own voice had risen.

"But, really," he went on, "it is a triumph. Steichen does beautiful work. The ones accepted were the gum process. I bought some of his things myself at the last exhibition."

"May I ask the price they brought?"

"On the average, one hundred and fifty dollars apiece."

"Have you a large collection?"

"Some very interesting things which I hope some day to give to the Metropolitan Museum."

"What turned you into this field of work?"

"Love of it. After fifteen years I am not a dollar ahead of the game. The camera always fascinated me; so did chemistry; I began to make mechanical drawings with it, and gradually switched over to the art side. I had a desire to make the camera do what I wanted it to."

"What brought about the glycerine process?"

"Oh, we experimented, and watched, and reduced it to a practical basis—that was all."

"Have you won many prizes?"

"Well, I have about 140 medals, but you know baubles don't count. We have ruled all that sort of junk out of expositions now, along with jealousy and factional competition. Two pictures hang side by side— both excellent in their way—how can you justly choose between them? It is honor enough to get your things shown at the expositions."

"Who are the best serious pictorial photographers in this country?"

"Well, there are Keiley, and Gertrude Kasebier,[4] and Frank Eugene,[5] here in New York; and Clarence H. White,[6] in Newark, Ohio, and F. H. Day,[7] in Boston, and Steichen—and I guess that is all we have here. There are about as many on the other side."

"In a word," I asked, "what is the secret of serious pictorial photography?"

"Individualism," was his quick answer; "working out the beauty of a picture as you see it, unhampered by conventionality—unhampered by anything—not even the negative."

"But strictly speaking, that is not photography," I ventured, tentatively.

"You admit it is beautiful," he retorted. "Well, then call it by any new name you please."

Dark clouds had clustered around the sun; gray tones were creeping over the plateau of roofs; the roar of the city surged up tense, somber, and pitiless.

"If we could but picture that mood!" said Mr. Stieglitz, waving his hand over the city. Then he led the way back to earth.

NOTES

"A Remarkable Art: Alfred Stieglitz," *Great Round World* 19 (3 May 1902): 430–34. Unsigned. Reconstructed from "A Master of Photography," *Success* 2 (10 June 1899): 471.

1. (Léon) Robert Demachy (1859–1936), a leader of pictorial photography in France, worked chiefly in the impressionistic style, using all manners of manipulative technique. He considered photography an art only when the photographer's hand transformed the image in some way.

2. Joseph T. Keiley (1869–1914), a Wall Street lawyer, was the associate editor of *Camera Notes* and then *Camera Work*. He joined the Camera Club of New York in 1899 and became a member of the Photo-Secession, acknowledged to be its historian. With Alfred Stieglitz, he developed a refinement of the glycerine process for local development of the platinum print. He used the platinotype process with a variation achieved through his work with Stieglitz.

3. Edward J. Steichen (1879–1973) was born in Luxembourg and died in Connecticut. Carl Sandburg was his brother-in-law. His family immigrated to the United States in 1882. He studied painting and learned photography in Milwaukee. Around the turn of the century he was strongly influenced by Stieglitz. In 1963 Steichen received the Presidential Medal of Freedom. His photographic work, spanning a career of seventy-seven years, ranged from his early impressionistic and manipulated images to the documentary work of World Wars I and II.

4. Gertrude Käsebier (1852–1934) was born Gertrude Stanton in Iowa and died in New York. She attended the Moravian Seminary for Girls in Bethlehem, Pennsylvania, and in the early 1890s apprenticed herself to a German chemist and to a commercial portrait photographer in Brooklyn. Establishing a studio in New York in 1897, Käsebier did portrait work and undertook magazine assignments for such publications as *McClure's, Scribner's, Camera Notes,* and *Photographic Times.* She was the first woman elected to the Linked Ring in 1900, a founder of the Photo-Secession in 1902, and a cofounder of the Pictorial Photographers of America in 1916. Considered a radical in her day, she departed from the artificial settings and flat lighting of accepted portrait photography.

5. Frank Eugene (1865–1936), a photographer, painter, and teacher, was born in New York City and probably died in Germany. In 1886 he attended the Bavarian Academy of Graphic Arts in Munich. About 1913 he was appointed royal professor of pictorial photography at the Royal Academy of Graphic Arts in Leipzig, considered the world's first academic position in the field. He was a member of the Linked Ring in 1900 and a founder of the Photo-Secession in 1902. His style is likened to Jugendstil, the South German and Austrian equivalent of art nouveau.

6. Clarence Hudson White (1871–1925) began his career in Newark, Ohio, by organizing the local camera club in 1898 and was elected to the Linked Ring in 1900. In 1899 he was made an honorary member of the New York Camera Club and was a founder of the Photo-Secession. In 1915 he helped found the Pictorial Photographers of America, of which he was the first president. A pictorialist, White also used artificial light. He chose varied subjects, showing special interest in women and children. Among his pupils were Ralph Steiner and Anton Bruehl.

7. Fred Holland Day (1864–1933) was born and died in Norwood, Massachusetts. He began studying photography about 1887 and, with Harvard professor Herbert Copeland, established the publishing company of Copeland and Day (1893–99). Day joined the Linked Ring in 1896 and carried on a correspondence with Stieglitz, but was in disagreement with him and refused to join the Photo-Secession. As a pictorialist, Day was mainly interested in recreating legendary and biblical scenes. He was well known for the remarkable series of about 250 photographs of the last days of Christ.

■ Part 2

THE WORLD OF MUSIC

■ Our Women Violinists

Among women who have won fame with the violin—the most sympathetic of musical instruments, and one that women have found especially congenial—some of the ablest and best known are Americans. The player who has long been known as the foremost of these, and as a violinist with no living superior of her sex, is an American only by adoption and long residence; but of the others whose portraits are given here almost all are of native birth.

Camilla Urso[1] was born in France, of Italian parents, but she crossed the Atlantic at the beginning of her career, and has made her home in San Francisco. She has played with the leading American orchestras—those of Seidl,[2] Thomas,[3] and Damrosch[4]—has appeared with specially organized companies of her own, and has made four successful tours of the world. Of late years she has devoted some of her time to teaching, and she is said to be a clever instructor. Her playing is remarkable for its vitality and fire, scarcely inferior to that of any of the great masters of the violin. She owns a celebrated Guarnerius, and her repertory is wonderfully complete. She can play from memory, and with unfaltering brilliance, quite or almost every important composition ever written for her favorite instrument.

Of the younger women who are rising up to dispute Mme. Urso's supremacy with the bow, probably the most prominent is Maud Powell.[5] Miss Powell is from the West, hailing from Aurora, Illinois. Since her professional début she has been an incessant traveler, but her home is in Washington, where her father is a superintendent of public schools. As a musician, she is known from Russia to Mexico. Her triumphs have

been won rapidly. Five years ago she was selected by Mr. Van der Stuck-en[6] as the soloist of the Arion Society's expedition to Europe, and her work won the approval of the most critical centers of musical art. This success led up to her selection as a representative American violinist at the congress held during the World's Fair, where again she scored a triumph.

Miss Powell has made several other notable tours, appearing as a soloist with Gilmore's band,[7] at the great German sängerfest held in Philadelphia not long ago, and at innumerable smaller concerts and recitals. Young as she is, her repertory is a remarkably wide one. Apart from her work as a performer, she was one of the first to give an impetus to the study and public performance of chamber music by her sex, by establishing string quartets and trios of women. She is an organizer of untiring energy, and has given freely of her time and energy to the perfecting of these combinations of feminine musicians. She has had her reward in seeing some of them rise to high musical rank. Besides this work, and her many tours, she is a student of literature and the drama, and has written numerous articles on subjects connected with her art.

Another Western girl who has made her violin heard all over the country is Ollie Torbett, a native of Ohio, and a graduate of the Cincinnati College of Music. Miss Torbett has also studied with Mme. Urso. She is still quite young, but she has been prominently before the musical public for several years. Last year she made a concert tour with a company of her own, and it was said that, financially speaking, hers was the most successful enterprise of the sort during the season, if not the only successful one.

Two of the youngest and most promising of our women violinists are Geraldine Morgan[8] and Elise Fellows.[9] Miss Morgan, who is not yet twenty-five, is a New York girl, both of whose parents were people of mark in their chosen fields. Her father was one of the leading organists of his day, and her mother was well known as an author and journalist. She obtained her musical education in New York and in Germany, studying in Berlin with the great Joachim,[10] who regarded her as one of his best pupils. For several years she has been playing successfully in concerts and with the Symphony and other prominent orchestras. Miss Fellows, who is still younger than Miss Morgan, is a Bostonian,

a pupil of Franz Kneisel.[11] She appeared as a soloist in concerts last year, and made a very favorable impression, but is now studying in Germany, and will not return to America for some time.

Another violinist who hails from the Massachusetts metropolis— a city which claims, not wholly without reason, to be the most musical in America—is Lillian Shattuck.[12] Miss Shattuck bears an old New England name, and is a musician of intelligence and ambition, besides possessing a remarkable command of her instrument. She belongs to the Eichberg string quartet in Boston,[13] and is well known upon the concert stage.

Martina Johnstone, who is grouped here as one of our best exponents of the art of Paganini[14] and Ole Bull,[15] is a Swede by birth, though she now makes her home in New York, and is firmly established on this side of the Atlantic. Born in Gothenburg, the second city of Sweden, her talent was precocious, and she was a very young girl when she was the star pupil of the conservatory at Stockholm. When she graduated there she received a medal from the hands of King Oscar himself. Then she went to Berlin, where for five years she studied with Emil Sauret.[16] She became a favorite at the German court, often playing for the empress, and the veteran Moltke[17] was one of her warmest friends. After appearing in several of the European capitals she came to America, where her recognition was immediate. Last season, as the soloist of Mr. Sousa's well known band,[18] she made a transcontinental tour of twenty-one thousand miles; and it is worthy of record that though the program of the tour was a very full one, frequently including two concerts, in different towns, in a single day, Miss Johnstone never missed a performance.

Dora Valeska Becker was also born abroad, her parents being Hungarians; but as she came to America when only a few months old, and was brought up at Galveston, she is claimed as a daughter of Texas. For her musical education she came to New York, and then went to Germany for a finishing course. It was in New York that she settled on her return, five years ago, and though she is still a young girl she has become very prominent in the metropolitan world of music. She is a member of the Manuscript Society, and the organizer and conductor of a women's string trio, and she has appeared as a soloist with the orchestras of Anton Seidl and Theodore Thomas.

NOTES

"Our Women Violinists," *Puritan* 2 (Nov. 1897): 34–35.

1. For more on Camilla Urso (1842–1902) see "American Women Violinists" in this volume.

2. Anton Seidl (1850–98), born in Hungary, studied at the Leipzig Conservatory. After serving as conductor of the Leipzig Opera and the Bremen Opera, he came to New York as Leopold Damrosch's successor at the Metropolitan Opera. In 1891 he succeeded Theodore Thomas as conductor of the New York Philharmonic Society. He also organized and led the Metropolitan Orchestra, with which he toured, and the Seidl Society, which performed in Brooklyn and in summer concerts at Brighton Beach.

3. For Theodore Thomas (1835–1905) see "His Life Given Up to Music: Theodore Thomas" in this volume.

4. Leopold Damrosch (1832–85), a German-born violinist, conductor, and composer, received a degree in medicine but devoted himself to the study of music. He came to New York in 1871, influencing the musical life of New York, where he founded the Oratorio Society and the New York Symphony Society and served as conductor of both societies until his death.

5. For more on Maud Powell (1867–1920) see "American Women Violinists" in this volume.

6. Frank Van der Stucken (1858–1929), a conductor and composer, was born in Fredericksburg, Texas, and died in Hamburg, Germany. In 1866 his family moved to Antwerp, where he studied with Peter Benoit at the conservatory. He returned to the United States in 1884 to succeed Leopold Damrosch as the conductor of the Arion Society, a male chorus in New York. He developed a reputation as an advocate of American music, including Edward Alexander MacDowell's piano concerto in D minor, and works by George Whitefield Chadwick, Arthur Foote, and John Knowles Paine at the Paris Exposition. Around the end of the nineteenth century he became the first permanent conductor of the Cincinnati Symphony Orchestra.

7. Patrick Sarsfield Gilmore (1829–92) organized his famous band in Boston in 1859. He later organized a concert band in New York, with which he toured the United States, Canada, and Europe. He also composed military band music and several songs, including "When Johnny Comes Marching Home."

8. For more on Geraldine Morgan (1868–1918) see "American Women Violinists" in this volume.

9. For more on Elise Fellows see "American Women Violinists" in this volume.

10. Joseph Joachim (1831–1907), a Hungarian violinist, teacher, and composer, was a follower of Robert Schumann and became an intimate friend of Johannes Brahms. His most important work is the *Hungarian Concerto*, a noble

and powerful conception for violin and orchestra, holding a place among the masterpieces for the instrument.

11. Franz Kneisel (1865–1926), a German violinist, conducted the Boston Symphony at the Chicago World's Fair in 1893.

12. For more on Lillian Shattuck see "American Women Violinists" in this volume.

13. The Eichberg string quartet in Boston was founded by Julius Eichberg (1824–1893), a German American violinist.

14. Niccolò Paganini (1782–1840), an Italian violinist, employed to the highest extent the possibilities of harmonics. His tricks of staccato and pizzicato threw the whole of Europe into excitement, wonder, and admiration.

15. Ole Bornemann Bull (1810–80), a Norwegian violinist and composer, came to the United States in 1852 to found a colony for Norwegian immigrants. Bull remained a great attraction and performed with undiminished success almost until his death. By 1855 he was describing himself as the country's "adopted son," and during his second visit he was more citizen than musician. His popularity was universal, from Boston salons to frontier steamboats, and depended as much on his colorful personality and his genuine affection for common people as on the remarkable virtuosity that made his name a byword for "fiddle" playing of legendary quality.

16. Émile Sauret (1852–1920) was a French violinist and composer.

17. Helmuth Karl Bernhard von Moltke (1800–1891) was one of the great military strategists of modern times.

18. John Philip Sousa (1854–1932), an American bandmaster and composer, was best known for "The Stars and Stripes Forever," probably the most popular march ever written.

■ Birth and Growth of a Popular Song

Since almost every one has, at some time or other, ventured the task of writing a popular song, either words or music, or both, without knowing much or anything of the difficulties which stand in the way of the ultimate success of such a composition, a slight discourse on the methods adopted at present to popularize a song cannot be far out of order. No one can truly say why such and such a song, out of the thousands that are annually written, strikes so wholly the popular fancy, netting the author thousands of dollars. The only thing that can definitely be set forth are the methods by which all songs are given publicity and an opportunity to appeal for the good favor of the public. It is all very much as a clever Broadway wit put it when he said, "I'll tell you, gentlemen, the art of song-writing is an exact thing. You can analyze it and discover the exact elements which make it up. There is just one little style or turn of strain that gives every song its popularity, and when you have found that out, learned all about it, and have it firmly fixed in your mind, why, you *can't* write the song."

Every new song success brings a fresh crop of writers. They are those who have read for the first time that of a little three-page ballad like "On the Banks of the Wabash"[1] the daily sales are thousands of copies, that the total sales will be over half a million, and that the author is making thousands of dollars, and who have proceeded forthwith to endeavor to do likewise. It looks easy, and the truth is, it really is easy for the person who has the popular-song vein in him. I know absolutely whereof I speak when I say that the words of "On the Banks of the Wabash" were written in less than an hour of an April Sunday after-

noon, and that the music did not require a much longer period. The whole deed was pleasurable and easy, while the reward was proportionately great. Yet there is not more than one good popular song turned out a year, and a great success such as "On the Banks of the Wabash" is not written once in ten years.

The history of the popularization of the average song begins with the aspiring author, who, having written what he is sure must eventually be an international song hit, sends his song to the publisher of whose business ability and general success he has heard the best report, or, if he lives convenient to New York, he takes it about in person. Usually the publisher controlling the latest song hit is the most popular victim of aspiring writers. To him they proceed, determined of course that their song shall not fail of proper recognition of its merits, if their personality counts for anything. As a rule, however, the publisher has not time to hear a new writer play over his own piece. When he appears he is courteously informed that of course a great many songs are brought in every day, and consequently each one must be left a few days for consideration. Almost invariably he will also volunteer the information that there is always a demand for good songs and that royalties are paid on all sales, usually from four to seven per cent.

This being satisfactory, the manuscript is left; or if not, and the author insists on being allowed to be present at the hearing of the piece or to play it for the publisher, he is invited to bring it in again. If he does so it is barely possible that some day he will bring in his manuscript at an opportunely dull time, and lo! the publisher will really allow him to play it over and receive judgment at once.

This, of course, is the new author, for the old one who has written one or many successes has no such trouble. For him everything is published. He goes to dinner with the publisher, has the freedom of the office, can even get the average songs of his friends a hearing, and is generally smiled upon and attended to, as beseems and befits the great in every field.

Granted, for the sake of forwardness, that the song is a good one and possesses that indefinable shade of sentiment in melody and words which make for popularity, and that it appeals to the very commercial judgment of the publisher, and that it is accepted. The next thing is to bind the author or authors by a contract, which reads that in consid-

eration of, let us say, four per cent of the net price of every copy sold, he or they relinquish all claim to right, title, or interest, etc. The manuscript is then sent to a professional arranger of music, who looks it over and rearranges the accompaniment to what is, in his judgment, the best for general piano purposes, and the song is printed.

Usually the first copies of the song printed are what are called "professional copies," for which the thinnest kind of news paper is used. Probably five thousand of these are struck off, all intended for free distribution among the singing profession on the stage. The giving of professional copies and orchestra parts to all singers of some standing is considered a very effective method of pushing a new song before the public.

If professional people, on hearing the song played for them in the publisher's parlors, think well of it, the publisher's hopes rise. It is then his policy to print possibly a thousand regular copies of the song, and these are sent out to "the trade," which is the mercantile term for all the small stores throughout the country which handle sheet music. A clever plan followed by some publishers is to enter into a contract with all the small dealers whereby the latter agree to take two copies of each of the publisher's new songs issued during the month, at, of course, a reduced rate. These copies being sold to the dealer at a cheaper rate than the older music, it is naturally to his advantage to sell them, since he makes a larger profit than on the copies of older songs regularly ordered. Thus the new song, being sent out at once under this contract, comes into the hands of singers and dealers throughout the country in very short order.

If, after a few months' standing, the song shows signs of the public's interest in it, if dealers occasionally order a copy, singers occasionally mention it as "going well" with their audiences, and the publisher likes the melody himself, he will endeavor to "push it" by advertising it on the backs and the inside margins of all his good selling pieces. Furthermore, if some able singer announces that he is going to "feature" the song in his tour, or if the sales of the song increase any after it has been well advertised upon the good selling pieces, a large advertisement will be placed in one of the papers which all the "professional" singers are known to take, in which the merits of the song are di-

lated upon and where it is announced as a coming success. Where a publisher has a reputation for good judgment and has already published a number of successes, the professional singers throughout the country are quite apt to take him at his word, or his advertisement, and write in for professional copies of the song. These are sent gratuitously, and the singers, finding it good, give it possibly an early trial before their audience. If the latter show any appreciation of its merits, it is very likely to be retained or "kept on" throughout the entire theatrical season by the keen vocalist.

In New York the work of booming the song is followed with the most careful attention, for it is well known among music publishers that if a song can be made popular around New York City it is sure to be popular throughout the country. Consequently canvassers are often sent about to the music halls where a song is being sung for the week, to distribute little hand-bills upon which the words are printed, to the end that the music-hall frequenters may become familiar with it and the sooner hum and whistle it on the streets. Boy singers are often hired to sit in the gallery and take up the chorus with the singer, thus exciting attention. Friends and hirelings are sent to applaud uproariously, and other small tricks common to every trade are employed to foster any early indication of public interest in the piece.

While the above tactics are more or less familiar to those who have essayed ballad-writing, very few know of the important part played by the hand and street organ and by the phonograph in familiarizing the masses with the merits of a song. Nearly all the piano-organs so numerously dragged about the city are controlled by an Italian padrone, who leases them to immigrant Greeks and Italians at so much a day. This business is quite an extensive one, involving as it does hundreds of organs and organ grinders, a large repair shop, and a factory where the barrels, upon which the melodies are indicated by steel pins, are prepared. The organs are quite intricate affairs, and their manufacture and control require no little knowledge and business skill, albeit they are of such humble pretensions.

With the organ-master-general the up-to-date publisher is in close communication, and between them the song is made a mutual beneficiary arrangement.

Note

"Birth and Growth of a Popular Song," *Metropolitan* 8 (Nov. 1898): 497–502. Republished in *Selected Magazine Articles,* 2:19–22.

1. "On the Banks of the Wabash," the official state song of Indiana, was originally composed by Paul Dresser (John Paul Dreiser Jr. [1858–1906]), Dreiser's older brother, with part of its lyrics written by Dreiser when he was the editor of *Ev'ry Month.*

■ His Life Given Up to Music: Theodore Thomas

Theodore Thomas Tells the Story of His Long and Persistent Struggle to Bring the People Nearer to Music—His Early, Unappreciated Efforts and His Later Triumphs

For eight years past, the music-loving people of Chicago have been in the enjoyment of weekly concerts given by the Chicago Orchestra, under the direction of the greatest living American leader, Theodore Thomas. For as many years, the percentage of losses in conducting a popular orchestra in that city have decreased until, at present, the magnificent body which has done so much for musical culture in Chicago, is almost self-supporting. As much cannot be said for any other great permanent orchestra in America, and the fact is a fine tribute to the genius of the veteran leader, now so familiar a figure in all musical centers of our great cities.

For a man of his advanced age, Mr. Thomas is an early riser, and I found him, one morning, in his chambers in Chicago, preparing to leave for rehearsal. The hale old gentleman actively paced the floor while I conversed with him, much preferring to stand.

"Mr. Thomas," I said, "those familiar with the events of your life consider them a lesson of encouragement for earnest and high-minded artists."

"That is the kind," he answered.

HIS FATHER A VIOLINIST

"I should like, if you will, to have you speak of your work in building up your great orchestra in this country."

"I Was Not an Infant Prodigy"

"That is too long a story. I would have to begin with my birth."

"Where were you born?" I asked.

"In the kingdom of Hanover, in 1835. My father was a violinist, and from him I inherited my taste, I suppose. He taught me music. When I was only six years old, I played the violin at public concerts. I was not an infant prodigy, however. My father had too much wisdom to injure my chances in that way. He made me keep to my studies in a manner that did me good. I came to America in 1845."

"Was the American music field crowded then?"

"On the contrary, there wasn't any field to speak of. It had to be

made. Music was the pastime of a few. The well-educated and fashionable classes possessed or claimed a knowledge of it. There was scarcely any music for the people."

"How did you come to get your start in the New York world of music?" I asked of him.

"With four associates, William Mason, Joseph Mosenthal, George Matzka and Frederick Berguer, I began a series of concerts of Chamber Music, and for many years we conducted this modest artistic enterprise. There was much musical enthusiasm on our part, but very little reward, except the pleasure we drew from our own playing."

These Mason and Thomas *soirées* are still remembered by old-time music lovers in New York, not only for the excellence of the music, but for the peculiar character of the audiences. They were quiet little monthly reunions, to which most of the guests came with complimentary tickets. The critics hardly ventured to intrude upon the exercises, and the newspapers gave them no more than a cavalier notice.

THE BEGINNING OF THE ORCHESTRA

"How did you come to found your great orchestra?"

"It was more of a growth than a full-fledged thought to begin with. It was in 1861 that I severed my connection with the opera and began to establish a genuine orchestra. I began with occasional performances, popular matinée concerts, and so on, and, in a few years, was able to give a series of Symphony *Soirées* at the old Irving Hall in New York."

To the average person, this work of Mr. Thomas may seem to be neither difficult nor great, but it must be remembered that anyone could have collected a band in a week, but to make such an orchestra as Mr. Thomas meant to have was a work of time and patience. It was at the time when the Philharmonic Society, after living through a great many hardships, was just on the full tide of popular favor. Its concerts and rehearsals filled the Academy of Music with the flower of New York society. Powerful social influences had been won to its support, and Karl Bergmann[1] had raised its noble orchestra of one hundred performers to a point of proficiency then quite unexampled in this country, and

in some particulars still unsurpassed. Ladies and gentlemen who moved in the best circles hardly noticed the parallel entertainment offered in such a modest way, by Mr. Thomas, on the opposite side of the street. The patrons of his Chamber Concerts, of course, went in to see what the new orchestra was like; professional musicians hurried to the hall with their free passes; and there were a few curious listeners besides who found in the programmes a class of compositions somewhat different from those which Mr. Bergmann chiefly favored, and, in particular, a freshness and novelty in the selections, with an inclination, not yet very strongly marked, toward the modern German school. Among such of the *dilettanti* as condescended to think of Mr. Thomas at all, there was a vague impression that his concerts were started in opposition to the

Theodore Thomas

Philharmonic Society, but that they were not so good and much less genteel.

It is true that Mr. Thomas was surpassed, at that time, by Mr. Bergmann's larger and older orchestra, and that he had much less than an equal share of public favor, but there was no intentional rivalry. The two men had entirely different ideas and worked them out in perfectly original ways. It was only the artist's dismal period of struggle and neglect which every beginner must pass through. He had to meet cold and meager audiences, and the false judgment of both the critics and the people. He was a singular compound of good American energy and German obstinacy, and never lost courage.

"How long did you struggle at that time?" I asked him.

"Not very long. Matters soon began to mend. The orchestra improved, the dreadful gaps in the audience soon filled up, and at the end of the year the Symphony *Soirées*, if they had made no excitement in musical circles, had at least achieved a high reputation."

"What was your aim, at that time?"

"When I began, I was convinced that there is no music too high for the popular appreciation,—that no scientific education is required for the enjoyment of Beethoven. I believed that it is only necessary that a public whose taste has been vitiated by over-indulgence in trifles, should have time and opportunity to accustom itself to better things. The American people at large then (1864), knew little or nothing of the great composers for the orchestra. Three or four more or less complete organizations had visited the principal cities of the United States in former years, but they made little permanent impression. Jullien[2] had brought over, for his monster concerts, only five or six solo players, and filled up the band with such material as he found here. The celebrated Germania Band of New York, which had first brought Mr. Bergmann (famous then as the head of the New York Philharmonic Society) into notice, did some admirable work just previous to my start in New York, but it disbanded after six years of vicissitude, and, besides, it was not a complete orchestra."

"You mean," I said, as Mr. Thomas paused meditatively, "that you came at a time when there was a decided opportunity?"

MUSIC HAD NO HOLD ON THE MASSES

"Yes. There had been, and were then, good organizations, such as the New York Philharmonic Society and the Harvard Musical Association in Boston, and a few similar organizations in various parts of the country. I mean no disparagement to their honorable labors, but, in simple truth, none of them had great influence on the masses. They were pioneers of culture. They prepared the way for the modern permanent orchestra."

"They were not important?"

"No, no; that cannot be said. It would be the grossest ingratitude to forget what they did and have done and are still doing, or detract in the smallest degree from their well-earned fame. But from the very nature of their organization, it was inevitable that they should stand a little apart from the common crowd. To the general public, their performances were more like mysterious rites, celebrated behind closed doors, in the presence of a select and unchanging company of believers. Year after year, the same twenty-five hundred people filled the New York Academy of Music at the Philharmonic concerts, applauding the same class of master works, and growing more and more familiar with the same standards of the strictly classical school. This was no cause for complaint; on the contrary, it was a most fortunate thing that the reverence for the older forms of art and canons of taste were thus devoutly kept alive; and we know that, little by little, the culture which the Philharmonic Society diffuses, through the circle of its regular subscribers, spreads beyond that small company, and raises the æsthetic tone of metropolitan life. But I believed then, as I believe now, that it would require generations for this little leaven to leaven the whole mass, and so I undertook to do my part in improving matters by forming an orchestra."

"You wanted to get nearer the people with good music?"

"No, I wanted the people to get nearer to music. I was satisfied that the right course is to begin at the bottom instead of the top, and make the cultivation of symphonic music a popular movement."

"Was the idea of a popular permanent orchestra new at that time?"

"Yes."

"Why was it necessary to organize a permanent orchestra?"

"Why! Because the first step in making music popular then was to raise the standard of orchestral performances and increase their frequency. Our country had never possessed a genuine orchestra, for a band of players gathered together at rare intervals for a special purpose does not deserve the name. The musician who marches at the head of a target company all the morning and plays for a dancing party at night, is out of tune with the great masters. To express the deep emotions of Beethoven, the romanticism of Schumann, or the poetry of Liszt, he ought to live in an atmosphere of art, and keep not only his hand in practice, but his mind properly attempered. An orchestra, therefore, ought to be a permanent body, whose members play together every day, under the same conductor, and devote themselves exclusively to genuine music. Nobody had yet attempted to found an orchestra of this kind in America when I began, but I believed it could be done."

WORKING OUT HIS IDEA

"Did you have an idea of a permanent building for your orchestra?"

"Yes. I wanted something more than an ordinary concert-room. The idea needed it. It was to be a place suitable for use at all seasons of the year. There was to be communication in summer with an open garden, and in winter it was to be a perfect auditorium."

Mr. Thomas's idea went even further. It must be bright, comfortable, roomy, well ventilated,—for a close and drowsy atmosphere is fatal to symphonic music,—and it must offer to the multitude every attraction not inconsistent with musical enjoyment. The stage must be adapted for a variety of performances, for popular summer entertainment as well as the most serious of classical concerts. There, with an uninterrupted course of entertainments, night after night, the whole year round, the noblest work of all the great masters might be worthily presented.

The scheme was never wholly worked out in New York, great as Mr. Thomas's fame became, but it was eventually partially realized in the old Exposition building in Chicago, where he afterwards gave his sum-

mer concerts, and it is still nearer reality in the present permanent Chicago orchestra of his, which has the great Auditorium for its home and a $50,000 annual guarantee.

"What were your first steps in this direction?" I asked.

"I began with a series of *al fresco* entertainments in the old Terrace Garden, in June, 1866. They were patronized, and repeated in 1867. Then, in 1868, we removed to better quarters in Central Park Garden, and things prospered, so that, in 1869, I began those annual tours, which are now so common."

The first itinerary of this kind was not very profitable, but the young conductor fought through it. Each new season improved somewhat, but there were troubles and losses. More than once, the travelers trod close upon the heels of calamity. The cost of moving from place to place was so great that the most careful management was necessary to cover expenses. They could not afford to be idle, even for a night, and the towns capable of furnishing good audiences generally wanted fun. Hence they must travel all day, and Thomas took care that the road should be smoothed with all obtainable comforts. Special cars on the railways, special attendants to look after the luggage, and lodgings at the best hotels contributed to make the tour tolerably pleasant and easy, so that the men came to their evening work fresh and smiling. They were tied up by freshets and delayed by wrecks; but their fame grew, and the audiences became, daily, greater. Thomas's fame as a conductor who could guarantee constant employment permitted him to take his choice of the best players in the country, and he brought over a number of European celebrities as the public taste improved.

Theodore Thomas did another wise thing. He treated New York like a provincial city, giving it a week of music once in a while as he passed through it on his travels. This excited the popular interest, and when he came to stay, the next season, a brilliantly successful series of concerts was the result. At the close, a number of his admirers united in presenting him a rich silver casket, holding a purse of $3,500, as a testimonial of gratitude for his services to all. The Brooklyn Philharmonic Society placed itself under his direction. Chicago gave him a fine invitation to attend benefit entertainments to himself, and, when he came, decked the hall with abundant natural flowers, as if for the reception

of a hero. He was successful financially and every other way, and from that time on he merely added to his ability and his laurels.

THE CHIEF ELEMENT OF HIS SUCCESS

"What," I asked of him, "do you consider the chief element of your success?"

"That is difficult to say. Perseverance, hard work, stern discipline,— each had its part."

"You have never attempted to become rich?"

"Poh!"

"Do you still believe in the best music for the mass of the people?"

"I do. My success has been with them. It was so in New York; it is so here." (Chicago).

"Do you still work as hard as ever?" I inquired.

"Nearly so. The training of a large orchestra never ends. The work must be gone over and over. There is always something new."

"And your life's pleasure lies in this?"

"Wholly so. To render perfect music perfectly—that is enough."

NOTES

"His Life Given Up to Music: Theodore Thomas," *Success* 2 (4 Feb. 1899): 167–68. Reprinted as "How Theodore Thomas Brought People Nearer to Music" in *How They Succeeded: Life Stories of Successful Men Told by Themselves*, ed. Orison Swett Marden (Boston: Lothrop, 1901), 314–26. Also reprinted as "His Life Given Up to Music: Theodore Thomas,"in *Selected Magazine Articles*, 2:23–30.

1. Karl Bergmann (1821–76), a German-American violoncellist, was the conductor of the New York Philharmonic Society (1866–76). An ardent champion of Franz Liszt and Richard Wagner, Bergmann did much to promote their works in America.

2. Louis Jullien (1812–60) was a French conductor and composer whose career was spent primarily in London. Jullien's declared aim was to provide amusement as well as instruction, blending the most sublime works with lighter ones.

■ American Women Who Play the Harp

Society Ladies and Others Who Have Won Distinction on the Noble Instrument Which Soothed the Melancholy of Soul, and Thrilled the Halls of Tara

Of all musical instruments familiar to our modern life, not one stirs such affectionate regard for itself in the breasts of the masses like the harp. It may not, perhaps, be successfully asserted that it is an instrument whose music touches a deeper and more sympathetic vein than any other, but no one can deny that in name at least, it is associated with much that is poetic, more that is sentimental, and some things that are sad. The harp of David, as well as "the harp that once through Tara's halls," have been long familiar, in name at least, to the humblest of men, and the glamour with which time and poetry have invested them has risen as a mist before the eye, through which the ancient instrument is looked upon with reverence and affection.

It is not, to begin with, a commonplace or popular instrument, in the sense of individual possession, although the future seems now to hold much in store for it. The great cost of a good harp, and the trouble to many amateurs, of tuning, stands in the way. The more convenient and useful pianoforte has been its successful rival. Its only advantages are its peculiarity and beauty of tone, its elegant ornamental appearance, and its grace of form. These seem to commend it to those who look most charming as players of it, the women, and its fate really seems to literally rest in their hands.

At present there are over a hundred society ladies in New York who are skillful performers on the harp. Ten years ago there were less than a dozen. There are in addition some ten women who have reached dis-

tinction professionally, with this instrument. So far, the increase of play-
ers has been among the wealthy, for it is an expensive taste. The "Little
Grecian," the cheapest of harps, costs five hundred dollars, the "Semi-
Grand," seven hundred and fifty dollars, and the "Grand," one thou-
sand two hundred dollars. Besides, they are difficult to keep in condi-
tion, their strings being affected by every change of weather, and having
to be renewed at least every second year. Some of those who practice
daily wear out a harp altogether in a couple of years, the whole mecha-
nism going to pieces under the high tension of the French concert pitch.

A woman of strong physique and determined mind, the daughter
of one of America's best known organists, Miss Maud Morgan, brought
rare energy and musical instinct to the study of the instrument which
she has so completely mastered. Her efforts in the field of populariz-
ing the harp are evidenced by some twelve hundred programmes in
which she has taken part during her various tours. Her fine intelligence
and appreciation of her instrument, as well as of its history, have giv-
en rise to a public interest which she has fostered by various public harp
matinees, at which the history of the harp has been traced in a form of
lecture, musically illustrated by selections from various periods.

Miss Morgan was born in New York City, about 1860. Her musical
education was received from her father, George W. Morgan, and her
first public appearance was with Ole Bull,[1] when she was eleven years
old. At the age of twelve, she made a tour of the United States with
Wilheling, and later, several tours with Emma Thursby,[2] under the
management of Maurice Staokosch. Subsequent appearances, *en tour,*
are too numerous to mention, but at the present time she is the harp-
ist of Grace Church, with quite wide fame also as a composer of harp
music.

With Miss Morgan must be mentioned Miss Avice Boxall, whose
fame has steadily grown from year to year until she may now be called
a celebrity in the truest sense of the word. Miss Boxall is a pupil of John
Thomas.[3] Her prestige has been acquired by great numbers of public
recitals in which she has by her playing stirred great interest. It is due
to such efforts as hers, and those of Miss Morgan, that the harp recital
has become an event of as much musical interest as a piano recital, and
the result of this is that they are fast becoming as profitable. It is true
that there is as yet no Paderewski[4] of the harp to fill a Carnegie Lyce-

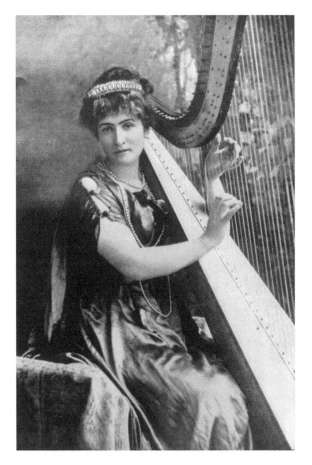

Miss Maud Morgan

um with four thousand enthusiastic lovers of music, but the time is undoubtedly coming, and will be as unquestionably due to such efforts as are now being put forth. Miss Boxall is a New Yorker by birth. Her parents are well known in the business and social world.

Miss Clara Winters's reputation is the growth of nine years of study and work. She has played in a number of New York churches as well as the orchestras of several New York theatres, notably that of Abbey's Theatre, (now the Knickerbocker), during the appearance of John Hare, the English actor, and also during the presentation of "Izeye," by Sarah Bernhardt. For several years preceding the present, Miss Winters

Miss Avice Boxall Mme. Inez Corusi

Miss Clara Winters

Miss Florence B. Chatfield

was connected with the Harlem Philharmonic Society as harp soloist, but has now entered the National Conservatory of Music for an additional period of study before her public appearance next year. Miss Winters is an able and sympathetic virtuoso who believes that the harp is yet destined to occupy as prominent a place on every musical programme as is now given to the violin or piano, and to this end her labors are earnestly directed.

Miss Florence Chatfield is another delightful harpist who has graduated from the drawing rooms of New York society into the professional field. For a number of years her talent was employed exclusively in

entertaining society in a social way, until she became convinced of the merit and more serious import of her ability as a player. She then took up the professional field and now appears regularly in public, being acknowledged as one to whom greater distinction and general public approval is yet to come.

Julia Poole Blaisdell, another of the foremost women harpists, is one of the world-renowned Poole family of Swiss bell-ringers, whose name is so well known among music loving people. She is a pupil of the distinguished composer and harpist, Aptommas,[5] and is one of the most able of the American masters of the instrument. Her public career has been one of the most successful and her fame as a teacher of the instrument is only second to that of Miss Morgan.

Mme. Inez Corusi, though of foreign extraction, has spent nearly

Mrs. Blaisdell

all her life in America, acquiring even her mastery of the harp in this country. Mme. Corusi's reputation and achievements represent the merit of the harp as an orchestral adjunct. She has been affiliated with the Damrosch, Seidl, Thomas, and other orchestras and is a perfectly familiar figure in metropolitan musical affairs. The range of her performance covers the best harp music, and her great personal strength makes the harp an easily controlled and sympathetic instrument in her hands. She is a woman who practically devotes all her time to the study of the instrument, and one whose great energy gives encouragement to those who would extend the field of the harp.

Mabel Munro is yet another of the women who have taken up the harp with that serious intent which has accomplished so much for it

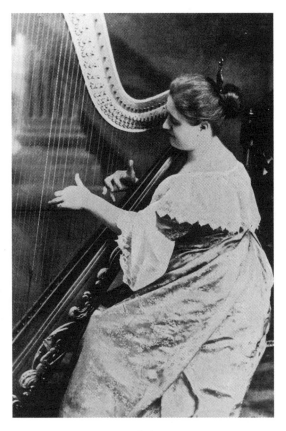

Miss Mabel Munro

in the past twenty years. Her mastery of its history and its music has given her standing professionally, and her work is of the concert character that attracts favor for and popular interest in the harp. She should really be joined in notice with Miss Edith Le Gierce, for both possess an equal technique and have had experience in orchestral work. Miss Le Gierce is, however, a younger woman, has had more experience as a soloist with the great orchestras, and perhaps more favor with the public outside of New York. They are both recruits from society and had for years been known as distinguished amateurs whose efforts were exclusively and unremuneratively exercised for the pleasure of society in its ceaseless search for amusement.

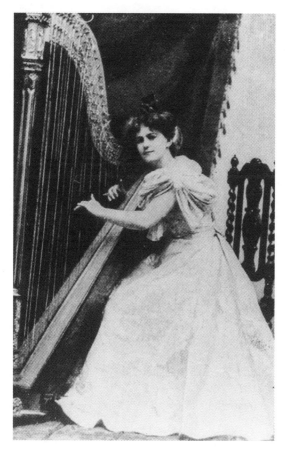

Miss Edith Le Gierce

MISS DREXEL AS AN AMATEUR

Outside of the professional phase of the harp, where its fate is so ably championed, it will be interesting to note the hold it has taken in an amateur way. Miss Lucy Drexel, the daughter of the late Joseph Drexel,[6] is one of the best amateur harpists in America. She excels as a soloist, a point only reached by long years of teaching and incessant practice. Her touch is delicate, but firm, and her slender strength readily calls thunder from the strings. Another accomplished soloist is Miss Olive Elverson Woodward, daughter of a New York architect, who is esteemed by good judges as second only to Miss Drexel.

Others well known in New York who have become noted for their skill on this delightful instrument are Mme. Francesca de Barrios, the rich widow of the late dictator of Guatemala; Miss Selma Lilienthal, daughter of the New York merchant, and Baroness Jermonowski. Mrs. Lilla Steele-Madeira is, perhaps, one of the best accompanists. The list could easily be extended.

Not all of those who at the present time essay to play the harp know, or think, that so many as a dozen distinguished musicians owe their reputations to their harp compositions, and that an average collection of master harp compositions is an imposing affair. Several of the women harpists mentioned have libraries of exclusively harp music, the greater portion of which is not to be had for any other instrument. What Liszt, Gounod,[7] Mendelssohn, have done for the piano, Bochsa,[8] Dizi,[9] Labarre,[10] Alvars,[11] and John Thomas have done for the harp. Zamara,[12] Overthür, Aptommas, Posse,[13] Ziech,[14] and Chatterton[15] are noted names, and they are not inclusive. Much excellent music has recently been composed for this instrument, among which may be mentioned nearly all of the compositions of Miss Morgan.

NOTES

"American Women Who Play the Harp," *Success* 2 (24 June 1899): 501–2.

1. Ole Bornemann Bull.

2. Emma Thursby (1845–1931), an American soprano, was known for her

coloratura technique, her avoidance of scooping, and the evenness of her instrument throughout its unusually large range.

3. John Rogers Thomas (1830–96), a Welsh-born American baritone and composer, made his first appearance in New York in 1899. He also taught music in New York and composed many songs that were popular in his day.

4. Ignacy Jan Paderewski (1860–1901), a Polish pianist, composer, and statesman, gave his first concert at Carnegie Hall in November 1890, and during the next four months gave over a hundred performances in the major cities of the United States and Canada. Almost annually afterward he made a similar concert tour of North America while he played throughout the world.

5. John Aptommas (born 1826) and Thomas Aptommas (1829–1913), English harpists and brothers, were teachers in London. Thomas also played and taught in New York for several years. Their compositions for the harp were excelled only by those of Elias Parish-Alvars.

6. Anthony Joseph Drexel (1826–93), an American banker and philanthropist, founded the Drexel Institute of Technology in Philadelphia.

7. Charles François Gounod (1818–93) was a French composer.

8. Robert Nicholas Charles Bochsa (1789–1856) was a French composer and harpist.

9. François Joseph Dizi (1780–1847) was a French harpist.

10. Théodore Labarre (1805–70) was a French harpist and composer.

11. Elias Parish-Alvars (1808–49) was an English harpist.

12. Antonio Zamara (1829–1901) was an Italian harpist.

13. Wilhelm Posse (1852–1925) was a German composer, harpist, and teacher.

14. Otakar Ziech (1879–1934) was a Czech composer and teacher.

15. John Balsir Chatterton (1805–1871) was an English harpist.

■ American Women Violinists

Fair Ones who Have Gained Success and Fame in Playing the Violin—
Hard Work the Secret of their Triumph—Camilla Urso Sacrificed
Every Other Object and Desire to Art

Violin playing has been repeatedly demonstrated to be one of woman's fortes. In foreign countries successful women violinists have risen up and prepared the way for greater success by other women in the United States; quite a number have appeared; and one or two have attained to international fame. The result is that, to-day, the widest opportunities for talent in this direction present themselves to beginners. Permanent fame and large incomes are readily realized by those possessing sufficient talent.

Miss Maud Powell[1] is unquestionably the most gifted and artistic of all American violinists. Ever since her return from Europe in the season of 1885–6, when she made her first appearance with the Philharmonic Society of New York, playing the Bruch concerto in G minor, with the orchestra, her powers have been steadily ripening and her reputation growing more sure and solid. Between that time and her present visit to Europe, which has covered two years, she has accomplished a great deal.

SHE WON MUSICAL TRIUMPHS IN EUROPE

Miss Powell was born in Aurora, Illinois, and received her first violin instruction in Chicago. While very young, her mother took her to

Leipzic, where she studied at the conservatory, and thence to Paris, where she received instruction from Dancla.[2] She played in concerts in London, made a tour through the provinces, and was about to return to America when she met Joachim,[3] and decided to spend one year studying with him in Berlin. She again made a concert tour in England, played at Buckingham Palace in London before the royal family, and returned to America for the season of 1885–6. Since then Miss Powell has played many times with the orchestras of Theodore Thomas, Gericke,[4] Seidl, Nikisch,[5] and Damrosch. She is in frequent demand for musical festivals, and has given innumerable recitals in conservatories, colleges, and concert halls throughout the United States and Canada. Four years ago she organized the Maud Powell String Quartette, with which she made several long tours and achieved great success. She also organized the Maud Powell Ladies' Trio, which was popular the year before she last sailed for Europe. She knows the literature of music very thoroughly, and has a very large *répertoire* to which she is constantly adding. Miss Powell is unusually graceful and yet powerful with her instrument, and is the fortunate possessor of a beautifully rounded arm.

CAMILLA URSO

If age were not at all a factor in the popularity of a woman violinist, Camilla Urso[6] would have to be declared not only the greatest but also the most popular American woman violinist. Time and greater experience placed Madame Urso first in public favor long ago: and, were she not growing old, she could probably retain distinction.

No one who is at all familiar with the history of music in America need be told much of the career of Madame Urso. She is a master of her art and possesses the vitality and fire which has been heretofore attributed only to men noted as great violinists. In her time she made four tours of the world, which were in a public way everything comprehended in the word "success." Although a native of France, but born of Italian parents, she early made her home in America and has been for years a resident of San Francisco. In the country, what time Madame Urso has devoted herself to professional work, she has always been iden-

tified with the great musical organizations, and has often appeared with the great orchestras of the Arion Societies, Seidl, Thomas, and Damrosch. She has also toured the country with splendidly equipped companies of her own, and created no end of interest and enthusiasm.

AN UNTIRING WORKER

Of late years, Madame Urso has devoted most of her time to teaching a few talented pupils. Many of the prominent young women violinists of the present owe their instruction in their art to her. She is an untiring worker and only attained her high position by sacrificing, as she has often said, every other object and desire.

Madame Urso has splendidly equipped apartments in San Francisco, where she is constantly sought by those desirous of obtaining instruction from so brilliant a source. She is the owner of a noted *Guarnerius* violin, and not only plays brilliantly the entire *répertoire* of music for the violin, but also all modern music, from memory.

A VIOLINIST FROM CHILDHOOD

Another interesting violinist is Dora Valeska Becker, a modern, unassuming young woman with a grave face and large, earnest eyes. She comes of a musical family, and it was not surprising that she should evince, as a child, a predilection for music, but it was nothing short of wonderful to see her make her first public appearance when she was only nine years old, when she played a melody, a fantasia of De Beriot's, with much expression and even with precision of execution.

The South claims her, for she was born in Galveston, Texas, twenty-nine years ago. She studied in New York and appeared at several concerts. Then she went to Berlin, where she studied with the famous Joseph Joachim. In 1890, she made her *début* in that city at a Philharmonic concert. The "Reichbote" announced her as a success, saying: "She played before a large audience the difficult 'Scotch Fantasia, in E flat,' by Max Bruch; it was her first number, and behold, she did full justice to her work; the young artist exhibited musical conception as well as artistic zeal. A brilliant future is sure to rise before her."

SHE PLAYED WITH THEODORE THOMAS

On returning to America, Miss Becker played frequently in important concerts in New York, and on several occasions with Thomas's Orchestra. She organized a successful ladies' trio, which gained considerable distinction for excellent parlor music. She still holds to solo work in the main, however, and her reputation has steadily broadened. She now ranks as one of the best of American women violinists, having much power and brilliancy of style.

Miss Martina Johnston, who is now practically identified with American women in this field, was originally known as a Swedish violinist. This is due to the fact that her artistic training is entirely foreign. She was born in Gothenburg, Sweden, and as a child showed a remarkable predilection for, and power to utilize, her favorite instrument. She was finally set forward in a musical career; and, when old enough, entered the Royal Conservatory at Stockholm, where she won the first prize, receiving it from the hands of the King of Sweden, upon her graduation. She was then sent to Berlin for five years, as a special pupil of Emil Sauret, the able violinist who was heard in this country a few years ago. In the German capital Miss Johnston soon became a favorite, playing often for the empress, Princess Meninigen, and for Field Marshal von Moltke, in whose palace she was very many times a welcome guest. After appearing in a number of European cities, Miss Johnston came to America, making New York her home. Since then she has traveled about the country considerably every season, several times as a leading soloist with Sousa's Band. She has made tours covering twenty-one thousand miles, in which she usually played in two towns a day, and yet never missed a concert. She is a young woman of strong physique and great energy, and she attributes all her success to hard work.

Miss Flavie Van den Hende is usually included in every list of American women violinists, though her forte is the playing of the violoncello. Miss Van den Hende is a handsome, clever young lady, who is now well identified with the work of Thomas, Van der Stucken[7] and Damrosch orchestras. She is a native of Sweden, but has been a resident of New York ever since childhood. For a woman, she handles her difficult instrument with much delicacy and tone and evinces rare musical

thought and breadth of conception. She really outstrips most American-born women cellists and takes her distinction modestly. To those who express wonder at her playing what seems an unwieldy instrument, she makes no apologies. "It is all the more creditable that a woman should be able to master it at all," is her only comment.

During last winter, she was particularly successful, having been identified with the rendition of some of the best chamber music that New York has heard.

A NEW YORK GIRL

One of the younger women violinists who has recently gained favorable recognition is Geraldine Morgan,[8] a New York girl, whose parents were both noted in chosen fields, before her. Miss Morgan's father was one of New York's famous organists years ago, and her mother will be recalled as a correspondent of New York's great dailies and a woman journalist of high repute. The favored daughter of these two completed her school training in New York, and, having long shown her preference for the violin, received instruction in that art and was subsequently sent to Germany. In the high school at Berlin, she became the favorite pupil of the renowned Joachim. After completing her studies there, she returned to New York and was immediately engaged for a tour with the Damrosch Symphony Orchestra. During several years following, she was allied with several others of New York's orchestras when she began her successful concert work. Although Miss Morgan is twenty-four years of age, she is well placed in her art, and shares a fair amount of general public attention.

A SUCCESSFUL TOUR

It is said that, of all the women violinists who entered upon concert tours during the past season, only one truly succeeded from a financial point of view, and that one was Miss Ollie Torbett. This young violinist is a native of Ohio, and received her general and musical education in her own state, having acquired her knowledge of the violin at the Cincinnati College of Music, before coming to New York. While

in the latter city, and engaged upon professional work, Miss Torbett also found time to study as a pupil under Camilla Urso, who was then in the city. Several years ago, Miss Torbett began a tour of America under Major Pond,[9] and last year organized a concert company of her own, with which she proved decidedly successful. Miss Torbett is very young and very energetic, and is looked upon, by those familiar with her work, as one likely to further distinguish herself.

BOSTON VIOLINISTS

Boston is the birthplace and residence of a number of women violinists, and Miss Elise Fellows[10] is one of the number who, during the past two years, has come into some prominence. Miss Fellows is a pupil of Franz Kneisel, of the famed Kneisel Quartette. She is an accomplished player, and last year made her concert appearance under the direction of Carl Wolfsohn,[11] achieving no little popular approval. During the coming season, Miss Fellows will study abroad, and will not return to the concert stage until after an extended stay in Germany. She is a petite girl, only twenty-two years of age, and possessed of much energy and talent.

Miss Lillian Shattuck[12] is mistress of her instrument, and handles it with vigor and rare grace. Her playing is sympathetic and her execution brilliant. She is a studious laborer in her chosen field. Miss Shattuck is a native of Boston, and comes of a family that is well known in New England history. Besides concert work, in which she has been very successful, she has allied herself with the now famous Eichberg String Quartette, of Boston, which is a well-known organization in the world of music. Miss Shattuck is an energetic young woman, and works hard, with the firm determination to attain rank and national distinction.

Miss Della Rock and Miss Rossi Gish are fast winning public notice and approval by their able handling of the violin. Both women are young and of uncommon personal attractiveness, but their art commands their sole devotion, and they hope in time to take leading places among the talented members of their sex who have achieved fame with the violin.

NOTES

"American Women Violinists," *Success* 2 (30 Sept. 1899): 731–32.

1. For more on Maud Powell (1867–1920) see "Our Women Violinists" in this volume.

2. Leopold Dancla (1823–95) was a French violinist, composer, and music teacher.

3. Joseph Joachim.

4. Wilhelm Gericke (1845–1925) was a German conductor and composer.

5. Artur Nikisch (1855–1922) was a Hungarian pianist, conductor, and composer.

6. For more on Camilla Urso (1842–1902) see "Our Women Violinists" in this volume.

7. Frank Van der Stucken.

8. For more on Geraldine Morgan (1868–1918) see "Our Women Violinists" in this volume.

9. For Major James Burton Pond see "Literary Lions I Have Met" in this volume.

10. For more on Elise Fellows see "Our Women Violinists" in this volume.

11. Carl Wolfsohn (1834–1907), a German pianist and teacher, came to Philadelphia in 1854 and in 1873 moved to Chicago, where he continued to teach and directed the Beethoven Society Choir.

12. For more on Lillian Shattuck, see "Our Women Violinists" in this volume.

American Women Who Are Winning Fame as Pianists

A Peculiarly Difficult Field for Women in which Some Have Achieved Brilliant and Notable Success

Successful and noted women pianists are not numerous, either in America or in the world in general, but there are a few whose labors and present success entitle them to general recognition, and of these America has its share.

The study of the piano is one involving so much labor and patience and requiring so much innate ability and predisposition for it, that it is scarcely a subject of comment that so few women succeed in that field. The art requires an iron constitution coupled with the patience of Job, and the most resplendent talent may be wasted by subsequent poor management and inability to gain a moderate and respectful public hearing. But, in spite of these conditions, there are noted women pianists, whose example should inspire others to emulation.

Therese Carreno is acknowledged to be the greatest living woman pianist, and she ranks with the two greatest men,—Paderewski[1] and Eugene d'Albert.[2] Her technique is wonderful, her reverence for her art, her faultless rhythm, her musical erudition, and her industry, combined with a most dazzling personality and radiant temperament, make her a genius. She is the Calvé[3] of the pianoforte. Mme. Carreno was born in Venezuela, and came with her father to New York, where she spent her early life. Her talent was recognized and she was sent to Europe, where she became the spoiled child of the great musicians of the day. She has never had any conservatory training, but was helped toward a successful career by Liszt, Rubinstein,[4] Saint-Saens, and other celebri-

ties. Of all composers, Mme. Carreno prefers Beethoven. "He," she says, "satisfies both heart and mind."

A NOTED CHICAGO PIANIST

Fannie Bloomfield-Zeisler has proved herself a master of the first rank in the field of piano-playing, and has been praised and honored by the music-loving public of two continents. Although possessed of a frail, delicate body, she has given to her art untiring devotion and singleness of purpose which have sufficed to produce a magnificent artist. She has toured both Europe and America repeatedly and each time has added to her great reputation. Mrs. Bloomfield-Zeisler is a native of Chicago, and has, with the exception of her foreign study, always resided in that city. She is young and is constantly winning the distinguished praise which her art deserves.

Ellen Berg-Parkyn, who has taken rank as one of the most promising of American women pianists, is a native of Stockholm, Sweden, but the wife of an American. For many years now she has resided in this country, developing her powers and adding to her reputation by serious effort. She is a graduate of the Royal Conservatory of Music, of Stockholm, and the winner (for three consecutive years) of the medal bestowed by King Oscar, of Sweden, at the annual public exhibitions of the conservatory. In this country, Mme. Berg-Parkyn has been identified with the Schumann quartette, and her playing has proved admirable in its steadiness, precision, and buoyancy. Her execution is finished and her reading intelligent. On her first appearance, she gave a most agreeable surprise, for, at first sight, she seemed a slight and timid girl about eighteen, but in power and artistic conception she proved herself to be eminently worthy of her position among so great artists. At present, Mme. Berg-Parkyn is a resident of New York.

Miss Katherine Ruth Heyman is a California girl, who has worked hard for the recognition thus far extended to her. In April, 1897, Miss Heyman was called from New York to Washington to appear as solo pianist at a reception tendered by Baroness Hengelmuller to the Austro-Hungarian legation. At the close of the entertainment, the Baroness complimented Miss Heyman on her playing and, taking her by the

hand, led her to the drawing-room, and, kissing her cheek, placed in her hand a package. On reaching her carriage, she found the package to be an exquisite white satin bag with a beautiful gold bracelet in it, of fine workmanship, on the inside of which was engraved, "Souvenir du Avril, 1897." Miss Heyman was born and brought up in Sacramento, California, and is the daughter of Arnold Heyman, a violin teacher. She has visited Berlin and pursued her studies with Barth,[5] the court pianist, and has had a career in London and Paris. Miss Heyman says her favorite music is that of Beethoven, and afterwards, of Grieg.[6] She is a beautiful interpreter of the former.

Shortly before Anton Seidl died, he heard, at the request of some friends, a young lady pianist for whom he expressed much admiration. The hearing took place at his house. When she played for him a Brahms concerto and a number of smaller works, Mr. Seidl did not hesitate to express in unequivocal language his admiration for the young woman's talents. This was Miss Ida Simmons, a young lady who, having finished her studies abroad, had returned to this country and entered upon her professional career. Since then, Miss Simmons has risen steadily. She possesses all the requisites of a successful pianist,—an artistic temperament, a bright musical intelligence, an adequate technic, an abundance of strength, and a captivating feminine delicacy. Her hands were made for the piano. They are flexible, and possess extraordinary strength for a woman. Their reach, too, is exceptional.

Miss Ida Simmons

A charming and modest woman, distinguished for talent at piano playing, is Stella Hadden-Alexander, a pupil of Professor MacDowell,[7] of Columbia College, and, in many respects, a product of the American music schools. Mrs. Alexander is a native of Michigan, although claimed by Sandusky, Ohio, and New York City. She received her impulse toward musical art by inheritance, her mother being an accomplished organist, pianist, and singer, who guided her daughter's first steps in music until her twelfth year, when she was accounted a musical prodigy. She was then placed under the tuition of Eugene Bonn, a graduate of the Royal Conservatory of Music. During a five years' course with this well-grounded musician, Miss Hadden studied at Oberlin College, where she took a course in literature and the higher mathematics. From Oberlin, Miss Hadden proceeded to Boston, where she studied under such masters as George W. Chadwick,[8] J. C. D. Parker,[9] Louis C. Elson[10] and Otto Bendix.[11] At the end of a year, she made her *début* at a conservatory recital, in which she played Beethoven's "Emperor Concerto," Chopin's "E flat Polonaise," and other selections, in which she gave unmistakable proof of the position her talents would enable her to achieve. Since that day, Mrs. Alexander has risen steadily, until to-day she is looked upon as a pianist of high ability.

CLASS LESSONS WHICH ARE CONCERTS

Miss Lotta Mills is one of the most talented and promising of the young American pianists. She is a native of Washington, D. C. Miss Mills first studied under Richard Burmeister,[12] in Baltimore, and afterwards she went to Vienna to study under Leschetizky.[13] She remained two years and won a reputation at the class lessons which, like those of Liszt, at Weimar, are really concerts, when any one of the hundred pupils assembled may be suddenly called upon to play a solo. Returning to America, Miss Mills selected New York for her home. She has appeared with Seidl's orchestra, and has given recitals in Baltimore and Washington.

Among eleven pianists selected from seventy-five competitors at the entrance examination of the Hochschule a few years ago, was one young lady who is this year attracting considerable attention. On that occasion, Joachim, the director, had scarcely heard her finish her playing before he stepped forward and told her that she was accepted, at the

Miss Marguerite Stillwell

One of Our Leading Pianists at Rehearsal

Ellen Berg-Parkyn Mrs. Van Leer Kirkman Therese Carreno

Helen Hopekirk Adele Aus der Ohe

same time congratulating her upon her playing of Brahms. That was Miss Marguerite Stillwell, who, this winter, is to tour America for the first time.

Miss Stillwell is yet a young girl. She was born in Utica, New York, and was graduated from the local conservatory there in 1892, when she received the gold medal. Thereafter, she visited Vienna, where she spent a year. On her return to this country, she showed such promise for still

higher attainments that her friends, the Herreshoffs, of Rhode Island, and others, arranged to send her to Berlin for a number of years. Miss Stillwell has spent five winters in Berlin, pursuing her studies under Heinrich Barth, at the Royal Hochschule, and afterwards with De Rachmann.[14]

Miss Judith Graves, Mrs. Van Leer Kirkman, Miss Helen Hopekirk, and Miss Adele Aus der Ohe[15] have also earned merited distinction as pianists.

Notes

"American Women Who Are Winning Fame as Pianists," *Success* 2 (4 Nov. 1899): 815.

1. Ignacy Jan Paderewski.
2. Eugène d'Albert (1864–1932) was a Scottish composer and pianist.
3. Emma Calvé (1858–1942) was a French soprano.
4. Anton G. Rubinstein (1830–94) was a Russian pianist and composer.
5. Heinrich Barth (1847–1922) was a German court pianist and composer.
6. Edvard Hagerup Grieg (1843–1907) was a Norwegian composer.
7. Edward Alexander MacDowell (1861–1908) was an American composer and a professor at Columbia College.
8. George Whitefield Chadwick (1854–1931) was an American composer.
9. James Cutler Dunn Parker (1828–1916) was an American composer, organist, and teacher.
10. Louis Charles Elson (1848–1920) was an American writer of musical subjects, a lecturer, and a teacher.
11. Otto Bendix (1845–1904), a Danish-born pianist, teacher, and composer, came to Boston in 1880 to teach at the New Conservatory of Music.
12. Richard Burmeister (1860–1944), a German composer, teacher, and pianist, was the director of the piano department at the Peabody Institute in Baltimore.
13. Theodor Leschetizky (1830–1915), a Polish pianist, teacher, and composer, developed his own system of piano instruction.
14. Vladimir De Rachmann (1848–1933) was a Russian pianist.
15. Adele Aus der Ohe (1864–1937) was a German pianist and composer. Beginning in 1887 she toured the United States for seventeen consecutive years as a recitalist and as a soloist with the principal symphony orchestras.

■ The Story of a Song-Queen's Triumph: Lillian Nordica

Distinction in Art is Not Thrust Upon Any One
I Felt That the World Was Mine, if I Would Work

Of the five internationally famous singers,—Melba,[1] Calvé,[2] Nordica,[3] Eames,[4] and Lehmann,[5]—none is a greater favorite than Madame Lillian Nordica. She has had honors heaped upon her by every music-loving country, including her own, America. Milan, St. Petersburg, Paris, London, and New York, in turn accepted her, and the music-lover of those cities received her with a *furore* of praise. Jewel cases filled with bracelets, necklaces, tiaras, and diadems, of gold and precious stones, attest the unaffected sincerity of her admirers in all the great music-centers of the world. She enjoys, in addition, the distinction of being one of the first two American women to attain to international fame as a singer in grand opera. Madame Nordica is in New York at present, fulfilling her part in the most brilliant operatic season the city has ever known. She lives in sumptuous style at the Waldorf-Astoria Hotel,[6] where I met her by appointment. She accepted the statement, that the public is interested in the details of her career, as most natural, and was pleased to discuss the philosophy of a singer's success from the point of its difficulties.

"You would like to know how distinction in the field of art is earned. Well, it is not thrust upon anyone. The material for a great voice may be born in a person,—it is, in fact,—but the making of it into a great voice is a work of the most laborious character."

"Is the matter of nationality of any advantage to the aspirant?"

"You wish to know—"

"Whether, in some countries, the atmosphere is not very favorable to a beginner;—the feeling of the public and the general support giv-

en to music not particularly conducive to the musical development of, we will say, a young girl with a promising voice."

"Yes. I should judge almost any of the greater European nations would be better in this respect than the United States: not much better, however, because nearly all depends upon strength of character, determination, and the will to work. If a girl has these, she will rise as high, in the end, anywhere; perhaps not so quickly, in some places, but no less surely."

"You had no European advantages?"

"None whatever."

"Were you born in the West?"

"No. I come of New England stock. You will understand that more readily when I tell you that my real name is Norton. I was born at Farmington, Maine, and was reared in Boston."

"Were your parents musically talented?"

"Not at all. Their opinion of music was that it is an airy, inviting art of the devil, used to tempt men's feet to stray from the solemn path of right. They believed music, as a vocation, to be nearly as reprehensible as a stage career, and for the latter they had no tolerance whatever. I must be just, though, and own that they did make an exception in the case of church music, else I should never have received the slightest encouragement in my aspirations. They considered music in churches to be permissible,—even laudable. So, when I displayed some ability as a singer, I was allowed to use it in behalf of religion, and I did. I joined the church choir and sang hymns about the house almost constantly."

"You had a natural bent for singing."

"Yes, but I needed a world of training. I had no conception of what work lay ahead of anyone who contemplates singing perfectly. I had no idea of how high I might go myself. All I knew was that I could sing, and that I would win my way with my voice if I could."

"How did you accomplish it?"

THERE MUST BE NO PLAY, ONLY STUDY AND PRACTICE

"By devoting all my time, all my thought, and all my energy to that one object. I devoured church music,—all I could get hold of. I practiced new and difficult compositions all the time I could spare."

"Naturally, your efforts attracted attention?"

"Yes, I became a very good church singer; so much so that, when there were church concerts or important religious ceremonies, I was always in demand. Then there began to be a social demand for my ability, and, later, a public demand in the way of concerts."

"At Farmington?"

"Oh, no. At Boston. I forgot to say that my parents removed, while I was still quite young, to Boston."

"Did you give much of your time to public concerts?"

"None at all. I ignored all but church singing. My ambition ran higher than concert singing, and I knew my parents would not consent. I persuaded them to let me have my voice trained. This was not very difficult, because my church singing, as it had improved, became a source of considerable profit, and they saw even greater results for me in the large churches, and in the religious field generally. So I went to a teacher of vocal culture."

"Where, if you please?"

"Professor John O'Neill, one of the instructors in the New England Conservatory of Music, Boston, was a fine old teacher, a man with the highest ideals concerning music, and of the sternest and most exacting method. He made me feel, at first, that the world was mine if I would work. Hard work was his constant cry. There must be no play, no training for lower forms of public entertainment, no anything but study and practice. I must work and perfect myself in private, and then suddenly appear unheralded in the highest class of opera and take the world by storm. It was a fine fancy."

"Did you manage to work it out so?"

"No. It wouldn't have been possible. O'Neill was a fine musician. In his mind and heart, all his aspiration was sincere, but it was not to be."

"Were you ambitious enough?"

"Oh, yes! and most conscientious. Under him I studied the physiology of the voice, and practiced singing oratorios. I also took up Italian, familiarizing myself with the language, with all the songs and endless *arias*. In fact, I made myself as perfect in Italian as possible."

"How much time did the training take?"

"Three years."

"And what was the result?"

"Well, I had been greatly improved, but not perfect. Mr. O'Neill employed methods of making me work which discouraged me. He was a man who would magnify and storm over your slightest error, and make light of or ignore your sincerest achievements. If anything, he put his grade of perfection so high that I began to consider it unattainable, and lost heart. Finally, I gave it up and rested awhile, uncertain of everything."

"And then?"

"After I had thought awhile and regained some confidence, I came to New York to see Mme. Maretzek. She was not only a teacher, but also a singer quite famous in her day and knew the world of music thoroughly. She considered my voice to be of the right quality for the highest grade of operatic success, and gave me hope that, with a little more training, I could begin my career. She not only did that, but also set me to studying the great operas, 'Lucia' and the others, and introduced me to the American musical celebrities. Together we heard whatever was worth hearing in New York. When the renowned Brignoli[7] came to New York, she took me to the Everett House, where he was stopping, and introduced me. They were good friends, and, after gaining his opinion on the character of my voice, she had him play 'Faust.'

"That was a wonderful thing for me. To hear the great Brignoli! It fired my ambition. As I listened, I felt that I could also be great and that people, some day, might listen to me as enraptured as I then was by him. It put new fire into me and caused me to fairly toil over my studies. I would have given up all my hours if only I had been allowed or requested."

"And then, what?"

"Well, so it went until, after several years of study, Madame Maretzek thought I was getting pretty well along and might venture some important public singing. We talked about different ways of appearing, and what I would sing, and so on, until finally Gilmore's[8] band came to Madison Square Garden. He was in the heyday of his success then, both popular and famous, and carried important soloists with him. Madame Maretzek decided that she would take me to see him and get his opinion; and so, one day, toward the very last of his Madison Square engagement, we went to see him. Madame Maretzek was on good terms with him also. I remember that she took me in, one morning, when he was rehearsing. I saw a stout, kindly, genial-looking man who was engaged

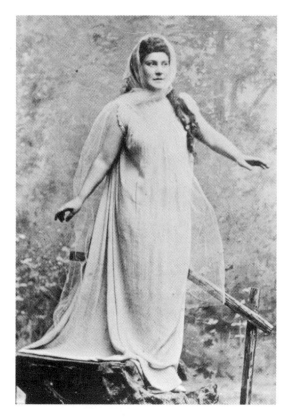

Madame Nordica

in tapping for attention, calling certain individuals to notice certain points, and generally fluttering around over a dozen odds and ends. Madame Maretzek talked with him a little while and then called his attention to me. He looked toward me.

"'Thinks she can sing, eh? Yes, yes. Well, all right! Let her come right along.'

"Then he called to me:—

"I WAS TRAVELING ON AIR"

"'Come right along, now. Step right up here on the stage. Yes, yes. Now, what can you sing?'

"I told him I could sing almost anything in oratorio or opera, if he

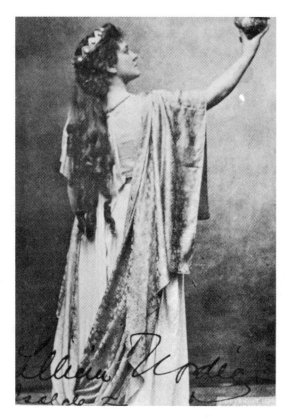

Nordica, as Isolde

so wished. He said: 'Well, well, have a little from both. Now, what shall it be?'

"I shall never forget his kindly way. He was like a good father, gentle and reassuring, and seemed really pleased to have me there and hear me. I went up on the platform and told him that I would begin with 'Let the Bright Seraphim,' and he called the orchestra to order and had them accompany me."

"You must have been slightly nervous."

"I was, at first, but I recovered my equanimity and sang up to my full limit of power. When I was through, he remarked, 'Very good! very good!' and then, 'Now, what else?' I next sang an *aria* from 'Somnambula.' He did not hesitate to express his approval, which was always, 'Very good! very good! Now, what you want to do,' he said, 'is to get

some roses in your cheeks and come along and sing for me.' After that, he continued his conference with Madame Maretzek, and then we went away together.

"I was traveling on air when I left, I can assure you. His company was famous. Its engagement had been most successful. Madame Poppenheim was singing with it, and there were other famous names. There were only two more concerts, concluding his New York engagement, but he had told Madame Maretzek that, if I chose to come and sing on these occasions, he would be glad to have me. I was more than glad of the opportunity and agreed to go. We arranged with him by letter, and, when the evening came, I sang. My work made a distinct impression on the audience and pleased Mr. Gilmore wonderfully. After the second night, when all was over, he came to me, and said: 'Now, my dear, of course there is no more concert this summer, but I am going West in the fall. Now, how would you like to go along?'

"I told him that I would like to go very much, if it could be arranged; and, after some negotiation, he agreed to pay the expenses of my mother and myself, and give me one hundred dollars a week besides. I accepted, and when the western tour began, we went along."

"How did you succeed on that tour?"

"Very well indeed. I gained thorough control of my nerves in that time and learned something of audiences and of what constitutes distinguished 'stage presence.' I studied all the time, and, with the broadening influence of travel, gained a great deal. At the end of the tour, my voice was more under my control than ever before, and I was a better singer all around."

HER FIRST EUROPEAN TOUR

"You did not begin with grand opera, after all?"

"No, I did not. It was not a perfect conclusion of my dreams, but it was a great deal. My old instructor, Mr. O'Neill, took it worse than I did. He regarded my ambitions as having all come to naught. I remember that he wrote me a letter in which he thus called me to account:—

> "After all my training, my advice, that you should come to this! A whole lifetime of ambition and years of the hardest study consumed to fit you to go on the road with a brass band! Poh!

"I pocketed the sarcasm in the best of humor, because I was sure of my dear old teacher's unwavering faith in me, and knew that he wrote only for my own good. Still, I felt that I was doing wisely in getting before the public, and so decided to wait quietly and see if time would not justify me.

"When the season was over, Mr. Gilmore came to me again. He was the most kindly man I ever knew. His manner was as gentle and his heart as good as could be.

"'I am going to Europe,' he said. 'I am going to London and Paris and Vienna and Rome, and all the other big cities. There will be a fine chance for you to see all those places and let Europeans hear you. They appreciate good singers. Now, little girl, do you want to come? If you do, you can.'

"I talked it over with my mother and Madame Maretzek, and decided to go; and so, the next season, we were in Europe."

"Did it profit you, as you anticipated?"

"Very much. We gave seventy-eight concerts in England and France. We opened the Trocadero at Paris, and mine was the first voice of any kind to sing there.

"This European tour of the American band really was a great and successful venture. American musicians still recall the *furore* which it created and the prestige which it gained at home. Mr. Gilmore was proud of his leading soloists. In Paris, where the great audiences went wild over my singing, he came to praise me personally in unmeasured terms. 'My dear,' he said, 'you are going to be a great singer. You are going to be crowned in your own country yet. Mark my words: they are going to put diamonds on your brow!' [Madame Nordica had good occasion to recall this, in 1898, many years after, when her enthusiastic New York admirers crowned her with a diamond tiara as a tribute of their admiration and appreciation.]

"I FOUND JUST DOUBLE THE AMOUNT"

"It was at the time when Gilmore was at the height of his Paris engagement that his agent ran off with his funds and left the old bandmaster almost stranded. Despite his sincere trouble, he retained his imperturbable good nature, and came out of it successfully. He came to me, one morning, smiling good-naturedly, as usual. After greeting me and in-

quiring after my health, he said: 'My dear child, you have saved some little money on this tour?' I told him I had.

"'Now, I would like to borrow that little from you.'

"I was very much surprised at the request, for he said nothing whatever of his loss. Still, he had been so uniformly kind and generous, and had won our confidence and regard so wholly, that I could not hesitate. I turned over nearly all I had, and he gathered it up and went away, simply thanking me. Of course, I heard of the defalcation later. It became generally known. Our salaries went right on, however, and, in a few months, the whole thing had been quite forgotten, when he came to me, one morning, with money ready in his hand.

"'To pay you what I owe you, my dear,' he said.

"'Oh, yes!' I said; 'so and so much,'—naming the amount.

"'Here it is,' he said; and, handing me a roll of bills, he went away. Of course, I did not count it until a little later; but, when I did, I found just double the amount I had named, and no persuasion would even induce him to accept a penny of it back."

"When did you part with Gilmore?"

"At the end of that tour. He determined to return to America, and I had decided to spend some of my earnings on further study in Italy. Accordingly, I went to Milan, to the singing teacher San Giovanni.[9] On arriving there, I visited the old teacher and stated my object. I said that I wanted to sing in grand opera.

"WHY DON'T YOU SING IN GRAND OPERA"

"'All right!' he answered; 'let me hear your voice.'

"I sang an *aria* from 'Lucia'; and, when I was through, he said, dryly: 'You want to sing in grand opera?'

"'Yes.'

"'Well, why don't you?'

"'I need training.'

"'Nonsense!' he answered. 'We will attend to that. You need a few months to practice Italian methods,—that is all.'

"So I spent three months with him. After much preparation, I made my *début* as Violetta in Verdi's opera, 'La Traviata,' at the Teatro Grande, in Brescia."

The details of Madame Nordica's Italian appearance are very interesting. Her success was instantaneous. Her fame went up and down the land, and across the water,—to her home. She next sang in Gounod's "Faust," at Geneva, and soon afterwards appeared at Navarro, singing Alice in Meyerbeer's "Roberto,"[10] the enthusiastic and delighted subscribers presenting her with a handsome set of rubies and pearls. After that, she was engaged to sing at the Russian capital, and accordingly went to St. Petersburg, where, in October, 1881, she made her *début* as La Filma in "Mignon."

There, also, her success was great. She was the favorite of the society of the court, and received pleasant attentions from every quarter. Presents were made her, and inducements for her continued presence until two winters had passed. Then she decided to revisit France and Paris.

THIS WAS HER CROWNING TRIUMPH

"I wanted to sing in grand opera at Paris," she said to me. "I wanted to know that I could appear successfully in that grand place. I counted my achievements nothing until I could do that."

"And did you?"

"Yes. In July, 1882, I appeared there."

This was her greatest triumph. In the part of Marguerite, she took the house by storm, and won from the composer the highest encomiums. Subsequently, she appeared with equal success as Ophélie, having been specially prepared for both these roles by the respective composers, Charles Gounod and Ambroise Thomas.[11]

"You should have been satisfied, after that," I said.

"I was," she answered. "So thoroughly was I satisfied that, soon afterwards, I gave up my career and was married. For two years, I remained away from the public; but, after that time, my husband having died, I decided to return. I made my first appearance at the Burton Theater in London, and was doing well enough when Colonel Mapleson[12] came to me. He was going to produce grand opera,—in fact he was going to open Covent Garden, which had been closed for a long time, with a big company. He was another interesting character. I found him to be generous and kind-hearted and happy-spirited as anyone could be. When he came to me, it was in the most friendly manner. 'I

am going to open Covent Garden,' he said. 'Now, here is your chance to sing there. All the great singers have appeared there,—Patti,[13] Gerster,[14] Nilsson,[15] Tietjens,[16]—now it's your turn,—come and sing.'

"'How about terms?' I asked.

"'Terms!' he exclaimed; 'terms! Don't let such little details stand in your way. What is money compared to this? Ignore money. Think of the honor, of the memories of the place, of what people think of it;' and then he waved his arms dramatically.

"Well, we came to terms, not wholly sacrificial on my part, and the season began. Covent Garden had not been open for a long time. It was in the spring of the year, cold and damp. There was a crowded house, though, because fashion accompanied the Prince of Wales there. He came, night after night, and heard the opera through with an overcoat on.

"It was no pleasant task for me, or healthy, either, but the Lord has blessed me with a sound constitution. I sang my parts, as they should be sung, some in bare arms and shoulders, with too little clothing for such a temperature. I nearly froze, but it was Covent Garden and a great London audience, and so I bore up under it."

"And then what?"

SHE WAS INDISPENSABLE IN "AIDA"

"Well, things went on this way, very successfully, of course, until Sir Augustus Harris[17] took Drury Lane and decided to produce grand opera. He started in opposition to Colonel Mapleson, and so Covent Garden had to be given up. Mr. Harris had more money, more prestige with society, and Colonel Mapleson could not live under the division of patronage. When I saw the situation, I called on the new manager and talked with him concerning the next season. He was very proud and very condescending, and made sure to show his indifference to me. He told me all about the brilliant season he was planning, gave me a list of the great names he intended to charm with, and wound up by saying he would call on me, in case of need, but thought he had all the celebrities he could use, but would let me know.

"Of course, I did not like that; but I knew I could rest awhile, and so was not much disturbed. The time for the opening of the season

arrived. The papers were full of accounts of the occasion, and there were plenty of remarks concerning my non-appearance. Then 'Aida' was produced, and I read the criticisms of it with interest. The same afternoon a message came for me: 'Would I come?' and 'Would I do so and so?' I would, and did. I sang 'Aida' and then other parts, and gradually all the parts but one, which I had longed to try, but had not yet had the opportunity given to me. I was very successful, and Sir Augustus was very friendly."

"What was your next venture?"

"Nothing much more interesting. The summer after that season, I visited Ems,[18] where the De Reszkes were.[19] One day they said: 'We are going to Beirut to hear the music,—don't you want to go along?'

"I thought it over and decided that I did. My mother and I packed up and departed. When I got there and saw those splendid performances, I was entranced. It was perfectly beautiful. Everything was arranged after an ideal fashion. I had a great desire to sing there, and boasted to my mother that I would. When I came away, I was fully determined to carry out that boast."

"Could you speak German?"

"Not at all. I began, though, at once, to study it; and, when I could talk it sufficiently, I went to Bayreuth and saw Madame Wagner."

THE KINDNESS OF FRAU WAGNER

"Did you find her the imperious old lady she is said to be?"

"Not at all. She welcomed me most heartily; and, when I told her that I had come to see if I could not sing there, she seemed much pleased. She treated me like a daughter, explained all that she was trying to do, and gave me a world of encouragement. Finally, I arranged to sing and create 'Elsa' after my own idea of it, during the season following the one then approaching."

"What did you do, meanwhile?"

"I came to New York to fulfill my contract for the season of 1894–1895. While doing that, I made a study of Wagner's, and, indeed, of all German music; and, when the season was over, went back and sang it."

"To Frau Wagner's satisfaction?"

"Yes."

"Have you found your work very exacting?"

"Decidedly so. It leaves little time for anything else."

"To do what you have done requires a powerful physique, to begin with?"

"Yes. I should judge so."

"Are you ever put under extraordinary mental strain?"

"Occasionally."

"In what manner?"

"Why, in my manner of study. I remember once, during my season under Augustus Harris, of an incident of this order. He gave a garden party, one Sunday, to which several of his company were invited,—myself included. When the afternoon was well along, he came to me and said: 'Did you ever sing "Valencia" in "The Huguenots"?' I told him I had not.

"'Do you think you could learn the music and sing it by next Saturday night?'

"I felt a little appalled at the question, but ventured to say that I could. I knew that hard work would do it.

"'Then do,' he replied; 'for I must have you sing it.'

"The De Reszkes, Jean and Eduard, were near at the time, and offered to assist me. 'Try it,' they said, and so I agreed. We began rehearsals, almost without study, the very next day, both the De Reszkes prompting me, and by Friday they had me letter-perfect and ready to go on. Since the time seemed so peculiarly short, they feared for me, and, during the performance, stationed themselves, one in either wing, to reassure me. Whenever I approached near to either side of the stage, it was always to hear their repeated 'Be calm!' whispered so loud that the audience could almost hear it."

"Did you make any mistakes?"

"None. I sang easily, never thinking of failure."

"Let me ask you one thing," I said. "Has America good musical material?"

THE MUSICAL TALENT OF AMERICAN GIRLS

"As much as any other country, and more, I should think. The higher

average of intelligence here should yield a greater percentage of musical intelligence."

"Then there ought to be a number of our American women singers rise up in the future?"

"There ought to be, but it is a question whether there will be. They are not cut out for the work which it requires to develop a good voice."

"You think there is good material for great voices in American women, but not sufficient energy?"

"That is my fear, not my belief. I have noticed that young women here seem to underestimate the cost of distinction. It means more than most of them are prepared to give; and, when they face the exactions of art, they falter and drop out. Hence we have many middle-class singers, but few really powerful ones."

"What are these exactions you speak of?"

"Time, money, and loss of friends, of pleasure. To be a great singer means, first, to be a great student. To be a great student means that you have no time for balls and parties, very little for friends, and less for carriage rides and pleasant strolls. All that is really left is a shortened allowance of sleep, of time for meals, and time for exercise."

"Did you ever imagine that people leaped into permanent fame when still young and without much effort on their part?"

"I did. But I discovered that real fame,—permanent recognition, which cannot be taken away from you,—is acquired only by a lifetime of most earnest labor. People are never internationally recognized until they have reached middle life. Many persons gain notoriety young, but that goes as quickly as it comes. All true success is founded on real accomplishment, acquired with difficulty; and so, when you see some one accounted great, you will usually find him to be in the prime of life or past it."

"You grant that many young people have genius?"

"Certainly I do. Many of them have it. They will have waited long, however, before it has been trained into valuable service. The world gives very little recognition for a great deal of labor paid in; and, when I earn a thousand dollars for a half hour's singing sometimes, it does not nearly average up for all the years and for the labor much more difficult which I contributed without recompense."

NOTES

"The Story of a Song-Queen's Triumph: Lillian Nordica," *Success* 3 (Jan. 1900): 6–8. Reprinted as "Nordica: What It Costs to Become a Queen" in *How They Succeeded,* 149–70. Reprinted as "A Great Vocalist Shows That Only Years of Labor Can Win the Heights of Song—Lillian Nordica" in *Little Visits with Great Americans,* ed. Orison Swett Marden (New York: Success Company, 1903), 541–57. Also reprinted as "The Story of a Song-Queen's Triumph—Lillian Nordica,"in *Selected Magazine Articles,* 1:37–61.

1. Dame Nellie Melba [stage name of Helen Porter Mitchell] (1861–1931) was an Australian soprano.

2. Emma Calvé.

3. Lillian Nordica was the stage name of Lillian Norton (1857–1914).

4. Emma Eames (1865–1952) was a Shanghai-born American soprano.

5. Lilli Lehmann (1848–1929) was a German soprano who made her debut at the New York Metropolitan in 1885.

6. Carrie Meeber, the heroine of *Sister Carrie,* rises to prominence on the stage as Carrie Madenda and lives in the Waldorf-Astoria Hotel.

7. Pasqualino Brignoli (died 1884), an Italian tenor, first performed in the United States with Adelina Patti.

8. Patric Sarsfield Gilmore.

9. Antonio Sanguiovanni (1831–92) was an Italian vocal teacher.

10. Giacomo Meyerbeer (1791–1864), who was born in Berlin and died in Paris, was an eminent romantic composer in France.

11. Ambroise Thomas (1811–96) was a French composer.

12. James Henry Mapleson (1830–1901), an English impresario, conducted opera seasons in New York at the Academy of Music from 1878 to 1886 and again in 1896 and 1897.

13. Adelina Patti (1843–1919) was a Spanish-born Italian operatic soprano.

14. Etelka Gerster (1855–1920) was a Hungarian soprano.

15. Christina Nilsson (1843–1921) was a Swedish soprano.

16. Therese Johanna Alexandra Tietjens (1831–77) was a German dramatic soprano.

17. Sir Augustus Harris (1852–96), an English impresario, formed his own opera company, obtaining the services of such celebrated artists as Lillian Nordica and Dame Nellie Melba.

18. Ems is a German town located southeast of Koblenz.

19. Jean (Jan Mieczislaw) de Reszke (1850–1925) was a Polish opera singer. His brother, Edouard (1853–1917), was a bass.

Whence the Song

Illustrated by William J. Glackens

Along Broadway, in the height of the theatrical season, but more par-
ticularly in that laggard time from June to September, when the great
city is given over to those who may not travel and actors seeking en-
gagements, there is ever to be seen a certain representative figure, now
one individual and now another, of a world so singular that it might
well engage the pen of a Balzac or that of a Cervantes. I have in mind
an individual whose high hat and smooth Prince Albert coat are still a
delicious presence. In his coat lapel is a ruddy boutonnière—in his hand
a novel walking-stick. His vest is of a gorgeous and affluent pattern; his
shoes shining new and topped with pearl-gray spats. He is the cyno-
sure of all eyes, the envy of all men. He is the successful author of the
latest popular song.

Any fair day during the period of his artistic elevation he is to be
seen. Past the rich shops and splendid theatres he betakes himself with
leisurely grace. In Twentieth Street he may turn for a few moments, but
it is only to say good-morning to his publishers. In Twenty-eighth Street,
where range the host of those who rival his successful house, he stops
to talk with lounging actors and ballad-singers. Well-known variety stars
nod to him familiarly. Women whose sole claim to distinction lies in
their knack of singing a song smile in greeting as he passes. Occasion-
ally there comes the figure of a needy ballad-monger, trudging from
publisher to publisher with an unavailable manuscript, who turns upon
him in passing the glint of an envious glance. To these he is an impor-
tant figure, satisfied as such with their envy as with their praise; for is
not this also his due—the reward of all who have triumphed?

I have in mind another figure, equally singular—a rouged and powdered little maiden, rich in feathers and ornaments of the latest vogue, gloved in blue and shod in yellow, pretty, self-assured, daring, and even bold. There has gone from her all the traditional maidenly reserve you would expect to find in one so young and pleasing, and yet she is not evil. The daughter of a Chicago butcher, you knew her when she first came to the city, a shabby, wondering little thing, clerk to a music-publisher transferring his business East, and all eyes for the marvels of life.

Gradually the scenes and superlatives of elegance, those showy men and women coming daily to secure or sell songs, have aroused her longings and ambitions. Why may not she sing—why not she be a theatrical celebrity? She will. The world shall not keep her down. That indescribable company designated as *they*—whose hands are ever against the young—shall not hold her back.

Behold, she had gone, and now, elegant, jingling with silver ornaments, hale and merry from good living, has returned. To-day she is playing at one of the vaudeville houses. To-morrow she leaves for Pittsburg. Her one object is still a salary of one hundred and fifty a week and a three-sheet litho. of herself in every window and upon the billboards.

"I'm all right now," she will tell you, gleefully. "I'm 'way ahead of the knockers. They can't keep me down. You ought to have seen the reception I got in Pittsburg. Say! it was the biggest yet."

Blessed be Pittsburg, which has honored one who has struggled so hard, and you say so.

"Are you here for long?"

"Only this week. Come up and see my turn. Hey, cabbie!"

A passing cabman turns in close to the walk with considerable alacrity.

"Take me to Proctor's. So long. Come up and see my turn to-night."

This is the woman singer—the complement of the male of the same art—the couple who make for the acceptation and spread of the popular song, as well as the fame of its author. They sing them in every part of the country; and here in New York, returned from a long season on the road, form a very important portion of this song-writing, song-singing world—they and the authors and the successful publishers. But we may simplify by yet another picture.

In Twenty-eighth Street

In Twenty-seventh or Twenty-eighth Street, or anywhere along
Broadway from Madison to Greeley Square, are the parlors of a score
of publishers; gentlemen who co-ordinate this divided world for song-
publishing purposes. There are an office and a reception-room, a
music-chamber where songs are tried, and a stock-room. Perhaps, in
case of the larger publishers, the music-rooms are two or three, but
the air of each is much the same. Rugs, divans, imitation palms, make
this publishing-house more studio, however, than office. Three or four
pianos give to each chamber a parlorlike appearance. The walls are
hung with the photos. of celebrities, elegantly framed—celebrities of
the kind described. On the floors are thick carpets and rugs, in the pri-
vate music-rooms rocking-chairs. A boy or two serve to bring *profes-
sional* copies at a word. A salaried pianist or two wait to *run over pieces*
which the singer may desire to hear. Arrangers wait to make orches-
trations or *take down* the melody which the popular composer can-
not play. He has evolved the melody by a process of whistling, and
must have its fleeting beauty registered before it escapes him forever.
Hence the salaried arranger.

Into these parlors come the mixed company of this distinctive world—authors who have or have not succeeded; variety artists who have some word from touring fellows or who know the firm-masters of small bands throughout the city, of which the name is Legion; orchestra leaders of Bowery theatres and uptown variety halls and singers.

"You haven't a song that will do for a tenor, have you?"

The inquirer is a little, stout, ruddy-faced Irish boy from the gashouse district. His common clothes are not out of the ordinary here, but they mark him as, possibly, a non-professional seeking free copies.

"Yes—let me see. For what do you want it?"

"Well, I'm from the Arcadia Pleasure Club. We're going to give a little entertainment next Wednesday, and we want some songs."

"Certainly. Wait till I call the boy. Harry! Bring me some professional copies of ballads."

The youth is probably a representative of one of the many Tammany pleasure organizations,[1] the members of which are known for their propensity to gather about east and west side corners at night and sing. One or two famous songs are known to have secured their start by the airing given them in the night on these corners.

Upon his heels treads a lady, whose ruffled sedateness marks her as one unfamiliar with this half-musical, half-theatrical atmosphere.

"I have a song I would like to have you try over if you care to."

The attending publisher hesitates before even extending a form of reception.

"What sort of a song is it?"

"Well, I don't exactly know. I guess you'd call it a sentimental ballad. If you'd hear it I think you could—"

"We are so overstocked with songs now that I don't think there would be much use in our hearing it. Could you come in next Tuesday? We'll have more leisure then, and can give it more attention."

The lady looks the failure she has scored, but retreats, leaving the ground clear for the chance arrival of the real author—the individual whose position is attested by one hit or mayhap many. His due is that deference which all publishers, if not the public, feel called upon to render even if at the time he may have no reigning success.

"Hello, Frank! how are you? What's new?"

Along Broadway

The author may know of nothing in particular.

"Sit down. How are things with you, anyhow?"

"Oh, so-so."

"That song of yours will be out Friday. We'll have a rush order on it."

"Is that so?"

"Yes; and I've got good news for you: Windom is going to sing it next year with the minstrels. He was in here the other day and thought it was great."

"I'm glad of that."

"That song's going to go all right. You haven't got any others, have you?"

"No, but I've got a tune. Would you mind having one of the boys take it down for me?"

"Certainly not. Here, Harry, call Hatcher."

Now come the pianist and a rehearsal in the private room. The favored author may have piano and pianist for an indefinite period. Lunch with the publishers awaits him if he remains until noon. His song, when ready, is heard with attention. The orders which make for its publication are rushed. His royalties are paid with that rare smile which accom-

panies the payment of anything. He is to be petted, conciliated, handled with gloves.

At his heels, perhaps, is the other author, equally successful, but almost intolerable from certain marked eccentricities of life and clothing. He is a negro—small, slangy, strong in his cups, but able to write a good song—occasionally a truly pathetic ballad.

"Say, where's that gem of mine?"

"What?"

"That effusion."

"What are you talking about?"

"That audience-killer—that there thing that's going to sweep the country like wild-fire—that there song."

Much laughter and apologies.

"It will be here Saturday."

"Thought it was to be here last Monday."

"So it was, but the printer didn't get it done. You know how those things are, Gussie."

"I know. Gimme twenty-five dollars."

"What are you going to do with it?"

"Never you mind. Gimme twenty-five bones. To-morrow's rent day."

Twenty-five is given as if it all were a splendid joke. Gussie is a bad negro—one day radiant in bombastic clothing, the next wretched from dissipation and neglect. He never accepts royalty. All his songs are sold outright.

"I wouldn't take no royalty," he announces with mellow negro emphasis. "Doan' want it. Too much trouble. All I want is a most equitable arrangement." He could have several thousand instead of a few hundred, but being shiftless, he does not care. Ready money is the thing with him—twenty or fifty when he needs it.

And then the "peerless singers of popular ballads," as their programmes announce them; men and women whose pictures you will see upon every song sheet, their physiognomy underscored with their own written "Yours, sincerely"—every day they are here, arriving and departing, carrying the latest as to songs to all parts of the land. These are the individuals who, in their own estimation, "make" the songs the successes they are. In all justice they have some claim to the distinction. One such, raising his or her voice nightly in a melodic interpretation

The successful Author of the latest popular Song

of a new ballad, may, if the music be catchy, bring it so thoroughly to the public ear as to cause it to begin to sell. These gentlemen and ladies are not unaware of their services in the matter, nor slow to voice their claims. In flocks and droves they come, whenever good fortune brings "*the company*" to New York, or the end of the season causes them to return, to tell of their success and pick new songs for the ensuing season. Then, indeed, is the day of the publishers' volubility and grace. These gentlemen must be attended to with deference, which is the right of the successful. These ladies must be praised and cajoled.

"Did you hear about the hit I made with 'Sweet Katie Leary' in Pittsburg? I knocked 'em cold. Say! it was the biggest thing on the bill."

The publisher may not have heard of it. The song, for all the up-roarious success depicted, may not have sold an extra copy, and yet this is not for him to say. Has the lady a good voice? Is she with a good company? He may so ingratiate himself that she will yet sing one of the newer compositions into popularity.

"Was it? Well, I am glad to hear it. You have the voice for that sort of a song, you know. I've got something now, though, that will just suit you. Oh, a dandy! It's by Harry Welch."

The singer may but smile indifferently for this flood of geniality. Secretly her hand is against all publishers. They are *out* for themselves. Successful singers must mind their P's and Q's. She demands an arrangement by which she shall receive a stated sum per week for singing a song. The honeyed phrases are well enough for beginners, but we who have succeeded need something more.

"Let me show you something new. I've got a song here that is fine. Come into the music-room. Charlie, get a copy of 'Just Tell Them That You Saw Me.'[2] I want you to play it over for Miss Yaeger."

The boy departs and returns. In the exclusive music-room sits the singer, critically listening while the song is played.

A Rehearsal in the Private Room

"Isn't that a pretty chorus?"

"Yes. I like that."

"It would suit your voice exactly. I think that's one of the best songs we have published in years."

"Have you the orchestration?"

"Yes. I'll get you that."

Somehow, however, the effect has not been satisfactory. The singer has not enthused. He must try other songs and give her orchestrations of many. Perhaps out of all she will sing one. That is the chance of the work.

As for her point of view, she may object to the quality of anything except that for which she is paid. It is for the publisher to see whether she is worth subsidizing or not. If not, perhaps another house will see her merits in a different light. Yet she takes the songs and orchestrations along.

Your male singer is a bird of the same fine feather. If you wish to see the ideal of dressiness as exemplified by the gentlemen of the road, see these individuals arrive at the office of the publishers. The radiance of half-hose and neck-ties is not outdone by the sprightliness of the suit pattern or the glint of the stone in the shirt front. Fresh from Chicago or Buffalo they arrive, rich in self-opinion, fostered by rural praise, perhaps possessed of a new droll story, always loaded with the details of the hit they made.

"Well, well, you should have seen how that song went in Baltimore. I never saw anything like it. Why, it's the hit of the season."

New songs are forth-coming, a new batch delivered for his service next year.

Is he absolutely sure of the estimation in which the house holds his services? You will hear a sequel to this. Not this day, perhaps, but a week or a month later, during his idle summer in New York.

"You haven't twenty-five handy you could let me have, have you?"

Into the publisher's eye steals the light of wisdom and decision. Is this individual worth it? Will he do the songs of the house twenty-five dollars' worth of good next season? Blessed be fate if there's a partner to consult. He will have time to reflect.

"Well, George, I haven't it right here in the drawer, but I can find

"Let them stare in envy."

out. I always like to consult my partner about these things, you know. Can you wait until this afternoon?"

Of course the applicant can wait, and between-whiles are conferences and decisions. All things considered, it may be advisable to do it.

"We will get twenty-five out of him, anyhow. He's got a fine tenor voice. You never can tell what he might do."

So a pleasant smile and the money may be waiting when he returns.

There are cases when not even so much delay can be ventured—where a hearty "Sure!" must be given. This is to that lord of the stage whose fame as a singer is announced by every minstrel bill-board as the "renowned barytone Mr. Calvin Johnson," or some such. Alas, also there is the less important type who has overmeasured his importance. For him the solemn countenance and the suave excuse, at an hour when his need is greatest. Lastly, there is the substrata applicant in tawdry, make-believe clothes, whose want peeps out of every seam and pocket. His day has never been as yet, or, mayhap, was and is over. He has a pinched face, a livid hunger, a forlorn appearance. Shall he be given anything? Never! We cannot afford it. It is enough if we look after those

"In the exclusive Music-Room sits the Singer, critically lis-
tening."

of whose ability we are absolutely sure. Therefore he must slop the
streets in old shoes and thin clothing, waiting.

Out of such tragedies, however, spring occasional successes. They
do not understand why fate should be against them—why they should
be down. Oh, the bitterness of it; the hardness of the world!

"I'll write a song yet," is the dogged, grim decision. "I'll get up,
you bet."

Once in a while the threat is made good, some mood allowing. Stroll-
ing along the by-streets, ignored and self-commiserated, the mood seizes
him. Words bubble up and a melody, some crude commentary on the
contrasts, the losses or the hopes of life, rhyming, swinging as they come,
straight from the heart. Now it is for pencil and paper—quick! Any old
scrap will do—the edge of a newspaper, the back of an envelope, the edge
of a cuff. Written so, the words are safe, and the melody can be whistled
until some one will take it down. Thus is born the great success—the

land-sweeping melody, selling by hundreds of thousands, and netting the author a thousand a month for a year.

The humors of it come with the possible strike. Before, he was commonplace, hungry, envious, wretchedly clothed. After it he is the extreme of the reverse. Do not talk to him of other authors who have struck it once, had their little day, and gone down again, never to rise. He is for the sunlight and the bright places. No clothing too showy or too expensive. No jewelry too rare. Broadway is the place for him—the fine cafés and rich hotel lobbies. What are other people? Ha! they looked down upon him, did they? They sneered—eh? Would not give him a cent? Let them come and look now. Let them stare in envy. Let them make way. He is a great man and the world knows it. The whole country is making acclaim over that which he had done.

For the time being this little theatre of song writing and publishing is for him the all-inclusive of life's importances. From the street organs at every corner is being ground the *one* melody, so expressive of his personality, into the ears of all men. In the vaudeville houses and cheaper concert-halls men and women are singing it nightly to uproarious applause. Parodies are made and catch-phrases coined— all speaking of his work. Newsboys whistle and old men pipe its peculiar notes. Out of open windows falls the distinguished melody, accompanied by voices both new and strange. All men seem to recognize that which he has done, and for the time compliment his presence and his personality.

Then the wane.

Of all the tragedies this is, perhaps, the bitterest, because of the long-drawn memory of the thing. Organs continue to play it, but the sale ceases. Quarter after quarter the royalties are less, until, at last, a few dollars per month will measure them completely. Meanwhile his publishers ask for other songs. One he writes and then another, and yet another, vainly endeavoring to duplicate the original note which made for his splendid success the year before. Other songwriters displace him for the time being in the public eye. His publishers have a new hit. A new author is being bowed to and taken out to dinner. A new tile-crowned celebrity is strolling up his favorite Broadway path.

At last, after a dozen attempts and failures, there is no hurry to

publish his songs. If the period of failure is too long extended, he may even be neglected. More and more, celebrities crowd in between him and that delightful period when he was greatest. At last, chagrined by the contrast of things, he changes his publishers, changes his haunts, and, bitterest of all, his style of living. Soon it is the old grief again, and then, if thoughtless spending has been his failing, shabby clothing and want. You may see the doubles of these in any publisher's sanctum at any time—the sarcastically referred to *has been*.

Here, also, the disengaged ballad-singer—"peerless tenor" of some last year's company, suffering a period of misfortune. He is down on his luck in everything but appearances—last year's gorgeousness still surviving in a modified and sedate form. He is a singer of songs, now, for the publisher—by toleration. His one lounging-place in all New York, where he is welcome and not looked at askance, is the chair they allow him. Once a day he makes the rounds of the theatrical agencies— once or, if fortune favors, twice a day visits some cheap eating-house. At night, after a lone stroll through that fairyland of theatres and gaudy palaces which is Broadway, he returns to his bed—the carpeted floor of a room in the publisher's office—where he sleeps by permission.

Oh, the glory of success in this little world in his eye at this time! How now, in want, it looms large and essential! Outside, as he stretches himself, may even now be heard the murmur of that joyous rout of which he was so recently a part—the lights, the laughter, the songs. Only he must linger in the shadow.

To-morrow it will come out in words, if you talk with him. It is in the office, where gaudy ladies are trying songs, or on the street, where others, passing, notice him not, but go their way in elegance.

"I had it once, all right," he will tell you. "I had my handful. You bet I'll get it next year."

It is of the money he is thinking.

A coach swings past, and some fine lady, looking out, wakes to bitterness his sense of need.

"New York's tough without the coin, isn't it? You never get a glance when you're out of the game. I spend too easy—that's what's the matter with me. But I'll get back, you bet. Next time I'll know enough to save. I'll get up again, and next time I'll stay up, Annie—see?"

Next year his hopes may realize again—his dreams come true. If so, be present and witness the glories of all radiance after shadow.

"Ah, me boy, back again, you see!"

"So I see. Quite a change since last season."

"Well, I should smile! I was down on my luck then. That won't happen any more. They won't catch me. I've learned a lesson. Say! we had a great season."

Rings and pins attest it. A cravat of marvellous radiance speaks for itself in no uncertain tone. Striped clothes, yellow shoes, a new hat and cane. Ah, the glory, the glory! He is not to be caught any more, and yet, here is half of his subsistence blooming upon his merry body!

They will catch him, though—him and all—in the length of time. One by one they come—old angular misfortune grabbing them all by the coat tails. The rich, the proud, the great among them, sinking, sinking, staggering backward, until they are where he was and deeper, far deeper. I wish I could quote those little notices so common in all our metropolitan dailies—those little perfunctory records which appear from time to time, telling volumes in a line. One day our singer's voice is failing—one day he has been snatched by disease! One day our radiant author arrives at that white beneficence which is the hospital bed, and stretches himself to a final period of suffering. One day a black boat, steaming northward along the East River to a barren island and a field of weeds, carries the last of all that was so gay, so unthinking, so—after all—childlike of him who was greatest in this world. Weeds and a head-board—salt winds and the cry of sea-gulls—lone blowings and moanings—and all that was light and mirth is buried here.

Here and there in the world are those who are still singing melodies created by those who have gone this unfortunate way. The authors of "Two Little Girls in Blue," and "White Wings," "Little Annie Rooney," and "The Picture and the Ring," of "In the Baggage Coach Ahead," and "Trinity Chimes," "Sweet Marie," and "Eileen," all are in the Potter's Field.[3] There might be recited the successes of a score of years, quaint, pleasing melodies which were sung the land over—which even to-day find an occasional voice and a responsive chord—and of the authors not one but would be found in some field for the outcasts, forgotten. Somehow the world forgets—the peculiar

"That Fairyland of Theatres and gaudy Palaces which is Broadway."

world in which they moved, and the larger one which knew them only by their songs.

It seems wonderful that they should come to this, singers, authors, women, and all; and yet not more wonderful than that their little feeling, worked into a melody and a set of words, should reach far out o'er land and water, touching the hearts of the nation. In mansion and hovel, by some blazing furnace of the factory or some open windows of the farm-land cottage, is trolled the simple story, written in halting phraseology, tuned in repetitions. We have seen the theatres uproarious with the noisy recalls which bring back the sunny singers, harping their one indifferent lay. We have heard the street bands and the organs, the street boys and the street loungers, all expressing this brief melody snatched from the unknown by some process of the heart. Here it is wandering the land over like a sweet breath of summer, making for matings and for partings, for happiness and for pain. That it may not endure is also meet, going back into the soil as it does with those who hear and with those who create.

Only those who venture here in merry Broadway shall witness the contrast, however. Only they who meet these radiant presences shall know the marvel of the common song.

NOTES

"Whence the Song," *Harper's Weekly* 44 (8 Dec. 1900): 1165–66a. Illustrated by William J. Glackens. Reprinted, with minor stylistic alterations, in Dreiser's *The Color of a Great City* (New York: Boni and Liveright, 1923), 242–59. The *Harper's Weekly* version is reprinted in *Selected Magazine Articles,* 2:50–61.

1. The Tammany Society was a political organization in New York City that exercised or sought municipal political control by methods often associated with corruption and bossism.

2. This song was written and composed by Paul Dresser, Dreiser's older brother.

3. A potter's field is a public graveyard for paupers, unidentified persons, and criminals.

■ Part 3

LITERARY HERITAGE

■ Historic Tarrytown: Washington Irving

"In the bosom," writes Washington Irving, "of one of those spacious coves which indent the eastern shore of the Hudson, at that broad expansion of the river denominated by the ancient Dutch navigators as the Tappan Zee, and where they always prudently shortened sail, and implored the protection of St. Nicholas when they crossed, there lies a small town or rural port, which by some is called Greensburgh, but which is more generally and properly known by the name of Tarry Town." And thus was Tarrytown introduced to a whole world of lovers of the beautiful, and given over to perennial fame, and it would be presumption both vain and ridiculous to revive an impression of it, in any other words.

What the idyllic-minded Irving chronicled of it might for all time be offered as sufficient, and scribblers might well hesitate before speaking further, were it not that the beloved chronicler himself has been gathered to his fathers, and what was commonplace to him, as his own, has become lovely and reverential shrines to those with whom his memory is dear. I question whether in all America there is one other name which so instantly and vividly calls up all that is satisfying and delightful in green woods that drowse in the heat of a summer noon, in silvery, rippling streams that glint and gurgle between modest banks festooned with greenery, which sun and blue sky make beautiful, or in hollows, where, though all outside be parched and listless, it is sweet and cool, as this selfsame Tarrytown, with its world-renowned Sleepy Hollow.

Whatever were its characteristics before the denizen of Sunnyside took pen in hand, certainly "a drowsy, dreamy influence seems to hang

Road Leading to Sleepy Hollow

over the land" now, and although he quoted the beliefs that it had been "bewitched by a high German doctor, during the early days of the settlement," and "that an old Indian chief, the prophet or wizard of his tribe, held his pow-wows there, before the country was discovered by Master Hendrick Hudson," I make no apology in confessing to this belief that the true magician who has so infused this village with charm and witchery is none other than one Master Washington Irving—God rest his soul.

One might well complain these days when increase of population and wealth has brought a thriving brood of bankers and brokers into this lovely village. Their desire to be comfortable within these sacred precincts, and to acquire, as it were, some additional shade of dignity by rubbing up against things consecrated both by time and genius, has led to changes innumerable. That famous Sleepy Hollow, where as a stripling, Irving had his "first exploit in squirrel shooting," and where owing to the peculiar noon-time quiet, he was startled by the roar of his own gun, is now a home-infested valley, not as it was then, two miles from the village, but safely within the much extended limits. The old road, too, which wound through it and over the "small brook

which guides through it, with just enough murmur to lull one to repose," has been duly modernized or macadamized, and is much traveled with an unholy brood of bicyclers, "scorchers," and what not, who come from all parts to see. Even the old wooden bridge which stood until a few years ago, has given place to a solid stone arch of modern design—an innovation wholly reprehensible as you may well know, and due entirely to the shameless desire of some multi-millionaire residents, who not content with a plentitude of this world's expensive goods, must needs make place here to drive fast horses. Worse, and more of it, gas lamps light the Hollow road where the renowned Ichabod[1] once galloped furiously for his life with no other light than that which shone from the gleaming eyes of the dissevered head, carried in the hands of the pursuing Hessian trooper.[2] Now, by my faith, even arc lights with their unseemly glare are talked of, and goodness knows what other incongruous trick has yet to come. Suffice it to say the Headless Horseman, returning, would certainly now recognize his quondam haunts, and you may be sure he would never care to visit a night infested by such unfeeling mortals as now abide in this realm of story.

Bridge over Pocantico River, Sleepy Hollow

A little way along this historic road, quite in the city of Tarrytown, and fully a mile before one comes to the little Sleepy Hollow brook, stands a monument to the countrymen who captured the unfortunate André,[3] and discovered the treasonable papers in his boot. This monument marks the exact spot of the capture, and hard by in the early days "stood an enormous tulip tree, which towered like a giant above all other trees of the neighborhood, and formed a kind of landmark." Needless to say that it is no longer there, and in its stead is the even road, and about are the pleasant homes of many who should bless themselves morning, noon, and night for being privileged to dwell on such lovely ground. In the time of which Irving writes it was a tragical spot in the outskirts of the village, awesome at dusk, and "by the common people regarded with a mixture of respect and superstition."

Farther along this now fashionable roadway, and before reaching the brook, one comes to an old dilapidated mill, a relic of Revolutionary days. It stands within half a mile of the stone bridge over the brook, and in the days when Ichabod Crane was belaboring his little school of hardy

Monument to the Captors of Major André

The Old Mill, Sleepy Hollow

Dutch urchins along the "flowery path of knowledge," "the low mur-
mur of his pupils' voices, conning over their lessons, might be heard
in a drowsy summer's day, like the hum of a bee-hive." The school-
house, which is described as "a low building of one large room, rudely
constructed of logs," is now no more. It stood at the foot of the woody
hill, just beyond the little brook, and between the old mill and the old
Dutch church, which are somewhat more than a half-mile apart.

At one time this mill was an exceedingly industrious institution,
grinding corn, as it did for all the Dutch burghers within a radius of
twenty miles. Its big wheel, now silent and moss-grown, was turned by
the water of the brook, which was held back by a dam, and conducted
through a formidable sluice, to serve the cause of the original owner.
The water which this dam held back formed a very considerable mill
pond, of which the traces yet remain in a broad, reed-grown, watery
plot, of which the brook is, but an inconsiderable portion, and now
half-hidden by the grass. "It was here," to quote Irving, "that the wor-
thy Ichabod could be found of a Sunday morning, sauntering with a
whole bevy of country damsels along the banks of the adjacent mill
pond; while the more bashful country bumpkins hung sheepishly back,
envying his superior elegance and address." Alas! mill and pond and

school are now no more, or nearly so, for though the first remains, it is but illy cared for. Its shingles are green with lichens, and its sides black with rain. Great willows half hide it from the eye, its wheel is rotted, and even the stone dam is broken, the fragments forming stepping stones across the brook.

Leaving it one crosses the bridge, the heart of Sleepy Hollow, and then it is but a few hundred feet up the winding, elm-shaded road to the old Dutch church. There are few more ancient edifices in the country, and scarcely anywhere is there a more interesting relic. This quaint and venerable structure was built about two hundred years ago by one Frederick Phillip, then Lord of the Manor, whose monogram is still on the vane at the eastern end of the building, and whose remains are buried beneath the floor. I have read long articles about this church alone, and most interesting they were, but, bless us, if we recount that it was built in 1683, and that in 1697 the Rev. Guilliamus Barthalf, "stated minister of God's word at Hachensach," was invited to preach there, three or four times a year, we have said a great deal.

It was the sturdy descendants of sturdier Dutch forefathers, who built the church, who called the valley in which it stands, "Sleepy Hollow," in recognition of the somnolent charm which has hovered about

The Old Dutch Church

the locality since Wolfert Ecker, who built Wolfert's Roost, was an elder. Then all the tribes of Van Weerts, Covenhovens, Van Texels, Sies, and the rest, trooped down to the Pocantico on Sunday morning, where the lusty lads and unabashed maidens washed their feet before entering the church.

Time has not worked so greedily here. True, the road outside is modern, the school is gone, the gates to country residences of modern money-lords peep through the trees, and trespass-warnings are numerous, but the little church and graveyard are much as before. To the musical chime of the little bell still there, a multitude of notable men and women have crowded through the narrow doorway. They have sat in patience upon its hard and backless benches, listening to interminable sermons droned from the bell-flower pulpit, while swallows and phebe birds twittered cheerfully in the rafters overhead. There were legislators and chief justices, dignified possessors of fine old American names—Beekmans,[4] Van Cortlandts,[5] Schuylers,[6] Clintons,[7] and a host of others, high in the councils of the state and country.

Washington's diary tells how, in the troublous days of the War for Independence, he rested in the grateful shadow of the church; Commodore Perry,[8] when a resident of Tarrytown, was a frequent attendant at the simple services held there, and Washington Irving, whose remains lie almost within touch of its time-scorning foundations, loved the old church as the very embodiment of local tradition. Did he not affirm that the voice of the unfortunate Ichabod still leads a ghostly choir on moonlit summer nights, and the old lords of the manor listen silently from their snug crypt under the floor?

And there is the graveyard. Take off thy shoes, reader, for now certainly we are on sacred ground. Surely of all places, this ancient churchyard invites to reverie and sentiment. Its brown and leaning headstones are quaintly carved and inscribed as often in Dutch as in English. Both the bones of the Revolutionary patriots and of British soldiers rest there. Even the good Irving's grave is farther up the green hillside, looking down where his created Ichabod, of a Sunday morning was so much in evidence. "How he would figure among them in the churchyard," said the author, "between services on Sundays! Gathering grapes for them from the wild vines that overrun the surrounding trees; reciting for their amusement all the epitaphs on the tombstones."

The Tomb of Washington Irving

The grave of the author is marked by a simple white slab, where many another unknown nearby has a veritable pyramid of costly stone. If he sat up in his grave he could see the sweet little church tucked away in the trees, and surrounded by its array of faithful stone guardsmen. Far off rise the green top of the Katskills, which he loved, and high in the blue heavens sails here and there a wide-winged buzzard, idly circling the summer sky. At evening the bark of a dog comes from afar, and the low of cattle, and all is peaceful.

NOTES

"Historic Tarrytown: Washington Irving," *Ainslee's* 1 (Mar. 1898): 25–31. Reprinted in *Selected Magazine Articles,* 2:65–69.

1. Ichabod Crane, the ingenuous school teacher in Irving's "The Legend of Sleepy Hollow," courts Katrina Van Tassel, the daughter of a wealthy pre-Revolutionary Hudson farmer.

2. A Hessian was a German mercenary who fought for the British during the American Revolutionary War.

3. John André (1751–1780) was a British major and a spy in the American Revolution.

4. Gerardus Beekman (died 1728) was the colonial governor of New York.

5. Oloff Stevense Van Cortlandt was a Dutch officer who came to New Netherlands in 1638. One of his descendants, Pierre Van Cortlandt (1721–1814), was the first lieutenant governor of New York.

6. Philip John Schuyler (1733–1804) was an American general and statesman.

7. George Clinton (1739–1812) was vice president of the United States (1805–12).

8. Matthew Galbraith Perry (1794–1858) was an American commodore who began the first trade negotiations with Japan.

■ Anthony Hope Tells a Secret

A Photographic Talk with the Great English Novelist Discussing his Early Struggles and Later Triumphs

It has been said, more than once, of Anthony Hope, (whose name, as is well known, is Anthony Hope Hawkins in private life), that he is one of those favored children of fortune whom nature endows with every requisite for success, and sends forward as an example of life without care. I, myself, have heard struggling literary men roundly berate those peculiar workings of nature which could give to one every advantage of physique, natural talent, and high aspiration, and to many others only burning aspiration without either strength or other qualities to satisfy it. Mr. Hope is not an inaccessible celebrity, and I determined to seek him personally, and ask some questions upon the subject. At the time, he was in the hurry of a great lecture tour. His hours, when not lecturing, might well have been spent consulting timetables. As it was, the catching of trains was a passing need, and the necessity of meeting socially a great number of New York's distinguished literary men and women, occupied to the utmost his few spare hours. He was at one of the great New York hotels, and to him I was admitted one morning, without ado or delay of any kind. Though early in the day, he was already hard at work and evidently had been for some time. His writing desk was covered with letters, the floor about littered with them, and rows of invitations, three deep, ornamented the mantelpiece. Also, on the tables and around the room generally, books were freely scattered.

The author was extremely courteous, after the pleasing English fash-

ion. He had already risen from his task when I was admitted, and came forward, smiling. I stated my object quickly and he answered:—

"Why, certainly we can discuss the subject. It will give me pleasure, though I doubt if I can enlighten you."

He then offered me a chair, and sought one for himself.

"It is often said," I began, "that you are an example of the ease with which some men attain to distinction."

"My ability to tell stories certainly is a gift," he answered, "and is not dependent upon personal experience. I dare say I have studied in directions which now suggest these plots and incidents, however."

"Then your power of story-telling is the result, in a measure, of study," I said.

"To a certain extent, surely," he answered. "It certainly would not be just to say that I write without study, any more than it would be to say that I do so with ease. It may not be absolute toil, but I assure you it is labor."

"Then you may have worked exceedingly hard, after all."

"Getting along is a grind," he answered. "It was the usual one with me, and you know that all work is hard when people are born with a desire to play."

"You must have done a great deal of reading in your day?"

"Oh, a moderate amount," he said.

"Are you reading any of these?" I ventured, taking an inclusive glance at the books scattered about.

"All," he replied, modestly, at the same time reaching for his pipe.

It was a rather startling answer, considering the number in evidence; but, as I knew, a great writer is usually an omnivorous reader. The books were largely those of American authors, dealing with phases of our national life.

I was about to offer another question, when he resumed with: "I judge there is considerable error in the minds of most individuals as to the ease with which success is attained in literature. My experience extends only through law and literature, but I know of nothing more trying than the failure of beginners in this field. Literary aspirants who have real merit are usually extremely sensitive, and their ambition is most soaring. Consequently, failures, indifference of others, and lack

of friendly criticism, weigh heavily. To endure long hours on meagre pay, in mercantile or other pursuits, cannot be more trying to the beginner than to endure rejections and lack of recognition with a sensitive, high-strung nature in the literary world."

"Is that the usual experience of literary workers?" I ventured.

"Yes," he answered. "It is the usual thing for a beginner to work eight hours a day at something he does not care for, or perhaps despises, in order to live, and be able to work two hours at his chosen profession."

"I might ask where you obtained your training."

"Well," he said, "in my ninth year my father, who is now Vicar of St. Bride's, London, moved to Leatherhead, where he took St. John's School, an establishment for boys, and intended exclusively for the sons of clergymen. I was there several years. Then, at thirteen, I won a scholarship at Marlborough College. Few boys work hard at an English public school."

"But you were an exception."

"A College Education Is an Advantage for a Writer, but Not a Necessity."

"Oh, no! I studied the prescribed text-books fairly well, and played football a trifle better."

"And from Marlborough?" I questioned.

"I passed to Baliol College, Oxford. There, as during all my boyhood and youth, my life was commonplace and uneventful. Afterwards, I took up law as a profession, and followed it for six or seven years. It was my choice, and I did fairly well."

"How did you come to leave it, and take up literature?" I queried.

"Oh, I fancied I could write a story. I began to write short ones in my spare time."

"How long was it before your efforts were remunerated at a reasonable rate?"

He smiled. "I can't remember exactly; it was a gradual affair. I had the usual experience, you know,—wasting my good stamps on returned stories. I published 'A Man of Mark,' but it didn't sell."

"You were finally induced to give up the practice of law, I believe, were you not?"

"Yes, by success. My income from my stories was larger than that from my practice, and I elected to stick to stories altogether."

"Right here I should like to ask if you think a college education an advantage, or a necessity, to success?"

"It is an advantage, surely. Of course, it's an advantage, but I should not say a necessity. Men do succeed, you know, without one. Of course, all things help; but we all know how men succeed."

"Do you believe a distinctive style and a mind for inventing interesting plots is a given or an acquired talent?"

"It's born with a man, of course. Study will develop, and work perfect a style, but it won't give a bent to it. You must have an innate liking for the thing, an aptitude, say, or you never would give the time to working at it. The ability to invent a plot is a gift. I don't believe anyone could train his mind to an inventive state. It's a gift, of course."

"Then you don't accept Balzac's maxim, 'Genius is a capacity for taking infinite pains'?"[1]

"Oh, no! It seems to me that it must have been a pleasant epigram with him. Of course, genius sometimes has the capacity for taking infinite pains; sometimes it hasn't. But there must be something else

behind that,—the tendency or desire to take infinite pains. Nothing is done strikingly well without a liking for it."

"Do you imagine it is more difficult to succeed in literature than in many other professions?"

"No; not exactly. It is a field in which it is impossible to succeed without talent. Some fail to succeed with it. There are possibilities of quicker success, if you can bring forward the individual fitted to take advantage of the possibilities. Even with genius, though, it is usually a matter of years before one is accepted by both critics and public."

"What do you say is the first requisite for success in the literary field?"

"I can only answer for my style of literature, and there I should say the ability to invent a plot. Style is excellent; it can be acquired, I think, but is absolutely useless without a plot. To have something to say is the first thing. Many people can say it. Some writers have a good style, but no merit of thought. Some have something to say; and, even if they say it poorly, it brings them success."

"How many hours a day do you work?" I asked.

"A varying period," said Mr. Hope, now behind his desk and abandoning the pipe, probably in despair. "Five to six hours, usually,—that is, writing. Of course, I think about my work a great deal; invent plots when I knock around, and so on. But I write at a desk thus much time."

"Does your work require much historical investigation?"

"No; none. I say none, but I except a historical novel which I am now at work upon. That required a little investigation about the time of Charles II."

"And your other novels," I went on, "do they not represent wide if not special historical reading?"

"I read much of German history, and all my reading helps, I suppose; but I assure you the stories are purely imaginary. They come as pleasing fancies."

"And, no work to think them up?"

"No, I rather enjoy it."

"Did you ever think of abandoning literature after you had once started?"

"No. You see I took it up gradually, never burned my bridges behind me, until the road was clear before;—that is, I stayed with law until

my stories earned me enough to live on. After I left the law, I wouldn't go back. Pride alone settled that."

A little article which I had looked up the previous day states that a brief resumé of Mr. Hope's work reveals the fact that no blood of the idler flows in his veins. After publishing, in 1889, "A Man of Mark," Mr. Hope endeavored laboriously to dispose of a number of his short stories to the magazines of England, but only one or two ever got into type. The temperature of this cold water was not low enough, however, to chill his ardor, and he kept at his task, unflinching. One day he came forth from his den, with his brief-bag, and in it the manuscript of "Father Stafford," which nearly every publisher in London hastened to decline with thanks. Finally it was issued from the press of the Cassell's, but was a financial failure. He then began to contribute short tales of the "St. James Gazette," a journal that has given signal encouragement in their days to the now famous author of "The Play Actress," "A Gentleman of France," and "The Seats of the Mighty." From these contributions of Hope, fifteen in all, the stories were selected which compose the volume entitled, "Sport Royal." Afterwards came "Mr. Witt's Widow," which was only a partial success; then "A Change of Air," then "Half a Hero." He then set diligently to work upon "The God in the Car," but left it for "The Prisoner of Zenda." After completing the temporarily abandoned African tale, he began writing the "Dolly Dialogues," which sparkled with such Parisian brilliance in the "Westminster Gazette." Next appeared "The Indiscretions of the Duchess." To these he has since added "Phroso," and "The Heart of the Princess Osra."

I asked one more question. "Do you feel that there is happiness in anything but work?"

"There is," he answered, "great pleasure in work, for me. At times I have been content in idleness; but, now that I think, perhaps it was idleness of body. To be idle and content, one must be ignorant of great energy."

"For my part," he went on, "to be lost in work is to be unconscious of other difficulties and approaching annoyances. To one with a bent, it is pleasure, wearying and confining, but still agreeable. With moderate talents and hard work," he added, in concluding the interview, "any one can certainly succeed."

NOTE

"Anthony Hope Tells a Secret," *Success* 1 (Mar. 1898): 12–13. Reprinted as "A Secret Told by Anthony Hope" in *How They Succeeded,* 300–305.

 1. In 1894, four years before Dreiser wrote this article, he was a newspaper reporter in Pittsburgh. Because of his light assignments, he often crossed the Allegheny River and made his way to the Carnegie Library, where he read works by the French novelist Honoré de Balzac (1799–1850) for the first time. Reading *The Human Comedy, Cousin Betty, Father Goriot,* and *Great Man from the Province* made lasting impressions on the young literary aspirant and influenced him in writing novels.

How He Climbed Fame's Ladder: William Dean Howells

William Dean Howells Tells the Story of His Long Struggle for Success, and his Ultimate Triumph
A Most Unique and Inspiring Photographic Interview
A Poor Ohio Printer Boy who Became a Great Novelist

"I should like, Mr. Howells," said I, by way of opening my interview with the famous novelist, "to learn your opinion concerning what constitutes success in life. You should have the American view?"

"Not necessarily," said the novelist, seating himself.

"Do you share the belief that everything is open to the beginner who has sufficient energy and perseverance?"

"Add brains, and I will agree," said Mr. Howells with a smile. "A young man stands at the 'parting of two ways,' and can take his path this way or that. It is comparatively easy then, with good judgment. Youth is certainly the greatest advantage which life supplies."

"You began to carve out your place in life under conditions very different from those of to-day?"

"Yes. I was born in a little south-eastern Ohio village,—Martin's Ferry,—and, of course, I had but little of what people deem advantages in the way of schools, railroads, population, and so on. I am not sure, however, that compensation was not had in other things."

"Do you consider that you were specially talented in the direction of literary composition?"

"I should not say that. I think that I came of a reading race, which has always loved literature in a way. My inclination was to read."

"Would you say that, with a special leaning toward a special study,

"I Read Pretty Constantly."

and good health, a fair start, and perseverance, anyone can attain to distinction?"

EARLY IDEALS

"That is a probability, only. You may be sure that distinction will not come without those qualities. The only way to succeed, therefore, is to have them; though having them will not necessarily guarantee distinction. I can only say that I began with a lofty ideal, without saying how closely I have held to it. My own youth was not specially marked by advantages. There were none, unless you can call a small bookcase full of books, which my home contained, an advantage. The printing-office was my school from a very early date. My father thoroughly believed in it, and he had his belief as to work, which he illustrated as soon as we were old enough to learn the trade he followed. We could go to school and study, or we could go into the printing-office and work, with perhaps an equal chance of learning; but we could not be idle."

"And you chose the printing-office?"

"Not wholly. As I recall it, I went to and fro between the schoolhouse

and the printing-office. When I tired of one, I was promptly given my choice of the other."

"Then you began life in poverty?"

"I suppose that, as the world goes now, we were poor. My father's income was never above twelve hundred a year, and his family was large; but nobody was rich then. We lived in the simple fashion of that time and place."

"You found time to read?"

"My reading, somehow, went on pretty constantly. No doubt my love for it won me a chance to devote time to it."

"Might I ask how much time you devoted each day to your literary object?"

"The length varied with varying times. Sometimes I read but little. There were years of the work, of the over-work, indeed,—which falls to the lot of many, that I should be ashamed to speak of except in accounting for the fact. My father had sold his paper in Hamilton, and had bought an interest in another at Dayton, and at that time we were all straining our utmost to help pay for it."

"And that left you little time?"

"In that period very few hours were given to literature. My daily tasks began so early, and ended so late, that I had little time, even if I had the spirit for reading. Sometimes I had to sit up until midnight, waiting for telegraphic news, and be up again at dawn to deliver the papers, working afterwards at the case; but that was only for a few years."

"When did you find time to seriously apply yourself to literature?"

ACQUIRING A LITERARY STYLE

"I think I did so before I really had the time. Literary aspirations were stirred in me by the great authors whom I successively discovered, and I was perpetually imitating the writings of these,—modeling some composition of my own after theirs, but never willing to own it."

"Do you attribute your style to the composite influence of these various models?"

"No doubt they had their effect, as a whole, but individually I was freed from the last by each succeeding author, until at length I came to understand that I must be like myself, and no other."

"Had you any conveniences for literary research, beyond the book-case in your home?"

"If you mean a place to work, I had a narrow, little space, under the stairs at home. There was a desk pushed back against the wall, which the irregular ceiling sloped down to meet, behind it, and at my left was a window, which gave a good light on the writing leaf of my desk. This was my workshop for six or seven years,—and it was not at all a bad one. It seemed, for a while, so very simple and easy to come home in the middle of the afternoon, when my task at the printing-office was done, and sit down to my books in my little study, which I did not finally leave until the family were all in bed. My father had a decided bent in the direction of literature; and, when I began to show a liking for liter-ature, he was eager to direct my choice. This finally changed to merely recommending books, and eventually I was left to my own judgment,—a perplexed and sorrowfully mistaken judgment, at times."

"The Only Way to Succeed Is to Have Those Qualities."

"I Began with a Lofty Ideal."

"In what manner did you manage to read the works of all your favorite authors?"

"Well, my hours in the printing-office began at seven and ended at six, with an hour at noon for dinner, which I used for putting down such verses as had come to me in the morning. As soon as supper was over, I got out my manuscripts, and sawed, and filed, and hammered away at my blessed poems, which were little less than imitations, until nine, when I went regularly to bed, to rise again at five. Sometimes the foreman gave me an afternoon off on Saturday, which I devoted to literature."

"Might I ask concerning your next advance in your chosen work?"

"Certainly. As I recall it, my father had got one of those legislative clerkships, in 1858, which used to fall sometimes to deserving country editors, and together we managed and carried out a scheme for corresponding with some city papers. Going to Columbus, the State Capital, we furnished a daily letter giving an account of the legislative proceed-

ings, which I mainly wrote from the material he helped me to gather. The letters found favor, and my father withdrew from the work wholly."

"How long were you a correspondent?"

"Two years. At the end of the first winter, a Cincinnati paper offered me the city editorship, but one night's round with the reporters at the police station satisfied me that I was not meant for that kind of work. I then returned home for the summer, and spent my time in reading, and in sending off poems, which regularly came back. I worked in my father's printing-office, of course; but, as soon as my task was done, went home to my books, and worked away at them until supper. Then a German bookbinder, with whom I was endeavoring to read Heine[1] in the original, met me in my father's editorial room, and with a couple of candles on the table between us, and our Heine and the dictionary before us, we read until we were both tired out."

"Did you find it labor?"

"I fancy that reading is not merely a pastime, when it is apparently the merest pastime. It fatigues one after the manner of other work, and uses up a certain amount of mind-stuff; and I have found that, if you are using up all the mind-stuff you have, much or little, in some other way, you do not read, because you have not the mind-stuff for it. You cannot say more of any other form of work."

"Then it might be said that you worked at separate and equally difficult tasks, constantly?"

"Perhaps not equally difficult, but, certainly, constantly."

"Rather a severe schooling to give oneself, don't you think it?"

Mr. Howells smiled. "It was not without its immediate use. I learned how to choose between words, after a study of their fitness; and, though I often employed them decoratively, and with no vital sense of their qualities, still, in mere decoration, they had to be chosen intelligently, and after some thought about their structure and meaning. I would not imitate great writers without imitating their method, which was to the last degree intelligent. They knew what they were doing, and, although I did not always know what I was doing, they made me wish to know, and ashamed of not knowing. The result was beneficial."

"It is very evident that you recovered your health, in spite of your toil?"

"Oh, yes. I got back health enough to be of use in the printing-office at home, and was quietly at work there, when, to my astonishment, I was asked to come and take a place upon a Republican newspaper at the Capital. I was given charge of the news department. This included the literary notices and the book reviews, and I am afraid that I at once gave my prime attention to these."

"When did you begin to contribute to the literature of the day?"

"If you mean, when did I begin to attempt to contribute, I should need to fix an early date, for I early had experience with rejected manuscripts. One of my pieces, which fell so far short of my visions of the immense subjects I should handle as to treat of the lowly and familiar theme of Spring, was the first thing I ever had in print. My father offered it to the editor of the paper I worked on in Columbus, where we were then living, and I first knew what he had done when, with mingled shame and pride, I saw it in the journal. In the tumult of my emotions, I promised myself that if ever I got through that experience safely, I would never suffer anything else of mine to be published; but it was not long before I offered the editor a poem, myself."

"When did you publish your first story?"

"My next venture was a story in the Ik Marvel manner,[2] which it was my misfortune to carry into print. I did not really write it, but composed it, rather, in type, at the case. It was not altogether imitated from Ik Marvel, for I drew upon the easier art of Dickens, at times, and helped myself out in places with bald parodies of 'Bleak House.' It was all very well at the beginning, but I had not reckoned with the future sufficiently to start with any clear ending in my mind; and, as I went on, I began to find myself more and more in doubt about it. My material gave out; my incidents failed me; the characters wavered, and threatened to perish in my hands. To crown my misery, there grew up an impatience with the story among its readers; and this found its way to me one day, when I overheard an old farmer, who came in for his paper, say that he 'did not think that story amounted to much.' I did not think so, either, but it was deadly to have it put into words; and how I escaped the mortal effect of the stroke I do not know. Somehow, I managed to bring the wretched thing to a close, and to live it slowly down."

AN EXPERIENCE IN COLLABORATION

"My next contribution to literature was jointly with John J. Piatt, the poet, who had worked with me as a boy in the printing-office at Columbus. We met in Columbus, where I was then an editor, and we made our first literary venture together in a volume entitled, 'Poems of Two Friends.' The volume became instantly and lastingly unknown to fame; the West waited, as it always does, to hear what the East should say. The East said nothing, and two-thirds of the small edition of five hundred copies came back upon the publisher's hands. This did not deter me, however, from contributing to the periodicals, which, from time to time, accepted my efforts."

"Did you remain long, as an editor, in Columbus?"

"No; only until 1861, when I was appointed Consul at Venice. I really wanted to go to Germany, that I might carry forward my studies in German literature; and I first applied for the Consulate at Munich. The powers at Washington thought it quite the same thing to offer me Rome, but I found that the income of the Roman Consulate would not give me a living, and I was forced to decline it. Then the President's private secretaries, Mr. John Nicolay and Mr. John Hay, who did not know me, except as a young Westerner who had written poems in the 'Atlantic Monthly,' asked me how I would like Venice, promising that the salary would be put up to $1,000 a year. It was really put up to $1,500, and I accepted. I had four years of nearly uninterrupted leisure at Venice."

"Was it easier, when you returned from Venice?"

"Not at all. On my return to America, my literary life took such form that most of my reading was done for review. I wrote at first a good many of the lighter criticisms in 'The Nation,' and then I went to Boston, to become assistant editor of 'The Atlantic Monthly,' where I wrote the literary notices for that periodical for four or five years."

"You were eventually editor of the 'Atlantic,' were you not?"

"Yes, until 1881; and I have had some sort of close relation with magazines ever since."

"Would you say that all literary success is very difficult to achieve?" I ventured.

"All that is enduring."

"It seems to me ours is an age when fame comes quickly."

"Speaking of Quickly-Made Reputations"

"Speaking of quickly made reputations," said Mr. Howells, medi-tatively, "did you ever hear of Alexander Smith? He was a poet who, in the fifties, was proclaimed immortal by the critics, and ranked with Shakespeare. I myself read him with an ecstasy which, when I look over his work to-day, seems ridiculous. His poem, 'Life-Drama,' was her-alded as an epic, and set alongside of 'Paradise Lost.' I cannot tell how we all came out of this craze, but the reading world is very susceptible of such lunacies. He is not the only third-rate poet who has been thus apotheosized, before and since. You might have envied his great suc-cess, as I certainly did; but it was not success, after all; and I am sure that real success is always difficult to achieve."

"Did you believe that success comes to those who have a special bent or taste, which they cultivate by hard work?"

"I can only answer that out of my literary experience. For my own part, I believe I have never got any good from a book that I did not read merely because I wanted to read it. I think this may be applied to any-thing a person does. The book, I know, which you read from a sense of duty, or because for any reason you must, is apt to yield you little. This,

I think, is also true of everything, and the endeavor that does one good,—and lasting good,—is the endeavor one makes with pleasure. Labor done in another spirit will serve in a way, but pleasurable labor brings, on the whole, I think, the greatest reward."

THE REWARDS OF LITERATURE

"You were probably strongly fascinated by the supposed rewards of a literary career?"

"Yes. A definite literary ambition grew up in me, and in the long reveries of the afternoon, when I was distributing my case in the printing-office, I fashioned a future of overpowering magnificence and undying celebrity. I should be ashamed to say what literary triumphs I achieved in those preposterous deliriums. But I realize now that such dreams are nerving, and sustain one in an otherwise barren struggle."

"Were you ever tempted and willing to abandon your object of a literary life for something else?"

"I was, once. My first and only essay, aside from literature, was in the realm of law. It was arranged with a United States senator that I should study law in his office. I tried it a month, but almost from the first day, I yearned to return to my books. I had not only to go back to literature, but to the printing-office, and I gladly chose to do it,—a step I never regretted."

"You started out to attain personal distinction and happiness, did you not?"

"I did."

WHAT TRUE HAPPINESS IS

"You have attained the first,—but I should like to know if your view of what constitutes happiness is the same as when you began?"

"It is quite different. I have come to see life, not as the chase of a forever-impossible personal happiness, but as a field for endeavor toward the happiness of the whole human family. There is no other success.

"I know, indeed, of nothing more subtly satisfying and cheering than a knowledge of the real good will and appreciation of others. Such happiness does not come with money, nor does it flow from a fine

physical state. It cannot be bought. But it is the keenest joy, after all, and the toiler's truest and best reward."

Notes

"How He Climbed Fame's Ladder: William Dean Howells," *Success* 1 (Apr. 1898): 5–6. Reprinted as "How He Worked to Secure a Foothold" in *How They Succeeded*, 171–84. Reprinted as "A Printer's Boy, Self-Taught, Becomes the Dean of American Letters—William Dean Howells" in *Little Visits with Great Americans*, 283–95, and in *American Literary Realism* 6 (Fall 1973): 339–44.

1. Heinrich Heine (1797–1859), a German poet and critic, gained his fame for such lyrical ballads as "The Grenadiers" and "Lorelei."
2. Ik Marvel [pseud. of Donald Grant Mitchell] (1822–1908), an American essayist, became famous for his book *Reverie of a Bachelor* (1850).

■ Haunts of Nathaniel Hawthorne

However Salem may have looked in the days when the numerous craft of the old colonies harbored in the smooth waters of its bay, and when, as one humorist has put it, "Witch Hill was its chief centre of amusement," it has to-day many of the ear-marks of a modern city. The railroad, electric light, and trolley have so threaded, glared upon, and outraged its ancient ways, that you, who are only familiar with all that is historic and quaint in its affairs, stay in disappointment and chagrin, to exclaim, "Can this be?" It is so modern in parts. Why, only a block from the now large and grimy railroad station, there stood in Hawthorne's time "the town pump," which gave forth such a dainty and inspiring rill of thought concerning its own vocation. Some seven trolley lines pass around that identical corner now! The very bowels of the earth from which it drew the sparkling liquid, have been torn out to make way for a smoky two-track tunnel, and steam cars now pass where once the darksome well held its cool treasure in store for man and beast.

It is the public square and the newer portions of Salem which stir the feeling that all the quaintness and charm have departed, and, on the whole, it is well, for after the first cursory glance, expecting little, there is a reviving pleasure in finding a great deal.

While there are new streets, new homes, and new interests, there are still the old streets and the old homes, now dark, and tottering, and bleak. In Charter street, only a few blocks from the depot, in what is now the "old portion" of the town, lies the little cemetery familiar to the readers of "Dr. Grimshaw's Secret" and "The Dolliver Romance." Such an ancient, moss-grown burying ground it is a melancholy pleasure to look

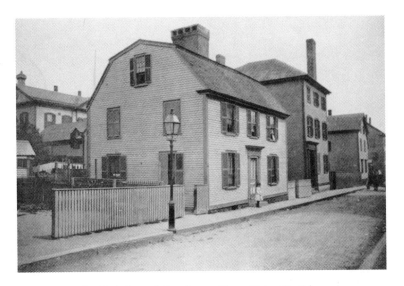

The Birthplace of Hawthorne. No. 21 Union St., Salem

upon, for it smiles sadly with the memory of the burials of hundreds of years. Here, among the sunken and turf-grown graves, reposes the dust of many a worthy colonial dignitary, all solemn in his living pretensions, and grimly written over as befits his chill and sanctimonious ashes. Some of the graves contain Hawthorne's mariner ancestors, some of whom sailed forth on the ocean of eternity nearly two centuries ago. Among the curiously carved gravestones of slate, we see that of John Hawthorne, the "witch-judge" of Hawthorne's note books, and close at hand are the graves of the ancestors of the novelist's wife. The sombre house which encroaches upon a corner of the cemetery enclosure, with the green willows surging about it so closely, that its side windows are within our reach from the gravestones, was the home of the Peabodys, whence Hawthorne wooed the amiable Sophia, and where in his tales he domiciled Grandsir "Dolliver" and "Dr. Grimshaw." You find it rather a poor mansion, big-roofed and low studded, with small windows and weather-beaten sides. Evidently once a very respectable "mansion" after the New England acceptance of the word, but now exceedingly humble and the abode of many a hidden grief, no doubt.

Only a few blocks further off is the Custom House where Hawthorne did irksome duty as "Locofoco Surveyor," its exterior being,

except for the addition of a cupola, essentially unchanged since his description was written. The wide, worn granite steps still lead up to the entrance portico, and above hovers the same enormous gilded eagle, "a shield before her breast, and, if I recollect aright, a bunch of intermingled thunderbolts and barbed arrows in each claw." In Hawthorne's time the customs collections amounted to about $50,000 a year, where now they scarcely average $10,000, and Derby wharf, which once was alive with merchantmen from all parts of the world, now stretches for an eighth of a mile, a dilapidated and partially deserted structure, with bleak sheds and decaying structures on every hand. It was in this Custom House, in an old baggage room, that the old scarlet letter A was found by Hawthorne, and subsequently used as the basis, in idea, of his romance.

Still a little way on, and in a side street called Turner, which runs directly down to the water-side, we find the much disputed "House of Seven Gables," with its peaked roof, small glazed windows, and wealth of overhanging trees. Whether this is for certain the identical house of Hawthorne's romance or no, is a subject not broachable here for discussion. Certainly it originally had many gables, which have now dis-

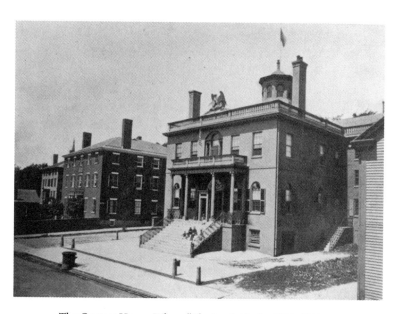

The Custom House, Where "The Scarlet Letter" Was Written

appeared, and it answers more nearly the description given in the book than any other in Salem or elsewhere.

Sauntering along the "Main Street" of Hawthorne's sketch, and the other shady avenues he knew so well, the curious old tower, which in the discontent of arrival we called tame and unattractive, seems to grow more and more picturesque, and even beautiful. If we follow "the long, lazy street," Witch Hill, which the novelist describes in "Alice Doane's Appeal," we may behold from that unhappy spot, where men and women suffered death for imagined misdoings, the whole of Hawthorne's Salem, with the environment he pictures in "Sights from the Steeple." We see the house-roofs of the town—half hidden by clustering foliage—extending now from the slopes of the fateful hill to the glistening waters of the harbor, the farther expanse of field and meadow, dotted with white villages and scored with shadowy waterways; the craggy coast with the Atlantic thundering endlessly against its headland.

It was here that Hawthorne began his life and achieved his distinction. And the number of pilgrims from all parts of the world who go to Salem to look at the old, brown, gambrel-roofed house, numbered 21 Union street—because here nearly a century ago, in 1804, Nathaniel

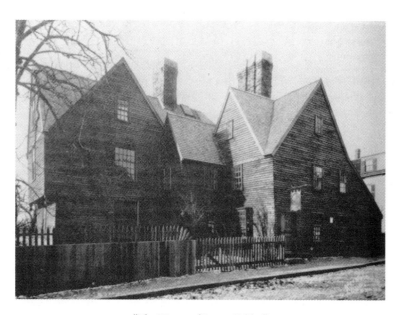

"The House of Seven Gables"

Hawthorne was born in its northwest corner, second story room—is very large, and each year increasing. It is the same old house, with the same monster chimney, that it was in 1804, or for that matter, in 1704, so long has it been in existence. It is said to have been built by Capt. Benjamin Pickman, who was a Salem shipmaster in 1700. At all events, Nathaniel Hawthorne's grandfather lived in it as early as 1772, and it was the home of his father and mother from their marriage until 1808, when the father, also a shipmaster, died in foreign parts. The house is now the home of a "family of foreign extraction," but is well preserved, neat, and tidy.

It was only for four short years that Hawthorne lived here. Immediately upon the death of Robert Hawthorne,[1] Mrs. Hawthorne moved to No. 12 Herbert street, a house owned and partly occupied by her father, Richard Manning. This is, and was then, the next street east of Union, and the backyards of the two houses joined. Mr. Manning had a large stable and a stage office near by on Union street. The Manning house was a large, three story one, severely plain. To-day it is a common tenement house. Once it was Hawthorne's home for nearly a quarter of a century in all; now a strange assortment of humanity fills it and gives an atmosphere of narrow means and depressing difference to the entire scene.

It is not difficult, however, to identify the haunted chamber which was Hawthorne's bedroom and study. The little dark, dreary apartment under the eaves, with its multi-paned window looking down into the room where he was born, is to all of us one of the most interesting of the Hawthorne shrines. Here the magician kept his solitary vigil during the long period of his literary probation, shunning his family, declining almost all human fellowship and sympathy, and for some time going abroad only after nightfall. Here he studied, pondered, wrote, revised, destroyed, day after day, as the slow months went by; and here, after ten years of working and waiting for the world to know him, he triumphantly recorded, "In this dismal chamber fame was won." He had completed the first volume of "Twice-Told Tales."

His first period of residence here lasted from 1808 to 1818, when the family moved to Raymond, Maine, for four years. Hawthorne was away scarcely twelve months when he returned to Salem to fit for college early the next fall, his college expenses being defrayed by his maternal uncle,

Robert Manning, a brother of Richard Manning, who owned the No. 12 Herbert street house, and permitted his sister, Hawthorne's mother, to dwell there, rent free.

It was in his year at Raymond that Hawthorne began his life of restlessness. Here, he says he "got his cursed habit of solitude. He would skate for hours on the great lake in the solitude" of night, and if he got too far away from home to return, would seek shelter in some logger's cabin and there pass the night, warmed by a roaring wood fire, watching the silent stars.

After his two years' preparation in Salem, he entered Bowdoin, where he remained four years, returning to Salem and the Manning house during vacation. The habit of roaming the country, begun at Raymond, was continued in Brunswick. The companionships there formed are as widely known almost as is the story of Hawthorne's own life. There were Longfellow, Franklin Pierce,[2] and Horatio Bridge.[3] With Bridge, Hawthorne explored the country round for many miles. There is even to-day the Hawthorne brook at Brunswick. In that then unnamed stream "we often fished for the small trout," says Bridge, "that were to be found there; but the main charm of these outings was in indolent loitering along the low banks of the little stream."

When Hawthorne left college, his mother had removed from Raymond, Maine, to the house at 12 Herbert street, and here he returned. For some little time thereafter he seems to have drifted. It was of his life at this time, from 1825 to 1828, that Hawthorne himself, wrote: "I had always a natural tendency toward seclusion; and this I now indulged to the utmost, so that, for months together, I scarcely had human intercourse outside my own family, seldom going out except at twilight, or only to take the nearest way to the most convenient solitude, which was often at the seashore."

From Herbert street, sometime in 1828, the Hawthornes moved to Dearborn street, in North Salem, remaining there four years in comparative comfort. In 1832, the family left this house and moved downtown again into dingy Herbert street. I take it these frequent changes were the result of Mrs. Hawthorne's dependency, and their living at all times in Mr. Manning's houses, and were made to accommodate him or his family. This time Hawthorne lived at 12 Herbert street, most of the next seven years. He boarded in Boston a few months at a time, on

one or two occasions, while engaged in editorial and other literary work there, but came down to Salem every week or two. During this time also, his contributions to magazines were becoming notable, and Peabody girls of Salem, one of whom was to become his wife, were attracted by them, although they did not discover that he was the author until 1837, and it was nearly a year later that they made his acquaintance. From that time until Dr. Peabody and his family moved to Boston, Hawthorne was a frequent visitor to the Charter street house, which I have already spoken of as "Dr. Grimshaw's" abode. During these years Hawthorne also completed the first volume of "Twice-Told Tales," which gained him recognition as the greatest master of pure English living.

In 1838, he became engaged to Miss Peabody, and under stress of shortly needing to provide a home for his wife to be, he secured a position as weigher and gauger in Boston Custom House, which he held from January, 1839, to April, 1841. His diary and letters bear evidence of his distaste for his duties, and he decided not to trust to that for a livelihood, in view of his matrimonial venture. When he began his work there, he wrote to Longfellow, telling how many and what kind of sketches he intended to produce as a result of his leisurely official life, but he did absolutely nothing of that kind. A few lines from the notebook will show how irksome to him was the weighing of coal on an old schooner. "April 19, 1840. What a beautiful day yesterday! My spirit rebelled against being confined in my darksome dungeon at the Custom House. When I shall be again free, I will enjoy all things with the fresh simplicity of a child five years old. I will go forth and stand in a summer shower, and all the worldly dust that has collected on me shall be washed away at once, and my heart will be like a bank of fresh flowers for the weary to rest upon."

His duties finally ended here with a political change in the Government, and the young romancer now indulged in that venture into communism which is really too well known to require repetition. It was in 1841–42 that he was a member of the Brook Farm community, and it scarcely need be remarked that his joining it was but one more mark of his restlessness of spirit. He joined the company the year before his marriage, thinking to bring his wife there the next year should his own experiment prove satisfactory. It did not. There was too much restraint, or not enough freedom for a man of his roving disposition, and he

produced noting at all in a literary way. His diary records an occasional walk and general complaints.

There was once more a return to Salem, then, and Herbert street, where he married Miss Peabody, and where he brought her to board for the first seven months of his married life. After that, in July, 1842, having hired the Old Manse at Concord, of Dr. Ripley,[4] he removed there, and the most delightful period of his life began. It was a beautiful old house which his modest income permitted him to support. The picturesque old mansion stands amid greensward and foliage, its ample grounds divided from the highway by a low wall, its northernmost lawn washed by the quiet waters of the Concord River. "It was created," he wrote at the time, "by Providence expressly for our use, and at the precise time when we wanted it," and then added, with his frequent twists of humor, "it contains no water either fit to drink or bathe in. Only imagine Adam trudging out of Paradise with a bucket in each hand, to get water to drink, or for Eve to bathe in. Intolerable!"

His diary reeks with the delights of the new life. After breakfast one morning, he took his fishing-rod and went down through the orchard to the riverside, but as three or four boys were already in possession of the best spots, he did not fish. He swam in it from time to time, and was three weeks in discovering which way the tide moved. Once he declared, "I bathe once and often twice a day in our river but one dip into the salt of the sea would be worth more than a whole week's soaking in such a lifeless tide."

At Concord Hawthorne found many friends, among whom were Emerson, Thoreau, Bronson Alcott[5] and his family, including Louisa May,[6] Ellery Channing,[7] the poet, Margaret Fuller,[8] and others. Naturally where so many literary celebrities were located there was a procession of distinguished visitors, and we hear of almost every great American literary personage as having called at the house at sometime or other during Hawthorne's stay. He explored the surrounding territory with Thoreau and Ellery Channing, and the volumes of those gentlemen, who make it a point to seek out the weep over every nook wherein those noble souls disported themselves, tells us of dozens of shadowy places along the river where Hawthorne frequently went to drowse and ponder. He was conspicuous as a character to Concord residents, who often observed the darkly clad figure of the recluse hoe-

ing in his patch, where he went to destroy what he spoke of as "weeds," next "more weeds," then a "ferocious banditti of weeds," with which "the other Adam," could never have contended.

His stay in the old Manse was for an all too brief period of four years, when financial circumstances dictating, he accepted the office of Surveyor of the Port of Salem. When he left Concord, he resided for a few months on Carver street, Boston, where the first child, a son, was born. In November the family entered Salem, and took the house which is now numbered 18 Chestnut street, but soon changed to decidedly less pretentious quarters on a downtown side street; having accomplished no literary work of whatsoever character at the other place.

14 Mall street (the less pretentious spot) is, to many, the most noted of all the Hawthorne houses in America or Europe, because in it he wrote his masterpiece, "The Scarlet Letter." The house dates back into the last century, but is still well preserved and even charming in appearance, being quite large, three stories, and surrounded by trees and shrubbery. Hawthorne's study was in the third floor front room, but the room where he kept the manuscript of "The Scarlet Letter" is believed to have been on the second floor. It was in this house, in the winter of 1849–50, that James T. Fields[9] found Hawthorne "alone in a chamber over a sitting-room of the dwelling, and as the day was cold he was hovering near the stove." After trying to get from him some statement as to what he had been writing, and failing of a satisfactory answer, Fields started to go downstairs, having bade his host good-by and shut the door. Hawthorne came running quickly after with a manuscript in his hands which he handed to the publisher, and hurried back to his chamber. The result is a matter of common knowledge. "The Scarlet Letter" made its author famous—the most noted man of letters of his time and country. It was substantially the only work he did while living in the Mall street house, but if it had been all that he ever did, his name would be imperishable, and the house in which he penned it, of the greatest historic interest.

Hawthorne evidently had this story in mind sometime before he began to write it. He really dawdled through his Custom House years, and did little or no literary work until after his removal from the sur-veyorship through the trickery and betrayal of professing friends. He had saved nothing from his salary, and, but for the forethought of his wife in laying aside a hundred or two dollars of the money given to her

for household expenses, they would have been penniless. As it was, sickness in the family, and the death of Hawthorne's mother, reduced them to straitened circumstances. This set the author to work. A liberal contribution from admiring and appreciative friends relieved them for the while, and until "The Scarlet Letter" was published. From that time to the end, Hawthorne's reputation enabled him to earn enough with his pen to provide the necessaries of life and much more, if he would work. From Mall street, in the summer of 1850, the Hawthornes went to live in Lenox. It was then that they left Salem for good.

At Lenox he produced his other great romance, "The House of Seven Gables." The success of "The Scarlet Letter" contributed, no doubt, very largely to Hawthorne's incentive to do other literary work, and then, he needed the money. He had a small, red house at Lenox, near the Stockbridge Bowl, and although far from comfortable, he had no means of obtaining a better one. He only dwelt in Lenox one year, but in that time produced "The House of Seven Gables," and the "Wonder Book." In November, 1851, he removed to West Newton, where he set to work upon "The Blithedale Romance," and completed it by the last of the following April. In 1852 he returned to Concord, after a winter in Newton, having bought a modest house which he named The Wayside, and where, last summer, I saw as many as twenty-seven sightseers lined up before it, gazing in upon the affairs of the present quailing resident. It was in the house once occupied by the good Bronson Alcott, and where Louisa May, really lived out the story of "Little Women."

Hawthorne dwelt here in much dignity during the remainder of his days, excepting, of course, the seven years in which he traveled abroad, first as Consul at Liverpool, and then as our foremost man of letters. He resumed all his relations with his old Concord friends, and busied himself with many a literary affair. It was during his first year at the Wayside that he wrote "Tanglewood Tales" and "The Life of Franklin Pierce," his life-long friend. Besides some papers for the *Atlantic* he wrote "One Old Home," "Dr. Grimshaw's Secret," "Septimius Felton," and "The Dolliver Romance" fragment.

For some months after the election to the Presidency of his friend, Franklin Pierce, the Wayside was frequented by office-seekers, but ordinarily Hawthorne had few visitors besides his Concord friends. Fields, Holmes,[10] Hilliard, Whipple,[11] Longfellow, Howells,[12] Horatio Bridge,

the poet Stoddard,[13] Henry Bright,[14] and others visited him. Yet his own visits were very infrequent, and Alcott said that in the several years he lived next door Hawthorne came but twice into his house, good friends as they were; the first time he quickly excused himself because "the stove was too hot"; next time "because the clock ticked too loud."

This "Wayside" was the only home Hawthorne ever owned. To it he came from the "little red house" in Berkshire, and to it returned from his sojourn abroad. Here, with failing health and desponding spirits, he lived the gloomy war days—writing in his study, or, with step more uncertain, pacing his hill-top; from here he set out with Pierce on the last pleasure trip, which ended in his death, and from this house his body was taken to the old colonial church in Concord and thence to "Sleepy Hollow," the beautiful graveyard where all the whole Concord company now sleep.

The funeral took place on the 23d of May, 1864, and was conducted by the Rev. James Freeman Clark, who had performed Hawthorne's marriage service two-and-twenty years before. It was a mild, sunny afternoon, "the one bright day in the long week of rain" as Longfellow said, and the cemetery at Sleepy Hollow was full of the fragrance and freshness of May. The grave was dug at the top of the little hill, beneath a group of tall pines, where Hawthorne and his wife had often sat in days gone by and planned their pleasure hours. When the rites at the grave were over, the crowd moved away, and at last the carriage containing Mrs. Hawthorne followed. But at the gate of the cemetery stood, on either side of the path, Longfellow, Holmes, Whittier,[15] Lowell,[16] Pierce, Emerson, and a half dozen more; and as the carriages passed between them they uncovered their honored heads in honor of Hawthorne's widow.

If there be any solace for the bereaved in this transient world of ours, I think it must be in some such expression of reverence and honor. It surely can be found in nothing less.

NOTES

"Haunts of Nathaniel Hawthorne," *Truth* 17 (21 Sept. 1898): 7–9; (28 Sept. 1898): 11–13. Reprinted in *Selected Magazine Articles*, 1:57–66.

1. Robert Hawthorne, Hawthorne's father, was a sea captain and died of yellow fever in Surinam.

2. Franklin Pierce (1804–69), the fourteenth president of the United States (1853–57), appointed Hawthorne, who had written Pierce's campaign biography, as consul to Liverpool in 1853.

3. Horatio Bridge (1806–93), the author of *Journal of an African Cruise,* formed a lifelong friendship with Hawthorne at Bowdoin College.

4. George Ripley (1802–80) was a prominent native citizen of Concord.

5. Amos Bronson Alcott (1799–1888), father of Louisa May, was a teacher and philosopher.

6. Louisa May Alcott (1832–88) is best known for *Little Women.*

7. William Ellery Channing (1780–1842) is known primarily for his liberal theological teachings, for founding Unitarianism in the United States, and for his indirect influence on New England transcendentalism.

8. Margaret Fuller (1810–50) was a critic and reformer.

9. James Thomas Fields (1817–81) was an American poet and editor of the *Atlantic Monthly* (1861–71). His wife held a literary salon in their home.

10. Oliver Wendell Holmes (1809–94) is perhaps best known for "Old Ironsides."

11. Edwin Percy Whipple (1819–86) contributed his critical essays to the *North American Review.*

12. For William Dean Howells (1839–1920) see "How He Climbed Fame's Ladder: William Dean Howells" in this volume.

13. Richard Henry Stoddard (1825–1903) was a poet and critic.

14. Henry Authur Bright (1830–84) was educated at Cambridge, was a regular contributor of literary criticism to the *Athenaeum,* and wrote hymns and religious poems for Unitarian collections. He was an intimate friend of Hawthorne, and his name is often mentioned in the *English Note-Books.*

15. John Greenleaf Whittier (1807–92), one of the most popular American poets of the nineteenth century, was known for his role as the poetic spokesman of the abolitionist movement.

16. James Russell Lowell (1819–91), the founding editor of the *Atlantic Monthly,* was involved in the abolitionist movement as well as in reform causes.

■ Literary Lions I Have Met

Reminiscences of Major James Burton Pond, Being the Story of Twenty Years' Experience in the American Lyceum Field

Of dealers in brains, or, better still, reputations, America possesses but one with distinction enough to be unique. He is a man who is perfectly convinced that, next to having great talent or present fame, is the ability to make use of the talent and fame of others, and he has worked out this conviction so thoroughly that to-day he possesses the field of the Lyceum quite to himself, unshared and undisturbed,—a kind of lord in his own domain. He is James Burton Pond,—Major J. B. Pond,—and he has been the cause of more celebrities visiting this country than any other man in it. His great persuasive influence is well embodied in the word "self-interest," and his last word is "money."

He has sent many to England, and he has toured others even more successful in America, and has supplemented the home platform by such eminent foreigners as Canon Kingsley, Wilkie Collins,[1] Charles Bradlaugh,[2] Matthew Arnold,[3] Archdeacon Farrar, Henry M. Stanley,[4] Max O'Rell, Dean Hole, Ian MacLaren,[5] Edwin Arnold, William Parsons, Mrs. Annie Besant,[6] A. Conan Doyle,[7] Archibald Forbes, Frederic Villiers,[8] Marion Crawford,[9] Hall Caine,[10] Dr. Joseph Parker, R. A. Proctor, Anthony Hope,[11] George Augustus Sala, Israel Zangwill,[12] and Justin Hunley McCarthy, M. P.[13]

With all of these men, he has been successful. Some have not ranked with others,—indeed, the degree of public interest excited by some has far outreached that of others, but the very poorest tour has never been unprofitable. Some proved successful far beyond the hope of their man-

Samuel L. Clemens, "Mark Twain"—Henry M. Stanley and Party at Monterey, Cal.—Paul Blouet, "Max O'Rell," and Child

ager, and some whose fame warranted great public appreciation scarcely reached the measure of what might be termed success. Concerning these, the reminiscences of the major are most interesting.

"Which of your *protégés* failed worst?" I asked him.

"I don't think I ever had a 'worst failure.' I have been disappointed in the drawing power of some men whose fame is wide. One of these was Wilkie Collins, if you can believe it. Great as he was, he had not the gift of lecturing, and what he had to say could not be heard. Mat-

Wm. D. Howells and Daughter

thew Arnold was another disappointment as a lecturer. He made his first appearance in America before one of the finest audiences ever gathered in New York, but he could not be heard beyond the front rows.

"General Grant and his wife had seats in a remote part of the gallery. They strained their ears, but couldn't catch a word. I was near by, and General Grant said: 'We paid to hear the British lion, but he won't roar; so we are going out,' and they went. Nevertheless, for all his poor speaking powers, Matthew Arnold attracted the public, and made much money."

"Who among them succeeded best?" I asked.

"Among Englishmen, Henry M. Stanley, and he earned the most money. On the first occasion that I engaged Stanley, it was at $100 a night, with the proviso that if the King of the Belgians wanted him, he was to leave at once. Henry Ward Beecher[14] advised me to get Stanley, and, at his opening lecture in America, he took the chair. We had a $375 house. Every lecture of his after that drew better.

"I laid out a plan for one hundred lectures, and was in a fair way to make a fortune. Stanley had delivered his eleventh lecture, presided over by Mark Twain, when he received a message from the King of Belgium,

asking him to return at once to head an expedition to Africa in search of Emin Pasha.[15] He left hurriedly. As he was going, he took me by the hand and said, 'I owe you eighty-nine lectures, which I will deliver if ever I come back from Africa.'

"Three years later, he came back a hero. I saw him in London. Managers offered him fabulous sums for lectures. One man offered fifteen hundred dollars a lecture for one hundred lectures. Stanley, however, kept his word with me. I made him an offer of one thousand dollars a lecture for one hundred lectures. In every part of America, he drew packed audiences. He gave one hundred and ten lectures. The average receipts were $2,870 each lecture. Stanley took $1,000, and, after paying expenses, I had the balance. He went back to England with $110,000. That is my record tour."

"Henry Ward Beecher was my greatest American and long-time star," continued the Major, proudly. "He was eleven years under my management, and during that time traveled over 400,000 miles. Mr. Beecher made very nearly $250,000 in that period through his lectures alone. He was my nearest and dearest friend for those eleven years. With the exception of Arizona and New Mexico, there was not a state in the Union that we did not traverse together. In sunshine and in storm, by night, by day, by every conceivable mode of travel, in special Pullman cars, the regular passenger trains, mixed trains, freight trains, on steamboats and rowboats, by stage, and on the backs of mules, I journeyed by his side. He had marvelous powers of endurance as a lecturer. In one season he preached and lectured 232 times in 235 days. Altogether, Mr. Beecher lectured 1,262 times for me."

"Was not Ian MacLaren the most popular lecturer of recent years?" I asked.

"For a short season, Ian MacLaren holds the record. He lectured 107 times in fifty-four days, and in the last two weeks gave thirty lectures. He took away $40,000 as his share of the profits."

"How about other modern speakers?"

"Well, William Parsons, the Irish orator, made from $10,000 to $15,000 a year, for ten years, under my management in this country. Canon Kingsley was a poor speaker, but he made much money. Charles Bradlaugh was also a great attraction, and was much liked by Americans. A. Conan Doyle wouldn't stay long enough. He made $4,000 in

five weeks, and could have made many times as much more. The people liked his manly personality and his manner.

"Edwin Arnold is another lecturer who is also in great favor here. He gave about thirty lectures and readings, five or six years ago, and was making money fast, when illness compelled the sudden abandonment of his tour. I had to return money to people who had paid in advance. I am frequently asked when he is coming back."

There are but a few of Major Pond's Old World "successes." Nearly all of them lectured in the hey-day of their popularity, and only a few could return to-day with any hope of success. Curiously enough, William Parsons held on very long, and still has a following, but the only four who could return with a certainty of success are Ian MacLaren, Henry M. Stanley, A. Conan Doyle, and Edwin Arnold.

Not all celebrities are at the beck of this able manager. Some men have an innate prejudice against the platform, and some are too busy. For twenty years, Mr. Pond sought to secure Gladstone,[16] but he used his persuasive powers in vain. The aged Premier listened genially, but always refused. As far back as 1880, he declined a liberal offer in the following language, which he wrote, as was his custom, on a postal card:—

> *Dear Sir:—*I have to acknowledge the receipt of your letter, with all the kindness it expresses, and the dazzling proposals which it offers. Unhappily, my reply lies not in vague expressions of hope, but in the burden of seventy years, and of engagements and duties beyond my strength, by the desertion of which, even for the time needed, I should really be disentitling myself to the good will of the people of America, which I prize so highly. I remain, dear sir, your most faithful servant, W. E. GLADSTONE.
> *February 7, 1880.*

This did not end the matter. Many times thereafter, Mr. Pond returned to the assault. I recall his saying, not long after one of his regular visits to England, and while Gladstone was still alive: "I made the Grand Old Man one more offer of $20,000 for twenty lectures. Of course, he did not accept, yet if he only knew the reception he would get here, and the anxious, almost feverish desire there is on the part of the people to see him, I think he would be inclined to run across. There

is no building in the country that he could not fill night after night at good prices."

Charles H. Spurgeon was another man who would never come across. Major Pond has an interesting letter of his which tells the story. Here it is:—

NIGHTINGALE LANE,
BALHAM, SURREY,
June 6, 1879.

Dear Sir:—I am not at all afraid of anything you could say by way of temptation to preach or lecture for money; for the whole United States in bullion would not lead me to deliver one such lecture. It would only waste your time and mine for you to see me, though I feel sure that you are one of the pleasantest men upon earth. Your good-natured pertinacity is so admirable that I trust you will not waste it upon an impossible object; but be content to have my acknowledgment that if success could have been achieved, you would have achieved it. Yours, truly,

C. H. SPURGEON.

Still another was John Bright,[17] whom the major angled for over and over again, but without success.

"I met him twice in London," he says, "and submitted propositions for a tour of fifty lectures. He did not discourage me, at first, but, later on, said he thought he was too old to make the trip. 'Besides,' he added, 'why should I go to America? Don't all the Americans come to see me?'"

It will surprise many to learn of the diffidence in this matter of J. M. Barrie.[18] The author of "The Little Minister" met the major's generous proposition with this brief but decisive note:—

No. 133 GRAND ROAD, S. W., February 27, 1897.
Dear Sir:—I thank you for your letter, but not all the king's horses nor all the king's men would induce me to go a-lecturing. Yours truly,

J. M. BARRIE.

Others of the Scottish school look upon the matter differently, as, witness Ian MacLaren; and S. R. Crockett is like him. The latter has not arrived yet, but he has promised to come, and will in a year or so. In a letter from Penicnick, the author of "The Stickit Minister" says: "I am

a sort of hermit crab, you see, and I get glued to my shell up among the mountains." And he adds, in a postscript: "I hai n't been 'Reverend' for a good many years,—indeed, quite the contrary."

Last year, Anthony Hope was Major Pond's best speaker, and the author of the "Prisoner of Zenda" did well enough, indeed. He came just when his book and the play from it were the subjects of popular conversation, and was well received. He gave fifty lectures, which netted him something like $30,000. Not having much new to tell the public, and not desiring to pose as a lecturer, the author of "The Dolly Dialogues" contented himself with reading from his most successful novels.

This year, Major Pond has introduced Israel Zangwill, the eminent Jewish author and critic, as well as Justin Hunley McCarthy, M. P., the translator of Omar's verses.[19] Both of these men are well in the public eye, and have proved fully as popular as it was thought they would be.

The major does not experience so much difficulty in securing American celebrities, and is justifiably proud of the good lecturing work he has done with some of them, particularly with those belonging to what is known as the Lyceum platform. Particularly is he fond of his early work as a manager, and it is pleasant to hear him talk so familiarly, as he can, of the great stars of the Lyceum fifteen and twenty years ago. According to him, no other man in this world ever achieved so much popularity or made such a record in lecturing as Henry Ward Beecher, John B. Gough, and Wendell Phillips.[20] "The Great Triumvirate of Lecture Kings," he calls them, and they were all under his management for the greater part of their lecturing careers.

John B. Gough was, in his estimation, "king of the lecture world in America for forty years." Only Henry Ward Beecher and Wendell Phillips could contest the title with him. "He delivered," says the major, "nine thousand six hundred addresses and lectures in his lifetime, nearly all of them on temperance. For the last ten years of his life, he was under my management. He never asked for a fee in his life. He left his remuneration wholly to his manager. In the ten years with me he earned $30,000 a year. Wendell Phillips was similarly successful. His popularity lasted a lifetime.

"Among all the heroes and explorers that I have had," says the major, "the greatest orator has been Lieutenant Peary,[21] the Arctic explorer. I

have managed three successful seasons for him, and he is still very popular. If he would give up the navy and exploration, and take to lecturing, I am convinced he would eclipse any other lecturer I have had. He is far the best of living lecturers in America."

"Is n't the Lyceum as good and powerful as it ever was?" I once inquired of him.

"No; the intellectual character of the entertainments has been gradually falling. There is seldom a lecture course nowadays that can get support from the general public and be in demand. There will always be some one person more famous and universally popular than all the rest. Just now that person is Rudyard Kipling. His books are in every home, and his name is a household word. Such a man makes average popular lists impossible.

"'To be 'attractions,' heroes must make the history they relate. There will never be another Stanley. I doubt if there will be another George Kennan, who delivered two hundred lectures on two hundred consecutive secular nights, the season after his return from Siberia. Here is Borchgrevingle, the first man to set foot on the Antarctic Continent. Times have so changed that it is impossible to bring this one of the bravest of our young heroes into public demand. Of late, our people have so much to read about and to talk about that even heroes are common.

"In the palmy days of the Lyceum, great magazines were of limited circulation. Now they are almost incalculable. The Sunday newspapers employ a hundred writers where, years ago, they had one. Only the facilities for the manufacture of printing paper have increased in proportion to the writers. The machinery for printing one thousand newspapers an hour, twenty years ago, was considered wonderful. Now, we expect a hundred thousand to be printed in the same space of time, and their pages contain almost everything that is to be said on the subjects of progress, genius, education, reform, and entertainment, that formerly was the function of the Lyceum."

Major Pond, despite the pessimism of this view, still makes the lecture field as profitable as it ought to be, by bringing before the people the celebrities they desire to hear. He has a charming old house, of rural aspect, in the heart of Jersey City, but a half hour's ride from the New York ferry. He has a spacious office in the Everett House in New York, and both places are filled with mementoes suggestive of association

with famous men. His library consists almost entirely of first editions, and every book may be said to be an autograph volume. Not merely signatures of great men are here, but witty sayings and impromptu doggerel, put down to express their kindly sentiments toward him. He has letters by the hundred, every one of which would be well worth fac simile reproduction at any time, which he holds as sacred to himself. One particularly interesting thing I recall just at present is an original check drawn by Charles Dickens in favor of his son, "Charles Dickens, Esq., Junior," for fifty pounds, on June 13, 1863.

Of Rudyard Kipling's script the major has an abundance, most of it interesting reading, of course. One letter in particular is well worth quoting, as it is pure humor and relates to a demand for autographs. It runs:—

Dear MAJOR POND:—Your order of the twenty-second instant has been filled: we trust, to your satisfaction: and the stuff is returned herewith. We did not know that there would be such a mass of timber to put through the mill: and we write to state that your order covers at least two supplementary orders: (*a*) in the case of a young lady aged nineteen, [not in original contract,] and (*b*) an autograph book for which we have supplied one original hardwood verse.

Our mills are running full time, at present, in spite of business depression: but we are very reluctant to turn away any job that offers. Under these circumstances, and making allowances for time consumed repolishing, setting, packing and addressing finished goods, we should esteem it a favor if you would see your way to forwarding an additional ten dollars ($10) to the "Tribune" Fresh Air Fund. Very sincerely yours,

R. KIPLING.

(Autographs supplied on moderate terms: guaranteed sentiments to order: verse a specialty. *No discount for cash.*)

Kipling was then fostering a Fresh Air Fund, and made all autograph hunters contribute to it. The "one original hardwood verse" referred to was the following, inscribed in the major's autograph book:—

In the Iroquois at Buffalo the partnership broke up,
To the melancholy tooting of a six-shot boudoir Krupp;
And the bellboys on the staircase counted pistol crack and oath,
While the partners argued hotly if the earth could hold them both.
"The Story of a Lecture." (RUDYARD KIPLING.)

And so I might go on quoting, but enough has been told. Suffice it to say that the major is a *rara avis* among business managers,—a man with a heart and a sense of generosity. He has the faculty of keeping the monetary side of his association with great men as much in the background as possible. That is his secret. He makes friends with his lecturers, and, what is more, keeps them. They cease to look upon him as an agent, and come to know and cherish him as a friend.

NOTES

"Literary Lions I Have Met," *Success* 2 (25 Feb. 1899): 223–24.

1. Wilkie Collins (1824–89) was an English novelist.

2. Charles Bradlaugh (1833–91) was an English political leader.

3. Matthew Arnold (1822–88) was an eminent English poet and critic.

4. Henry Morton Stanley (1841–1904) was a British explorer in Africa.

5. Ian MacLaren [pseud. of John Watson] (1850–1907) was a Scottish clergyman and author.

6. Annie Besant (1847–1933) was an English theosophist. In 1893 as a reporter for the *St. Louis Globe-Democrat,* Dreiser interviewed Besant, who came to the city to give a lecture.

7. Sir Arthur Conan Doyle (1859–1930) was a British physician, novelist, and detective story writer best known for his character Sherlock Holmes.

8. George William Frederic Villiers (1800–70), the fourth Earl of Clarendon, was a British statesman.

9. Francis Marion Crawford (1854–1909) was an American author of romantic fiction.

10. Hall Caine (1853–1931) was an English novelist.

11. For more on Anthony Hope (1863–1933) see "Anthony Hope Tells a Secret" in this volume.

12. Israel Zangwill (1864–1926) was an English dramatist and novelist. Dreiser wrote "The Real Zangwill," *Ainslee's* 2 (Nov. 1898): 351–57.

13. Justin Hunley McCarthy, M. P. (1861–1936) was an Irish dramatist, novelist, and historian.

14. Henry Ward Beecher (1813–87) was an American clergyman.

15. Mehemet Emin Pasha (1840–92) was a German explorer and administrator in Africa.

16. William Ewart Gladstone (1809–98) was a British statesman and prime minister (1868–74, 1880–85, 1886, 1892–94).

17. John Bright (1811–89) was an English orator and statesman.

18. James Matthew Barrie (1860–1937), a Scottish novelist and dramatist, is best known for *Peter Pan*.

19. Omar Khayyam (d. 1123) was a Persian poet and astronomer best known for his "Rubaiyat."

20. Wendell Phillips (1811–84) was an American orator and reformer.

21. Robert Edwin Peary (1856–1920) was an American explorer.

■ Amelia E. Barr and Her Home Life

Her Early Struggles and Final Success—What She Thinks of Men, Women, and Things

Novel readers are familiar with the name of Amelia E. Barr. She has a record which makes less energetic women stand aside in awe. She has been the mother of fourteen children, has written thirty-two novels, has prepared a professor for Princeton College, and at sixty years of age is fresh and bright, and devotes nine hours daily to her work.

MRS. BARR'S COUNTRY HOME

Every resident of Cornwall-on-the-Hudson knows Mrs. Barr, and can point the way of the winding road which ascends in long lines and curves 1,750 feet above the level of the river before it passes her gate. The mountain side is broad and green, and from the wide veranda, which encircles three sides of the house, the peaks of the Adirondacks can been seen in fine weather and miles and miles of the Hudson. There are orchards and cultivated fields above and below. Comfortable residences of men with plenty of money sit in staid dignity among fine old trees, and an air of reserve in comfort permeates the entire landscape.

Mrs. Barr's home is a house of plenty. It has a dozen or more large rooms, gables and striped awnings, a display of green plants in bright porcelain, and the windows are hung with good lace. Rugs and bric-à-brac, fine pictures and sketches, long shelves of elegantly bound volumes set in polished cases, and great solid pieces of furniture are arranged to invite comfort and ease. There are servants, both men and

Mrs. Barr at Work

women, and last of all Mrs. Barr, as hostess, dressed richly, as becomes her means, and of much amiability, as befits one who is successful.

HER EARLY WORK

This is a very fine picture of success in letters, but fifteen years ago it was very different. Then it was a small apartment in a New York flat-house, a scarcity of even poor furniture, no means of support except a daily round of hack work for the papers, and a number of daughters to support. Mrs. Barr was then not many years in New York. She had been in Texas with her husband, a Scotch Presbyterian minister, who had brought her as his wife from a quiet English home. She had learned the calamitous lesson which love and death can often teach. Yellow fe-ver had killed her husband and all her sons, leaving her helpless with her daughters looking to her for support. She had begun writing, and at the time of the turn in affairs had been writing for fifteen years. Not novels, however, for she did not know she could write a novel, but short stories, poems, editorials, and articles on every conceivable subject, from Herbert Spencer's theories to gentlemen's walking sticks.[1] Dur-

ing the earlier years of this hard apprenticeship she worked on an av-
erage for fifteen hours a day.

HER FIRST NOVEL

Then came an accident. She fell and both dislocated and broke a leg. It
was no time to be ill, but ill she was and the ability to earn anything
temporarily cut short. Her strongest connection was with the *New York
Times,* and after ten days of absence they sent to her for "copy." It was
a friendly inquiry, however, and accompanied by the comforting assur-
ance that her salary would go on, such as it was. The emissary who
called asked about what she had on hand and learned of a story which
she had started, the pages of which lay in the drawer of a wash-stand,
also used for a writing-desk. These he surreptitiously took away, and
did her the service of conferring with a New York publisher concern-
ing the tale. She had quite a reputation as a contributor, poor as she was,
and the book company, seeing indications of great merit in these open-
ing chapters of the story, sent an agent to bargain for its completion
and purchase. He set out with a $200 check in his pocket, but was re-
fused admission to the sick chamber. He insisted, however, brushed past
the guardian daughter, came to where the invalid lay, and explained his
errand. The story had merit; the publishers wanted it; would she take
$200 on account and finish it? She distinctly would and did. Incapac-
itated as she was, a writing chair was brought in and she began toiling
to conclude "Jan Vedder's Wife," which she finished in six weeks. The
publishers thought it fine and rushed it on the market. There was a big
sale, some additional checks for royalty, and then the tide turned. She
launched out as a novelist.

Those who visit the author's pleasant home at Cornwall will find
no trace of all this struggle. The shadow of grief has passed. Instead,
there are merriment and good dinners. Mrs. Barr moves in the picture
as the most natural and important thing in it. She even takes a philo-
sophical view of the past, and if asked about the old days, sees only their
training influence.

"The fifteen years," she said to the writer once, "which I spent work-
ing for the weekly and monthly periodicals were all for good. They gave
me the widest opportunities for information. I was amassing facts and

Library in Mrs. Barr's House

fancies, and developing intelligence. Struggles and sufferings were doing me good. You can't form many characters for successful labor without the aid of much suffering. I had an alcove in the Astor Library, and I practically lived in it. I slept and ate at home, but I practically lived in that City of Books. I was in the prime of life, but neither society nor amusements of any kind could draw me away from the source of all my happiness and profit. Why, at the time when I broke my leg, and said to myself, 'I shall lose all I have gained, I shall fall behind in the race, all things are against me,' they were even then all for me, only I did not know it."

Thus one may see how time can change an individual's point of view.

HER VIEWS OF LIFE

"What do you think of life now?" I asked her.

"It's a very good thing. If you have thought it a very hard thing and a very bad thing, and then matters swing around and the causes of your ill feeling and suffering are taken away, you naturally have, or should have, a better feeling about it. I have. It isn't so much that one has ex-

tra to eat or wear, but the approbation, which is pleasant. You toil, and are rewarded by praise, let us say. That makes toil pleasant."

"You believe, of course, that everyone should work to remove the things that are in the way of happiness?"

"Why, of course. Only I feel also that it is a pleasant thing to help people who are trying to help themselves. The people who are closest to me are young strugglers who are trying to get up in the world. You can interest yourself in and do things for young strugglers which make them dear to you, wherever they come from."

There may be a touch of pathos in this, but with Mrs. Barr it is of a wholesome kind. She has just such a company of "young strugglers," as she calls them, who look up to her with affection and whom she does for, in the way of advice and literary assistance. Young people take to her in a most interesting manner, and it is truthfully related of her that during the last winter, spent at one of the fashionable hotels at Old Point Comfort, the most attended woman of the company of fair young ladies and gracious dames of fashion was Mrs. Barr. She was invariably accompanied by a train of young men, who basked in the sunshine of her radiating good nature, until the younger set remarked it, and common gossip demanded to know why. Finally, one of the more daring asked her: "How is it, Mrs. Barr, that you have so many young men to dance attendance on you all the time?"

"Why?" she answered; "why? Because I understand them and their aspirations. Young women don't. Young men come where they can hear the best sentiments expressed and where they will be encouraged in their ideals." And then she added one of her strongest thrusts at women in general: "Young men are better than young women. They have aims in life and they want to hear what to do. That's what I am constantly telling them."

WHAT SHE SAYS OF WOMEN

Her views concerning women are rather severe. She has the idea that most women are more or less vain, that they are *poseurs* and lack the fine aspiration and spiritual beauty of men. This is, of course, a prejudice, but interesting nevertheless.

"They are a queer lot," she said to me. "Not as good as men, by half; not as developed. They expect everyone to consider their feelings without examining their motives. To-day they are paddling in the turbid maelstrom of life and dabbling in unwomanly affairs and the most unsavory social questions, and yet they still think that men, at least, ought to regard them as the sacred sex. Men are noble about this thing and still generous believers in them. But women are not sacred by grace of sex if they voluntarily abdicate its limitations and its modesties, and make a public display of unsexed sensibilities and unabashed familiarity with subjects they have nothing to do with. If men criticise such women with asperity, it is not to be wondered at; they have so long idealized women that they find it hard to speak moderately. They excuse them too much, or else they are too indignant at their follies. Women want to be criticised by women, and then they will hear the bare uncompromising truth, and be the better for it. But it is good that women should be idealized, for in a measure they are elevated by it."

REWARDS OF LITERATURE

On the subject of rewards of literature Mrs. Barr holds very interesting views. The discussion came about by the asking of whether she wrote a novel a year.

"Just about," she said. "I do fragmentary things between times, such as essays and so on, but manage to finish a novel with some regularity."

"The royalties on all the novels of yours that have been successful ought to make a handsome income by this time?"

"Well, they don't. I never published my books on royalty. I did my first one, which sold immensely well, and got a little over five hundred dollars out of it in dribs and drabs, which I spent as fast as they came. After that I demanded a lump sum of $5,000, selling the work outright. I don't worry over how much the publishers make. I get my $5,000 in such a shape that I can do something with it—buy property or bonds, and that pays; whereas, if I took royalty it would come dribbling in, $300 to $800 the quarter. I would spend it and always be poor."

"Your novels have a great sale in England. Don't you sell the English right for a good sum?"

"No; $5,000 covers everything. I give the American publisher all the

On the Veranda

Summer Home of Mrs. Barr at Cornwall-on-the-Hudson

rights. If I am going to be swindled I would rather be swindled by an American than an Englishman."

"I don't see the logic of that."

"Well, you would if you were an American author. For years I kept the English rights and sold them to an English publisher. When the year was up I would write and write for a settlement, but no answer. Never a word heard I, until I took a ship and strolled into the London office, defiant. Then there was a counting up and a payment, which just about covered my expenses, while my time and trouble went for nothing. Finally I decided not to run any more, and simply sold the whole thing out on this side."

"I count that truckling to injustice."

"Well, maybe so. Anyhow, the English house will have more trouble swindling my American publisher, and I gain some good will here by being liberal. It's the only way."

This system has been profitable in Mrs. Barr's case, anyhow, for with the "lump sums" annually she has been able to buy property and bonds of various kinds until now she has a tidy income and a dignified position in the world of finance. Her Cornwall place is large and well taken care of, the grounds beautiful, the house ornamental, and her style of living fashionable. In winter it is the Fifth Avenue Hotel, in New York, or the Hygeia, at Old Point Comfort, for her, with receptions and social calls, and the concluding of some work to pass away the day. She is a good manager in a way, and holds everything in hand with unrelaxing energy.

Mrs. Barr attributes her vitality and good spirits to her determination to be a philosopher and to her system of work. The quiet country life she finds best suited to her temperament. When she has a book on hand she devotes all her time to it, and she never writes at night. The early morning hours find her up and at work. She writes through the whole forenoon. After dining at noon she sleeps two hours, takes a cold plunge—the second of the day—and then carefully typewrites her morning's work. She never allows anyone to handle her manuscripts. Late in the afternoon come tea, callers, and pleasure, but, no matter what is going on, Mrs. Barr is off to bed at nine o'clock. This routine is carefully followed all the while a book is being written, and after the book is out of the way the author gives herself up to plea-

sure. Her summers are usually spent in England, or were up to a year ago, though she has decided that she will trouble herself to leave America no more.

NOTE

"Amelia E. Barr and Her Home Life," *Demorest's* 35 (Mar. 1899): 103–4. Reprinted in *Selected Magazine Articles,* 1:77–83.

1. In the late 1890s Dreiser was engaged in writing short stories, poems, editorials, and articles on numerous subjects, including Herbert Spencer. Like Barr, he had not yet tried his hand at the novel; shortly after writing this article he began writing *Sister Carrie* in earnest.

■ The Home of William Cullen Bryant

How the Famous American Poet and Journalist Made His Home in the Little Long Island Town of Roslyn, Where He Spent the Last Thirty Five Years of His Life, and Where He Lies Buried

At the head of one of the many bays that indent the northern shore of Long Island, at a point where the inflowing waters from the Sound narrow to a mere creek, whose wavelets wash the doorsteps of pleasant cottages, lies the village of Roslyn. It is an old settlement, and years ago it had more hopes and pretensions than it has today; but it has faltered and lagged in the race of modern progress, and in 1899 it is no more than an unimportant market town, a quiet, peaceful home dwelling community, charming in its rural qualities. A few oystermen "farm" the shallow waters of the bay, a host of clam diggers wait upon the tides in order to turn the wet sand, and fishermen put out into the Sound; but as for commerce, there is none. Such life as the village possesses is mainly due to those who come to it from the great metropolis, which lies within an hour's journey.

The beauty of the region is of the simple order which soothes rather than excites admiration. On the long arm of the sea known as Hempstead Bay, whose fingers of silvery water extend so placidly inland, many little craft sail or ride at anchor. On either hand rise low hills, festooned with the greenery of summer, their grass covered sides dotted with cottages. In the distance, on clear days, the ships of the Sound are seen to pass—some trailing long clouds of smoke, others spreading glorious white sails, like seagulls flying low to drink. Birds fill the thickets with multitudinous carolings; insects and flowers glorify the heights

and hollows with sound and color, and over all a blue sky arches, making the summer day one of cheering and drowsy charm.

Into this region, some fifty-six years ago, at the earliest period of his fortune, when the New York *Evening Post* began to repay him for his long devotion to its interests, came William Cullen Bryant. Through all his career as poet, lawyer, and editor he had never lost his love of rural life, nor the aptitudes that had characterized his young days in Hampshire County, Massachusetts. Almost fifty years of age, he had distinguished himself in the world of letters and the more mixed realm of politics and journalism. He had the love and respect of many of the famous men of his time, and the admiration of all who read English literature. And at Roslyn he decided to dwell for the remainder of his days, a total, as it proved, of thirty-five years.

Years before, so far back as 1825, he had left the region of Plainfield and Great Barrington in Massachusetts, where he had spent the first three decades of his life, and journeyed to New York. He had been a student at Williams College, a contributor of boyish satire to local papers, a student of law at Cummington, and a practitioner at the bar in Plainfield and afterward in Great Barrington. He had also been town clerk of Great Barrington, where the record of his marriage to Frances Fairchild, January 11, 1821, is still to be seen, entered by himself in the capacity of clerk. All these facts, of course, are well known. It is also well known that he found the law unprofitable, and that he betook himself to New York and journalism in the hope of bettering his fortunes.

Once in the city his hopes were destined to suffer severe modification, for the profits of journalism proved small. There was for him nothing but a faithful knuckling down to small taskwork in various literary ways—associating now with one paper and now with another. During this period he wrote for a once lively annual, the *Talisman,* and did other fugitive work, most of which has been lost. He occupied a room in Chambers Street, a thoroughfare now clogged with wholesale merchandise, but then a quiet residence street, on the outskirts of the city.

His employment in those days was not constant, and poetry brought him scanty dollars, so that from time to time the thought came to him of returning again to the practice of law. Journalism was a hard life; and

though he did not despair, some of its moodiness and gloom crept into his verse:

> The trampled earth returns a sound of fear—
> A hollow sound, as if I walked on tombs;
> And lights, that tell of cheerful homes, appear
> Far off, and die like hope amid the glooms.

In the same strain he wrote:

> How fast the flitting figures come!
> The mild, the fierce, the stony face;
> Some bright with thoughtless smiles, and some
> Where secret tears have left their trace.

Beyond doubt, Bryant was homesick, and longed for his northern hills—the hills where he had seen the water fowl, "lone wandering, but not lost," which gave him the idea of that exquisite poem.

By 1828, despite the hardships of living and struggling in the metropolis, he had gained a foothold, and was able to purchase a share in the *Evening Post*. This paper, which had been established as far back as

The View down Hempstead Bay from the Roslyn Road *From a photograph by Tuhill, New York*

1801, was, at Bryant's advent, controlled and largely owned by William Coleman, a New York lawyer. Mr. Coleman, who was old and crippled, no longer cared for active work, and the energetic young New Englander was soon in full charge of the *Post*.

In 1834 Bryant left his desk for a trip to Europe, where he remained for two years. On his return, and for some time afterward, the financial aspects of the paper were not inspiring. Times were bad; he would not make those many little concessions which sometimes bring patronage to a paper. His advocacy of free trade offended some friends; his outspoken hostility to slavery alienated others; and sturdy political independence robbed him of local party advertising and other profitable contracts. Still he stuck to his colors, not grieving over enemies made in fighting for what he counted good.

At one time he wrote to his brother, established in the West, asking as to the chances in that neighborhood, if he could sell out for a few thousands and transport his family there. Before 1844, however, the financial tide had turned, and in President Polk's time the net earnings of the *Post*, of which he was now half owner, were $10,000; in 1850 they had risen to $16,000; in 1860 they counted more than $70,000. After the poet's death his property in the journal he had virtually created sold for something more than $400,000.

At the lift in his fortunes, he began to look about him for a place in the country. It was not long before the beautiful bay at Roslyn caught his attention, and he decided to find on its shores an abode for his remaining years. In 1843 he bought a tract of land there, and wrote to his brother:

> DEAR JOHN: Congratulate me. I have bought forty acres of solid earth at Hempstead Harbor. There, when I get money enough, I mean to build a house.

He did not build, however, since there was a ponderous, Quaker fashioned house upon the site, which, with certain added dependencies, and some properly restrained decorative treatment, made a delightful home for the poet and his family. The place contained many rooms, was surrounded by shrubbery and fine trees, and looked over a shelving lawn to a pretty little fresh water lake. It promised snug retirement and an escape from the toil and noise of a New York newspaper office.

William Cullen Bryant *Drawn by M. Stein from the last photograph of the poet—Copyrighted by George G. Rockwood, New York*

What store he set by this place may be gathered from almost every letter which subsequently issued from his home there. In one of these missives of 1850 he says:

> I have been passing a few days at my place on Long Island, and to-morrow must go back to the town—the foul, hot, noisy town. . . . We have quite given the world the go by today. We have been no further than the garden, from the foot of which we saw this morning a sloop go down the bay, with a fiddle on board, and a score of young women in sunbonnets. . . . The temperature all day has been delightful, and now at two o'clock a delightful breeze has sprung up, which is bringing in at the window the scent of flowers of early summer, and some faint odor of hay fields. If you care for sea bathing, the tide is swelling up, and when it meets the grass I think I shall take a plunge myself.

In another letter, written nine years later, the same feeling holds—a feeling of constant satisfaction, for he writes: "I wish you could take a look at our little place in the country," and then goes on with a poet-

ic description of its surroundings. A friend who visited him at Roslyn wrote:

> It is under the open sky, and engaged in rural matters, that Mr. Bryant is seen to advantage—that is, in his true character. It is here that the amenity and natural sweetness of disposition, sometimes clouded by the cares of life and the outward circumstances of business intercourse, shine greatly forth under the influences of nature, so dear to the heart and so tranquilizing to the spirits of her child. Here the eye puts on its deeper and softer luster, and the voice modulates itself to the tone of affection, sympathy, and enjoyment. Little children cluster about the grave man's steps, or climb his shoulders in triumph, and serenest eyes meet his in fullest confidence, finding there none of the sternness of which casual observers sometimes complain.

That his affection for Cedarmere, as he called his place at Roslyn, was an enduring one is testified by the genial author of "Dream Life," who visited him there about eight years before Bryant's death. From an old notebook Mr. Mitchell (Ik Marvel) has transcribed some of his impressions of the pilgrimage to the veteran poet's home:

> The weather is doubtful as the little steamer Seawanhaka nears the dock at Great Bay. It is questioned if we should take the open carriage, which is drawn up in waiting, or run out (by boat) to the bay of Roslyn; but the voice of that one of the party who would seem least able to brave storms decides for the drive; and away we go through the pleasant roads that skirt the north shore; now brushing the boughs of a veteran wood, now rounding a placid inlet of the Sound, passing scant, quiet hamlets, old country homesteads, orchards, grain fields, wayside churches, seven miles or more, until we rattle down into the little village of Roslyn.
>
> Passing through the village and bearing north, we have at our right a bold, wooded bluff, and at our left a spit of land between the high road and the quiet bay, which there juts with a southward sweep into the Long Island shore. Upon this spit of land are scattered houses—three of which, by their orderly keeping, mark the beginning of Mr. Bryant's property. Farther on, the land between the road and the bay widens so as to give room for a couple of placid little lakelets, lying so high above tidewater as to supply a raceway for a picturesque mill, which stands on the farther shore of the northern pool, embowered in trees. The lands sloping to this pool are lawn-like in keeping, and a swan or two with a brood of ducks are swimming lazily over it; a post

bridge spans the narrowed part, and a skiff lies moored under a boat-house under the northern bank. Eight or ten rods beyond, under the shadow of a great locust and a tulip tree, we catch a glimpse of the homestead. The carriage comes to a stand under a bower of shade.

Along the walk we pass on and up the broad veranda, which sweeps around three sides of the homestead. No martinet-like precision shows in the keeping of either lawn or walks; everywhere turf and garden carry the homelike invitingness of look which testifies to the master-ship of one who loves the country and its delights.

Within doors a great welcoming blaze is upon the parlor hearth—a provision against the damp evenings of early June; piquant souvenirs of wide travel arrest the eye; dashes of watercolor, which friendly artists have contributed to the cheer of the master; a bit of ruin which may be the Roman Forum; a blaze of sunset, which may hover over the blue waters of Capri, or haply a stretch of the Rhone at Avignon; over the mantel a photograph from the fresco of the wonderful "Aurora" of Guido. In the library—no affectation of literary aplomb, or of literary disorder, but only markings of easy, every day, comfortable usage; may-be a little over heaping of such reference books as go—just at this date—to the furnishing or mending of the translation of Homer.

Thus Marvel found him, late in life, and thus he lived at Cedar-mere to the end of his days. Those who knew him well counted him intrepid, persistent, full of the love of justice, and rich in human sym-pathies. He was rather under than over the average height, firmly knit in figure, quick in motion, capable of large fatigues, and counted, by most, an austere man. Certainly he was not given to easy and uncalled for smiles, and invariably weighed his words, except in rare moments of vexation.

Ceremony he abhorred with all its trappings, never seeking willingly the men or the occasions which involved or demanded it. According-ly, for all his fame and influence, he was less than most men on terms of intimacy with office holders or those highly placed socially or finan-cially. He invariably refused all chance of office. It is said by Hawthorne[1] that he affected a New England twang while abroad, which Mitchell accepts as very probable, and attributes to a deep seated, rugged Amer-icanism, wholly unconventionalized by his success in the world. He was often acrid in his writings on public affairs. He carried his impetuosi-ties and prejudices into battle, and this was one reason why he seldom cared to meet political leaders.

The Entrance to Cedarmere from the Great Neck Road

If, however, he had no worship in him for great names or great places, and though his cold, reserved manner was not calculated to extend his range of friendship, he certainly lavished his best and truest social nature on his family and a few tried intimates. Not many of those who encountered him day by day knew where the gentleness lay, or how and in what terms it declared itself. We do not need to inquire at this date, however, for we find ample evidence in his poems. "Autumn Days" is but a simple expression of his long and tender recollection of the sister whom he lost in his early life.

So, too, his deep affection for his wife is now most plain, for among the unpublished poems found at his death was one written fifty-two years after his marriage, and when he had been seven years a widower, living quite lonely:

> Here, where I sit alone, is sometimes heard,
> From the great world, a whisper of my name,
> Joined, haply, to some kind, commending word
> By those whose praise is fame.
>
> And then, as if I thought thou still were nigh,
> I turn me, half forgetting thou art dead,
> To read the gentle gladness in thine eye,
> That once I might have read.

So he lived on, realizing that the end was drawing near. In a letter to the Rev. Orville Dewey, he voices the sentiments of age when he says:

> I do not know how it may be with you, but for my part I feel an antipathy to hard work growing upon me. This morning I have been laboriously employed upon the *Evening Post,* and do not like it. Did you ever feel a sense of satiety—a feeling like that of an uncomfortably overloaded stomach—at the prospect of too much to do? Does the love of ease take possession of us as we approach the period when we must bid the world good night, just as we are predisposed to rest when evening comes?

A good view of the veteran in his very last days is given in the reminiscences of Richard Henry Stoddard, who was one of his friends. Quite the last picture comes in connection with a poem which Stoddard had written in 1878, to recite before the Grand Army of the Republic, and which he had requested Bryant to read and criticise. Two or three days elapsed before the two men met again. Stoddard writes:

> When we did, and had exchanged greetings, he handed me a letter containing his criticisms. I wanted to talk with him, and would have done so but for the presence of one of our impecunious poets, who had evidently called upon him in his editorial room, and who had accompanied him into the business office of the *Evening Post.*
>
> I knew that a money transaction was about to take place, and not wishing, for the honor of the guild, to witness it, I left Mr. Bryant and his brother poet to themselves, noting, as I did so, that the hand of Mr. Bryant was in the act of slipping into his pocket. I folded up his letter, which was the last that he wrote, went away, and never saw him more, for in a week or ten days he was dead.

On Wednesday, May 29, 1878, Mr. Bryant repaired to the office of the *Post,* and, after a morning spent at editorial labor, and an hour for lunch, was driven to Central Park, where he made an address at the unveiling of the statue of Mazzini.[2] Going after ceremony to visit a friend whose residence was in Fifth Avenue, he stumbled at the doorstep and fell, injuring his head. He recovered sufficiently to return to his New York house, where he lingered in a weak, twilight state until, on the 12th of June, he fell into a sleep and passed away.

By order of the mayor the flags of the city were placed at half mast,

and draped portraits of "the good, gray head, which all men knew," were hung in many windows. Funeral services were held in All Souls' Church, after which a special train conveyed the body to Roslyn. It was laid to rest in the village cemetery, where, as he had said years before:

> Through the long, long summer hours,
> The golden light shall lie,
> And thick young herbs and groups of flowers
> Stand in their beauty by.

NOTES

"The Home of William Cullen Bryant," *Munsey's* 21 (May 1899): 240–46. Reprinted in *Selected Magazine Articles*, 1:92–99.

1. For Nathaniel Hawthorne see "Haunts of Nathaniel Hawthorne" in this volume.

2. Giuseppe Mazzini (1805–72) was an Italian patriot who, along with Giuseppe Garibaldi (1807–82), dedicated himself to the unification and independence of Italy.

■ American Women as Successful Playwrights

A Path to Fame and Prosperity Not Always Strewn With Roses—The Stories of Leaders Who Have Won Celebrity and Fortune as Authors of Plays of the Period—Lofty Standards of Dramatic Art

There may be spheres of human endeavor from which women will eventually turn away, as being unsuited to their capabilities, but playwriting will not be one. It has taken only two or three years to demonstrate this fact. In that time several of the great Broadway dramas have been written by women. The most recent, "That Man," by Anita Vivante Chartres, is considered as clever and witty as anything that has appeared in a long time. Again, that refined home of true dramatic art, the Lyceum Theater, has three times produced successful plays by the same woman, Madeline Lucette Ryley, and each time her work has remained deservedly conspicuous in that one place, for the greater part of the season in which it was produced. Lastly, it might be added that the successful translation of Edmond Rostand's "Cyrano de Bergerac,"[1] which Richard Mansfield produced, was made by Miss Gertrude Hall, a young woman who possesses distinguished ability as a writer of poetry and prose.

WOMAN'S SENSE OF HUMOR

We shall need to revise that time-worn philosophic sarcasm which says that women have no sense of humor. It has been dispelled by women in other branches of literature previously, and now it is completely annihilated in the realm of dramatic art. We have had, since 1894, not

less than a dozen successful plays by women, in which the elements of not only humor, but pathos, were delightfully interwoven. And yet the advent of women in this field practically dates from 1893.

Several years ago, Mrs. Minnie Madden Fiske[2] wrote "White Lilies" and some other plays, which showed distinguished dramatic talent; but her fame as an actress so rapidly increased, soon thereafter, that mere dramatic authorship was lost sight of. Mrs. Frances Hodgson Burnett[3] also began to appear, about that time, with interesting dramas, but her repute as a novelist was too well grounded to have this add to her renown. The public considered the drama to be secondary with these two clever women, and so time has proved. They cannot be included in my subject of playwrights.

The women who are mentioned here are serious in their attitude toward the weaving of plays, and have worked hard and long to make a place and a name for themselves in the world of dramatic art. They have many points in common, and yet many distinguishing features, not the least of which is the money-making capacity of their dramas. Madeline Lucette Ryley is clever at weaving intricate complications and introducing humorous lines. Miss Mary Stone has careful construction for her distinguishing trait; Miss Marguerite Merington has happy dialogue, sentiment, and humor; Mrs. Doremus, polished technique; Miss Morton, serious social problems; Miss Ives, rustic scenes; Miss Bascom, character drawing; and Mrs. Pacheco, a well told story.

Mrs. Ryley, whose last play, "An American Citizen," has proved equally as popular as the best of those which have preceded it, is a model of perseverance and courage. She has gained the goal of success after a long struggle, and now has the confidence and favor of the great managers, as well as a large income in royalties from her various plays.

Those who think that Mrs. Ryley won her honors easily, should hear her tell of her experiences. She has written twenty-seven plays, and the *libretti* for four comic operas, of which only six or seven have been very successful. This is no disparagement, for one great play can not only make its author a fortune, but can give him a place in the world's literature for hundreds of years,—as, for instance, "The Rivals." Still, Mrs. Ryley has had seven, and she can produce as many more, if present indications go for anything. She believes in application rather than

Miss Marguerite Merington Miss Mary Stone Mrs. Madeline Lucette Ryley

inspiration, and goes to her desk every morning, in New York or London, between which cities she divides her time, at nine o'clock, and works until five.

"When I take up my work," she says, "trying to think up, or perfect something already begun, I write out a careful analysis of each character I am to use in my play, and con them over until I have all their peculiarities and humors fixed in my mind. When I am as familiar with them as I am with my friends, I write out my play in the form of a story, and put in scraps of dialogue as they occur to me. After I have written a long, full story, I go back and change all of the descriptive matter I can into dialogue and action. Then I cut and throw out until I have condensed the story into the proper length."

Mrs. Ryley was born in London, where she became an actress at the age of fourteen. She was married to J. H. Ryley, the comedian, and came to America to sing in comic opera. She was the original "Patience" in America, and sang in "The Sorcerer," "The Princess of Trebizonde," and other light operas.

THE AUTHOR OF "A SOCIAL HIGHWAYMAN"

No living woman dramatist has written a better play than Miss Mary Stone's "A Social Highwayman." It has become a kind of stage classic, and bids fair to remain well known for a half century, at least. Her style is clear and sympathetic, and her thought deep. All of her plays have a

more serious turn, and partake of a dramatic quality not found in the plays of our other women authors.

Miss Marguerite Merington was famous for her minor poetry before she undertook playwriting. She was a student in one of the convents at Buffalo, and loved to take a hand in preparing the little affairs dramatic which the girls of the convent indulged in, but thought not of writing plays for the general public. No more did she think of the stage when, after graduation, she became an instructor in Greek and Latin in the Normal College of New York. She was witty and clever, however, and often indulged in little comediettas of her own construction, until finally she wrote the *libretto* of a comic opera, "Daphne, or, The Pipes of Pan," in competition for five hundred dollars offer by the New York Conservatory of Music. This was set to music by Arthur Bird, of London, and enacted here and there in society, but never publicly.

Having once gained a prize, her spirit of dramatic construction was aroused, and she wrote two other dramas, "Good-by," and "A Lover's Knot," which were produced in a rather unsatisfactory way, and came to nothing. She began to be heard of, however; and, in 1889, E. H. Southern proposed that she should write him a play, the leading character of which should be a captivating Irish gentleman. With a few suggestions from him, the play, "Captain Letterblair," was written, and proved one of the best mediums for that actor's talent that he had had in a number of years. It was decidedly fascinating, both for its dramatic fervor and its tender and pathetic incidents. Joseph Jefferson,[4] who saw the manuscript before it was publicly produced, praised it highly.

Since that time, Miss Merington has written one other successful play. She has considerable attraction toward steady effort in this direction, but finds her educational connections rather hard to sever. She is one of the women who are gladly listened to by any of the managers, and anything she proposes writing is sought with avidity.

INDUSTRIOUS AND SYSTEMATIC

Miss Martha Morton is a fine type of the industrious and systematic playwright. Since her rise to fame and fortune, she has built herself a house in which she has a small theater, suitable for the working out of her dramatic problems. She is an artist who loves to work out her in-

tricate plots slowly and carefully. Often she uses a chessboard to explain to herself the movements of her characters, at least until she has learned their actions thoroughly. She has made a large fortune out of her various plays, and has a ready and remunerative market for all that she can possibly do.

Since her first success, she has been constantly employed, and has reaped a large profit. Her income has been estimated at ten thousand dollars a year, which is not bad for a self-supporting young woman in 1899.

Not all of our distinguished women playwrights have struggled for recognition merely that they might better their condition. One, at least, whose position in life was already satisfactory, turned to it more as an intellectual diversion. She is Mrs. Romualdo Pacheco, author of "Incog.," "American Assurance," and a half dozen comedy-dramas which have proved successful in the past. Mrs. Pacheco was born in Madison, Indiana, but early removed to California, where her first play was produced. She did not turn to writing plays for a livelihood, but, in a fit of dramatic aspiration, she produced her first drama, "Betrayed," which John McCullough, who was at that time manager of the old California Theater at San Francisco, played. It was successful, and she turned her attention to another. In the meantime, she was married to Romualdo Pacheco, who latterly became governor of California, and United States minister to Central America; and together they traveled a great deal, spending much of their time in New York. Here it was that she produced "Loyal Till Death," "Nothing But Money," "To Nemesis," "American Assurance," and others. "Incog.," which was published in 1892, was the most successful of all, running one hundred nights in New York, and as many in London.

A DISCOURAGING EXPERIENCE

Ada Lee Bascom has produced plays of a very different order from any of the foregoing, but none the less successful. Mrs. Bascom's experience was a little bit discouraging at first, but it has interest. Her first play, "A Daughter of Uncle Sam," was rejected by various managers without comment, until at length one ventured the opinion that it had merit, but was not in his line. "Bring me a play," he said, "with four acts,

Miss Martha Morton Mrs. Ada Lee Bascom

each having a good, thrilling climax, and I will consider it." Mrs. Bascom went away, and in four weeks returned with "The Bowery Girl," which he accepted upon the first reading.

It must be said that she was not without some technical knowledge of the stage when she began her work. She had previously been an actress, and had a very good reputation as a recitationist and dramatic reader. Many of her characters are drawn from real life. Her next play was called "The Queen of Spades," a drama with a woman hero instead of the conventional villain. This was produced successfully, and then taken to England, where Mrs. Bascom now resides. She was born in San Francisco, of Kentucky parents, and takes great pride in her American lineage.

A RESULT OF SPECIAL STUDY

As indicated in the opening of this article, 1894 saw the appearance of several women dramatists, and one of them was Miss Alice Emma Ives, whose play, "The Brooklyn Handicap," was produced at that time. She had come from the West, where she had worked on various newspa-

pers, beginning with those in her home city, Detroit, where she was
born. She had written various plays, unknown to national fame, one
of which, her very first, "Don Roderic," was praised by Lawrence Bar-
rett for its fine dramatic language and heroic flavor. Miss Ives really
attained to great public notice by "The Brooklyn Handicap," which, she
says, cost her many an hour of labor. It has a sensational theme, and
incidents taken from a horse race. "I made a special study of the race
track," she says, "giving up several months to it, in order to make no
mistakes."

Miss Ives now lives in New York, and belongs to several of the prin-
cipal dramatic associations, including the Twelfth Night Club.

YANKEE LIFE DRAMATIZED

Lastly, there should be included the woman who wrote "'Way Down
East," a comedy which partakes of all the charm of "The Old Home-
stead," and yet possesses a much more modern air. It was written by
Mrs. Lottie Blair Parker, a woman almost entirely unknown to the world
when it first appeared. Mrs. Parker had only first thought of writing a
play in 1882, when she saw an announcement in one of the metropoli-
tan papers that a cash prize of five hundred dollars would be given for
the best play submitted to its dramatic department within a given pe-
riod. Among the many manuscripts received was one by her, called
"White Roses," which did not receive the prize, but was given honor-
able mention, and attracted considerable publicity. The notice of it at-
tracted the attention of Daniel Frohman, who sent for it and finally
arranged with the author to produce it at the Lyceum Theater that
spring, in conjunction with "The Gray Mare." He was not much mis-
taken in his judgment. The farce proved somewhat successful, and in-
spired the author to do more. She was, at that time, a hard-working
actress, who used such time as she could save for the observation and
noting of such ideas on human character and incident as would help
her in a possible play. She kept a note book, and out of its fullness was
soon able to construct "Dick of the Plains" for the Empire Theater stock
company, and, later, "The Broken Sword" for the American Academy
of Dramatic Arts, both of which were well received. She did not come

into notice, however, until "'Way Down East" made its long run at the Manhattan Theater.

Mrs. Parker is a playwright of great promise. She has a most delicate sense of humor, and a rare dramatic instinct. She has a favorite saying which speaks well for all she does,—a saying, indeed, that shows in all that she has already done. It is: "I think the greater part of a play is not what is written, but what is conveyed between the lines."

Notes

"American Women as Successful Playwrights," *Success* 2 (17 June 1899): 485–86.

1. Edmond Rostand (1868–1918) was a French poet and dramatist.

2. Minnie Madden Fiske (1865–1932) was an American actress. She gained stardom with her performance in an adaptation of Thomas Hardy's *Tess of the D'Urbervilles.*

3. Frances Hodgson Burnett (1849–1924), an English-born American writer, is best known for *The Secret Garden* and *Little Lord Fauntleroy.*

4. Joseph Jefferson (1829–1905) was an American actor. In Dreiser's *Sister Carrie,* Hurstwood invites Drouet and Carrie to a performance of *Rip Van Winkle* in which Jefferson plays the protagonist.

■ John Burroughs in His Mountain Hut

The visitor to John Burroughs's mountain cabin will, twice out of three times, find that distinguished naturalist and lover of out-of-door life absent. He leaves his little cottage open or closed as the mood pleases. A hospitable rocker or two await the casual visitor in the shade of the little porch. The door of the spring-house is open, where there is cool, sweet water. For greeting there is the mournful coo of a wood-dove and the silence of a mountain of trees.

Mr. Burroughs is as distinguished for his mode of living as for his writings and critical opinions. His little cabin, which lies back of West Park on the Hudson, is representative of his idea of simplicity and seclusion. He has builded it of quarter-sawed logs and bark-covered strips, and has left it bare of ornamentation. Inside it is without plaster or grooved flooring, but clean. Save for the tables and wooden chairs, the few books and papers, the pictures and little oddities of gift and discovery, it is bare. He has indulged himself in the luxury and delight of plain living, to say nothing of high thinking.

The occasion of the writer's visit found the cabin door closed. Sitting in the large wooden rocker, it seemed as if all the countryside had lain down for an afternoon nap. The chair, creaking, sounded unnaturally loud. Even the tinkle and flow of a spring a score of yards away grew distinct as time passed. Latterly the flight of a bird in the bush broke noisily on the ear. Then the faintest breeze wafted a trill of laughter.

Other peals of laughter followed, growing more and more clear, and at last a bevy of young women appeared surrounding the genial natu-

ralist. They were Vassar maidens whom he had been giving the benefit of his keen eyes. He talked and laughed as he bade them good-by.

"Vassar girls," he announced apologetically. "Persons often come to have me show them round, and I like to. I don't mind using my eyes for them, you know."

"You spend all of your time here alone?"

"Nearly all. As you see, visitors will come; but not every day."

After some moments of conversation upon his mode of living Mr. Burroughs left his chair. "I must be getting our supper," he said. Going into the house, he lighted a fire in the great fireplace built by his own hands. As he cleared a table and set it with a few plain dishes the conversation was continued.

"Many persons," I said, "think your way of living is ideal."

"There is nothing remarkable in that. A great many people are very weary of the way they think themselves compelled to live. Following convention, they do the disagreeable things that come up in their daily life. These may be trying and distasteful, but they would rather suffer somewhat than step out of the conventional. Consequently any independent form of existence appeals to them as ideal.

"Thoreau set an example which has influenced many. His secluded life at Walden Pond appealed to Stevenson.[1] It appealed to me. Stevenson's life was colored by it and made more independent. Others are now being influenced by him, and so the gospel spreads. Walt Whitman affects his admirers much the same way. It is not likely that many men will ever content themselves with a hut by the waterside. I believe that something of the freedom and independence of men like Stevenson and Thoreau will come into the lives of all those who admire them. You will find their influence modifying the crowded conditions of cities in time. Men will lead simpler, cleaner, more contented lives for their having set an example."

His table was now spread. He had put on some slices of cold meat, a platter of baked potatoes, a pitcher of milk, a pot of tea, and some white bread. There were sweet cakes and berries, a platter of cracked nuts, and a small pail of cold spring-water. Mr. Burroughs ate sparingly, but with a relish. He lightened the hour with nimble conversation compounded of opinion and experiences. Finally I asked him again about his own life.

John Burroughs
Philosopher, author, recluse

"Students of nature do not as a rule have eventful lives," he said. "Mine was plain enough. I am now 63, and there is not much to speak of.

"My father was a farmer at Roxbury, N. Y., and I was raised among the woods and fields. I won't say that my early surroundings were calculated to awaken the literary faculty. I came from an uncultivated and unreading class, and grew up amid surroundings the least calculated to awaken the literary faculty. Yet I have no doubt that daily contact with the woods and fields awakened my interest in the wonders of nature, and gave me my bent toward investigating them."

"When did you begin to write upon nature?"

"Not before I was 16 or 17. They were mere notes, however. It was

years before I wrote an intelligent paper. Earlier than that the art of composition had anything but charms for me. I remember that while at school, at the age of 14, I was required, like other students, to write compositions at stated times, but I usually evaded the duty one way or another. On one occasion I copied something from a comic almanac and unblushingly handed it in as my own. But the teacher detected the fraud, and ordered me to produce a 12-line composition before I left school. I remember I racked my brain in vain, and the short winter day was almost closing when Jay Gould, who sat in the seat behind me, wrote 12 lines of doggerel on his slate and passed it slyly over to me. I had so little taste for writing that I coolly copied that and handed it in as my own."

"You were friendly with Gould, then?"

"Yes—'chummy,' they call it now. His father's farm was only a little way from ours, and we were fast friends, going home together every evening."

"His view of life must have been somewhat different from yours."

"It was. I always looked upon achievement in life as being more of a mental than a material matter. That is, it was not wealth with me, but intellect. My ideals were literary men. Jay wanted the material appearances. He frankly set forth his objects, and I liked him. He was shrewd, but not a bad fellow at all. I remember that once we had a wrestling match. As we were about even in strength, we agreed to abide by certain rules—taking what we called 'holts' in the beginning, and not breaking them until one or the other was thrown. I kept to this when we began wrestling; but when Jay realized that he was in danger of losing he broke 'holts' and threw me. When I said he had broken his agreement, he only laughed, and said: 'I threw you, didn't I?' That irritated me, and I kept arguing the original point; but he only laughed the more, and covered my taunts with the same answer. He had won, and it pleased him, tho I often wondered how he could take any satisfaction in it."

"Did you ever talk over success in life with him?"

"Yes—often. He was, as I have said, looking forward to material success. Even then he was immensely clever and shrewd at a bargain. He did considerable trading among us schoolboys, and once sold me some of his old books. Even at that time I felt distinctly that I could

At Work on the Piazza

never interest myself in the things he sought. I had a leaning toward the more quiet side of life.

"After I had left the country school I attended the seminary at Ashland and at Cooperstown. I stood only about average in general scholarship, but in composition I was always first.

"I taught six months, and 'boarded round,' before I went to the seminary. That put $50 into my pocket and paid my way. Working on the farm, studying, and teaching filled up the years until 1863, when I went to Washington and found employment for nine years in the Treasury Department.

"I left the department in 1872 to become receiver of a bank, and

subsequently for several years performed the work of a bank examiner. I considered it only as an opportunity to earn and save up a little money on which I could retire. I worked that into a paying condition, and have since given all my time to the study of nature."

"What is your philosophy of life in a nutshell?" I asked.

"Be individual, I should say. I know of no better way to face life and enjoy it. I consider the desire which most individuals have for luxuries which are scared up to tease the palate and make the manufacturer rich to be an error of mind. Those things do not mean anything except a lack of higher ambition in the man who makes them, and a lack of understanding as regards the value of simplicity in the man who buys them. Such wants are unnecessary. Think of all the things people could do without if they chose—all the burden of keep and care they could unload. Those who can not get wealth and retain a noble purpose— how much better for them if they abandoned the chase and sought to sharpen their perception and make their lives examples of individual peace of mind! The person who gets this, and maintains himself in the plainest, cleanest way, is much more admirable to me than the man who gets wealth and loses it. I don't care if a man does no more than build a thatch to cover his head, he can possess his small corner in content and worship at a thousand peace-instilling shrines.

"I confess the realm of power has no fascination for me. I would rather have first this that I have. This log hut is sufficient. I am set down among the beauties of nature, and am in no danger of losing them. No one will take my walks and brook from me. I have enough to eat and to wear, and time to see how beautiful the world is. For the rest—well, others may have it."

"Do you still investigate the smaller forms of life much?"

"To a certain extent. I still climb an occasional tree to study the birds. My work is more often lying by the waterside to watch the fishes, sitting still in the grass for hours to study the insects, and tramping here and there—always to observe and study whatever is common to the woods and fields."

"In short, you live to broaden and enjoy our own life?"

"That would seem a selfish end, and it is not so. I should rather say I live as I do because of an innate tendency—a physical call to this sort of life. Men who, like myself, are deficient in self-assertion, or whose

personalities are flexible and yielding, make a poor show in business. In certain other fields, however, the defects become advantages. Certainly it is so in my case. I can succeed with bird or beast, for I have cultivated my ability in that direction. I can look in the eye of an ugly dog and subdue and win; but with an ugly man I have less success."

"Your success, then, has come by your living close to plants and animals and coming to understand them?"

"Yes. And yet I must add that if I ran after birds only to write about them I should never have written anything that any one else would have cared to read. I must write from sympathy and love—that is, from enjoyment—or not at all. I must come gradually to have a feeling that I want to write upon a given theme. Whenever the subject recurs to me it must awaken a warm, personal response. My confidence that I ought to write comes from the attraction which some subjects exercise over me. The work is pleasure and the result gives pleasure."

Here we closed. The shadows of the night had descended, and the trees about his isolated cabin ranged like a huge black wall. There was no light any where save from the clear stars overhead and the yellow flame in the fireplace inside. Light winds moved the trees to murmuring and the spring trickled audibly. When I went away the gentle, light-hearted recluse came down the long hillside path with me to "put me right." His many years and white hair seemed to sit as nothing upon him. He was merry. When safe in the open road I watched him retrace his steps up the steep, dark path, lantern in hand and singing. Long after the light melody had died away I saw the serene glimmer of the lantern bobbing up and down, disappearing and then reappearing. Finally it was gone altogether. The lone philosopher had repaired to his cabin and couch of content.

NOTE

"John Burroughs in His Mountain Hut," *New Voice* 16 (19 Aug. 1899): 7, 13. Reconstructed, verbatim in some places, from "Fame Found in Quiet Nooks—John Burroughs," *Success* 1 (Sept. 1898): 5–6. This article in *Success* was reprinted in *Selected Magazine Articles*, 1:50–56.

1. Robert Louis Stevenson.

Appendix:
Dreiser's Magazine Articles, 1897–1902

The following is a complete list of freelance magazine articles Dreiser wrote before *Sister Carrie* was published in November 1900. Since several articles published in 1901 and 1902 seem to have been prepared during, if not before, the writing of *Sister Carrie* (1899–1900), they are included in this list. All articles were signed by Dreiser unless otherwise noted.

The articles preceded by an asterisk (*) are included in this collection. Those preceded by a plus sign (+) are included in *Selected Magazine Articles of Theodore Dreiser: Life and Art in the American 1890s*, 2 vols., ed. Yoshinobu Hakutani (Rutherford, N.J.: Fairleigh Dickinson University Press, 1985, 1987).

1. "On the Field of Brandywine," *Truth* 16 (6 Nov. 1897): 7–10.

2. "New York's Art Colony," *Metropolitan* 6 (Nov. 1897): 321–26. Signed "Theodore Dresser."

*3. "Our Women Violinists," *Puritan* 2 (Nov. 1897): 34–35.

+4. "The Haunts of Bayard Taylor," *Munsey's* 18 (Jan. 1898): 594–601.

*5. "A High Priestess of Art: Alice B. Stephens," *Success* 1 (Jan. 1898): 55. Signed "Edward Al."

6. "A Talk with America's Leading Lawyer," *Success* 1 (Jan. 1898): 40–41.

+7. "The Art of MacMonnies and Morgan," *Metropolitan* 7 (Feb. 1898): 143–51.

+8. "Henry Mosler, a Painter for the People," *Demorest's* 34 (Feb. 1898): 67–69.

+9. "A Photographic Talk with Edison," *Success* 1 (Feb. 1898): 8–9.

*10. "Anthony Hope Tells a Secret," *Success* 1 (Mar. 1898): 12–13. Reprinted as "A Secret Told by Anthony Hope" in *How They Succeeded: Life Stories of Successful Men Told by Themselves,* ed. Orison Swett Marden (Boston: Lothrop, 1901), 300–305.

*+11. "Historic Tarrytown: Washington Irving," *Ainslee's* 1 (Mar. 1898): 25–31.

12. "A Vision of Fairy Lamps," *Success* 1 (Mar. 1898): 23. Signed "Edward Al."

*13. "Work of Mrs. Kenyon Cox," *Cosmopolitan* 24 (Mar. 1898): 477–80.

*14. "Art Work of Irving R. Wiles," *Metropolitan* 7 (Apr. 1898): 357–61.

+15. "Benjamin Eggleston, Painter," *Ainslee's* 1 (Apr. 1898): 41–47.

+16. "The Harp," *Cosmopolitan* 24 (Apr. 1898): 637–44.

*17. "How He Climbed Fame's Ladder: William Dean Howells," *Success* 1 (Apr. 1898): 5–6. Reprinted as "How He Worked to Secure a Foothold" in *How They Succeeded,* 171–84. Reprinted as "A Printer's Boy, Self-Taught, Becomes the Dean of American Letters—William Dean Howells" in *Little Visits with Great Americans,* ed. Orison Swett Marden (New York: Success Company, 1903), 283–95, and in *American Literary Realism* 6 (Fall 1973): 339–44.

18. "A Prophet, but Not without Honor," *Ainslee's* 1 (Apr. 1898): 73–79. Signed "Edward Al."

*19. "The American Water-Color Society," *Metropolitan* 7 (May 1898): 489–93.

+20. "A Great American Caricaturist," *Ainslee's* 1 (May 1898): 336–41.

*21. "Artists' Studios: Hints Concerning the Aim of All Decoration," *Demorest's* 34 (June 1898): 196–98.

*22. "A Painter of Travels: Gilbert Gaul," *Ainslee's* 1 (June 1898): 391–98.

23. "Where Battleships Are Built," *Ainslee's* 1 (June 1898): 433–39. Signed "Edward Al."

24. "Carrier Pigeons in War Time," *Demorest's* 34 (July 1898): 222–23.

25. "The Making of Small Arms," *Ainslee's* 1 (July 1898): 540–49.

26. "Scenes in a Cartridge Factory," *Cosmopolitan* 25 (July 1898): 321–24.

+27. "The Harlem River Speedway," *Ainslee's* 2 (Aug. 1898): 49–56.

*+28. "Haunts of Nathaniel Hawthorne," *Truth* 17 (21 Sept. 1898): 7–9; (28 Sept. 1898): 11–13.

*29. "America's Sculptors," *New York Times Illustrated Magazine* (25 Sept. 1898): 6–7.

+30. "Brandywine, the Picturesque, after One Hundred and Twenty Years," *Demorest's* 34 (Sept. 1898): 274–75.

+31. "Fame Found in Quiet Nooks," *Success* 1 (Sept. 1898): 5–6.

+32. "The Sculpture of Fernando Miranda," *Ainslee's* 2 (Sept. 1898): 113–18.

+33. "Great Problems of Organization III: The Chicago Packing Industry," *Cosmopolitan* 25 (Oct. 1898): 615–26.

+34. "Life Stories of Successful Men—No. 10, Philip D. Armour," *Success* 1 (Oct. 1898): 3–4.

+35. "The Smallest and Busiest River in the World," *Metropolitan* 7 (Oct. 1898): 355–63.

*+36. "Birth and Growth of a Popular Song," *Metropolitan* 8 (Nov. 1898): 497–502.

37. "Life Stories of Successful Men—No. 11, Chauncey M. Depew," *Success* 1 (Nov. 1898): 3–4.

+38. "The Real Zangwill," *Ainslee's* 2 (Nov. 1898): 351–57. Reprinted in part in *Theodore Dreiser: A Selection of Uncollected Prose,* ed. Donald Pizer (Detroit: Wayne State University Press, 1977), 124–30.

+39. "Life Stories of Successful Men—No. 12, Marshall Field," *Success* 2 (8 Dec. 1898): 7–8.

40. "A Leader of Young Manhood, Frank W. Gunsaulus," *Success* 2 (15 Dec. 1898): 23–24.

+41. "The Treasure House of Natural History," *Metropolitan* 8 (Dec. 1898): 595–601.

+42. "When the Sails Are Furled: Sailor's Snug Harbor," *Ainslee's* 2 (Dec. 1898): 593–601.

+43. "He Became Famous in a Day," *Success* 2 (28 Jan. 1899): 143–44.

+44. "Electricity in the Household," *Demorest's* 35 (Jan. 1899): 38–39.

+45. "The Making of Stained-Glass Windows," *Cosmopolitan* 26 (Jan. 1899): 243–52.

*+46. "His Life Given Up to Music: Theodore Thomas," *Success* 2 (4 Feb. 1899): 167–68. Reprinted as "How Theodore Thomas Brought People Nearer to Music" in *How They Succeeded*, 314–26.

*47. "America's Greatest Portrait Painters," *Success* 2 (11 Feb. 1899): 183–84.

+48. "The Career of a Modern Portia," *Success* 2 (18 Feb. 1899): 205–6.

*49. "Literary Lions I Have Met," *Success* 2 (25 Feb. 1899): 223–24.

+50. "The Chicago Drainage Canal," *Ainslee's* 3 (Feb. 1899): 53–61.

*51. "E. Percy Moran and His Work," *Truth* 18 (Feb. 1899): 31–35.

*52. "Karl Bitter, Sculptor," *Metropolitan* 9 (Feb. 1899): 147–52.

*53. "A Painter of Cats and Dogs: John Henry Dolph," *Demorest's* 35 (Feb. 1899): 68–69.

*+54. "Amelia E. Barr and Her Home Life," *Demorest's* 35 (Mar. 1899): 103–4.

+55. "Edmund Clarence Stedman at Home," *Munsey's* 20 (Mar. 1899): 931–38.

56. "The Town of Pullman," *Ainslee's* 3 (Mar. 1899): 189–200.

+57. "Women Who Have Won Distinction in Music," *Success* 2 (8 Apr. 1899): 325–26.

58. "Japanese Home Life," *Demorest's* 35 (Apr. 1899): 123–25.

+59. "The Real Choate," *Ainslee's* 3 (Apr. 1899): 324–33.

*+60. "The Home of William Cullen Bryant," *Munsey's* 21 (May 1899): 240–46.

+61. "The Horseless Age," *Demorest's* 35 (May 1899): 153–55.

+62. "A Monarch of Metal Workers," *Success* 2 (3 June 1899): 453–54.

+63. "A Master of Photography," *Success* 2 (10 June 1899): 471.

*64. "American Women as Successful Playwrights," *Success* 2 (17 June 1899): 485–86.

+65. "The Foremost of American Sculptors," *New Voice* 16 (17 June 1899): 4–5, 13.

*66. "American Women Who Play the Harp," *Success* 2 (24 June 1899): 501–2.

*67. "Concerning Bruce Crane," *Truth* 18 (June 1899): 143–47.

68. "Human Documents from Old Rome," *Ainslee's* 3 (June 1899): 586–96.

69. "An Important Philanthropy," *Demorest's* 35 (July 1899): 215–17.

+70. "The Log of an Ocean Pilot," *Ainslee's* 3 (July 1899): 683–92.

*71. "John Burroughs in His Mountain Hut," *New Voice* 16 (19 Aug. 1899): 7, 13. Reconstructed, verbatim in some places, from "Fame Found in Quiet Nooks—John Burroughs," *Success* 1 (Sept. 1898): 5–6.

+72. "Christ Church, Shrewsbury," *New York Times Illustrated Magazine* (27 Aug. 1899): 12–13.

+73. "From New York to Boston by Trolley," *Ainslee's* 4 (Aug. 1899): 74–84. Signed "Herman D. White."

74. "A Notable Colony," *Demorest's* 35 (Aug. 1899): 240–41. Reconstructed with substantial changes in content from "New York's Art Colony," *Metropolitan* 6 (Nov. 1897): 321–26.

75. "It Pays to Treat Workers Generously," *Success* 2 (16 Sept. 1899): 691–92.

*76. "American Women Violinists," *Success* 2 (30 Sept. 1899): 731–32.

+77. "C. C. Curran," *Truth* 18 (Sept. 1899): 227–31.

*78. "The Camera Club of New York," *Ainslee's* 4 (Oct. 1899): 324–35.

*79. "American Women Who Are Winning Fame as Pianists," *Success* 2 (4 Nov. 1899): 815.

+80. "Curious Shifts of the Poor," *Demorest's* 36 (Nov. 1899): 22–26. Each of the scenes in the article was incorporated into chapter 45, "Curious Shifts of the Poor," and chapter 47, "The Way of the Beaten: A Harp in the Wind," of *Sister Carrie* (New York: Doubleday, Page, 1900). Reprinted in *Sister Carrie*, ed. Donald Pizer (New York: Norton, 1970), 403–12; *American Thought and Writing: The 1890's*, ed. Donald Pizer (Boston: Houghton Mifflin, 1972), 288–97; and *Uncollected Prose*, 131–40. The second scene was republished as "The Men in the Storm" in *The Color of a Great City* (New York: Boni and Liveright, 1923).

81. "Our Government and Our Food," *Demorest's* 36 (Dec. 1899): 68–70.

82. "Atkinson on National Food Reform," *Success* 3 (Jan. 1900): 4. Signed "Edward Al."

*+83. "The Story of a Song-Queen's Triumph: Lillian Nordica," *Success* 3 (Jan. 1900): 6–8. Reprinted as "Nordica: What It Costs to Become a Queen" in *How They Succeeded*, 149–70. Reprinted as "A Great Vocalist Shows That Only Years of Labor Can Win the Heights of Song—Lillian Nordica" in *Little Visits with Great Americans*, 541–57.

+84. "The Trade of the Mississippi," *Ainslee's* 4 (Jan. 1900): 735–43.

+85. "Little Clubmen of the Tenements," *Puritan* 7 (Feb. 1900): 665–72.

+86. "The Railroad and the People," *Harper's Monthly* 100 (Feb. 1900): 479–84.

+87. "The Real Howells," *Ainslee's* 5 (Mar. 1900): 137–42. Reprinted in *Americana* 37 (Apr. 1943): 274–82; *American Thought and Writing*, 62–68; *American Literary Realism* 6 (Fall 1973): 347–51; and *Uncollected Prose*, 141–46.

88. "New York's Underground Railroad," *Pearson's* 9 (Apr. 1900): 375–84.

89. "Good Roads for Bad," *Pearson's* 9 (May 1900): 387–95.

90. "Champ Clark, the Man and His District," *Ainslee's* 5 (June 1900): 425–34.

91. "The Descent of the Horse: Tracing the Horse's History 2,000,000 Years," *Everybody's* 2 (June 1900): 543–47.

92. "Thomas Brackett Reed: The Story of a Great Career," *Success* 3 (June 1900): 215–16.

+93. "The Transmigration of the Sweat Shop," *Puritan* 8 (July 1900): 498–502.

94. "Apples," *Pearson's* 10 (Oct. 1900): 336–40.

95. "Fruit Growing in America," *Harper's Monthly* 101 (Nov. 1900): 859–68.

*+96. "Whence the Song," *Harper's Weekly* 44 (8 Dec. 1900): 1165–66a. Illustrated by William J. Glackens. Reprinted, with minor stylistic alterations, in *The Color of a Great City*, 242–59.

97. "Why the Indian Paints His Face," *Pearson's* 11 (Jan. 1901): 19–23.

98. "Delaware's Blue Laws," *Ainslee's* 7 (Feb. 1901): 53–57.

*99. "Lawrence E. Earle," *Truth* 20 (Feb. 1901): 27–30.

100. "Rural Free Mail Delivery," *Pearson's* 11 (Feb. 1901): 233–40.

101. "The Story of the State No. III—Illinois," *Pearson's* 11 (Apr. 1901): 513–43. Edited by William Penn Nixon.

+102. "Plant Life Underground," *Pearson's* 11 (June 1901): 860–64.

*+103. "The Color of To-Day: William Louis Sonntag," *Harper's Weekly* 45 (14 Dec. 1901): 1272–73. Reprinted, with many stylistic revisions, as "W. L. S." in Dreiser's *Twelve Men* (New York: Boni and Liveright, 1919), 344–60.

+104. "A True Patriarch: A Study from Life," *McClure's* 18 (Dec. 1901): 136–44.

105. "The New Knowledge of Weeds: Uses of the So-Called Pests of the Soil," *Ainslee's* 8 (Jan. 1902): 533–38.

+106. "A Cripple Whose Energy Gives Inspiration," *Success* 5 (Feb. 1902): 72–73.

107. "A Touch of Human Brotherhood," *Success* 5 (Mar. 1902): 140–41. Reconstructed, verbatim in some places, from the story of the captain in "Curious Shifts of the Poor," *Demorest's* 36 (Nov. 1899): 22–26.

+108. "The Tenement Toilers," *Success* 5 (Apr. 1902): 213–14, 232.

*109. "A Remarkable Art: Alfred Stieglitz," *Great Round World* 19 (3 May 1902): 430–34. Unsigned. Reconstructed from "A Master of Photography," *Success* 2 (10 June 1899): 471.

110. "A Doer of the Word," *Ainslee's* 9 (June 1902): 453–59. Reprinted in *Twelve Men*, 53–75.

+111. "Christmas in the Tenements," *Harper's Weekly* 46 (6 Dec. 1902): 52–53.

Index

Yoshinobu Hakutani is a professor of English at Kent State University. He is the author of *Young Dreiser* and the editor of *Theodore Dreiser and American Culture* and the two-volume collection *Selected Magazine Articles of Theodore Dreiser*.

Typeset in 10.5/13 Minion
with Minion display
Designed by Paula Newcomb
Composed by Celia Shapland
for the University of Illinois Press
Manufactured by Thomson-Shore, Inc.

University of Illinois Press
1325 South Oak Street
Champaign, IL 61820-6903
www.press.uillinois.edu